T0408055

Rethinking Heritage for Sustainable Development

Rethinking Heritage for Sustainable Development

Sophia Labadi

First published in 2022 by
UCL Press
University College London
Gower Street
London WC1E 6BT

Available to download free: www.uclpress.co.uk

Text © Sophia Labadi, 2022
Images © copyright holders named in captions, 2022

The author has asserted her rights under the Copyright, Designs and Patents Act 1988
to be identified as the author of this work.

A CIP catalogue record for this book is available from The British Library.

Any third-party material in this book is not covered by the book's Creative Commons
licence. Details of the copyright ownership and permitted use of third-party material
is given in the image (or extract) credit lines. If you would like to reuse any third-party
material not covered by the book's Creative Commons licence, you will need to obtain
permission directly from the copyright owner.

This book is published under a Creative Commons Attribution-Non-Commercial 4.0
International licence (CC BY-NC 4.0), https://creativecommons.org/licenses/by-nc/
4.0/. This licence allows you to share and adapt the work for non-commercial use pro-
viding attribution is made to the author and publisher (but not in any way that sug-
gests that they endorse you or your use of the work) and any changes are indicated.
Attribution should include the following information:

Labadi, S. 2022. *Rethinking Heritage for Sustainable Development*. London: UCL Press.
https://doi.org/10.14324/111.9781800081925

Further details about Creative Commons licences are available at
https://creativecommons.org/licenses/

ISBN: 978-1-80008-194-9 (Hbk)
ISBN: 978-1-80008-193-2 (Pbk)
ISBN: 978-1-80008-192-5 (PDF)
ISBN: 978-1-80008-195-6 (epub)
DOI: https://doi.org/10.14324/111.9781800081925

Contents

List of figures and tables

Figures

Table

List of acronyms and initialisms

AECID	Agency of International Cooperation for Development
ALIPH	International Alliance for the Protection of Heritage in Conflict Areas
ANAC	National Administration of Conservation Areas
AU	African Union
CAWHFI	Central Africa World Heritage Forest Initiative
CITES	Convention on International Trade in Endangered Species of Wild Fauna and Flora
ECOSOC	United Nations Economic and Social Council
EIG	Economic Interest Group
EU	European Union
FAO	Food and Agriculture Organisation
FGC	female genital cutting/circumcision
FRELIMO	Mozambique Liberation Front
GDP	gross domestic product
HUL	historic urban landscape
ICOM	International Council on Museums
ICOMOS	International Council on Monuments and Sites
IFACCA	International Federation of Arts Councils and Culture Agencies
IFCCD	International Federation of Coalitions for Cultural Diversity
ILO	International Labour Organisation
IUCN	International Union for Conservation of Nature
MDG	Millennium Development Goal
MDG-F	Millennium Development Goals Achievement Fund
MENA	Middle East and North Africa
NGO	non-governmental organisation
NSC	National Steering Committee
OECD	Organisation for Economic Co-operation and Development
PMC	Programme Management Committee
PMU	Programme Management Unit

SDG	Sustainable Development Goal
SRH	sexual and reproductive health
UCGL	United Cities and Local Governments
UK	United Kingdom
UN	United Nations
UNDAF	United Nations Development Assistance Frameworks
UNDP	United Nations Development Programme
UNEP	United Nations Environment Programme
UNESCO	United Nations Educational, Scientific and Cultural Organisation
UNFPA	United Nations Population Fund
UNHCR	United Nations Refugee Agency
UNIDO	United Nations Industrial Development Organisation
UNWTO	United Nations World Tourism Organisation
US	United States
USAID	United States Agency for International Development
WTO	World Trade Organisation

Acknowledgements

This research would not have been possible without the generous financial support of the Arts and Humanities Research Council in the UK (Grant Ref: AH/S001972/1), the University of Kent (UK), and the Caligara Foundation (Italy). I am grateful for the helpful suggestions – and generous support – from the anonymous reviewers of the grant applications. At the University of Kent, Gordon Lynch and Andrew Massoura provided countless valuable comments that helped to shape the project and ensure that my funding applications were successful. I am very grateful to Ellen Swift for having helped to shape the grant application, for essential feedback provided, often at very short notice, and for having assisted with the grant management. My deepest gratitude to Shane Weller, who provided professional support, and often believed in me more than I will ever believe in myself.

The two official partners of the project – the African World Heritage Fund and ICOMOS-UK provided essential support. At the African World Heritage Fund, I am particularly indebted to Albino Jopela for many discussions on the topic and for his support, particularly for the fieldwork in Mozambique, and to Souayibou Varissou for his astute comments on the text and for sharing his expertise. At ICOMOS-UK, Clara Arokiasamy and Susan Denyer provided useful and critical comments on the results; Caroline Sandes and Anthea Longo were crucial in promoting discussions of my ideas.

I am grateful to the international advisory group who believed in the research from the start and provided comments at its different stages: Stefania Abakerli (World Bank), Tim Badman (IUCN), May Cassar (UCL), Jyoti Hosagrahar (UNESCO), Aylin Orbasli (Oxford Brookes University), Mike Robinson (University of Birmingham), and Ege Yildirim (ICOMOS). Paul Basu (SOAS) also helped to shape the original project. George Abungu served as consultant for the project, and provided countless advice and comments, during its different phases.

Francesca Giliberto was a phenomenal post-doctoral associate and an amazing moral support, who conducted some background research at UNESCO (Paris) and the World Bank (Washington), undertook additional research on similar projects in the MENA region, commented on the draft chapters and the recommendations, participated in the final meetings, and helped to build and maintain the project website at https://blogs.kent.ac.uk/heritagefordevelopment/.

I am thankful to Ibrahima Thiaw and Mouhamed Ly (both from Cheikh Anta Diop University) for facilitating the data collection in Senegal, and for comments and corrections provided during the final meeting of the project. I could not dream of a better research assistant in Senegal than Yvette Senghor (Cheikh Anta Diop University), who assisted with conducting interviews, discussed various aspects of the research, and shared my love of the Jamel Comedy Club. Youssou (at Keur Youssou) in Toubacouta was not only a great host, but tracked and contacted most of the project participants in the Saloum Delta.

In Mozambique, Énio Tembe (Kaleidoscopio) was a highly committed research assistant who also provided insightful comments on the data, results, and recommendations, and checked some of the data multiple times over the course of the research. Euclides Gonçalves (Kaleidoscopio) provided logistical support and facilitated the data collection. I am thankful to Solange Macamo and Kátia Filipe (Eduardo Mondlane University) for helping with the final meetings.

I am eternally grateful to those who participated in different meetings on the topic and/or read chapters and enriched the manuscript with their comments and edits, including Muhammad Muhammad Juma, Susanna Kari, and Enathe Hasabwamariya from UNESCO (Paris); Sidonio Matusse from UNESCO (Maputo); Alison Heritage and Nicole Franceschini from ICCROM; Angela Martins from the African Union; Ilaria Rosetti and Linda Shetabi from the ICOMOS Sustainable Development Working Group; Alice Biada from ICOMOS Cameroon; Alpha Diop from ICOMOS Mali; Tokie Brown from ICOMOS Nigeria; Harriet Hoffler from the UK Department for Digital, Culture, Media and Sport (DCMS); Nikki Locke from the British Council; Olga Bialostocka from the Human Sciences Research Council of South Africa; Didier Houénoudé from Abomey-Calavi University; Pascal Assine, Lamine Badji, Maimouna Diallo, Nazir Ndour, Abdou Sall, and Aminata Sonko from Cheikh Anta Diop University; Felicia Fricke from the University of Copenhagen; Stela Gujamo, Filipe Mate, and Daniel Zacarias from Eduardo Mondlane University; Mark Watson from Historic Scotland; Karl Goodwin from the University of Kent; Keya

Khandaker from the University of Leeds; Cornelius Holtorf and Annalisa Bolin from Linnaeus University; Antonios Vlassis from the University of Liège; Loes Veldpaus from Newcastle University; Florentine Okoni from Université Paris 1 Panthéon-Sorbonne; Janet Blake from Shahid Beheshti University; Claudio Zonguene from the Conservation Office of the Island of Mozambique; and the independent consultants Haifaa Abdulhalim, Rim Kelouaze, Njeri Mbure, and Dennis Rodwell.

I have no words adequate to thank Peter Gould (University of Pennsylvania) for his detailed comments on the manuscript, and for sharing with me his in-depth knowledge of heritage for development.

This book was written during the difficult times of the Covid-19 pandemic. My family provided unfailing support. My four-year-old daughter Clarys taught me about the logic of persuasion and argumentation, and about many facets of gender stereotyping. Damien, my partner, undertook some of the domestic and care work, particularly when schools were closed, so that this book could be completed. This book is dedicated to him.

1
Introduction

Neglecting heritage in the Sustainable Development Goals

Agenda 2030, adopted by the United Nations (UN) in 2015, identifies 17 interconnected Sustainable Development Goals (SDGs) and 169 associated targets to address the most pressing challenges of our times, ranging from the fight against poverty, hunger and climate change to the reduction of inequalities. Inclusive and ambitious, these goals are intended to leave no one behind. They have influenced the actions of international and intergovernmental organisations and governments around the world and have dictated priorities for international aid spending. Indeed, the whole world is marching to the tune of these SDGs. In 2018, 72 per cent of companies mentioned them in their annual corporate or sustainability report.[1] Universities worldwide have incorporated the goals into their operations, and some higher education rankings are now based on their implementation, for example that of *The Times* in the United Kingdom (UK). Non-governmental organisations (NGOs) all over the world have adopted the language of the SDGs and are working towards achieving their key targets, while local efforts towards their realisation are being addressed by concerned-citizens groups, libraries, and local business owners. The UN has even published *The Lazy Person's Guide to Saving the World*,[2] which gives practical tips from turning the lights off when watching TV to printing less and taking shorter showers. The Covid-19 pandemic, the most challenging crisis the world has faced since the Second World War, has been considered by many a wake-up call to accelerate the implementation of the SDGs.[3]

Culture, including tangible and intangible heritage, is often presented as fundamental to addressing the SDGs: since 2010 the UN has adopted no fewer than five major policy recommendations that assert its importance as a driver and enabler of development. Heritage has been

considered a driver of economic development, with international tourism one of the fastest-growing economic sectors until Covid-19. Millions of people have visited cities such as Paris, Venice, and Dubrovnik annually, facilitated by affordable travel, disposable income, and the necessary infrastructure. Tourism has been very resilient in previous crises and has shown speedy recovery. Hence it is predicted that cultural tourism will continue to be a strong driver of development in a post-coronavirus world. But heritage is more than just a driver of the economy. Woven into many of our everyday actions, it provides a gateway to many other aspects of development. In 2017 I attended a talk by Mark Lowcock, given during an 'International Development Summit' organised by the Arts and Humanities Research Council in London, in which he discussed his work as Permanent Secretary of the UK Department for International Development. He explained that heritage is necessary for achieving the goal of good health, and used the Ebola virus as an example. The spread of Ebola in West Africa from 2013 to 2016 was partly due to intangible heritage practices, including funeral traditions that involved close physical contact with the deceased. Curbing the spread of the disease required working with local community leaders and members to modify these rituals. Considering the fundamental role of culture (including heritage), it is not surprising that the UN has adopted so many recommendations on the topic. A number of these recommendations were adopted at the same time as the major campaign 'The Future We Want Includes Culture', and the Twitter hashtag '#culture2015goal', which demanded a separate goal dedicated to culture and heritage in the 2030 Agenda.

If heritage (and culture in general) is so important for addressing global challenges, then why has it been marginalised from the SDGs? Heritage is directly mentioned in only one of the 169 targets (Target 11.4), which aims to 'strengthen efforts to protect and safeguard the world's cultural and natural heritage', which is part of Goal 11: to 'make cities and human settlements inclusive, safe, resilient and sustainable'. Some consider even this brief mention a major victory, since heritage was completely absent in previous international development frameworks. My concern is that this target focuses only on the protection of heritage. It does not link the protection and safeguarding of heritage to any broader challenges, such as poverty reduction, environmental protection and gender equality. In fact, Target 11.4 reflects a standpoint that has long been dismissed, namely that the protection and safeguarding of cultural and natural heritage is an inherently virtuous activity leading automatically to sustainable development (Labadi, 2013a; Labadi, 2019a; Labadi and Gould, 2015). Worse, the unique indicator identified for tracking progress on Target 11.4 is the 'total expenditure (public and

private) per capita spent on the preservation, protection and conservation of all cultural and natural heritage, by type of heritage, level of government, type of expenditure and type of private funding'. This indicator presents heritage as a burden and a liability. The idea that heritage can also be an asset and a form of cultural capital (Throsby, 1999) is missing. It seems that the UN recommendations on culture and development, the '#culture2015goal' campaign, and all the other efforts by different actors, were disregarded in the adoption of the SDGs.

Two of the SDG targets on tourism, Targets 8.9 and 12.b, which refer to policies and tools for establishing and monitoring sustainable tourism jobs that promote local culture and products, can in some circumstances apply to heritage. However, these targets do not distinguish cultural tourism from other forms of tourism (such as beach and recreational tourism). Target 4.7 refers to education and 'promotion of a culture of peace', and appreciation of 'cultural diversity and of culture's contribution to sustainable development', but no indicator relates to these issues, which thus remain vague. This marginalisation of culture and heritage has unfortunately continued since 2015. The UN uses several tools to assess progress and challenges in the implementation of the SDGs, and an overall picture is provided in an annual report. None of the annual reports released since 2016 mention heritage and/or culture. In addition, the UN holds annual evaluations of specific goals during the High-Level Political Forum on Sustainable Development. In 2018 Goals 11 and 12 were reviewed through assessing Voluntary National Reviews prepared by Member States, accompanied by the spoken contributions of panellists and statements by Member States. The final document, the Ministerial Declaration, combines all the available information on the implementation of the goals under study. The 2018 Ministerial Declaration and most of the Voluntary National Reviews show little acknowledgement or recognition of culture and/or heritage (ICOMOS, 2018: 11–16). Hence, not enough attention is being paid to these aspects in addressing the SDGs.

This volume therefore aims to understand whether and how heritage has contributed to three key dimensions of sustainable development (namely poverty reduction, gender equality and environmental sustainability) within the context of its marginalisation from the SDGs and from previous international development agendas. Heritage is understood here in its broadest sense as including both tangible and intangible manifestations as well as its entangled cultural and natural dimensions (the more political dimension of heritage is discussed below). The timing of this work is crucial. Improving people's lives, particularly those of disenfranchised communities, is the main ambition of the SDGs. However, voices

have recently begun to criticise this framework as insufficiently challenging of models that are currently failing, evidenced by continued severe poverty, inequality, resource depletion and the recent sanitary crisis. Is the marginalisation of heritage a setback in realising the international development agenda? Does heritage provide a new model for human development that might be better suited to addressing some global challenges? Is heritage one of the missing links that could help to address the SDGs more efficiently? And if so, how can heritage contribute to key challenges? It is important to consider these questions now, while Agenda 2030 is still ongoing. If heritage is fundamental for sustainable development, then it must be addressed more thoroughly in the current SDGs, in the framework that will replace them post-2030, or as a stand-alone paradigm.

To provide in-depth engagement with the topic, I adopt comprehensive historical, multi-scalar (international, national, local) and interdisciplinary approaches. I begin my investigation with a comprehensive history of the international approaches to culture (including heritage) for development from 1970 up to the present. Rather than concentrating only on heritage, I provide a more complete picture by outlining a history of culture in general and its connections to development. This is because, at the international level, heritage is often discussed in the broader context of culture. In these historical chapters I focus on the United Nations Educational, Scientific and Cultural Organisation (UNESCO) and the World Bank. UNESCO, being the only international intergovernmental organisation of the UN system with a mandate on culture, has been leading efforts to integrate culture (including heritage) in different international development frameworks. The World Bank is the leading development agency that has adopted, adapted, and put into practice some of the key ideas and models of culture (mainly heritage) and development proposed by UNESCO. My long-term direct involvement with both organisations (see below) has been invaluable in this research.

I drafted this comprehensive history through undertaking archival research at the UNESCO headquarters in Paris and at the World Bank headquarters in Washington, DC, complemented by face-to-face interviews with key actors and stakeholders. I travelled to Belgium, France, Canada, Spain, and the United States to interview experts who have worked in UNESCO and World Bank projects on culture for development, as well as for the main organisations that led the global campaign 'The Future We Want Includes Culture' (2013–15),[4] such as the International Council on Monuments and Sites (ICOMOS), Culture Action Europe, United Cities and Local Governments (UCLG), and the International Federation of Coalitions for Cultural Diversity (IFCCD).

Case studies

The historical and international framework on culture (including heritage) for development provides only one side of the story, however. For this reason, I also assess how narratives on culture for development framed in an international (mainly Western) arena have been implemented, adopted, adapted, transformed, and resisted on the ground. I identify the negative and positive impacts of all the international projects implemented in sub-Saharan Africa that aimed to provide evidence of the contribution to development of culture (understood primarily as heritage) in time for the negotiation of the SDGs. I thus examine past instances that sought to demonstrate the contribution of heritage for development to explain the present situation. Understanding what happened in these projects, their legacy, and what they can teach us in terms of design, management and implementation is very important, especially since more recent initiatives adopted their approaches and methods in an uncritical manner. Learning lessons from the past through critical analyses ensures that we avoid repeating mistakes in the future. These four projects are: 'Harnessing Diversity for Sustainable Development and Social Change in Ethiopia' (July 2009–December 2012); 'Strengthening Cultural and Creative Industries and Inclusive Policies in Mozambique' (August 2008–June 2013); 'Sustainable Cultural Tourism in Namibia' (February 2009–February 2013); and 'Promoting Initiatives and Cultural Industries in Senegal – Bassari Country and Saloum Delta' (September 2008–December 2012). Although not evident from some of the titles, intangible and tangible heritage were their focus. These projects were funded by the Millennium Development Goals Achievement Fund (MDG-F), set up in 2006 by the Government of Spain and the United Nations Development Programme (UNDP) to accelerate progress towards attainment of the Millennium Development Goals (MDGs). Between 2000 and 2015, the eight MDGs aimed to tackle major challenges ranging from eradicating extreme poverty to promoting gender equality and ensuring environmental sustainability. Convinced that the omission of culture was a determining factor in the previous lack of progress towards the MDGs, the Government of Spain funded a theme on 'Culture and Development' as one of eight challenges selected for the MDG-F (UNDP/Spain Millennium Development Goals Achievement Fund, 2007; Labadi, 2019b: 76–7; Bandarin, Hosagrahar and Albernaz, 2001).

Each of these projects received major funding from the MDG-F (at least US$5 million per project), which is remarkable considering that heritage (and cultural) schemes usually lack significant investment.

The scale of funding reflected strong political support from the Spanish Government. Through this investment, Spain wished to demonstrate the power of culture (particularly heritage) for accelerating implementation of the MDGs and the three pillars of sustainable development, particularly the goals on poverty eradication (economic pillar), gender equality (social pillar), and environmental sustainability. These challenges are also central to the SDGs, with SDG 1 focusing on 'No poverty'; SDG 5 on 'Gender equality' and SDG 15 on 'Life on land'. Agenda 2063 from the African Union (AU), the master plan for transforming Africa into the global powerhouse of the future, also focuses on these challenges, particularly Goal 1 on 'high standards of living', Goal 7 on 'environmental sustainability' and Goal 17 on 'full gender equality'. There is thus a contemporaneity in the projects I have selected for analysis. Through such a focus on four cases, the three key challenges of poverty reduction (Chapter 5), gender equality (Chapter 6) and environmental sustainability (Chapter 7) can be considered at length. Hence, this book moves beyond the mere consideration of heritage management and conservation to address its contribution to wider and pressing challenges.

It is appropriate to select sub-Saharan Africa as a geographical focus for the research because there is often an immediate association of this sub-region with issues of development. I have sat on many evaluation panels for grant applications in the Humanities and Development, and most of the research proposals concentrated on sub-Saharan Africa. The great majority of sub-Saharan countries face acute challenges, which is why 33 in total are classified as 'least developed countries' by the UN. For instance, 48 per cent of the population of Mozambique live below the national poverty line (World Bank, 2018a: 11). Extreme poverty, low levels of educational attainment, and the HIV/AIDS epidemics have all contributed to the precarious status of women and girls in the country (USAID/Mozambique, 2019). In recent years, Mozambique has also faced large-scale environmental challenges, including widespread deforestation and overfishing. It is not therefore surprising that the sub-region is the highest regional recipient of international aid. By focusing on sub-Saharan Africa I also continue the debate on whether international development aid is useful for its culture sector (see Labadi, 2019a), or whether this aid is in fact the reason why Africa faces so many challenges, thereby expanding on earlier criticisms (e.g. Moyo, 2009; Easterley, 2006; Escobar, 1995). Additionally, sub-Saharan African independence and political leaders have regularly called for a re-appropriation of their culture for endogenous development, rather than depending on foreign

inputs, as charted in Chapter 2 of this book and echoed in Agenda 2063. This sub-region thus provides a rich terrain for analyses.

More specifically, the programme 'Strengthening Cultural and Creative Industries and Inclusive Policies in Mozambique' was implemented between August 2008 and June 2013 in the Nampula, Inhambane, and Maputo regions. With a budget of US$5 million, it was executed by UNESCO (as lead agency), the Food and Agriculture Organisation (FAO), the UN Refugee Agency (UNHCR), the International Labour Organisation (ILO), and the United Nations Population Fund (UNFPA). Its official aims were to promote community-based cultural tourism through setting up four pilot cultural tourism tour packages. Two were prepared on the Island of Mozambique, a World Heritage site in the north of the country, and two in Inhambane city in the south, with the hope that they could be replicated in other parts of Mozambique as well (see Figure 1.1). Large-scale capacity-building was also provided, to boost the quantity and quality of cultural goods and services, with the intention that these would lead to increased market access and better income generation in tourism-related sectors (such as restaurants, craftmanship and the creative industries). To ensure that the capacity-building activities were comprehensive and inclusive, the

Figure 1.1 Map of Mozambique with the locations of the activities. Original map courtesy of www.freevectormaps.com, revised by Francesca Giliberto.

legal framework was also improved, for instance through the draft revision and draft regulation of Mozambique's copyright law and its related rights.

Women were a key target of these capacity-building activities, through ensuring at least an equal number of female participants. The project also aimed to improve the use of traditional knowledge systems in local development, and to mainstream socio-cultural elements in strategies combating HIV/AIDS, as a strategy to empower women. Finally, activities aimed to improve reforestation efforts and encourage the sustainable management of forestry resources. Two wood banks were created, one in the northern province of Nampula and another in the capital Maputo, to provide artisans with secure access to raw materials for their products and prevent, in the process, illegal wood cutting. As part of efforts to replant native and endangered tree species that support intangible heritage practices, *mwendje* seeds were also widely distributed in Zavala. *Mwendje* trees are used to make *timbila* (singular *mbila*), traditional xylophones inscribed on the UNESCO Representative List of the intangible cultural heritage of humanity in 2008. I travelled to the three regions (Nampula, Inhambane and Maputo) where the different activities took place to assess their impacts.

'Promoting Initiatives and Cultural Industries in Senegal – Bassari Country and Saloum Delta' was carried out from September 2008 to December 2012. Benefiting from a budget of US$6.5 million, this project was implemented by UNESCO (lead organisation), the UNDP, the United Nations Industrial Development Organisation (UNIDO), the United Nations World Tourism Organisation (UNWTO), and UNFPA through different mechanisms. The key results were the inscription of the 'Saloum Delta' and the 'Bassari Country: Bassari, Fula and Bedik Cultural Landscapes' on the World Heritage List in 2011 and 2012 respectively, followed by the construction of an interpretation centre in Toubacouta (Saloum Delta) and a community village in Bandafassi (Bassari Country) (see Figure 1.2). These inscriptions and new structures aimed to strengthen and accelerate socio-economic benefits, including tourism. A multifunction space, the interpretation centre in Toubacouta planned to house 30 booths for artists and artisans; a room for women to prepare and sell their products; a space for rehearsal for local groups; a multimedia centre and a library for young people; and a museum on the Outstanding Universal Value of the property. The centre would also promote the economic growth of two promising sectors: fishing and cashew nuts. Sharing a similarly ambitious plan, the community village in Bandafassi, to be managed by locals, would provide information on the values of the site: food security though crops to be cultivated in its

Figure 1.2 Map of Senegal with the locations of the activities. Original map courtesy of www.freevectormaps.com, revised by Francesca Giliberto.

garden, with some surplus sold to tourists. Tourists would be housed in huts, could visit ethno-cultural spaces reproducing the architectural techniques of each local minority, and buy local crafts from an exhibition space. *Fonio* (the Senegalese couscous) and *shea* (a tree whose seeds are used to produce shea butter) were identified as two promising sectors, whose growth would be piloted from the community village.

As part of this initiative in Senegal, two community radios were also built for locals to share news and events and discuss some issues in local languages, including gender equality and the empowerment of women. Women were also targeted to improve the competitiveness, quality, quantity, market reach and added value of their crafts, tourism, and *fonio* and *shea* merchandise. Natural resources were also supposed to be protected, to ensure livelihood sustainability for vulnerable groups. Two particular areas had been selected: the support of artisanal fishery and the fight against (mangrove) deforestation. I travelled to Dakar, the Saloum Delta, and Bassari Country to hear from the stakeholders how these different facets of the programme were set up and implemented.

'Sustainable Cultural Tourism in Namibia', coordinated by UNESCO, the United Nations Environment Programme (UNEP), the ILO, and UN-Habitat, ran from February 2009 to February 2013, with a budget of

US$5,976,934. It aimed to build nine pilot sites for cultural tourism development in remote rural regions, in Khorixas and Opuwo (in the Kunene region), in Tsumkwe (Otjozondjupa region), Rundu (in the Kavango region), Otjinene (in the Omaheke region), King Nehale Conservancy (Oshikoto region), and Duineveld (in the Hardap region) and trails in the Omusati region and Katima in the Caprivi Strip (see Figure 1.3).

Linked to the liberation struggle or the post-colonial period, these fully equipped heritage/interpretation centres housing new exhibitions intended to transform the map of tourism, and to move away from its sole focus on the colonial history of Namibia (at sites such as Swakopmund, Lüderitz, and Henties Bay), as a vehicle for poverty reduction, particularly among women and other disadvantaged and vulnerable groups. To ensure such a transformation, various committees were set up, including ministries, national government institutions, regional and local government and community representatives. Capacity-building training was provided focusing on topics that included tour-guiding and producing, marketing and selling traditional handicraft. In addition, the 'Start Your Cultural Business' training efforts aimed to expose a large number of individuals to the entrepreneurial opportunities around cultural heritage utilisation across the country. To ensure gender equality, at least

Figure 1.3 Map of Namibia with the locations of the activities. Original map courtesy of www.freevectormaps.com, revised by Francesca Giliberto.

60 per cent of trainees were required to be women, while to ensure natural heritage protection, it was expected that the Protected Area and Wildlife Bill, almost twenty years in the making, would be passed by the Namibian parliament before the end of the funding, and would facilitate the establishment and management of the Gondwanaland Geopark, which includes parts of the Namib desert. In fact neither condition was achieved, as detailed in Chapters 4 and 7.

Finally, 'Harnessing Diversity for Sustainable Development and Social Change in Ethiopia' ran from July 2009 to December 2012. Implemented in Addis Ababa, Amhara (particularly in Lalibela and Gondar), Tigray (for instance in Wukro), Harar, Oromia, and the Southern Nations, Nationalities, and Peoples (particularly in Tiya) with a budget of US$5 million (eventually reduced to $3,576,632), the project was coordinated by UNESCO and UNDP (see Figure 1.4). It aimed to promote cultural heritage and diversity, as well as to develop creative industries and encourage dialogue about environmental preservation among the country's diverse communities. The activities promoted inter-faith and community-based dialogue, with a focus on the needs of minority, marginalised, and disadvantaged groups. Like the other three selected projects, various capacity-building activities were rolled out, with the ultimate objective of poverty reduction. Training courses

Figure 1.4 Map of Ethiopia with the locations of the activities. Original map courtesy of www.freevectormaps.com, revised by Francesca Giliberto.

in product design, quality control, marketing, accounting, and business planning were delivered. Again, to ensure gender equality, at least 50 per cent of the participants in these courses had to be women. A website was also created to promote Ethiopian crafts internationally. To enhance heritage conservation and management, protection laws were prepared for the World Heritage properties of Aksum, Lalibela, Tiya, and Fasil Ghebbi, and were submitted to the Council of Ministers for endorsement. Awareness was also created for people in the communities about the impact of environment degradation on human life, particularly for the communities living around the national parks. However, many delays in the implementation of plans in Ethiopia led to the budget being cut by more than US$1 million.

To assess these cases, I conducted desk-based analyses of existing official information, starting with the joint project documents explaining their goals and outputs. I also accessed the different evaluations conducted: knowledge management reports by UNESCO, and mid-term and final evaluations prepared by independent consultants for UNDP, providing a more critical viewpoint. These independent evaluations did not try to conform to the goals of donors and their expected results, as seems to have been the case with the UNESCO evaluations. To complete the assessment, I undertook in-depth ethnographic work in Mozambique and Senegal. I travelled to the locations of activities to interview hundreds of participants and other concerned stakeholders, ranging from international and national civil servants to regional and local authorities and villagers. Data collection was thus both top-down and bottom-up. The multiplicity of interviews and data sources ensured that views on implementation were triangulated as much as possible.

Four case studies were selected – yet my results can also be generalised. For instance, all the 130 MDG-F funded projects were required to follow the same management structure and principles. The discussion on these issues in Chapter 4 can therefore also be applied to these 130 initiatives that tackle a wide diversity of global challenges. In addition, the selected cases are far from being the only ones that have tried these approaches to poverty reduction, for example the training of tourism guides and the professionalisation of craftspeople. Again, the in-depth reflections can easily be extended to other examples. Finally, whenever possible, I cross-referenced my results with shorter analyses Giliberto and I conducted of similar MDG-F culture for development projects implemented in the Middle East and North African region (MENA) (Giliberto and Labadi, 2022).[5]

Analyses and discussions were also enriched by my vast practical experience in heritage for development, gained in working for

different initiatives for UNESCO, ICOMOS and the World Bank over the past twenty years.[6] In 2012 I co-wrote a report for the World Bank on heritage-led regeneration. I drafted a background paper on *Culture and Social Cohesion* for UNESCO for the 2013 Hangzhou International Congress on 'Culture: Key to Sustainable Development'. I was a core member of the drafting team of the 2015 UNESCO Policy on World Heritage and Sustainable Development, and I subsequently organised many workshops on this policy, including in and on sub-Saharan Africa. I have also acted as the coordinator of the ICOMOS document 'Heritage and the SDGs: Policy Guidance for Heritage and Development Actors' (2019–21). Like my previous publications, this volume (Labadi *et al.*, 2021) is based on solid academic research, as well as on this practical experience, thereby connecting academic scholarship to the difficulties of project implementation on the ground. This publication should therefore be of assistance to students, academics, practitioners, policymakers, and funders: it addresses academic concerns, but also presents concrete, practical recommendations for future work.

What's in a name?

To address my aim and analyse the data collected, I have adopted a transdisciplinary approach, borrowing from economics, gender studies, development, anthropology, tourism studies, environmentalism, health studies, international development, and of course heritage and archaeology. More specifically, I am interested in highlighting how, when, and why specific discourses on heritage for development have been set up. I also investigate how narratives of 'success' have been created about heritage for development projects internationally, and how these narratives can be contrasted with the situations on the ground. In adopting this approach, I aim to highlight differences of understanding on the topic according to different actors, perspectives, and historical approaches. In the first two chapters, I assess how and why specific ideas of culture for development emerged in the international arena, and where they originated. I then assess how these ideas have evolved. I pay particular attention to powerful actors (primarily UNESCO Directors-General) and how and why they were able to impose their own vision on culture for development, despite dissent from some governments, other UN organisations, and intellectuals. I also assess how their visions were framed in relation to contemporary geopolitics.

The chapters analysing the four projects focus on how an official narrative of 'success' was created on poverty reduction, gender equality and environmental sustainability, and how this fulfils the requirements of donors. Departing from these narratives, I assess the complex web of structures, power networks, actors, and contexts that constrain or enable actions, and I unravel the complexity of project results on the ground. I recognise that activities cannot have exclusively 'good' or 'bad' impacts. Instead, each situation is recognised as having possible positive dimensions as well as negative ones, with heritage project participants having various – even opposing – motivations, opinions and behaviours. Addressing such complexity on the ground highlights the multiplicity of possible narratives on heritage for development.

Because of my approach, I am careful not to impose any pre-established definitions. One of the aims of the first two chapters is to assess how culture was defined over time, and how this definition impacted on understandings of development, and vice versa. These definitions range from narrow humanistic understandings of culture as referring to artistic activities, literature, and heritage, to those encompassing anthropological approaches and seeing culture as the whole complex of distinctive spiritual, material, intellectual, and emotional features that characterise a society or social group, including modes of life, value systems, traditions, and beliefs. The following chapters focus on both tangible heritage (such as buildings, statues and monuments) and intangible heritage manifestations (for instance social practices, rituals and festive events). In my assessment, I have been keen to consider whether and how the apolitical and universal consideration of heritage promoted by international organisations in the selected projects has been accepted on the ground. Indeed, heritage is and has always been politicised because it gives flesh to, constructs, and materialises the abstract idea of the 'nation', as I have detailed in a previous book (Labadi, 2013a: 59–76). Heritage has also been used to legitimise those in power. An example can be seen in the statues of Samora Machel recently erected in several cities in Mozambique. Machel fought in the War of Independence against the Portuguese, and served as the first President of independent Mozambique, under the colours of FRELIMO (Mozambique Liberation Front). The statues are heritage objects and have been erected to construct materially post-independent Mozambique as well as to legitimise FRELIMO, which is still in power (Jopela, 2017). In the following pages I will consider whether and how these politicised and instrumentalised considerations of heritage fit within its more benign and apolitical understanding by international organisations, and how they were used for development.

Another theme of the book is the connection between cultural heritage, cultural diversity, and development. In theory, all heritage manifestations are equal and cultural diversity should be preserved as the basis for development. This has long been a credo of international organisations, particularly of UNESCO. However, at international, national, and local levels, different heritages are not necessarily given equal value or legitimacy, often depending on whom they belong to. The World Heritage List is surely the most visible example of this difference in valuation. The fact that almost 50 per cent of the sites on the list are in Europe and North America, and that less than 10 per cent are in sub-Saharan Africa[7] (as has been the case for the past forty years), is a clear political sign that Westerners (who have dominated the World Heritage Committee) value their heritage the most highly and consider it to be most worthy of associated socio-economic development (Terrill, 2014; Ndoro, Chirikure and Deacon, 2018). Interestingly, those countries that have played a primary role in shaping the World Heritage List are also major donors of international and bilateral aid (Meskell, 2018). However, it would be naive to think that this bias occurs only in international spheres. Similar differences in valuation and legitimation occur at national and local levels. The best-known examples might relate to Indigenous people, whose heritage was often dismissed and delegitimised by later colonisers. For instance, I am a Kabyle, a member of a Berber ethnic and indigenous group from Northern Algeria.[8] Like most Indigenous people around the world, Berbers and Kabyle people have been discriminated against, and are often considered culturally, socially, and economically 'backwards' by the (in this case, Arab) majority. Their/our heritage has been undermined and often suppressed. How, then, has the idea that all cultures and heritages are equal, and that they should be promoted and used as the basis for development, been translated and adapted nationally and locally in the selected cases? How has this concept responded to the fact that some forms of heritage and diversity are considered more important and legitimate than others? A related issue is the tendency to reify and essentialise culture and heritage. Heritage is often viewed as bounded, homogenous, unchanging, and as a way to define people stereotypically. However, heritage (particularly intangible heritage) is complex and fluid, and is constantly being made, remade, reinterpreted, and contested by individuals and groups. How have these constant redefinitions been addressed in the projects considered, and how did they mesh with fixed national conceptions of heritage?

Erasure and *a culture of erasure* is a related concept, which has provided a useful lens to consider a number of themes in this book.

Here I borrow the idea of erasure from Thuram (2020: 39) who posits the hegemony of white/Western heritage and culture and the erasure of non-European ones. The World Heritage Convention is again a good example to illustrate this concept, as most of the sites on the list from Africa relate to European understandings of heritage and Africa (e.g. as a continent of wilderness; and with an emphasis on architectural and archaeological sites), at the expense of more localised forms of heritage (Chirikure, Ndoro and Deacon, 2018). However, this concept can be considered as running deep into other issues, including the imposition of Western values and vision in projects on tourism, gender equality and environmental sustainability. Have the selected projects been able to address this pervasive 'culture of erasure'? And have they been able to shed light on other forms of heritage and practices that are not Eurocentric, for local development? If so, how have they been able to do so?

'Development' is another central theme of the book. The first two chapters consider the different understandings of development in relation to culture over time, and according to different stakeholders, whether as mere economic growth, gross domestic product, industrialisation, modernism, dependence theory, adoption of neoliberalism, sustainability, as a way to expand people's choices and capability, or to improve people's well-being and happiness. In addition to considering these approaches, the following chapters focus on development as poverty reduction, gender equality and environmental sustainability. In other words, these subsequent chapters focus on the three traditional pillars of sustainable development (environment, society, and economy) defined at the 2002 World Summit on Sustainable Development, which have structured the MDGs and the SDGs. The selected projects were structured around these three themes, which therefore influenced their chosen foci. However, I often use the term development in the book, and not 'sustainable' development, to reflect the official terminology used.

An important additional aspect analysed is the 'cultural turn' in development. Did the selected heritage-led projects follow this cultural turn? Did they fall into the trap of more traditional, top-down models? Or did they propose hybrid approaches? The cultural turn was considered the solution to externally driven models of development as economic growth – which seemed, more often than not, to fail. It intended to get development right, based on bottom-up approaches, on being more ethical, and on taking greater account of local communities and local contexts, in comparison to other types of international projects. Activities could then be framed around the actual needs of local communities and respond to them more effectively. Here, I am particularly

vigilant in assessing whether and how it was possible to involve local communities and address their needs meaningfully. Deepening some of my earlier reflections on the topic (see Labadi, 2019a), this book also discusses whether such a cultural turn can ever be successful in light of the issues of power relations, discrimination, and access to resources. In this context, post-development can also be a lens through which to assess the projects. Unlike the cultural turn, the post-development model rejects development as market-driven, Westernising, and modernist, and calls for grassroots approaches that focus on 'anti-imperialist, anti-capitalist, anti-productivity, anti-market struggles' (Escobar, 1995: 431). Heritage projects may fit this post-development and decolonial framework, and I consider whether the case studies have proposed such alternative approaches.

The more traditional models of development reflect its colonial roots, with European countries' plans to bring education, progress, infrastructure, and medicine to the colonial world. In the words of Kipling, colonisation is *the white man's burden*: 'To fill full the mouth of Famine / and bid the sickness cease' (Kipling, 1899). Some colonial-era heritage sites even depict this 'white man's burden': the Musée National de l'Histoire de l'Immigration in Paris, for instance, is housed in what used to be the Palace of the Colonies, built in 1931 for the International Colonial Exhibition. Frescoes decorating the walls of the function room, executed by Pierre Ducos de la Haille, celebrate a rose-tinted view of the 'civilising' and 'positive' roles that France was supposed to have played in its then colonies, offering medicine, justice, and science (Labadi, 2013b). In reality, colonialism was an enterprise of exploitation, repression, subjugation, and alienation. Africa was plundered, including its heritage (Pwiti and Ndoro, 1999); all sectors of society were in the hands of Europeans, and Africans had very few options for education or betterment and had to perform subaltern tasks. On the ground, many development initiatives post-independence have been viewed as neocolonialism, since they are often tied to the national agenda of donor countries, which use international projects to strengthen their trade and investment opportunities or their diplomatic powers (Thiaw and Ly, 2019; Logan, 2019). The frameworks and concepts they employ originate from the Global North, and international development experts tend to work on, and for, local communities rather than with them. I am careful to map out such asymmetrical power dynamics and the impacts they had on project design, delivery, and legacy.

Although this book focuses on sub-Saharan Africa, it also considers the wider complex relationships between the Global North and the Global

South – terms I have consciously chosen to use knowing that vocabulary is not neutral, and understanding as well that these encompassing terms hide vastly varying realities. However, I find other concepts, such as 'developed' and 'developing' countries, which are widely used by international organisations, even more problematic, as they suggest that countries make linear progress from underdevelopment to development. This idea, which borrows from Rostow's 'stages of growth' (Rostow, 1960), has long been dismissed. The terms 'developing' and 'developed' have strong connotations of inequality. As an Algerian citizen, I find it patronising and condescending that my country is considered 'developing', like a child. As a French citizen as well, I am aware that 'developed' countries establish the rules of the game and decide when a 'developing' country has reached a sufficient level of economic growth and progress, echoing Escobar's view (1995). Of course, I could have chosen to use this terminology to denounce the asymmetrical power relations between the two territories, and the domination and control of the Global North over the Global South. However, I find it more ethically sound to move away from 'developing' and 'developed', and to use more neutral terms even though they erase some variables.

Building on a growing body of research

My own interest in these topics goes back a long time. I have already researched and written extensively about the World Heritage Convention and (sustainable) development, highlighting how this instrument was adopted to protect heritage against the negative forces of development, but then became a tool for economic development (primarily through tourism) from the end of the 1990s onwards (e.g. Labadi, 2013a; Labadi, 2017a). I have also exposed trends that negatively affect World Heritage sites worldwide, from infrastructure development to natural resource extraction and over-tourism, and I have identified potential solutions (Labadi, 2019c). My latest edited volume also critically considers international aid for heritage projects and the creative industries, but does not touch upon issues of gender or environmental sustainability (Labadi, 2019a). The present book is very different from these earlier reflections. More ambitious in my approach, I do not limit myself to the concepts of heritage defined by the 1972 World Heritage or 2003 Intangible Heritage conventions, but instead cover tangible and intangible heritage in general, thereby embracing more complex situations. I also expand my subject to include the key international frameworks of development (the

MDGs and the SDGs) and their implementation in different settings. I believe my approach makes this book the first to discuss the official narratives and policies of the past fifty years on heritage for development at an international level. This is also the first time that the MDG-funded projects on heritage for poverty reduction, gender equality, and biodiversity conservation in sub-Saharan Africa will be critically assessed, providing valuable lessons about the past, to inform the future.

It is particularly important to conduct such a study now. Many publications call for more evidence on whether and how heritage contributes to development (for instance Pereira Roders and Van Oers, 2014: 9; Basu and Modest, 2015: 26; Madden and Shipley, 2012: 110). Some important publications focus on culture and/or heritage for development (primarily Basu and Modest, 2015; Rao and Walton, 2004; Barthel-Bouchier, 2012; Nederveen Pieterse, 2010; Gasper, 2004; Radcliffe, 2006; Stupples and Teaiwa, 2017), but no chapter from the volume edited by Basu and Modest assesses the implementation of heritage schemes funded as part of the MDGs, and a number of the chapters (for instance those by Van Hout, 2015 and McLeod, 2015) focus on museums, which present a closed environment different from heritage sites or intangible heritage manifestations. *Culture and Public Action*, edited by Rao and Walton (2004), is a seminal work arguing for the importance of culture and heritage in internationally funded development projects. However, it was released seventeen years ago and requires considerable updating. Barthel-Bouchier (2012) focuses on heritage and climate change, loss of the natural environment, and tourism. Yet her approach is very broad and a number of the issues have not been considered in great depth. Both Nederveen Pieterse (2010) and Gasper (2004) dedicate one chapter to culture and development, but they neither assess its historical evolution at an international level, nor consider culture for development projects in developing countries. The edited volume by Radcliffe (2006) on culture and development focuses on issues of social capital and environmental protection in Africa (Porter and Lyon, 2006 and Watson, 2006), but does not consider the specific context of the international development agenda. The edited volume by Stupples and Teaiwa (2017) focused on the arts and creative industries only.

The 2011 *UNESCO Recommendation on the Historic Urban Landscape* resulted in a surge of publications on urban heritage management and development, including my own (Labadi and Logan, 2015a; see also Bandarin and Van Oers, 2012, and Pereira Roders and Bandarin, 2019). However, these books do not focus on the international development agenda in place since 2000. They often focus on heritage management

without considering other development issues (see Ginzarly, Houbart and Teller, 2019 for similar findings). This is the case for a number of other publications on (world) heritage as sustainable development or sustainability, understood as the mere inscription of sites on the World Heritage List, and their management or reuse (e.g. Cave and Negussie, 2017; Makuvaza, 2014; Albert, Bandarin and Pereira Roders, 2017; Albert, 2015). However, I have explained using diverse case studies, that the inscription of sites on the list, their management, and their reuse do not necessarily lead to (sustainable) development (see for instance Labadi, 2013a; Labadi and Gould, 2015). The edited collections *World Heritage and Sustainable Development* (Larsen and Logan, 2018) and *African Heritage Challenges: Communities and sustainable development* (Baillie and Sørensen, 2021a) have begun shifting the scholarship onto some of the issues also considered in this volume. I continue and expand the discussion they have started and provide contrasting and in-depth evaluations of four projects through focusing on their varying impacts for their various stakeholders.

Several academic publications have focused on specific aspects of heritage for development, primarily economic growth, tourism, poverty reduction, and the benefits and issues for local communities (for instance Hutter and Rizzo, 1997; Rizzo and Throsby, 2006; Staiff, Bushell and Watson, 2013; Gould and Pyburn, 2017; Timothy and Nyaupane, 2009; Lafrenz Samuels, 2010; Labadi and Gould, 2015; Chok *et al.*, 2007). My research departs from these previous publications in its more in-depth and fine-grained analysis of the positive and negative impacts of heritage for poverty reduction for different stakeholders, as well as the impact of power relations on projects. In addition, I assess how pro-poor, inclusive, and community-based tourism approaches, advocated by some of these publications, have been implemented in the selected countries.

Publications on the connections between cultural heritage and environmental protection, as well as between nature and culture, have discussed the fallacy of the nature–culture divide (for example Harrison, 2015; Ingold, 2000; Descola, 2005); the importance of, and issues with, community- (including Indigenous-) based approaches to biodiversity conservation (Kumar, 2005; DeWalt, 1994; Larsen, 2015); and the imagined and colonial construction of nature in Africa (for instance Meskell, 2012). Voices have also been raised (such as in Wijkman and Rockström, 2012) about the paradoxical aggregations of the different pillars of sustainable development, which may be detrimental to environmental protection, as well as proposing a potential solution to these contradictions with a social-justice approach (Parra, 2018: 60–1). My research will

consider whether and how these different debates have been taken into consideration on the ground. In another point of departure from these previous studies, it will consider how heritage has been used to address three of the most pressing environmental issues facing sub-Saharan Africa: the illegal ivory trade, deforestation and overfishing.

There is also a growing literature on heritage and gender (such as Grahn and Wilson, 2018; Smith, 2008; Reading, 2014). However, more research is needed on whether and how heritage can be a force for promoting gender equality, the empowerment of women, and fighting against discrimination and unequal power relations. This book continues and amplifies some of my previous efforts in filling this research gap (for instance Labadi, 2018a); considers how gender has been defined and whether and how the concerns of women and men have been integrated into the different projects; and discusses how discriminatory practices, stereotypes and neocolonial frameworks have been acknowledged and acted upon.

Some non-academic publications are also worth mentioning, including the series of case studies on community participation published by UNESCO for the 40th anniversary of the World Heritage Convention (Galla, 2012), the proceedings of the ICOMOS 17th General Assembly Scientific Symposium (ICOMOS, 2011), the UNESCO report on gender and heritage (UNESCO, 2014a) and World Bank reports (such as Bigio and Licciardi, 2010 or Christie *et al.*, 2013). These are important clarifications of the contributions of heritage, primarily to economic development. However, they tend to provide only descriptive case studies lacking analytical discussion on the similarities, differences, strengths, and weaknesses of the examples. In addition, these volumes do not tend to discuss issues of inequality, power relations between different stakeholders and regions, or the geopolitical dimensions of the narratives on heritage for development.

Structure of the book

Chapters 2 and 3 present the history, discourses, and initiatives on culture (including heritage) for development, as adopted first by UNESCO and then by the World Bank. Chapter 2 covers the period from the 1970s to 2000, while Chapter 3 covers the following twenty years. These two chapters focus particularly on the impacts of each successive UNESCO Director-General, of the geopolitical contexts and power relations between institutions, individuals, and member states on the definition of culture and heritage for development. These two chapters provide the

historical, international, and contextual framework on culture for development, within which the four selected projects were prepared.

The rest of the book focuses on thematic and interconnected analyses of the four case studies on heritage for development in Ethiopia, Mozambique, Namibia, and Senegal. Chapter 4 (Project design and management) refers to the overall structure, rules, and regulations guiding the projects' design, implementation, and monitoring. This analysis provides a macro understanding of the initiatives, whilst the subsequent chapters provide fine-grained analyses of the contribution of heritage to key global challenges, focusing on the local and grassroots levels. Chapter 5 on poverty reduction critically assesses the use of heritage for comprehensive local and regional economic growth, tourism and tour guiding activities, as well as capacity-building initiatives. Strategies for promoting gender equality and the empowerement of women are considered in Chapter 6, particularly whether and how the concerns of different genders were taken into account in the design of the activities, and whether and how discriminatory and exclusionary practices were dealt with to ensure equal conditions, treatment and opportunities. Chapter 7 on environmental sustainability discusses the connections between heritage, environmental protection, and development, as well as between nature and culture. Three of the most pressing challenges facing sub-Saharan Africa are discussed here in relation to heritage: the illicit ivory trade, overfishing, and deforestation.

Mindful that a number of the concepts relating to poverty, gender equality, and environmental protection originate from the West and are entangled with stereotyped considerations of Africa, these chapters discuss whether and how these terms were adopted, transformed, and/or resisted in the selected cases. Of course, it is clear that Chapters 5, 6, and 7 are organised according to an artificial separation. Issues on the ground were often interconnected, and the point of sustainable development is to consider challenges holistically. Connections were therefore retained as much as possible in the text. Yet, because these challenges are also considered separately and have their own international development goals, I felt that it was important to acknowledge this official and artificial structure and follow it.

Finally, the conclusion proposes and discusses key recommendations for rethinking heritage for development while reflecting on the major shortcomings of the selected projects. To ensure their relevance, the recommendations take account not only of the results of my research, but also of the more practical work I have been involved in over the past twenty years, as well as the continuing impacts of the Covid-19

pandemic. These recommendations will be useful for a range of people, from academics to practitioners, in their implementation of the SDGs and of future international development frameworks in Africa and beyond.

Notes

1. As reported in the 'SDG Reporting Challenge' by PWC, based on reviews and six business sectors in 19 countries: https://www.pwc.com/gx/en/services/sustainability/sustainable-development-goals/sdg-reporting-challenge-2018.html.
2. https://www.un.org/sustainabledevelopment/takeaction/.
3. See for instance https://feature.undp.org/covid-19-and-the-sdgs/.
4. This campaign aimed to include a full goal on culture in the post-2015/2030 agenda.
5. These projects were: 'The Dahshour World Heritage Site Mobilization for Community Development' (2009–13) implemented in Egypt by UNESCO, UNWTO, ILO, UNIDO and UNDP; 'Cultural Heritage and Creative Industries as Vectors for Development in Morocco' (2008–12) implemented by UNESCO, UNDP, UN Women, UNFPA and UNIDO; and finally 'Culture and Development in the OPT' (2009–12) implemented with UNDP, UN Women and the FAO.
6. To ensure that I had the necessary critical distance, I never worked for or on any MDG-F project.
7. https://whc.unesco.org/en/list/stat/.
8. Kabyle people became a well-known group thanks to Zinedine Zidane, who was instrumental in winning the 1998 Football World Cup and 2000 Euro Football Cup for France. At the turn of the millennium, whenever I said that I was a Kabyle, people would automatically respond 'Ah, like Zidane!'

2
International approaches from 1970 to the turn of the millennium

This historical chapter details the different narratives adopted and initiatives implemented on culture for development at the international level from 1970 to 2000. This chapter fills a gap, as these narratives and initiatives have never been discussed at length. UNESCO was the key player, and its approaches were then adopted by other actors, mainly the World Bank. Hence the focus on these two organisations. This investigation documents how the international discourses on culture for development have been established over the past fifty years, why they were developed, how they relate to geopolitical events, and why these approaches had only a marginal impact on the global development agenda. This investigation also provides the historical, international and contextual framework on culture for development, within which the four selected projects analysed in this book were developed.

Narratives and approaches on culture for development reflect both the ideas and visions of UNESCO Directors-General and the contemporary geopolitical positions of member states. This chapter recognises the enunciative and normative power of international organisations, although it must always be understood within the enabling or restrictive capacities of relevant nation-states. In other words, narratives on culture for development do not represent an objective reality, but instead are changing and relate to specific political agendas, geopolitical dynamics, and power relations between institutions, powerful individuals, member states and geopolitical forces. This chapter and the next unravel these changing narratives and their connection to wider geopolitical considerations.

More specifically, the chapter starts with an analysis of the little-known 1970 Intergovernmental Conference on Institutional, Administrative and Financial Aspects of Cultural Policies, which cannot

be separated from the vision of the Director-General at that time, René Maheu, and the mid-20th century decolonisation movements. Analyses of the 1982 World Conference on Cultural Policies are then presented and explained according to Amadou-Mahtar M'Bow's visions and the Cold War context. The next section focuses on the World Decade for Cultural Development and the years following it (1988–99), which reflects the views of the Director-General of that time, Federico Mayor, and an international context of increasing interethnic tensions and conflicts. A tangible impact of the World Decade has been the adoption of the culture-for-development narrative by other international organisations, primarily the World Bank, which is then considered. The final part of the chapter explores why culture and heritage had so little impact on the international agenda in the late twentieth century and why they were excluded from the Millennium Development Goals adopted in 2000.

The 1970 Intergovernmental Conference on Institutional, Administrative and Financial Aspects of Cultural Policies (Venice)

The first major international event organised by UNESCO on culture and development was the Intergovernmental Conference on Institutional, Administrative and Financial Aspects of Cultural Policies, held in Venice in 1970. This event is often overlooked and most publications analysing UNESCO's work on culture and development begin in the 1980s (for instance Stupples and Teaiwa, 2017: 1–24). However, I argue that the events organised by UNESCO in the 1970s provided the intellectual framework that shaped its activities in the 1980s. Later efforts on culture and development by UNESCO cannot be understood if the 1970s are overlooked.

The organisation of the Venice conference took place in the context of the first UN Decade of Development, launched in 1960. As one of its specialised organisations, UNESCO took part in the implementation of the Decade, which aimed to bring economic growth to countries in the Global South, mainly through industrialisation. The UNESCO Director-General René Maheu, who served from 1961 to 1974, promoted not only economic, but also social and cultural development, in alignment with the competences of the organisation (Maurel, 2006: 135). As early as 1962, the General Conference of UNESCO[1] requested that the concept of development be understood to include 'economic and social factors, as well as the moral and cultural values on which depend the

full development of the human personality and the dignity of man in society' (UNESCO, 1962: 78). This was a strategic move, and meant that UNESCO could access technical assistance funding on development from the UN. In 1964, as much as 17 per cent (a sixth) of its total technical assistance funds would be provided to UNESCO (IEDES, 1964). With this new focus, a number of member states transferred responsibility for UNESCO's affairs from their education or science ministries to their ministry of overseas development, as was the case for the UK (Kozymka, 2014: 36).

The mid-1960s saw a growing dissatisfaction among newly independent countries with the first UN Decade of Development, which promoted a narrow understanding of development as economic growth (measured by the gross domestic product), progress from 'traditional' to 'modern' societies, and the exportation of Western models to 'developing countries' (Labadi, 2019d: 5–6). Results included increased disparities between the Global North and Global South, and greater inequalities within countries (El-Khatib and Wagner de Reyna, 1987: 16). Worse, the exportation of a Western model of consumption led to pollution, destruction of culture, and degradation of the environment. These issues led countries in the Global South, primarily African states, to be increasingly vocal in calling for the inclusion of culture in endogenous development. Preservation of African cultures had been devalued during colonial times, but became seen as the necessary foundation on which to create and educate newly formed nations, as reflected in the thinking of many freedom fighters from the region (see for instance Diop, 1974). For them, no development was possible without culture. Culture was seen not only as tangible heritage or artistic and creative expression, but extended to oral traditions, which required urgent preservation due to a lack of intergenerational transmission and limited written or audio recordings. The fight to preserve oral tradition was exemplified by the now famous interventions of the Malian writer Amadou Hampâté Bâ who, at the 1962 executive council meeting of UNESCO, proclaimed 'En Afrique, un vieillard qui meurt, c'est une bibliothèque qui brûle'[2] (UNESCO, 2016a: 58). He argued that, while old Africans might be considered illiterate, in reality they were 'illiterate scholars' with immense and unrecorded knowledge that might disappear in a generation if nothing was done. These diverse manifestations of culture, both tangible and intangible, written and oral, were therefore intended to form the basis of endogenous or individual national paths to development (El-Khatib and Wagner de Reyna, 1987: 20–1).

Countries from the Global South could be heard and listened to at UNESCO because of their organisation from 1964 as the Group of 77.[3]

This group aimed to have a stronger presence on the international scene, to request greater equity in international relations, and to advance their common concerns. Not only did this group command a majority in the organisation's General Conference (Kozymka, 2014: 36), it also had the support of René Maheu. In 1963 he publicly proclaimed in both *Le Monde* (Berry, 1963: 1–2) and *The Sunday Times* a 'radical reorientation' (Martin, 1963: 3) for UNESCO on three contemporary issues: racism, post-decolonisation, and disarmament. For Maheu, this positioning would make UNESCO a key force to combat the Cold War, construct a more just world, and realise its mission of building peace in the minds of humankind (Maurel, 2006: 139). This repositioning forms the institutional context for the preparation of the 1970 Venice Conference on Institutional, Administrative and Financial Aspects of Cultural Policies.

The preparations for the 1970 conference also reveal René Maheu's interests in the protection of Western and tangible heritage, and reflect contemporary negotiations at UNESCO that would lead to the adoption of the Convention Concerning the Protection of the World Cultural and Natural Heritage (better known as the World Heritage Convention) in 1972. It is rather telling that Venice was chosen as its location over Washington, DC or Stockholm, the two other host cities that had been proposed.[4] Following the 1966 flooding of Venice, UNESCO launched the International Campaign for the Safeguarding of Venice to restore the cultural properties damaged by the water, but also to preserve its wider cultural heritage whose poor state of conservation had been exposed by the flooding (Valderrama, 1995: 173). René Maheu had been personally involved in the campaign and was also behind the creation of a French committee assisting with heritage restoration in Venice. Selecting this Italian city signalled the continued personal engagement of Maheu in its heritage, and strategically demonstrated the fundamental role played by UNESCO in safeguarding what the organisation considered to be a symbol of Western (and hence 'universal') heritage (Standish, 2012). This was clearly expressed in Maheu's opening speech at the 1970 conference. For him, Venice is 'where culture radiated throughout Europe', and 'still constitutes one of Europe's and mankind's priceless ornaments: this city which is all the more precious because we know it to be in danger and an object of concern for us all' (Maheu, 1970a: 1). This quote prefigures ideas from the 1972 World Heritage Convention: the need to protect what is considered the heritage of all mankind, a priceless heritage, belonging to all and the concern of all, indiscriminately.

Participants from 86 member states or associate member states of UNESCO and two non-member states attended the Venice conference,

held from 24 August to 2 September 1970. This was the first ever inter-governmental meeting on such a scale to discuss matters relating to culture. Cultural development was a central theme of the meeting and was used in three different ways. First, cultural development was under-stood as cultural policies, or the public actions taken for the encour-agement of and participation in the arts, culture and heritage sectors. This is very much the French model of cultural development, and to some extent reflects French domination of the debates. Cultural devel-opment as cultural policies had become a major public action in France with the creation of the Ministry of Cultural Affairs in 1959 (Urfalino, 2004: 19). Under this ministry, national authorities in France became responsible for promoting and developing cultural actions, for subsidis-ing the heritage sector and cultural workers, as well as for democratising culture, which should be enjoyed by all and not only by the privileged few. Cultural policies can therefore fulfil Article 27(1) of the Universal Declaration of Human Rights which claims that 'Everyone has the right freely to participate in the cultural life of the community'. If individuals have the right to participate in cultural activities and in sharing their heri-tage, then authorities have a duty to provide individuals with the means for such participation (UNESCO, 1970: 10). However, this hands-on approach to cultural development was not universally accepted. During the Cold War, some delegates feared that public support for culture could influence the content of cultural activities or lead to censure or attacks on freedom of speech (see for instance René Maheu's opening speech to the conference: Maheu, 1970a).

Second, cultural development was understood as a very broad con-cept, as the ultimate goal of human development, and as the enrichment and fulfilment of humankind. In his opening speech, Maheu explained that a diversity of needs and aspirations should therefore be integrated within development policies, not only economic needs. If culture is con-sidered the ultimate form of human expression and identity, then cul-tural development as the flourishing of cultural lives is the ultimate goal of development (Maheu, 1970a and b).

Finally, cultural development was understood as sustainable economic development (primarily through cultural tourism) (Isar, 2017: 150), which actually contradicted the broader understanding of the concept through focusing solely on culture's economic value.

The final report of the conference provided recommendations for shaping cultural development as cultural policies for the Global South on the one hand, and the Global North on the other. These recommen-dations reflected the views of René Maheu – and those expressed at the

General Conference and Executive Board meetings of UNESCO during the 1960s – that in the Global South, cultural development as cultural policies should help homegrown cultural activities to flourish and replace an 'imported and alien élite culture' (UNESCO, 1970: 11). These Indigenous cultures require protection from 'neo-colonialism and ideological expansionism' (Resolution 4). Massive participation in cultural activities would be ensured through democratisation and increased cultural access. Such participation would foster feelings of national identity, considered a prerequisite for endogenous economic and social development. Cultural development was thus considered essential for the construction of newly decolonised nations. The recommendations imply that the social and economic development of the Global South would not occur without the flourishing of, first and foremost, home-grown cultural activities. These ideas echo the traditional use of culture, particularly heritage, for nation building (Labadi, 2013a: 59–75). Hence the request that international aid should target the protection of national heritage and the training of specialists in heritage conservation and restoration in the Global South.

The recommendations called for cultural policies in the Global North to give meaning to people's lives at a time when technologies and economic advances were becoming an alienating force. This was a thinly veiled criticism of the consumer and capitalist model promoted by the United States made by a number of French intellectuals (such as Debort, 1967). For these experts, consumerism and capitalism resulted in soulless, unsatisfied lives. Countries from the Global North were also encouraged to protect their cultural heritage, but more importantly to counteract the excessive exploitation of cultural heritage for tourism (UNESCO, 1970: 20). This reference to the limits of economic growth and the associated need to develop sustainable solutions for heritage sites was recognised by René Maheu as needing further study (1970b: 2).

Despite these clear outcomes, the conference faced a number of issues. Lack of distinction between each of the three understandings of cultural development made discussions rather unclear. Another shortcoming was the absence of a definition for the term 'culture' itself. In a vehement article published in *Le Monde*, the writer Eugène Ionesco (who participated in the conference) recounted passionate and contradictory debates on culture. He warned that culture is not an innocent idea but an 'ambiguous and dangerous' concept, a terribly powerful tool when used by politicians and administrators. He criticised the bureaucratic organisation of the conference with its plenary and specialist sessions, and its multiple commissions and sub-commissions writing reports that 'pile up [in] mountains of paperwork' (Ionesco, 1970: 1). Despite

these shortcomings, the sixteenth session of the General Conference (12 October to 14 November 1970) authorised the Director-General to give UNESCO's cultural programme a new focus on the concept of cultural development (Valderrama, 1995: 200).

The 1970s: exploring further cultural development

The 1970s saw the organisation of regional conferences aiming to explore further the concept of cultural development, and to assist with the adoption and implementation of cultural policies nationally. These meetings, held in Europe (Helsinki, Finland, 1972), Asia (Yogyakarta, Indonesia, 1973), Africa (Accra, Ghana, 1975) and Latin America (Bogota, Colombia, 1978), mainly repeated the content of the Venice conference. The conference in Accra, for instance, reiterated that cultural development as cultural policies would lead to cultural consciousness and collective identity and that it should be the first step before any economic development could happen in the region. Again, these meetings faced criticisms, with Eugène Ionesco writing another acerbic critique on what he saw as interference in a subject (culture) that should be kept free of political and administrative scrutiny:

> I was outraged to see and hear those delegates in Helsinki discuss semicolons, with their collars and ties, full of arrogance and an unconscious mediocrity, dipped in paper, out of all truth and all love, wanting to discuss what they do not understand: the drama of existence, the human tragedy, the problem of ultimate end. (Quoted in Silva, 2015)

In addition to the regional meetings, the 1970s also saw publications written for UNESCO to clarify the concept of cultural development (for example Girard, 1972). However, most of the research had to be undertaken in a shorter time-span than was required for any serious consideration. Authors exerted self-censure to avoid scandals and the discontent of governments, which led to the avoidance of certain necessary debates. In the end, none of the publications clarified the meaning of cultural development or provided specific plans to achieve it (Maurel, 2006: 598–602). In 1977 UNESCO also launched the International Fund for the Promotion of Culture, to encourage cultural activities in the countries of the Global South, but most of these funds were engulfed in administrative costs, being thus diverted from their original goals (Vlassis, 2012: 2).

Attempts to provide concrete steps for the implementation of the recommendations from the Venice conference were also entangled in Cold War politics, which greatly limited their scope. The 'Recommendation on Participation by the People at Large in Cultural Life and Their Contribution to It' (adopted on 26 November 1976 in Nairobi, Kenya, better known as the Nairobi Recommendation), for instance, should have been an important document providing advice for the democratisation of cultural life. The final text, borrowing from the French model, advocates for cultural staff or 'animateurs culturels' to be employed to make culture more accessible to the largest number of people and to serve as links or translators between the arts, artists, the public, and cultural institutions. However, debates were marooned on ideological standpoints. The preamble of the text criticises 'commercial mass culture which threatens national culture', an idea backed by France but also by the USSR and the Soviet Bloc because of its criticism of capitalism and commercial excesses, (a model they characterised as being pushed for by the United States). Other Western countries (including the United States, West Germany, and Canada), on the other hand, expressed concerns that public funding for cultural actions, the model promoted by France and the USSR, ran the risk of restricting freedom of expression and increasing state control, and that private support should be privileged (Wells, 1987: 165–6).

A key legal text adopted in 1972 was the World Heritage Convention. I have already written extensively about world heritage and its connections with development (for instance in Labadi, 2007; Labadi, 2013a; Labadi, 2017a; Labadi, 2019c). Rather than encouraging the use of heritage to contribute to development, this legal text protected heritage *against* the forces of rapid industrialisation and urbanisation. Implicit reference was made to the international campaign to salvage the two Abu Simbel Temples in Egypt dating from the reign of Pharaoh Ramesses II in the thirteenth century BCE, which were moved in 1964–8 onto an artificial hill to protect them from being submerged after the construction of the Aswan High Dam. While being against development, this legal text was also innovative in its reference to the principle of intergenerational equity, detailed in Article 4 of the World Heritage Convention, which recognises that heritage should be identified, protected, and transmitted to future generations. This idea will be found again in the definition of sustainable development in the 1987 Brundtland Report, which calls on present generations not to compromise the ability of future generations to meet their own needs.

To review experiences acquired from and about cultural policies since the Venice conference, and to clarify further and reinforce the

cultural dimension of development, the World Conference on Cultural Policies in Mexico City, better known as MONDIACULT, was organised in 1982 (UNESCO, 1982a: 5).

1982 MONDIACULT (Mexico City)

Like the 1970 Venice Conference, the 1982 MONDIACULT event reflected the vision of UNESCO's Director-General from that time, the Senegalese Amadou-Mahtar M'Bow, so far the only African to have led this international institution. Discussions between M'Bow and the US delegation reveal that M'Bow viewed his responsibility as being primarily to respond to the needs of Africa and the rest of the Global South (Grafeld, 1976). M'Bow's and UNESCO's approaches were closely aligned with the New International Economic Order that emerged from the mid-1970s onwards, aiming to transform radically the governance of the economy to redirect more of its benefits towards the Global South (Gilman, 2015). This Director General wanted to create a 'world structure without domination, and with just and free societies' (UNESCO, 1975: 116). His vision built on that of his immediate predecessor René Maheu, and was that endogenous development based on cultural identity and cultural rights should be the lynchpin of the new order: any development must be rooted in, and respect, the culture in which it is carried out. UNESCO therefore promoted several paths to development, rather than copying a single/Western blueprint (UNESCO, 1982b: 6–7). For M'Bow, endogenous development based on cultural identity required two steps. First, the development and strengthening of the cultural identity of countries in the Global South, to use it to guide their present and future. This would be achieved through the strengthening of cultural policies and the implementation of the various UNESCO conventions and recommendations nationally, as well as support for oral traditions, and for artists and their freedom (through the 1980 UNESCO Recommendation concerning the Status of the Artist). In this model, education was considered essential for fostering an endogenous path to development, with UNESCO promoting artistic and aesthetic education as well as the teaching of national and mother tongues inside and outside of schools. Second, a bottom-up approach needs to be set in place to define and implement development projects, as local communities embody the values, aspirations, and needs of endogenous development (UNESCO, 1977: 72). These two pillars of M'Bow's vision provided one of the intellectual frameworks for MONDIACULT.

However, the origin of MONDIACULT was also embedded in the geopolitics of the time, especially the Cold War. It began with a coalition of nearly three hundred Latin American and Caribbean intellectuals, writers, and artists publishing an open letter addressed to the people and intellectual communities of the United States in *The Nation*, a US weekly newspaper, on 10 October 1981. These intellectuals expressed their fear of the United States manufacturing the neutron bomb and becoming actively involved in armed interventions. Nonetheless, it was a message of optimism: there is 'still time for peace and life', the letter reads, and it calls for 'joint intellectual collaboration [between North and South America] to preserve peace, culture, human rights and national sovereignty' (Benedetti, 1981). As a response to this letter, a Resolution on Latin America was adopted at the 1981 American Writers' Congress. It fully endorsed the ideas of the open letter, which stated that US foreign policy supported 'repressive dictatorships in Guatemala, El Salvador, Uruguay, Argentina, Chile and other countries and [was] undermining democratic rights elsewhere in Latin America'. The congress condemned these dictators, who suppressed freedom of speech and the rights of intellectuals. It requested active cooperation between US and Latin American writers and artists, as an act of solidarity, to defend peace, culture, human rights, and national sovereignty. Building peace in the minds of women and men through intellectual cooperation and culture in this way is enshrined in the Constitution of UNESCO. Mexico, located in Latin America and sharing a long border with the United States, is one of the countries most exposed to US foreign policy. It is no surprise therefore that Mexico was the location for the 1982 conference. The choice of Mexico underscored the importance of peace and security for cultural development, as well as the essential role that intellectuals and artists can play in building a better world.

MONDIACULT ran from 26 July to 6 August 1982. It was attended by 960 participants from 126 member states of UNESCO, including one prime minister and twenty-seven ministers or secretaries of state. It also saw the participation of political organisations for freedom and self-determination, such as the African National Congress and the Palestine Liberation Movement, which may explain some of its resolutions (Vickery, 2018: 342). Archival files for this meeting describe what seems today a bygone world, at least in terms of the past splendour and prestige of UNESCO. For this meeting, UNESCO was able to request the government of Mexico to pay for the flights and accommodation of 135 of its employees (out of a total of 185 staff from the organisation who travelled to Mexico for the conference) who stayed in 'good category' hotels, in

addition to cars with chauffeurs for high-ranking staff and minivans for the rest. UNESCO has not been able to make such demands since at least the early 1990s. Working documents reveal further demands made by UNESCO, and act as a fascinating time machine into past working techniques. Requests include 1,000 black pencils, 100 blue and black pens and 20 red ones, 1,000 reams (500,000 sheets) of photocopying paper and 100 reams of typewriter paper, 10 packs of carbon paper, 50 boxes of paper clips, and 25 perforators. This long list predicted the huge volume of paperwork to be produced, echoing Eugène Ionesco's criticism of this bureaucratic organisation in his aforementioned article for *Le Monde*. It also highlights the complexity of organising large-scale conferences. From the mid-1980s onwards, spiralling costs, complexity and dwindling budgets meant that some events could only be organised at the UNESCO headquarters in Paris, for instance the General Conference.

MONDIACULT started with the recognition that the world had changed since 1970 and the Venice conference, with more than thirty countries having gained their independence in the interim. As a consequence, the conference was thought to be useful for more countries and people than before. Since 1970, three-quarters (117) of the member states of UNESCO had created a minister responsible for cultural affairs. Types of cultural activities supported included the protection of cultural heritage, tourism development, and the provision of teaching in national and regional languages. Moving to outputs, the definition of culture crafted at the conference has been recognised as a milestone and used many times since. According to the Mexico City Declaration, culture is:

> the whole complex of distinctive spiritual, material, intellectual and emotional features that characterise a society or social group. It includes not only the arts and letters, but also modes of life, the fundamental rights of the human being, value systems, traditions and beliefs … It is culture that gives man the ability to reflect upon himself. It is culture that makes us specifically human, rational beings, endowed with a critical judgement and a sense of moral commitment. It is through culture that we discern values and make choices. It is through culture that man expresses himself, becomes aware of himself, recognizes his incompleteness, questions his own achievements, seeks untiringly for new meanings and creates works through which he transcends his limitations. (UNESCO, 1982a: 41)

Both the Mexico City Declaration and the final conference report with its 181 recommendations were in line with the vision of M'Bow. Drawing

parallels with the New International Economic Order, delegates called for a New International Cultural Order to implement their vision of cultural development, based on a world without domination and more favourable to countries from the Global South. The recommendations made clear that cultural identity, the basis of development, could not thrive without the full sovereignty of nations (UNESCO, 1982a: 22). Cultural identity was defined as 'the defence of traditions, of history and of the moral, spiritual and ethical values handed down by past generations, but it could never signify excessive attachment to tradition and the past or stagnation' (UNESCO, 1982a: 17). Cultural and natural heritage was recognised as necessary for the promotion of national cultural identity (Recommendation 1). Further explaining the New International Cultural Order, Recommendations 2, 3 and 4 requested the elimination of cultural domination, cultural alienation, and continuing colonial situations everywhere, to ensure the survival of distinctly defined cultural identities. (Neo)colonialism was condemned as 'the negation of cultural development', and the subjection of cultures to domination (Recommendation 5, UNESCO, 1982a: 61). A number of recommendations condemned threats to national sovereignty and situations of cultural domination, including the Apartheid regime of South Africa (Recommendation 8) and the UK's interference in the activities of Argentine scientists (Recommendation 9). Support for the cultural identity and heritage of Palestine was reaffirmed (Recommendation 11). The strong political dimensions of the conference are hence reflected in these documents, supporting countries of the Global South in their quest for independence, sovereignty, and the freedom to choose their own path to development.

Two instruments were recognised as essential for cultural development: education and cultural policies, echoing both the efforts of UNESCO since the 1970s and M'Bow's vision. Education was considered the best way to transmit national and universal cultural values, to teach the history of a country, and to form and strengthen cultural identity (UNESCO, 1982a: 11). If education was key, then fighting illiteracy was also fundamental, and was a priority of the then President of Mexico, featuring strongly in the MONDIACULT documents and reports. Cultural policies were the second method identified to strengthen cultural development at national levels through promoting cultural practices and participation in cultural life, as already stipulated in 1970 at the Venice conference. As before, fears were expressed, mostly by Western delegates, that responsibility of public authorities for matters relating to culture would lead to interventions, instrumentalisation, and censorship

(Kozymka, 2014: 36). Voicing these concerns was a way for Western countries to criticise the politics of the communist bloc, for instance the USSR and China. Following the faultline of the Cold War, this conference was also used as a platform to criticise Western and capitalist (especially North American) models of development, as in Venice in 1970 and during the debates on the 1976 Nairobi Recommendation. Concerns were expressed that development as mere economic growth left men soulless and unfulfilled, with 'its consumer society, cancerous concentration in the large cities producing dislocation and depersonalisation, not to say dehumanisation' as well as 'the destruction of nature and the environment' (UNESCO, 1982a: 10). Technological development, mass media, and increased globalisation were also criticised as leading to standardisation and 'imperial culturalism' (UNESCO, 1982a: 11). It is not surprising, considering this tone, that some US reports concluded that the conference constituted an attack on Western capitalism and served 'communist and Third World political machinations' (Heritage Foundation, 1982).

While delegates opposed each other on ideological and political grounds, they nonetheless unified their voices to raise concerns about the difficulty of translating the principles and ideas of cultural development into actions. In particular, the conceptual work on this topic was considered too embryonic to be able to address the issues identified at the conference. Delegates requested further exploration of the concepts and ideas of, and practical progress on, cultural development (UNESCO, 1982a: 16). They further lamented the lack of professional staff for the conservation and management of cultural heritage and for the administration and promotion of cultural activities, primarily in countries in the Global South. At the end of the 1970s and during the first half of the 1980s, UNESCO provided technical assistance to member states for the elaboration and strengthening of their cultural policies and cultural development programmes. However, experts were usually sent for too short a time period. Worse, UNESCO applied the exact method it intended to fight against. Instead of promoting and developing national capacity and endogenous approaches, UNESCO sent international experts and consultants from the Global North to the Global South. These experts used 'sophisticated knowhow straight from' the North that often had only limited relevance to the field (Maurel, 2006: 469). Efforts to build capacity and implement cultural activities therefore had very limited impacts on the ground.

Scepticism was also felt at MONDIACULT about the priority given to cultural policies and cultural development at national and international levels. More pressing needs, including fighting against

malnutrition, hunger, and preventable diseases, were being prioritised over culture (UNESCO, 1982a: 14). Cultural concerns were felt to be neglected, marginalised or omitted in both the formulation and implementation of national development objectives. Other UN organisations, the very family of UNESCO, also funded or implemented narrow development projects focusing on economic growth. There was thus no practice or model for a cultural approach to development. These concerns and the clear need to translate the principles on cultural development into action led delegates to request the organisation of a World Decade for Cultural Development, as part of the Third Development Decade of the UN. The aims of this Decade would be to operationalise the discussions held at MONDIACULT (and at Venice) and to 'eradicate illiteracy; ensure broad participation in culture and emphasize the cultural dimension of development and the affirmation of the cultural identity of each nation' (Recommendation 27, UNESCO, 1982a: 79).

1988–97: the World Decade for Cultural Development

The World Decade started in 1988 in a context of crisis at UNESCO. Four years earlier, in December 1984, the United States had left the organisation, followed in 1985 by the United Kingdom. The two countries' governments opposed the New World Information and Communication Order, introduced in a 1980 report drafted by a commission chaired by Seán MacBride, Nobel Peace Prize laureate. Sharing similarities with the New International Cultural Order and reflecting M'Bow's ideas and vision for the organisation, this new information and communication order aimed to reduce the prominence and influence of news agencies from the North that dominated the market, such as Reuters and Associated Press, to rebalance media representation, and to make communication and information flows between the North and the South more equitable (Vlassis, 2014: 145). A redistribution of information sources and flow might empower the South to provide its own news content, information, and representation and prevent its constant association with specific negative topics, such as poverty, disasters, and corruption.

The United States and United Kingdom had left in protest against UNESCO's heavy focus on the Global South countries and their concerns, but also against its inefficient working system. Just as in previous decades, during the 1970s and early 1980s the working methods of UNESCO were criticised for creating unnecessarily heavy workloads, leading to delays in attaining their objectives. This has been the case for instance in

the preparation of the General History of Africa, a project started in 1964 that is still being implemented now. Over its 50-year history it has suffered from excessive bureaucratic red tape, including sending each text for comments to an international commission, a drafting committee, and contributors, as well as to relevant UNESCO national commissions. This system coupled with frequent meetings meant that delays were experienced right from the beginning of the project. Small wonder that the first two volumes (of a planned eight) were only published in 1981, seventeen years after the start of the project (Maurel, 2006: 596).

The two countries' departure from UNESCO had a major impact on resources available, as they contributed 25 per cent and 4.4 per cent of the budget respectively. The loss of almost 30 per cent of the finances meant a drastic reduction in programs and activities. The universal and multilateral nature of the organisation was also damaged, especially since the United States had been a prominent stakeholder since the foundation of UNESCO (Vlassis, 2014: 146). This crisis of funding, purpose, and meaning may have contributed to some of the shortcomings of the World Decade for Cultural Development.

The decade, led by UNESCO but involving the entire UN system as well, had four official aims:

1. Acknowledging the cultural dimension in development
2. Asserting and enhancing cultural identities
3. Broadening participation in cultural life
4. Promoting international cultural cooperation (UNESCO, 1990a)

These aims were slightly different from those adopted at MONDIACULT. Eradicating illiteracy, a priority for the then President of Mexico and therefore included as one of the original aims of the Decade, was removed. With this removal, the close connection between education and culture was lost. Instead, the promotion of international cultural cooperation was added in 1984 (UNESCO, 1985: 2). One might have assumed that the aims of the Decade would have been reframed to ensure that all the implementing parties agreed on the overall vision and trajectory of work. However, this was far from the case. Meeting after meeting and report after report, the decade was discussed and redefined and new priorities and activities regularly adopted to fulfil the main aims by the core body responsible for its implementation, the Intergovernmental Committee for the World Decade. These numerous changes may reflect a crisis of confidence in an institution that had lost its universal appeal and credential with the withdrawal of the US and UK. They may also reflect

the difficulties that member states had with further detailing, defining, and specifying the cultural dimensions of development and their specific remits. As shown in Table 2.1, remits changed yearly, incorporating very different fields, such as 'Enhancement of solidarity' to promote international cultural cooperation, 'Relations between culture, science, and technology', and 'Man and the mediasphere'. Some member states did complain that the aims were too broad, that 'almost every imaginable cultural activity may be considered as a contribution' to the Decade and that 'There is thus a clear risk of dispersion of effort and resources, unless further guidelines to narrow the scope and to concentrate the action on some important issues are established' (UNESCO, 1989a: 4). However, these views were not shared by all members, with some complaining of the restrictive focus of the Decade. This lack of consensus might provide some explanation for the expansion of its priorities, but also for the difficulties UNESCO had in moving from discussions on the remit of the Decade to action (UNESCO, 1989b: 16–17).

Another reason explaining the changes of focus was the election in 1987 of a new Director-General of UNESCO, Federico Mayor, leading to new priorities and ambitions for the organisation, and thus for the Decade. Mayor's vision was that the Decade would 'create a new state of mind conducive to dialogue between and joint action by individuals and nations' (UNESCO, 1988: 3). In other words, the hope was that the Decade would be the medium to implement his vision of a 'culture of peace'. He defined this as a:

> set of values, attitudes, traditions, modes of behaviour and ways of life based on respect for life, ending of violence and promotion and practice of non-violence through education, dialogue and cooperation; full respect for and promotion of all human rights and fundamental freedoms; commitment to peaceful settlement of conflicts; respect for and promotion of the right to development; respect for and promotion of equal rights of and opportunities for women and men; respect for and promotion of the rights of everyone to freedom of expression, opinion and information; and adherence to the principles of freedom, justice, democracy, tolerance, solidarity, cooperation, pluralism, cultural diversity, dialogue and understanding at all levels of society and among nations. (Mayor, 1999)

Mayor's approach goes back to the roots of UNESCO and can be understood as a renewed commitment to the preamble of its Constitution and its famous sentence: 'Since wars begin in the minds of men, it is in the

Table 2.1 Aims, thematic priorities, and project areas for the World Decade for Cultural Development (as identified between 1988 and 1991).

Action Plan for the Decade, drafted 1985, published 1990	Strategy for the Implementation of the World Decade for Cultural Development, 1988	Priorities adopted by the Intergovernmental Committee of the World Decade for Cultural Development, 1989	Project areas as adopted by the Intergovernmental Committee of the World Decade for Cultural Development, 1991
'I. Acknowledging the cultural dimension in development. (i) Development strategies and projects (ii) Methodological instruments and human resources (iii) Scientific development as a component of cultural development II. Affirmation and enrichment of cultural identities: (i) Preservation and enhancement of heritage (ii) Creative transformation of cultures (iii) Preservation and renewal of cultural values III. Broader participation in cultural life: (i) Participation in cultural life (ii) Promotion of creation and creativity IV. Promotion of international cultural cooperation: (i) Stimulation of intercultural communication (ii) Enhancement of solidarity' (UNESCO, 1990a)	'I. Making room in development for the cultural dimension: Key area 1 – Making room in development for the cultural dimension Key area 2 – Relations between culture, science and technology II. Affirmation of cultural identity: Key area 3 – Cultural values and changes Key area 4 – Physical and non-physical cultural heritage Key area 5 – Environment, architecture and urbanisation Key area 6 – Cultural industries III. Broader participation in cultural life: Key area 7 – Participation in development by women and young people Key area 8 – Stimulation of creation and creativity in the arts IV. Promotion of international cultural cooperation: Key area 9 – New ties of solidarity and dialogue between cultures' (UNESCO, 1988)	'Key area 1 – Acknowledging the cultural dimension in development Key area 2 –Relationship between culture, science and technology Key area 3 – Preservation of cultural heritage Key area 4 – Man and the mediasphere Key area 5 – Participation in cultural life and in development Key area 6 – Stimulation of artistic creation and creativity' (UNESCO, 1989a: 5–7)	• 'Cultural factors in management and development • Tourism • Culture and development • Cultural pluralism toward the year 2000 • Technology, cultural industries and development' (UNESCO, 1991: 2)

minds of men that the defences of peace must be constructed'. This programme is also a response to the geopolitics of the time, with ethnic hatred, cultural prejudices and interethnic tensions and conflicts happening in countries such as Rwanda, Lebanon, and the former Yugoslavia, leading some to believe that building a culture of peace was one of the major challenges of the late twentieth century (Kozymka, 2014: 42).

A culture of peace and its connection to development was further made explicit in the 1996–2001 UNESCO medium-term strategy, which explains that peace and development cannot be disassociated. This approach to a culture of peace from the mid-1990s took the form of promoting shared values between cultures, and also the rights of minorities within specific countries, including Indigenous people. But more importantly, a culture of peace is about promoting and constructing cultural pluralism through developing social cohesion within societies and between societies (UNESCO, 1996: 44–5). Such focus means that, for the leading figures of UNESCO and related bodies, the priority of the Decade was first and foremost to promote intercultural cooperation as well as cultural pluralism and dialogue, and then second, to clarify the contribution of culture to economic development (Mayor, 1993: 5). This prioritisation did not prevent the General Conference regularly requesting the Director-General to increase understanding of the relationships between cultural and other aspects of economic and social development (El-Khatib and Wagner de Reyna, 1987: 338–9). These competing understandings and definitions of the Decade can certainly explain its slow start, and the difficulties faced during implementation.

The lack of a clear focus for the Decade and the financial crisis experienced by UNESCO did not prevent activities from being carried out. Three types of activities were supported as part of the Decade, in addition to the final report 'Our Creative Diversity':

1. Flagship projects funded by UNESCO
2. Activities undertaken by a member state, an NGO or another UN agency, following calls for projects and funded by UNESCO
3. Activities undertaken by a member state, an NGO or another UN agency, with no financing but with the logo of the Decade.

A number of flagship projects implemented a culture of peace by documenting, promoting, and celebrating cultural connections and encounters through reviving historically loaded routes or roads. The *Integral Study of the Silk Road: Roads of dialogue* was one such project, which aimed to celebrate encounters between the Orient and the Occident.

The 200 scholars involved, from 45 countries, ran diverse activities, from recording tangible and intangible heritage along the road to studying languages and intercultural influences. Other similar projects focused on the *Slave Route, The Iron Roads in Africa,* and *The Roads of Faith.*

The rebuilding of the Library of Alexandria, in Egypt was another flagship project of the Decade. Led by the Egyptian government, in cooperation with UNESCO (UNESCO, 1994a: 16), it aimed to enhance cultural identity and strengthen a culture of peace. This example is a microcosm of some of the contradictions of the Decade, between its ideal principles and its reality. Conceived as an opportunity to broaden participation in cultural life and an example of democratisation, the library in fact became an exclusionary space for 'an educated minority' (Butler, 2007: 130). A culture of peace, which seemed so lofty and benign, also became embedded in national and regional politics and power struggles during its implementation in the library project. The library was supposed to stand for 'uniting the world' in a 'common future' and a way to 'enhance the welfare of humanity at large' through education and culture (Brundtland in GOAL, 1990: 33). However, using the reconstruction, the then president of Egypt Hosni Mubarak could position himself as a 'peacemaker in the Middle East' (Buckley, 2000: 12). As for Saddam Hussein, the then President of Iraq, providing the largest contribution to the project (US$21 million) enabled him to position himself as a 'patron of world civilisation' (Butler, 2007: 121).

In addition to these flagship projects, over 1,200 smaller projects were implemented by 166 member states, 14 intergovernmental organisations (IGOs), and 66 NGOs during the Decade, of which 400 received a total funding of more than US$5 million (UNESCO, 1997: 2). Most of the projects thus received less than US$10,000. Allocation of resources followed an internal assessment by the UNESCO secretariat, based on a short application form. Criteria for evaluation included the alignment of the proposed project with the Plan of Action or the Decade Strategy; the probable impact; the innovative dimension of the project; the interdisciplinary nature of the plan; and its potential to meet local needs. Yet the application form was too short to allow provision of detailed information on the activities and applications therefore often remained vague, and difficult if not impossible to assess. While flagship projects benefited from publicity and evaluations, there was no funding to publicise smaller projects, evaluate their results, and publish on their impacts and lessons learnt. As a result, it is difficult to assess how or if they fulfilled the aims of the Decade (UNESCO, 1994b: 9). Archival research I undertook reveals that some of the funded proposals were for

projects that complemented flagship ones. For instance, the government of Mozambique received modest funding in 1991 to undertake research on ironworks in the country, to organise a specialist meeting on the topic, and to disseminate results with a publication, to feed into the flagship project on the Iron Roads in Africa. Other proposals tried to fit within a culture for development framework. This was the case, for instance, for the 'Training programme for rural women and youth in cultural development' proposed and co-funded by Nigeria in 1990. This started with a national workshop to identify training components for rural women and youth on development topics, to be followed by local workshops on the unique role of women in cultural development and socio-economic issues. However, detailed information on the actual content of the workshop and trainings, on how the realities on the ground and the needs of women would be taken into account, and on how the training could be linked to improving the lives of women and young people, was lacking. With such a lack of information on the projects and their results, it is impossible to know how culture for development was articulated on the ground, how a bottom-up approach was achieved, and what was learnt.

This project in Nigeria was the exception rather than the rule. Most of the Decade projects fit the definition of cultural development as cultural policies in that they aimed to promote cultural activities *stricto sensu* (see also Claxton, 2000), as already done by UNESCO in the 1970s and early 1980s. These activities fit the Decade's aims of 'asserting and enhancing cultural identities' and 'broadening participation in cultural life'. One example was the 'Grapholies, Salon Africain des arts plastiques', which aimed to exhibit art by painters, sculptors, and graphic artists from the Ivory Coast and elsewhere, as a networking platform and a way of promoting participants. This narrow focus on cultural activities led the former Assistant Director-General for Culture of UNESCO (from 1994 to 1998), the Mexican anthropologist Lourdes Arizpe to conclude, in retrospect, that 'the Decade had dissipated itself into hundreds of folklore and art events and music festivals but had not generated new guidelines for international policies linking culture and development' (2015: 20). This comment might need to be softened in light of the long-term impacts of some of the small-scale events. The Grapholies exhibition, for instance, happened only once (in 1993), but served as a major platform to promote the work of young artists like Dominique Zinkpe, and there has been talk of reviving the initiative as recently as 2014 (Dabou, 2013).

The slow implementation of the Decade and the scattering of the budget into more than a thousand projects led to the increasing belief

that a final report on culture and development would be needed to increase the Decade's visibility and provide it with a concrete long-term legacy (UNESCO, 1991). The preparation of the report was proposed in 1989 at the 25th Session of the General Conference by the representatives of Sweden and the other Nordic countries. The ambition was for this book to have the same impact that *Our Common Future*, better known as the Brundtland Report, had on the environment, with Gro Harlem Brundtland and her commission succeeding in bringing environmental issues onto centre stage (World Commission on Environment and Development, 1987). The Nordic countries hoped to transform the international landscape and narrative on culture for development, to ensure that culture would become central to development issues and, in the process, that the report would become a significant output of the Decade (World Commission on Culture and Development, 1995: 8). To achieve these ambitions, in 1992 the World Commission on Culture and Development was established, chaired by Javier Pérez de Cuéllar, who had just completed his term as Secretary General of the UN. The other twelve members of the commission included 'eminent men and women from every region and from the most varied intellectual backgrounds' (UNESCO, 1993: 1), such as the historian/archaeologist Yoro Fall from Senegal, the economist Mahbub ul Haq from Pakistan, and the sociologist Elizabeth Jelin from Argentina. The large budget of around US$6 million for the creation of the report was provided mainly by the Nordic countries, Switzerland, the Netherlands, Germany, UNDP and UNESCO, with additional in-kind contributions made by these countries.

Entitled *Our Creative Diversity*, this final report was a wide-scale and inclusive work, the result of the collective effort of experts, specialists, artists, and members of the commission. Conceived as policy-oriented, it clearly recognises the challenge of how to 'promote different paths of development, informed by a recognition of how cultural factors shape the way in which societies conceive their own futures and choose the means to attain these futures' (World Commission on Culture and Development, 1995: 11). Development was defined as the 'universal physical, mental and social well-being of every human being' provided through the widening of human opportunities and choices (16). The report and its commission move away from considering 'cultural development' as cultural policy, towards a focus on 'culture and development', a broader understanding of values and ways of living together affecting choices and well-being in line with Amartya Sen's conception of development as capability (Isar, 2008: 10–11; Sen, 1999).

Because of its ambitious nature and the polysemic nature of both culture and development, de Cuéllar recognised that the task of

drafting it was 'of daunting complexity' (World Commission on Culture and Development, 1995: 10). The report begins by expressing its support for cultural pluralism and the diversity of cultures, considered as equally valuable (Chapter 2). This recognition of pluralism goes hand in hand with the definition of global ethics in Chapter 1, which is the universal respect of human rights and the equal treatment of all irrespective of class, gender, race, community, or generation. Chapters 1 and 2 thus recognise the importance of diversity within a universal framework. Commitment to cultural pluralism should lead to the widest participation of people in creative endeavours (Chapter 3). Media technologies should be democratised and pluralised (Chapter 4). Chapter 5 deals with gender and culture and warns against imposing unacceptable Eurocentric values and norms on women in the name of culture. The basic human rights of young people, their dignity, education, and health should be respected and protected (Chapter 6). A whole chapter focuses on tangible and intangible heritage (Chapter 7, entitled 'Cultural heritage for development'), recognising that the World Heritage Convention is a Eurocentric framework that is more suited to Western countries. Observing that Western countries have the means to preserve their heritage, the report calls for the creation of 'Human Heritage Volunteers' to assist with the conservation of buildings, sites and monuments in other parts of the world. More than just preserving tangible heritage, the volume calls for halting the disappearance of languages through multilingual education. A section of Chapter 7 calls for bottom-up approaches that provide social and economic benefits from heritage for local communities, primarily through tourism. The intimate connections between cultural diversity and biodiversity are detailed in Chapter 8, and the greater consideration of cultural values in environmental protection is asked for. Chapter 9 discusses the importance of cultural policies, as a way of encouraging multicultural activities for human development. The report closes with a list of research needs and an international agenda, requesting among other things the preparation of an annual report to document further the links between culture and development. Some requests were implemented, including the publication of two World Reports on Culture (1998 and 2000), and the organisation of the 1998 Stockholm Intergovernmental Conference on Cultural Policies for Development. Internally, the report also laid the groundwork for key standard-setting texts that would be adopted at the turn of the millennium, as discussed in the next chapter.

Despite the ambitious nature of the report, its coverage of a wide range of issues, the prestigious contributors and the major resources for its drafting, *Our Creative Diversity* 'went largely unnoticed' outside of

UNESCO (Wright, 1998: 7; Eriksen, 2001: 129). This was confirmed in the interviews I conducted with experts who had first-hand experience working on the report. For some, failure to attract attention and make an impact was due to the very concept of culture, which is 'not a survival issue. It is not a question of life and death. It is not a question that really affects people in such a strong and direct way [as the environment]'.[5] Drafters of the report also reported internal leadership opposition, and a lack of available information to identify new paths of development that would take culture into account in a meaningful way.[6] Others noted that *Our Creative Diversity* did not have the same support that the Brundtland Report had. The Brundtland Report presented and promoted the views of hundreds of environmentalists, and therefore had a large base of supporters ready to embrace it and use it to further their cause (Eriksen, 2001: 129). Finally, the Brundtland Report was published by a major international publisher (Oxford University Press), whereas *Our Creative Diversity* was published 'in-house' by UNESCO, which does not have a publishing distribution network into bookshops or a marketing department with the experience or budget for promotion of a big-selling trade title.

For me, the very contents of *Our Creative Diversity* might be the reason for its failure to attract attention and to make the planned impacts. These contents reflect the conflicting conceptual priorities of the World Decade. Rather than clarifying how culture contributes to development, a culture for peace is promoted in line with the vision of UNESCO's then Director-General, focusing on cultural diversity and pluralism, on equal rights and opportunities for women, men, and youth, as well as on freedom of expression through new technologies. According to the report, promoting and respecting diversity, human rights, and equal opportunities will lead to a culture of peace, which would subsequently lead to development. However, the report does not explain how issues of discrimination, violence, or human rights violation can be addressed to reach a culture of peace. In addition, it is not clear how existing development models can better take account of diversity and cultural rights. The report does not provide any new models of development based on diversity. The report thus misses an opportunity to clarify, beyond the anecdotal, how taking account of cultural values, traditional systems, and diverse world views can help to enhance the well-being of local communities. Additionally, the report conflates different understandings of culture and development (Isar, 2017: 150). 'Cultural development' is used both in its narrow sense of cultural policies, focusing on artistic and cultural production as promoted in the 1970s and early 1980s by

UNESCO, but also in its more anthropological sense (considering culture to be every human activity and the flourishing of a way of life as a whole). These two understandings of culture used interchangeably make the report difficult to understand, as it refers to two different phenomena (a point also noted by Eriksen, 2001: 131). The report further uses terms such as 'human development', 'people-centred development', 'sustainable development', and 'culturally sensitive development' (Eriksen, 2001: 137) without defining them or clarifying whether they all have the same meaning.

Anthropologists have criticised the report for focusing primarily on the benevolent and positive dimensions of culture as an inclusive mechanism. The negative aspects and impacts of culture have mostly been omitted. This includes, for instance, the political uses of culture for identity and nation-building through the exclusion of minorities and the promotion of the culture of the majority (Wright, 1998: 12–17). The report fails to recognise that UNESCO's very own programmes, primarily the World Heritage Convention, run counter to the promotion of cultural diversity. Nominating sites on the World Heritage List has often been used for nation building by states parties, an approach that has been validated by UNESCO when inscribing sites on the list (Labadi, 2013a: 59–76). World heritage has been used by some countries to represent a national cultural identity that is homogeneous, without consideration for diversity. *Our Creative Diversity* also glosses over contradicting conceptions of cultural diversity, referring to both bounded cultures (an archipelago view of different nations each made of people having a coherent and distinct culture) and to fluid identities. The problem with its treatment of bounded cultures is that, rather than being seen as changing and evolving, cultures are presented in the report as 'rooted and old, and shared within a group' (Eriksen, 2001: 132). Such an understanding of cultural diversity does not leave space for people with multiple identities and cultures that are fluid, hybrid, and constantly evolving. The report does not engage with these contradictions or try to find potential solutions, and it uses both understandings without much contextualisation.

In addition, much of the report remains simply declaratory. This is the case with Chapter 7, which insists upon tourism as a double-edged sword that can be positive for heritage but can also destroy it. Despite expressing these concerns, no concrete solutions were provided to ensure that heritage can contribute to development in a sustainable manner and bring sustained social and economic benefits for local communities. This is surprising, considering that the report is part of the World Decade, and it seems that no result from the pool of the 1,200 sponsored projects was

considered. Its largely declaratory nature and lack of solutions means that the report might not be as useful as it was intended to be, which may partially explain why it went largely unnoticed.

Finally, the report and even the Decade suffered from a lack of interest from the very member states and some UN organisations that were supposed to support and implement them. UNESCO tried to link the World Decade with the Fourth United Nations Development Decade, which ran concurrently (1991–2000), proposed amendments in its draft documents defining the goals and priorities, and even requested national governments to lobby the UN for the inclusion of references to culture. Yet no mention was made of culture in the documents of this Development Decade (UNESCO, 1990b: 3). However, two intergovernmental organisations stand out. The first is the UNDP, which supported more than 100 Decade projects, primarily for the conservation and rehabilitation of tangible heritage and the safeguarding of intangible heritage. It also provided funding for feasibility studies for cultural tourism development, including in China, Guinea-Bissau, and Cambodia, and for flagship projects, including the rebuilding of the library in Alexandria. The second organisation that fully embraced the aims of the Decade was the World Bank. These external appropriations were fundamental, considering the shortcomings with the World Decade and *Our Creative Diversity*.

The 1990s: the World Bank and wider impacts of the Decade

The World Bank's interest in cultural heritage took different forms. In the mid-1980s cultural heritage became protected against the forces of development. The 1986 World Bank operational policy OPN 11.03 required projects to avoid, minimise, or otherwise manage adverse impacts on heritage (Goodland and Webb, 1987; Lafrenz Samuels, 2019: 55–72). Interestingly, this is one of the reasons for the adoption of the 1972 World Heritage Convention as already discussed (Labadi, 2017a: 45–60). At this time, heritage was not really considered an asset but as a liability that needed to be protected. This understanding of heritage as a liability has continued to this day, and is very much the lens through which the latest Guidance Note for Borrowers on Cultural Heritage has been drafted (World Bank, 2018b).

The presidencies of Lewis T. Preston (1991–5) and James D. Wolfensohn (1995–2005), the vice-presidency of Ismail Serageldin for Environmentally and Socially Sustainable Development (1992–8),

and other Special Programs (1998–2000) proposed a new approach to culture and development. UNESCO is credited with stimulating this turn, particularly the World Commission on Culture and Development (World Bank, 1999: 13). The failure of the Bank's projects, particularly in Africa, can explain such a change of methods, with the recognition that successful development could only happen if culture and cultural identity were fully taken into account, supported and integrated into programmes of work. This was a clear acknowledgement that some externally imposed models of development and economic approaches such as structural adjustment policies had failed. Rather logically and symbolically, one of the first major events to discuss this turn was a conference on Culture and Development in Africa (1992), a continent which, more than any others, had endured decades of externally imposed and failed ideas for progress and growth. At this 1992 conference, some of UNESCO's narratives were appropriated and repeated. It was highlighted that development could only be successful if it was based on cultural identity, and if people were empowered through effective participation and enabled to live fuller lives with the ability to choose their own destinies. However, a cultural approach was recognised as difficult to implement because it can be misused for political and exclusionary purposes, and the 1954 Bantu Education Act in South Africa was discussed as an example. The act's official aim was to create a culturally sensitive education system, but its real aim was to sustain the Apartheid regime (Serageldin, 1994: 23). The report of this conference is thus rather realistic in its consideration of the potentially damaging and manipulative aspects of culture, and thus moves beyond what UNESCO had proposed.

From the mid-1990s onwards, the Bank continued to promote a cultural lens through which to draft and implement projects, as reflected for instance in the 1997 Annual Meeting Address of President Wolfensohn. To realise this vision, the World Bank staff was enlarged to include sociologists, anthropologists and environmentalists, in addition to the existing staff, consisting mainly of economists.[7] However, when moving from lofty speeches to actions, heritage conservation was unambiguously utilitarian in manner, aiming for social and economic development (World Bank, 1999: 8). In other words, rather than mainstreaming culture and heritage in development, projects aimed to use culture primarily as a driver of economic development. Tangible and intangible heritage were indeed increasingly seen as key assets of the poor, providing these communities with new income-generating and employment opportunities through their special knowledge and skills (for instance knowledge of history, traditions, and culinary practices). From the mid-1990s

onwards, cultural heritage preservation was therefore increasingly associated with economic vocabulary: heritage sites were 'valuable endowments', and they contributed to 'the reduction of poverty', 'the decrease of chronic joblessness', and 'growth enhancing strategy' (World Bank, 2001). Tourism and craft industries were presented as the way tangible and intangible heritage could be harnessed for social and economic development. Ultimately, the process of heritage conservation and tourism development, particularly in urban centres (such as the medinas of North African cities), would result, for the World Bank, in the improvement of living and social conditions for resident populations.

From 1996 onwards, and working in collaboration with UNESCO (often with the World Heritage Centre), projects on heritage conservation for poverty reduction and the strengthening of social capital were rolled out, for instance in the Middle East and North African region (in Algeria, Egypt, Iran, Jordan, Lebanon, Morocco, Syria, Tunisia and Yemen among other countries). A number of these projects focused on medina rehabilitations, as was the case in Fez, Morocco (1998–2005). The objectives were to preserve heritage and use it for economic development through tourism and crafts as well as to address the needs of the local communities by improving their daily life conditions (such as access to basic infrastructure, improvement of housing conditions, and job creation).

A cultural approach to development was further promoted at two international conferences organised by the World Bank in cooperation with UNESCO: *Culture in Sustainable Development: Investing in cultural and natural endowment* (held in Washington, DC in 1998) and *Culture Counts: Financing, resources and the economics of culture in sustainable development* (Florence, 1999). These two events aimed to discuss further some of the recommendations from the UNESCO Intergovernmental Conference on Cultural Policies for Development (Stockholm, March–April 1998), including that more resources and partners were needed for cultural development. These events were a public platform for the World Bank to repeat their approach to culture/heritage for development – that is, to use heritage conservation to provide new economic opportunities, jobs and revenues, to improve local communities' daily lives, and to strengthen social capital (Wolfensohn, 1999: 285). Following the *Culture Counts* conference, a programme of work was rolled out between the World Bank and the Government of Italy (2000–13), with 49 activities totalling US$8 million.[8]

However, despite all of these efforts and programmes promoted by the highest-ranking individuals at the World Bank, a cultural approach

to development remained marginal within the organisation. Archival documents from 1998 reveal that mainstreaming this cultural model to development was 'too early for the World Bank'.[9] There was a lot of resistance against seriously considering culture for development, as it was not regarded to be as urgent a need as education, health, or sanitation. Interviews also reveal that staff at UNESCO were themselves not convinced of the narrative on culture for development, which led to a reluctance in promoting it.[10] Besides, priorities had changed at UNESCO with the arrival of its new Director-General, Kōichirō Matsuura, in 1999. He would use one of the key legacies of the Decade, the Action Plan of the 1998 Stockholm Conference on Cultural Policies for Development, to focus on its targeted actions on cultural diversity, and to further his own agenda on intangible heritage and the diversity of cultural expressions, as discussed in the next chapter.

The Millennium Development Goals

Considering these different shortcomings, and the fact that efforts on culture and development did not receive a lot of support outside the cultural world – and even within UNESCO and the World Bank – it is not at all surprising that culture was totally excluded from the Millennium Development Goals (MDGs). These were eight goals adopted by the UN in 2000, to be implemented until 2015, and aiming to address global challenges. The MDGs were a rallying framework for bilateral and multilateral aid and aimed to tackle a diversity of issues, including the eradication of extreme poverty and hunger (Goal 1), achieving universal primary education (Goal 2), promoting gender equality and empowering women (Goal 3) and ensuring environmental sustainability (Goal 7). Lourdes Arizpe, UNESCO Assistant Director-General for Culture from 1994 to 1998, recorded attempts to push the UN General Assembly to include 'cultural aims' in the Millennium Development Goals. However, there was strong resistance to such inclusion as there was a 'fear that "culture" invites consideration of conflicts between different cultural minorities' (Arizpe, 1998: 17). This distrust reveals that the culture of peace focus and larger debates held during the World Decade did not consider culture in all of its complexity, and perhaps projected a positive and benevolent stance that remained unconvincing for many. Besides, as I have documented elsewhere (Labadi, 2018b: 44), culture is often presented as an obstacle to development, as it represents the past rather than the future, traditions rather than progress and modernity (see also Basu and Modest, 2015: 1–32).

Nonetheless, the culture sectors should not bear sole blame for having so little impact on the international development agenda and the Millennium Development Goals. Selecting the goals was an exclusive process led by economic organisations, primarily the International Monetary Fund, the World Bank and the Organisation for Economic Cooperation and Development. Grassroots organisations, civil societies, and NGOs were largely excluded from the process (Kabeer, 2005; Fehling, Nelson and Venkatapuram, 2013: 1111; Amin, 2006). The goals are not inclusive in their approach and they simplify the key challenges that they focus on. Poverty, for instance, was defined as being US$1 per day and reduced to material issues, despite being much more complex and multi-dimensional (Lafrenz Samuels, 2010: 204–5; Maxwell, 2003: 5–25). Another example is the target for Goal 3, which centres on eliminating gender disparity in primary and secondary education. It has been heavily criticised for neglecting key issues preventing gender equality and the empowerment of women, including violence and discrimination against women (Labadi, 2018a: 90; Fehling, Nelson and Venkatapuram, 2013: 1109–22; Subrahmanian, 2005: 395–407). Finally, several key issues for development, including peace, security, disarmament, human rights, and democracy were not included in these goals, further highlighting their exclusionary nature (Hill *et al.*, 2010). However, the difficulty these goals faced in implementation quickly raised the issue of including a window on culture, as further detailed in the next chapter.

Conclusions

The culture for development narrative originated in the Global South, as explained at the beginning of this chapter. In the 1960s and 1970s, recently independent African countries wanted to move away from Western models of development. Instead, they wanted to forge their own destiny and future, from their own history, culture, and pasts, which had been erased and deemed 'uncivilised' by colonising powers. Rediscovering their history and culture would help these countries construct more authentic cultural identities, the basis of endogenous development. These ideas were supported and promoted by the Directors-General of UNESCO, first René Maheu but most importantly Amadou-Mahtar M'Bow. However, giving flesh to this idea of culture for development was difficult. At the international level, the domination of French intellectuals at the 1970 Venice conference and 1982 MONDIACULT resulted in the prominence

of the concept of cultural development as a narrow understanding of cultural activities and policies.

The World Decade for Cultural Development (1988–97), rather than providing clarifications on the debate, may have added to the confusion, especially since it took place in a world that saw major changes with the end of the Cold War and a rise in interethnic conflicts within states. Different definitions of culture, development, and culture and/for development, were concomitantly used. Culture was considered interchangeably as both a restricted creative production and also – in a more anthropological manner – as every human activity. Development was defined as economic growth only, but also as human development, a way of opening choices and leading the life one values, and as a peaceful world where minorities and different ethnic groups co-exist in harmony.

Having different definitions might not have been too much of a problem if roadmaps and ways to implement culture for development approaches had been clarified. However, despite more than 1,200 projects implemented during the World Decade for Cultural Development, the different policies adopted since 1970 and a World Report on Culture and Development, implementation strategies for development that take culture into account remained unclear. Many projects consisted of cultural activities with little connection to economic or human development. Projects promoting and celebrating cultural connections and encounters did not necessarily lead to a more peaceful world. Many projects undertaken during the Decade also had political objectives, rather than cultural or development ones. It was only in the mid-1990s that various locally grounded heritage projects were devised to bring socio-economic benefits through tourism, craft, and the improvement of living conditions, and the World Bank became an active proponent of this instrumental use of heritage. Yet, by the end of the millennium, few monitoring or evaluation reports were available for these projects. It is not therefore surprising that culture and heritage were absent from the MDGs (2000–15), even when accounting for the narrow focus of this new international framework. Yet the lack of clear success in achieving these goals led to culture being taken more seriously than ever before, as detailed in the next chapter.

Notes

1. The General Conference is the gathering of all of the representatives of UNESCO's member states, meeting every two years to vote on its programmes and budget.
2. 'In Africa, the death of an old man is like the burning of a library.'

3. The group was formed at the UN Conference on Trade and Development in 1964. It was originally a coalition of 77 countries, but today includes 134 states.
4. ADG/SHC/3.3/2337. Box no. B7S1.18-46. AG 8. 265 CLT/131/5 008 A 06 70.
5. Interview International/06 (21 March 2019).
6. Interview International/06 (21 March 2019).
7. Interview International/07 (29 May 2019).
8. One of the key outputs of this project was an evaluation of the projects on culture and development, including the rehabilitation of the medinas in the MENA region. These evaluations paint a mixed picture of the projects. Home owners saw an increase in their property values and artisans had more customers as a result of rehabilitation work. Conversely, some of these projects lack national and local buy-in, as they were considered to be externally driven and motivated (Cidre and Nardella, 2015: 57–79). The rehabilitation of historic centres led to gentrification, which drove renters away. Tourism-focused establishments (hotels, restaurants) have replaced shops catering to local needs (Bigio and Licciardi, 2010: 10).
9. Folder or item No. 1832280. ESDVP – Vice President's Correspondence – Chronological Records – Ismail Serageldin – Lotus Notes – Log Book 98-4303.
10. Interview International/06 (21 March 2019).

3
International approaches from 2000 onwards

Culture was not included in the MDGs. Yet, since the turn of the millennium, culture for (sustainable) development has been an important theme in international debates. This chapter charts the various international narratives and initiatives on culture for development, continuing from the previous chapter and again focusing primarily on UNESCO, the key international organisation responsible for this sector. The early new millennium saw the adoption of two key UNESCO texts: the 2003 Convention for the Safeguarding of the Intangible Cultural Heritage and the 2005 Convention on the Protection and Promotion of the Diversity of Cultural Expressions, each applying specific understandings of culture for development. Later, there was a focus on lobbying for the inclusion of culture, understood in its widest form as the whole complex of distinctive spiritual, material, intellectual and emotional features that characterise a society or social group in the post-2015 development agenda.

As in the previous chapter, the ideas, visions, and ambitions of successive UNESCO Directors-General, alongside contemporary geopolitics, are seen to guide the programmes and initiatives of the organisation. Hence, culture for development approaches cannot be understood without first understanding each Director-General's views and approaches. For this reason, this chapter explains both the approaches of each Director-General as well as the enabling or disempowering impact of contemporary geopolitics and powerful member states. It starts with explaining Kōichirō Matsuura's priorities, and then focuses on how the 2003 and 2005 conventions were concerned with overcommercialisation and with addressing the uniqueness of heritage and the creative industries. A section on tourism at World Heritage sites and the processes that led to the adoption of the 2011 Recommendation on the Historic Urban Landscape

are then discussed. The second part of the chapter explains the actions of Irina Bokova, UNESCO Director-General from 2009 to 2017, as well as the entanglement of her ambitions for UNESCO with her personal goal of becoming UN Secretary General, which can partly explain why UNESCO was active on the international scene but did not support the adoption of a single goal relating to culture as part of what would become the SDGs. Ongoing programmes on culture for development are then critically assessed, to provide a comprehensive historical framework.

Kōichirō Matsuura (1999–2009): continuity and rupture

As explained in the previous chapter, the withdrawal of the United States from UNESCO in December 1984 had a major negative impact on its international credibility and finances. Thus, the most important event that marked the start of Kōichirō Matsuura's mandate was the return of the United States to membership. Almost a year after the attacks of 11 September 2001, American President George W. Bush announced that his country would re-join the organisation after nearly twenty years of absence (Maurel, 2009: 142). This return, although short lived (see below), meant that UNESCO could be considered a strong organisation that had regained some of its credibility as a multilateral agency. In the words of Matsuura, the return of the most powerful country in the world would 'make an enormous difference' to the organisation. He continued, 'Dealing with global issues, you need the participation of the global power ... For global action, we need the United States' (cited in Azzi, 2005: 774). It also significantly increased UNESCO's budget, with the United States making a compulsory contribution of US$134.2 million to the organisation's US$610 million two-year budget in 2004.

Matsuura's leadership and early reforms should be partially credited for this return. During his tenure, Federico Mayor had made several appointments or promotions at top-level positions, leading to a structure with too many directors, some of whom had unclear responsibilities. The result was a lopsided pyramid with a hypertrophy of senior management staff. Additionally, and in parallel to the official staff structure, Mayor also appointed senior special advisers. This dual system resulted in task duplication, as well as a lack of accountability and responsibility for programme implementation (Carillo and Matsuura, 2002). Despite all these appointments, a 'severe mismatching of skills to actual needs' was noted by Matsuura when he took over in 1999 (Loder, 2000). This was

due to unclear recruitment criteria and practices, and appointments that were often politically motivated or that benefited friends of the Director-General (Crossette, 2000: 15). Indeed, this situation of poor staff management and unclear structure had been one of the reasons given by the United States for staying away from UNESCO. During the first two years of his mandate, Matsuura therefore undertook a wide reform of the organisation, removing job duplication, and establishing 'clear hierarchical lines so that structures should serve the programmes and not the reverse' (Carillo and Matsuura, 2002). As a result, he reduced UNESCO staff by 25 per cent, even provoking a hunger strike by two employees whose contracts were terminated (Azzi, 2005: 773). However, it would be naive to consider the return of the United States as resulting only from Matsuura's reforms. For some, it was also self-motivated, as the Bush administration wanted to show commitment to multilateralism even while it was preparing to invade Iraq against international law (Marwecki, 2019). For others, the United States had rejoined UNESCO merely to fight the cultural diversity movement and what would become the 2005 Convention, which it saw as a threat to its direct commercial interests (Azzi, 2005: 774).

Upon his election as Director-General of UNESCO, one of Kōichirō Matsuura's priorities was the safeguarding of intangible heritage, which he considered equally as important as tangible heritage. While a programme already existed with the 'Proclamation of Masterpieces of the Oral and Intangible Heritage of Humanity' (with 90 such Masterpieces recognised between 2001 and 2005), Matsuura was the leading force behind the adoption of the 2003 Convention for the Safeguarding of the Intangible Cultural Heritage. As this Director-General often explained, he came from a region, Asia, and a country, Japan, where intangible heritage was widely recognised, protected, and promoted (Matsuura, 2009: 2–3). Not only was he the driving force behind the adoption of this convention, but he was also directly responsible for the exceptional speed of its entry into force in 2006. Noriko Aikawa-Faure, the first director of the intangible heritage section at UNESCO, explained how she pleaded for the ratification with member states: 'When permanent delegations of countries due to receive the Director-General on an official visit discreetly asked me what would be a welcome gift, I replied: "May your country ratify the Convention on Intangible Heritage"' (Aikawa-Faure, 2009). Unlike the World Heritage Convention, with which it is often compared, the text of the 2003 Convention does mention sustainable development. Intangible heritage, including social practices, festive events, knowledge, and practices are often key for sustainable development, as further

detailed in the following chapters. A major thread of this book addresses whether it is desirable to separate tangible from intangible heritage at all, and particularly when considering it for sustainable development.

Like his predecessor, Matsuura was also preoccupied by peace, without which no sustainable development can happen, as has been extensively discussed in the previous chapter. In one of his interviews, he explained that, as a little boy, he witnessed the end of the Second World War and how it had scarred his country. He lived two hours away from Hiroshima, where the first atomic bomb fell, and this experience led him to pursue the noble ideals of peace and tolerance, and greater understanding between cultures and civilisations (Carillo and Matsuura, 2002). The geopolitics of the late 1990s also made its impact on Matsuura's approach. There was a real worry that the arguments of Samuel Huntington, with his 'clash of civilisations', particularly between the West and the Islamic world, would become reality (Huntington, 1998), and some saw the 11 September 2001 attacks as the first illustration of this thesis. The state of the world can explain why Matsuura continued the work of his predecessor in promoting cultural diversity for peace and for sustainable development. His approach led to the adoption of the 2001 Universal Declaration on Cultural Diversity, which reiterated some ideas from *Our Creative Diversity* and the Stockholm conference, and served as a framework for the 2003 Convention and for the 2005 Convention on the Protection and Promotion of the Diversity of Cultural Expressions. The latter text is particularly important for this book, as it aims to ensure that cultural goods and services are considered and treated differently from other commercial merchandise (see the section on this convention below). The four selected projects analysed in this research were originally supposed to assist with the implementation of this specific convention. In addition, from 2001 onwards, UNESCO would be the lead UN agency implementing a *Global Agenda for Dialogue among Civilizations* (Resolution 56/6 of 21 November 2001), following the celebration of the year 2001 as the United Nations Year of Dialogue among Civilizations. This global agenda aimed to promote cultural diversity, tolerance, dialogues among cultures and civilisations, and universally shared values. Its implementation was similar to that of the projects discussed at length in Chapter 2, with multiple events, conferences, publications, and small-scale artistic endeavours. However, these activities had limited impacts on the international agenda and on the furthering of peace (Mirbagheri, 2007: 305–16). The recognition of the state of Palestine by UNESCO in 2011 would further weaken this programme, as considered further below.

Having presented Matsuura's vision, I now focus on the key activities implemented during his time, related to culture for (sustainable) development and reflecting his visions.

The 2003 Intangible Heritage Convention

The 2003 Convention on Intangible Cultural Heritage was one of Matsuura's personal priorities. This section does not aim to explain how this convention works, as this has been covered in previous publications (Labadi, 2013a). Instead, I will focus on how this international framework connected with sustainable development in the first years of its implementation, during Matsuura's mandate, until November 2009. These reflections have been nourished by a series of discussions I ran on the topic (see Labadi, 2011a: 115–18). A subsequent section will discuss the evolution of the idea of intangible heritage for sustainable development during Bokova's mandate.

The recognition of intangible manifestations of heritage, including knowledge, oral traditions, performing arts or rituals, and festive events, reflects a move away from an overemphasis on monumentality, as reflected particularly in the World Heritage Convention. However, some authors question the validity of two separate legal texts and systems, with one focusing solely on intangible heritage and another one being more focused on tangible heritage. These parallel systems risk 'fixing a divide between place, object, and traditional practice. This may sever any integration of tangible and intangible in heritage place management, which are essential for sustainable development' (Truscott, 2011: 126). This divide is artificial, as recognised in the very processes of the 1972 and 2003 conventions. Criterion (vi) guiding the nomination of World Heritage sites recognises their intangible dimensions, while the preamble of the 2003 Convention also acknowledges the interdependence between these two forms of heritage. The impacts of this separation on sustainable development will be further discussed from Chapter 5 onwards.

'Sustainable development' is mentioned twice in the text of the 2003 Convention, reflecting its increasing relevance from the turn of the millennium onwards. In the Preamble, intangible heritage is recognised as 'a mainspring of cultural diversity and a guarantee of sustainable development', and in Article 2, the scope of the convention is limited to only such intangible cultural heritage as is 'compatible with … the requirements of … sustainable development' (UNESCO, 2003). But what does 'sustainable development' mean in this context? According to Blake, the concept is openly defined according to the 2001 UNESCO

Universal Declaration on Cultural Diversity, which associates this concept with human development, a bottom-up approach that is community driven, where people choose the forms of heritage they want to keep and perform, which help them to live a life they have reason to value. This understanding of sustainable development echoes the definition of social justice and capability by Amartya Sen (Blake, 2009: 49; Sen, 1999). In addition, the transmission of intangible cultural heritage from generation to generation refers to the concept of intergenerational equity, also central to sustainable development (Labadi, 2011a: 116). The convention aims to ensure that intangible heritage manifestations are constantly recreated, to ensure their viability as living and evolving heritage, transmitted and practised from one generation to the next (Keitumetse, 2006: 166–71). For such intergenerational equity to occur, certain socio-economic and environmental elements of the intangible manifestations must be preserved, particularly their raw materials. For instance *timbila*, the traditional xylophones of southern Mozambique that are inscribed on the Representative List, are made of the endogenous *mwendje* trees. These trees are endangered, as further discussed in Chapter 7, which threatens the viability of this intangible heritage manifestation.

Such direct references to sustainable human development, bottom-up approaches, viability, recreation, and continued practice may indicate a fear that the convention could be used to freeze intangible heritage manifestations as folkloric consumptions for tourists. From 2010 onwards successive versions of the Operational Directives have warned against 'commercial misappropriation' that distorts 'the meaning and purpose of the intangible cultural heritage for the community concerned' (UNESCO, 2010: paragraph 117). To consider and address issues of the commercialisation of intangible heritage through tourism, a regional meeting was organised by UNESCO in December 2007. Various examples were discussed, including that of the Gangneung Danoje festival in the Republic of Korea, inscribed on the Representative List in 2008. To attract more tourists and ensure that they could enjoy aspects of the religious rituals, shamanistic music, dance, and mask drama on one stage and in one sitting, new sequences of stories were created, their contexts were modified, and different components of the rituals artificially put together and made more accessible. The result was that some manifestations constituting the festival were transformed to correspond to the tastes and formats preferred by foreigners, thereby becoming detached from their local meanings and purposes (Bak, 2008: 28; see also Nut, 2019: 139–51).

However, despite these guidelines, meetings, and publications, no actual mechanism has been put in place to prevent such misappropriation

and commercialisation from occurring. In addition, for Boswell, the workings of UNESCO and its cultural conventions are not well suited to preventing such misappropriation. First, inscription on the Lists can result in communities, groups, and individuals being stripped of their intangible heritage by majority groups who can then fossilise them and turn them into folklore for their own commercial gain. Second, while intangible heritage often belongs to multiple ethnic and religious minorities, and sits across multiple national boundaries, its preservation at an international level tends to simplify and erase this complexity through a state-party-controlled process. Finally, the top-down workings of the convention, and control of processes by states parties, is not conducive to community participation (Boswell, 2011: 119–24; see also Boswell, 2008). The 2003 Convention and its Operational Directives have attempted to address this final issue by requiring the participation of communities, groups, and appropriate individuals, and the documentation of such participation in nominations for inscription. Written or recorded free, prior, and informed consent of the concerned communities or individuals is a central mechanism in such bottom-up processes. Yet, as I have explained elsewhere, some consent forms have been signed by national entities rather than by communities, as was the case for the dossier on Chinese calligraphy, which was signed by the China National Intangible Cultural Heritage Safeguarding Centre (Labadi, 2013a: 136). In addition, the term 'communities' has been understood rather vaguely, with some dossiers mentioning the entire populations of the nominating countries. The *radif* of Iranian music, the standard melodic patterns of Iranian classical music inscribed on the Representative List in 2009, is one such example. According to its nomination dossier, it is linked to the 'people of the state party concerned' (Labadi, 2013a: 136; see also Skounti, 2017: 61–76). These examples illustrate the issues with defining communities, meaningfully engaging them in state-controlled processes, and preventing commercialisation. Some of these issues will be further considered in the following chapters.

The 2005 Convention on the Diversity of Cultural Expressions

The second normative document in the field of culture adopted during Matsuura's mandate is the Convention on the Protection and Promotion of the Diversity of Cultural Expressions. Adopted in October 2005, with 148 UNESCO member states voting in favour, it saw the opposition of the United States and Israel, and five countries abstaining. Many countries supported this text, because they considered it as challenging the

cultural imperialism and economic hegemony of the United States. This resulted in the rapid ratification and subsequent entry into force of the convention in 2007 (Garner, 2016: 2).

For some authors, this convention was the pinnacle of the multiple reflections and events on diversity and (sustainable) development presented in the previous chapter, including *Our Creative Diversity*, the 1998 Stockholm conference, and the 2001 Universal Declaration on Cultural Diversity, which required the drafting of a legal instrument on the concept (Saouma and Isar, 2015: 70; De Beukelaer and Pyykkönen, 2015). However, while these earlier initiatives understood cultural diversity in its broadest sense, the 2005 Convention has a very specific focus. It aims to protect national and regional cultural and creative industries (such as films) from increasingly liberalised world trade forces, adopting and widening the French concept of *exception culturelle* (cultural exception) (Kozymka, 2014: 44). France, the European Union (EU), and Canada, the driving forces behind this new convention (Vlassis, 2015: 1651), sought a binding international document that would legitimise the rights of states to adopt protective measures for their cultural and creative industries, including quotas and subsidies, because these are not merely trade goods, but are also essential expressions of identities, values, and meanings (UNESCO, 2005). Another major ambition of the text was to ensure that States would be able to resolve trade disputes about cultural goods by cultural experts following the principles of the 2005 Convention, rather than under the economic provisions of the World Trade Organisation (WTO) (Maurel, 2009: 133; Garner and O'Connor, 2019: 10–11). Like previous UNESCO initiatives, the convention also refers to the importance of cultural diversity for (human) development as a form of well-being, in which culture understood as values and expressions should be protected, promoted, and shared (De Beukelaer and Freitas, 2015: 206). Yet, this loftier understanding of cultural diversity and development is not the core purpose of the convention.

The 2005 Convention's core aim is to support cooperation for international development, through specific mechanisms targeting the 'developing countries'. Provisions include creating and strengthening cultural production and distribution capacities in these countries; facilitating wider access to the global market and international distribution networks for their cultural activities, goods, and services; supporting and facilitating the mobility of artists from the 'developing world'; training of human resources from these countries; and providing official development assistance to stimulate and support creativity, as detailed in Article 14 of the Convention. Article 16 even calls for 'developed' countries to

grant preferential treatment to artists and professionals, in addition to goods and services, from countries considered as 'developing', and Article 18 sets up an International Fund for Cultural Diversity to fund projects from the Global South. While promoting protectionism for some (primarily Western) countries, the convention thus aims to strengthen the cultural production and capacities of Southern countries. This was an ambition of France in particular, to move away from a restrictive consideration of the convention as simply focusing on cultural exception, to encompassing more global considerations (Maurel, 2009: 137).

However, the provisions of the 2005 Convention are not binding and were expressed in a discretionary form, so that parties are only encouraged to take certain actions. Even the international fund consists of voluntary contributions made by states, and not compulsory ones. Experts, including the former director of the division responsible for the implementation of the 2005 Convention, agree that funds have 'fallen far short of real needs and expectations, since these are defined as voluntary contributions from states parties rather than obligatory ones' (Saouma and Isar, 2015: 68; see also Garner, 2016: 180). De Beukelaer and Feitas (2015: 211) also explain how demands for support from the fund exceed its capacity, and in 2013 alone, only 10 of 56 eligible proposals were funded, with 140 more considered ineligible. The discretionary nature of the convention has also meant that support for 'developing' countries, as detailed in Articles 14 to 16, has remained wishful thinking, rather than leading to real change (Figueira, 2015: 180). Trade in cultural products vastly benefits Western countries (Deloumeaux, 2017), and it is not clear that the mechanisms put in place by the 2005 Convention will rectify the situation, as will be further discussed in Chapter 5. This contrasts with the working of other agreements, such as WTO agreements, which have specific commitments made by states, with enforceable decision mechanisms (Neil, 2006: 260).

Article 20, which sets out the Convention's relationship to other treaties, is also weak and ambiguously worded. It is the result of a political compromise, with one side (including France and Canada) pushing for a strong treaty to protect cultural goods and services against trade agreements, and the other side (including the US, Japan, Australia, and Mexico) requesting that the obligations of states under other treaties should not be modified (Kozymka, 2014: 163). The final compromise reads: 'nothing in this Convention shall be interpreted as modifying rights and obligations of the Parties under any other treaties to which they are parties' (UNESCO, 2005). This effectively means that the existing WTO provisions cannot be overruled by the 2005 Convention,

putting an end to the ambitions of France and Canada to have a strong treaty on the exceptional aspects of the cultural and creative industries (Neil, 2006: 260; Maurel, 2009: 137). Although this 2005 text has had some influence on trade agreements, for instance in the content of the Economic Partnership Agreement between the EU and the Caribbean regional grouping CARIFORUM, it has had limited impacts in other cases. In 2007, for instance, the WTO ruled in favour of the US against Chinese restrictions on the imports of cultural goods and services from America, despite China citing the 2005 Convention (Garner and O'Connor, 2019: 11).

MDG-F projects

Despite all of these shortcomings, the government of Spain decided to assist in the implementation of the 2005 Convention and the other UNESCO cultural conventions through funding a 'Culture and Development' window, as part of the Millennium Development Goals Achievement Fund (henceforth MDG-F) (De Beukelaer and Freitas, 2015: 215). By 2006, progress towards the achievements of the MDGs was uneven. For this reason, the Spanish Government under the Spanish Agency of International Cooperation for Development (AECID) and UNDP established the MDG-F to accelerate progress towards attainment of these goals in selected countries (UNDP/Spain Millennium Development Goals Achievement Fund, 2007: 2). AECID supported 18 programmes under this thematic window on 'Culture and Development', with a total financial allocation of US$95.6 million, hoping that they could accelerate the achievement of the MDGs. The four projects analysed in the next chapters, located in Ethiopia, Mozambique, Namibia, and Senegal, formed all the programmes funded in sub-Saharan Africa as part of this thematic window. As the next chapters explain, the activities focused heavily on world and intangible heritage, as well as on supporting crafts at these sites for poverty reduction, gender equality, and environmental sustainability. They provide perfect examples of the impossibility of separating heritage from the creative and cultural industries, and highlight the artificial focus of the UNESCO conventions.

These 18 MDG-F funded programmes provided UNESCO with a perfect opportunity to gather the evidence on the role of culture for development that was missing at the end of the 1990s, identified as one reason why culture had been excluded from the MDGs. Why did Spain make such a significant investment? First, it corresponded to the doubling

of its international aid spending, from 0.23 per cent to 0.46 per cent of its GDP in the period 2003 to 2009 (OECD, 2011: 11). Spain also took the strategic objective of maximising the impact of its international aid spending through targeting significant projects and moving away from supporting small-scale programmes, as it had done in the past (Labadi, 2019b: 76–7). Finally, culture was recognised as the very fabric of society and as the internal force for its development (Calvo Sastre *et al.*, 2007: 9) in the Master Plan on Spanish Cooperation (Plan Director de la Cooperación Española, 2005–8), justifying the significant budget dedicated to this topic. Chapter 4 provides detailed and critical assessments of the setup and overall management of these projects, and the rest of the book focuses on their local impacts.

World heritage and (sustainable) development: threats and opportunities

The adoption and early implementation of the 2005 and 2003 Conventions expanded the conception of culture for development into new territories. The World Heritage Convention is also a key instrument to consider for a full picture on this topic. During Matsuura's mandate, development issues at World Heritage sites were considered both a threat and an opportunity. From the turn of the millennium onwards, international tourism grew enormously. To address the threats that it caused and harness its power to create socio-economic local opportunities, the UNESCO World Heritage Tourism Programme was launched in 2001, in line with Matsuura's views that tourism in general should be controlled, but that quality cultural tourism should be promoted (Carillo and Matsuura, 2002). In 2008, it became the World Heritage Sustainable Tourism Initiative (WHSTI), coordinated by the World Heritage Centre in partnership with the UN World Tourism Organization (UNWTO), UNEP, the Convention on Biodiversity, UNDP, the World Bank, the Nature Conservancy, the UN Foundation, and the Nordic World Heritage Foundation (Clarke, 2010: 11).

In some cases, activities implemented as part of the tourism programme were similar to those of the four projects considered in the following chapters of this book. This was particularly the case with the development of alternative livelihoods for local communities based on tourism, including for example the training of local guides and entrepreneurs, and the promotion of local crafts at different sites in Latin America, such as Sian Ka'an (Mexico), Tikal (Guatemala), and Río Plátano (Honduras). However, the official evaluation of the programme

concluded that these initiatives were too limited in scale, and it was not clear why tourism was selected as the most promising form of livelihood over other activities (such as agriculture) (Clarke, 2010: 21 and 25–6). Another strand of the programme was to engage tour operators in conservation, management, and sustainable tourism. Often left out of such projects (see the following chapters), tour operators, because of their business scale and reach, can have real impacts on the ground. However, their involvement in the programme was limited and they only provided small-scale funding for the restoration and interpretation of very few World Heritage sites. None of the problematic aspects of their company business models, with their high leakage, support for infrastructures belonging to the Global North, and restricted positive socio-economic impacts on localities, were challenged or addressed. In addition, the official evaluation lamented that the overall impacts of the programme were inadequate, as only around 25 sites were involved, without any attempt at disseminating and mainstreaming the results or the lessons learned. In conclusion, the evaluation stressed that the initiative 'has not been shown to have made a significant contribution to its overall objectives of reducing the threats to sites from tourism or providing opportunities for socio-economic development' (Clarke, 2010: 28). The four selected MDG-F projects shared some aims with the World Heritage Tourism Programme, and Chapter 5 will consider whether they integrated some of the shortcomings just highlighted.

Infrastructure development, fast-paced urbanisation, and modern construction threatening the visual integrity of World Heritage properties were also key concerns expressed by the World Heritage Committee. To address the specific issue of modern construction, an international conference was organised in Vienna, with the resulting Vienna Memorandum on 'World Heritage and Contemporary Architecture: Managing the historic urban landscape', adopted in May 2005. This memorandum is best remembered for having requested broader discussions on heritage, contemporary urban architecture, and development, as well as encouraging the setting-up of a recommendation on the historic urban landscape. Although adopted in 2011 during Bokova's mandate, most of the discussions on the recommendation had occurred previously, during Matsuura's time. I have explained elsewhere that the 2011 Recommendation on the Historic Urban Landscape (HUL) repeats ideas that had already been published and promoted elsewhere (Labadi and Logan, 2015b: 8). Geddes's calls for a holistic protection of the urban environment and for the harmonious integration of any development within the 'urban ecosystem' and its peripheries were an obvious source of inspiration for the text (Geddes,

1915). Indeed, rather than considering it an aggregation of monuments, the HUL understands the urban area as a comprehensive and dynamic geographic system beyond its centres, and as a historic layering of cultural and natural values and attributes, land use patterns, and spatial organisations (UNESCO, 2011: Art. 8 and 11; Giliberto, 2018: 88). The recommendation also offers a number of tools to help achieve a holistic and balanced approach between urban heritage conservation and socio-economic development. It promotes a bottom-up approach using participatory planning and stakeholder consultations to undertake comprehensive surveys and mapping of a city's natural, cultural, and human resources, and to assess the vulnerability of these elements. These maps should then be integrated into a wider framework of city development, to provide indications of areas of heritage sensitivity that require careful attention in the planning, design, and implementation of development projects. In simpler terms, the HUL recommendation aims to engage communities in identifying the values of urban heritage and places that need careful attention when planning and implementing development schemes (Bandarin and Van Oers, 2012: 144). In addition, the HUL aims to integrate urban heritage conservation within social and economic development (Article 11). However, the text does not provide a clear pathway for implementing such integration. During Bokova's mandate, a focus was thus put on clarifying how heritage contributes to (sustainable) development.

Irina Bokova (2009–17): crisis time

On 15 November 2009, Irina Bokova of Bulgaria became the first woman and the first Eastern European to be elected Director-General of UNESCO, leading to hopes that she would reform the organisation, still considered too bureaucratic, slow, and ineffective. Correspondence by the then US ambassador to UNESCO in the early months of her mandate reveals that Bokova had not 'got a settled vision of how she wants to reorganise and staff UNESCO' and that 'On program priorities, Bokova's preferences have also yet to gel' (Killion, 2009). Her early speeches reveal that she had a rather broad and ambitious agenda aiming to strengthen the five UNESCO sectors on culture, education, communication, social and human sciences, and natural sciences. Education, though, seemed to be her key priority. She considered it an 'accelerator of development', 'the best way to cultivate human rights and citizenship, promote tolerance and respect, and shape a new culture of sustainability' (Bokova, 2011a: 6). In the field of culture, her goal was to strengthen the implementation of all

the UNESCO conventions, and to integrate local cultures into (economic) development projects. She also aimed to defend freedom of expression as one of the key priorities of the Communication Sector, social inclusion in a changing planetary environment, the protection of biodiversity, and to mainstream gender equality in all the actions of UNESCO.

However, these ambitious and wide-ranging plans came to a standstill when UNESCO faced arguably its biggest crisis to date. On 5 October 2011, the Executive Board voted to recommend that the General Conference of UNESCO admit Palestine as a new member state. This request for admission was not new; it had first been submitted in 1989 and was subsequently resubmitted at each General Conference, each time postponed for consideration on the grounds that deliberations in the United Nations Security Council were still ongoing. On 31 October 2011, the 36th General Conference decided upon Palestine's application for admission with 107 votes in favour, 14 against, and 53 abstaining from voting (Hüfner, 2017: 97). At the ceremony for the admission of Palestine as a member state of UNESCO, Bokova explained that a solution with two states living in peace was long-awaited, and that she saw the recognition of Palestine as a chance to build peace in the region (Bokova, 2011b). In my view, two additional reasons can explain this unprecedented political move. First, Bokova was rumoured (particularly at UNESCO) to have an ambition to run for Secretary General of the UN, and she may have considered Palestine's admission a way of strengthening her world leader status as a maker of peace in the Middle East. Second, all the members of her senior cabinet were new to their functions, as Matsuura had 'found onward assignment for all senior officers in his cabinet' before his departure (Killion, 2009). Her newly formed team may have been unaware of the consequences of recognising Palestine in this way.

As soon as the vote took place, the United States and Israel froze their financial contributions to the organisation, which represented 28 per cent of the budget. The Government of the United States is prohibited by the 1990 Foreign Relations Authorization Act to finance any UN organisation that recognises Palestine as a member state (Hüfner, 2017: 97). This crisis was exacerbated by the fact that the United States paid their mandatory contributions at the end of the calendar year. When the decision occurred, the United States had not yet paid its yearly contributions and the organisation therefore immediately lost US$75 million of its budget for 2011. No specific contingency plans had been prepared in advance (Eckhard, Patz and Schmidt, 2019: 1646). I worked for UNESCO at the time, and can attest that no spending was allowed. As the

Associate Editor of the *International Social Science Journal*, I had to postpone most of my activities on editing, translating, and publishing indefinitely. We were all wondering whether the institution would survive. This weakened status surely had some impact on the international scene and on the negotiation for the SDGs, with UNESCO considered a 'politicised', pro-Palestine institution.

Bokova used this crisis as an opportunity to accelerate reforms at UNESCO. Significant changes were implemented in staff and equipment, with a reduction of staff travel costs by 73 per cent, consultants' costs by 70 per cent, and furniture and equipment costs by 64 per cent in the 2012–13 biennium (36 C/5) as compared to 2010–11 (35 C/5) (Hüfner, 2017: 97) This was accompanied by an incentive programme for voluntary staff departure. Bokova also used the crisis for an ambitious programmatic reform, as she believed that the organisation needed to concentrate on areas of clear comparative advantage in the international system (Eckhard, Patz and Schmidt, 2019: 1647). One proposal, to address what was seen as a fragmented organisational structure and proliferating tasks, was to reduce the vast mandate of UNESCO and its sectors, for example by merging the culture and communication sectors as well as the social and natural sciences. However, this proposal was not adopted by member states. No sector was cut, and programmes were reduced only from 48 to 42, with the old programmes integrated into approved ones (Eckhard, Patz and Schmidt, 2019: 1646). With a reduced staff and an amputated budget, UNESCO had to continue to carry out its mandates. The result was that many programmes had to rely on voluntary contributions from international experts or on extrabudgetary funding, as further detailed below.

I also believe that UNESCO's place in the negotiations for the SDGs was intimately linked to Bokova's decision to run for Secretary General of the UN, a race that officially started in December 2015. A candidate from the Eastern Europe Group was favoured, under the principle of regional rotation, as no Secretary-General had ever come from that region before. Conscious that she would never get elected without the support of the United States, Bokova set up partnerships with American cultural institutions, promoted Holocaust education, hired a public relations agency to work on credibility in Washington, and made publicity trips to the States to explain the benefits of returning to UNESCO. Despite these efforts, the United States was said to oppose her candidacy and newspaper articles reported that '[U.S. Ambassador] Samantha Power would rather eat her hair than support Bokova' (Oreskes and Heath, 2016). This was not only because of Bokova's work at UNESCO, but also because she was seen as Russia's preferred candidate, having worked closely with them during

her mandate in Paris (Bokova, 2016). António Guterres, the Portuguese candidate, was eventually chosen to lead the UN from January 2017.

At the end of Bokova's mandate, UNESCO was considered not only to have lost its international standing and credibility (see also Meskell, 2018), but also to be increasingly politicised, all of which negatively impacted its ability to negotiate for the SDGs. Despite all the efforts deployed, the United States and Israel officially left UNESCO in October 2017, leaving over US$600 million accrued in unpaid dues, because of a perceived anti-Israel bias and President Trump's withdrawal from multilateralism. Another example of the marginalisation of the institution was the creation of the International Alliance for the Protection of Heritage in Conflict Areas (ALIPH) by a consortium of countries led by France and the United Arab Emirates at the end of 2016. ALIPH aims to strengthen the means of combating the illicit trafficking of art; to fund directly the rehabilitation of heritage in conflict zones; and to create shelters in cities or countries to protect works threatened by conflicts, with the goal of eventually returning them to their country of origin (a controversial idea considering past issues with returning objects put in safe havens; see Van Krieken-Pieters, 2010: 85–96). This institution's competences overlap with those of UNESCO, which is only a non-voting member of ALIPH. A number of French political elites have clearly expressed concerns that UNESCO's mechanisms are too heavy and bureaucratic, hence the decision to create this separate organisation (Commission de la culture, de l'éducation et de la communication du Sénat, 2019).

Culture as driver and enabler of sustainable development?

Despite this context of crisis, the culture sector of UNESCO adopted a dynamic approach and led a number of initiatives to ensure that culture (including heritage) was included in the post-2015 international framework that was to become the SDGs. It was hoped that a full goal of this new framework would focus on culture, although that hope was short-lived (see below). This ambition was reflected in various brochures that promoted and defined the slogan of culture as a 'driver' and an 'enabler' of development (see for instance UNESCO, 2012c). In these documents, culture was presented as a driver because it is a means, or a resource, for achieving development objectives: it contributes to poverty eradication through income generation and job creation in the creative and cultural economy, as well as in cultural tourism. As a source of resilience, innovation, and creativity, culture was also presented as a driver of human development. However, development must be sensitive to the cultural

context for it to be effective (UNESCO, 2012c: 4). Culture was also defined in these documents as an enabler of social cohesion, which can only grow through respect for and understanding of cultural diversity and intercultural dialogue. In addition, both cultural and biological diversity, as well as local and Indigenous knowledge and management practices, were considered as contributing to sustainable environmental practices and to ensuring environmental, agricultural, and food sustainability. Culture was also presented as the key to effective education, in particular through the recognition, protection, and promotion of multilingualism, which can also make education more attractive to disadvantaged groups (UNESCO, 2012c: 5). Finally, peace-building could only thrive through culture and through 'empowering communities to participate fully in social and cultural life and facilitating governance and dialogue' (United Nations, 2015; see also Pereira Roders and Van Oers, 2014: 123–4).

To justify further the claim that culture contributes to development, a series of brochures on the impacts of the 18 MDG-F funded projects were also released (UNESCO, 2012b). Uncritical in their approach, these publications provided overwhelmingly positive results, detailing that most projects contributed to improved market, income, and employment opportunities for artisans and tourist guides, including for women; that new skills were acquired by trainees that resulted in improved quality and quantity of products; that natural heritage was better protected as a result of linkages between traditional and modern practices; and that social cohesion was ensured through increased cultural and religious dialogues between key stakeholders. These results will be critically assessed throughout this book, in relation to other official evaluations and participant interviews, demonstrating that they are overly positive and do not necessarily reflect the nuanced and complex reality on the ground.

A multitude of events were also organised to promote this new slogan on culture for development and encourage its wide acceptance by, and integration into, the work of institutions outside the culture sector. One such event was the 2013 Hangzhou International Congress, 'Culture: Key to sustainable development', the first international gathering of experts on this topic since the 1998 Stockholm conference. Some 500 participants from 82 countries attended the meeting, including governments and UN organisations, activists, experts, and academics (Wiktor-Mach, 2020: 318). Between 2010 and 2015, no fewer than five UN resolutions were also adopted on either Culture and Sustainable Development (UN Resolution 70/214, 2015; UN Resolution 69/230, 2014; and UN Resolution 68/223, 2013) or on Culture and Development (Resolution 66/208, December 2011; and Resolution 65/166, December

2010). Participation in initiatives by other UN organisations was another strategy to promote the rhetoric that culture is key for (sustainable) development beyond the culture sector, as exemplified by UNESCO's participation in the high-level meeting on 'Science, technology and innovation, and culture for sustainable development and the MDGs' organised by the UN Economic and Social Council (ECOSOC, July 2013). Finally, UNESCO also formed a 'Group of Friends on culture and development', a coalition of 30 governments launched in September 2013 to act as a political lobby for the integration of culture and development into UN debates and to push its agenda through the system. However, some of the leading donor countries, including the UK, the Netherlands, and Scandinavian countries, were all absent from this lobbying platform, which for Vlassis reflects their resistance to including culture in the SDGs, because cultural practices can be at odds with sustainable development goals, such as gender equality or human dignity (2015: 1656). The absence of these key donors may have weakened the group and its impact on negotiations for the post-2015 development agenda.

In parallel to these publications, events, and lobbying efforts, in 2013 the campaign 'The future we want includes culture' or '#culture2015goal' was launched, pressing for one full goal on culture to be added to the SDGs, as well as for specific dimensions of culture to be integrated across the other goals. This initiative was launched by a few NGOs, including the International Council on Monuments and Sites (ICOMOS); the International Federation of Arts Councils and Culture Agencies (IFACCA), a worldwide network of national arts funding agencies in 80 countries; the Committee on Culture of United Cities and Local Governments (UCLG), which aims to defend the interests of local governments on the world stage; the International Federation of Coalitions for Cultural Diversity (IFCCD); and Culture Action Europe, the major European voice of the cultural sector linking over 110 national and European networks. This coalition released a manifesto and various statements, led a Twitter campaign, and tried to have an impact on negotiations through advocacy work at the UN. However, these initiatives remained largely declaratory (Vlassis, 2017: 58) and, as explained below, were not as inclusive as other lobbying platforms.

The political reality

Despite these multiple initiatives, UNESCO, the only UN organisation with a remit for culture, decided that it would not campaign for one full SDG on culture. Rather, it campaigned to become the lead agency for the goal

on education. There were many reasons for such a paradoxical decision. First, education has the biggest budget of UNESCO. For instance, for the biennium 2014–15, the budget for education was US$117,964,600, more than twice the budget for the whole of the culture sector for that period ($54,122,000). Second, as one high-ranking UNESCO staff member interviewed for this book put it, this was also a pragmatic decision, as UNESCO 'wouldn't have succeeded with a goal on culture … because for many countries culture is not a priority'.[1] This reason was repeated to me by staff members of the organisations that supported the campaign 'The future we want includes culture'. The negotiation for the SDGs was competitive; everyone wanted to have their own goal. National priorities and the fulfilment of basic needs became the focus of many discussions, such as education, building infrastructure, and improving health.[2] Third, powerful lobby groups existed to ensure the inclusion of specific goals and targets, but the culture sector is not really supported by such mechanisms.[3] The exclusion of culture from the SDGs also revealed the lack of unity between international actors on culture. 'The future we want includes culture' campaign, for instance, was a unique lobbying platform of non-state actors, and one of the first of its kind. Yet a number of key non-state actors did not take part in this campaign, including for example the International Council on Museums (ICOM), one of the largest organisations of museums. This stands in stark contrast with other sectors, such as the environment, described by my interviewees as having better structured and better funded lobbies, which are also more unified and more experienced in international negotiation than those in the culture sector. Finally, for some, culture is a relative and localised concept that should not be included in an international framework, while for others, many aspects of culture (such as cultural traditions) are not aligned with sustainable development principles, and should therefore be excluded from them.

The lack of meaningful indicators and data collected internationally to measure progress was another reason why culture was marginalised from the SDGs. Any SDG and associated target must be monitored through internationally agreed indicators. UNESCO led a comprehensive project on the identification of indicators, with the main publication and website released in 2014, in time for the SDG negotiations (UNESCO, 2014b).[4] However, case studies conducted as part of this project confirmed that even basic data on employment in the cultural sectors are missing in a number of countries, one reason being that many people work in the informal economy,[5] as illustrated for instance by the evidence from Namibia. Statistics were also difficult to collect on the contribution of cultural activities to gross domestic product (GDP), because of a lack

of available figures and of a universally agreed method of data collection. Most importantly, a number of the indicators identified by UNESCO are rather problematic, as is the case for the indicator on 'Heritage Sustainability'. Described as an 'index of development of a multidimensional framework for heritage sustainability' (UNESCO, 2014b: 129), its calculation includes both quantitative and qualitative information, such as the number of sites on the World Heritage and Intangible Heritage Lists; nationally recognised heritage; the dedicated annual budget for the identification, protection, and safeguarding of heritage; the existence of laws and school programmes to raise awareness of heritage; and measures to involve civil society organisations (UNESCO, 2014b: 130–8). The indicator thus mixes up too many unconnected aspects, which are also in some cases individually difficult to measure. It is not surprising that the UN did not use such a murky index for SDG 11.4.

Above all, UNESCO did not campaign for a single goal on culture because of problems with its international standing, its perceived loss of credibility and universal status with the United States and Israel stopping their compulsory financial contributions, and its perceived increasing politicisation. Therefore, it was safer for Bokova to support only one goal, on education. Such a decision can also be understood in light of Bokova's decision to run for Secretary General of the UN and of her attempts to regain the support of the United States. Campaigning for a goal on culture could have been understood as an approbation of and support for Palestine's manoeuvring at UNESCO. Indeed, Palestine ratified the World Heritage Convention right after being voted into the organisation, in December 2011. By 2014, when negotiations for the SDGs were well under way, it already had two sites inscribed on the World Heritage List: 'The Birthplace of Jesus: Church of the Nativity and the Pilgrimage Route, Bethlehem', inscribed in 2012, and 'Palestine: Land of Olives and Vines – Cultural landscape of Southern Jerusalem, Battir', inscribed in 2014. 'Hebron/Al-Khalil Old Town' was subsequently inscribed in 2017. Heritage has been documented as being used by Palestinians to resist and to counter colonialism from Israel, as well as to create strategic spaces that constitute the skeleton of a state (De Cesari, 2019; Bosredon, 2017). Considering such political uses of heritage against one of the closest allies of the United States may have encouraged Bokova to move away from supporting a goal on culture as an attempt to appease the United States.

These factors resulted in heritage being mentioned in only one of the 169 targets, with the aim 'to strengthen efforts to protect and safeguard the word's cultural and natural heritage', as part of SDG 11, which had the overall title 'Make cities and human settlements inclusive, safe, resilient

and sustainable'. Although a number of my interviewees considered this a breakthrough, the target is not really a step forward, as it only focuses on the protection of heritage, rather than on how it can be used to address sustainable development challenges. Obviously, the fact that UNESCO did not officially support a goal on culture might explain the narrow focus of this target. However, it may also reflect the view of some international organisations and governments that 'urbanisation is an unstoppable phenomenon', with fast increasing urban populations coupled with unsustainable trends such as increased global carbon exposure, unplanned urbanisation, and unsustainable environmental conditions (United Nations, 2018: 8–9). In light of these stark forecasts, 'there is a need to safeguard a diverse range of tangible and intangible cultural heritage and landscapes, and … protect them from potential disruptive impacts of urban development', as highlighted in the New Urban Agenda, adopted by the United Nations Conference on Housing and Sustainable Urban Development (Habitat III) in Quito, Ecuador, on 20 October 2016 (United Nations, 2017: 32). Besides, the restricted focus of Target 11.4 might also reflect the views of Western and donor nations that any type of economic development should not be allowed at heritage sites, particularly in Africa. As discussed at length in Chapter 7, during World Heritage Committee meetings, African governments have often opposed the limits on development and acceptable change at World Heritage sites as neocolonialist impositions preventing their nations from achieving socio-economic prosperity. Hence, SDG 11.4 may have been drafted in this narrow manner to avoid such economic development at heritage sites in the Global South. Finally, the indicator identified to measure SDG 11.4 further moves away from considering heritage as an asset and a tool to address sustainable development. Instead, this indicator measures the 'total expenditure (public and private) per capita spent on the preservation, protection and conservation of all cultural and natural heritage'. This indicator perpetuates that idea that heritage is a liability requiring public and private investment for conservation and management, rather than one that provides diverse benefits. As a result, neither the selected indicator nor the selected target reflects how heritage can be a driver and an enabler of sustainable development, despite the vast explanation in UNESCO's documents and the related events organised.

Heritage in the SDGs since 2015

The lack of support for one full goal on culture during the negotiation of the SDGs did not prevent further reflections and projects on heritage for

(sustainable) development. However, because of the crisis at UNESCO, most of these initiatives have been voluntary, and based on individual goodwill. Implementation of the 2011 Recommendation on the HUL has generated keen interest on the part of both researchers and practitioners. Ginzarly, Houbart and Teller have analysed more than a hundred publications on the recommendation, concluding that discussions focus mainly on heritage values (2019: 999–1019). Pereira Roders and Bandarin provide a more focused assessment of the 160 cities that have participated in its implementation (2019: 26). For example, on the Island of Mozambique (Mozambique), cultural, natural and human resources were mapped, their vulnerability assessed in relation to existing threats such as natural disasters, and stakeholders identified for potential public–private partnerships. However, implementation faced several issues, including the reluctance of the municipal council to intervene in investors' projects, leading to some inappropriate demolition and construction; disempowered communities; and changing priorities with each new political team (Macamo, Hougaard and Jopela, 2019: 251–76).

To advance implementation of the HUL and conduct projects on tourism and cultural and creative industries, UNESCO and the World Bank signed an agreement in 2017. Although it is still too early to assess this joint work, in recent years the World Bank has published some assessments of the work it undertook at the turn of the millennium on heritage conservation for poverty reduction and on the strengthening of social capital in the MENA region (see Chapter 2). These frank assessments highlighted, among others, issues of governance; gentrification that led to changes in resident populations; and the replacement of traditional shops catering for local needs with tourist-serving establishments (Bigio and Licciardi, 2010: 10; Labadi and Gould, 2015: 202). In addition, the World Bank released critical research on community-driven development (Wong and Guggenheim, 2018), nourished by decades of investigation on the topic (Binswanger and Aryar, 2003; Mansuri and Rao, 2004 and 2013; Binswanger-Mkhize *et al.*, 2010). Cultural projects need to be community-based and community-led, because they need to reflect local specificities. According to the World Bank's research, such programmes are successful because women's participation is mandated under programme rules, because villagers are given a voice or because poverty levels have been reduced. Yet these projects are often isolated and do not have major impacts on local and national governance (Wong and Guggenheim, 2018: 18–21). All of these issues will be carefully considered and critically discussed in the following chapters.

In addition, a number of publications have detailed the contributions of culture to all of the SDGs (for instance, UNESCO, 2018 and Labadi *et al.*, 2021). Two texts are of particular importance for their attempt at legislating. The first is the 2015 UNESCO Policy for the Integration of a Sustainable Development Perspective into the Processes of the World Heritage Convention, which is innovative in its comprehensive attention to all four core dimensions of sustainable development. These are (1) inclusive social development (including respecting, protecting and promoting human rights and Indigenous peoples as well as achieving gender equality); (2) inclusive economic development; (3) environmental sustainability (including resilience to disasters and climate change); and (4) peace and security (UNESCO, 2015). I have detailed elsewhere the genesis and development of the text and the efforts for its implementation (see for instance, Labadi, 2019c: 15–26). Yet issues preventing the implementation of this policy are plenty, embracing its lack of inclusion in national legislations; lack of inclusion of traditional management systems; and the presence of exclusionary approaches to heritage conservation inherited from colonial times (Labadi *et al.*, 2020). The second text consists of chapters on safeguarding intangible heritage and sustainable development in the Operational Directives for the implementation of the 2003 Intangible Heritage Convention (UNESCO, 2016b). Organised around the pillars of inclusive social development, inclusive economic development, and environmental sustainability, it calls in particular for sustainable tourism to ensure the viability, social functions, and cultural meanings of intangible heritage, echoing some early concerns discussed above. Importantly for this research, one paragraph relates to intangible heritage, food security, and health care, recognising, as the selected MDG-F projects do, their intimate connection. The implementation of this text faces similar issues to those of the 2015 Policy, in addition to its non-binding nature, which means that it can simply be ignored.

Conclusions

International narratives and initiatives on culture for (sustainable) development expanded at the turn of the millennium, although they also faced many challenges and shortcomings. During Matsuura's mandate, the 2003 Convention on Intangible Heritage was adopted, aiming to be a guarantee of sustainable development. Yet it is not clear how the divided system – between tangible heritage covered by the 1972 World Heritage

Convention and the practices covered by the 2003 Intangible Heritage Convention – would ensure the achievement of such a goal, in addition to a top-down approach and the risk of commercialising these manifestations. And although the 2005 Convention on the Diversity of Cultural Expressions aimed to ensure that states could resolve trade disputes on the cultural and creative industries outside of the WTO provisions, this ambition was not realised. The 2005 Convention also promised to strengthen cooperation mechanisms, encouraging cultural and creative industries in the Global South to thrive. During that time, international tourism became one of the fastest-growing economic sectors, yet tourism programmes at World Heritage sites did not reduce threats incurred by this growth or develop meaningful socio-economic opportunities for locals.

Despite the large-scale crisis that hit UNESCO following its recognition of Palestine as a member state, this international organisation had a short-term ambition to lobby for one full goal on culture as part of the post-2015 development agenda. Yet, from 2013 onwards, it solely focused on supporting a goal on education. This was for several different reasons, including the weakness of support for considering culture as a priority, the increasingly politicised nature of culture, and the lack of meaningful indicators and data to measure progress. Bokova may also have been attempting to move away from Palestine's use of cultural heritage, at a time when she was running for UN Secretary General and trying to garner support from the United States.

The marginalisation of heritage and culture from the SDGs has not prevented UNESCO, and other key international organisations like ICOMOS, from attempting to clarify how both tangible and intangible heritage can contribute to addressing key sustainable development challenges since 2015. These efforts not only focus on poverty reduction or social cohesion, as they had done in the past, but also include gender equality, food security, health, and environmental sustainability. However, a major issue with these efforts has been a lack of critical engagement and their overwhelmingly positive, even biased, view that heritage contributes to (sustainable) development. Chapters 2 and 3 have attempted to explain why culture (including heritage) has, from an international perspective, been marginalised from the SDGs. However, in-depth analyses of the impacts of targeted heritage projects for sustainable development, providing more realistic assessments, are missing. The following chapters therefore provide such in-depth analyses of the four MDG-F projects implemented in sub-Saharan Africa, analysing whether and how they contributed to poverty reduction, gender equality, and environmental sustainability, guided by the international framework.

Notes

1. Interview International/01 (21 April 2016).
2. This mirrors the position of governments declaring that the culture sector was 'non-essential' during the Covid-19 pandemic.
3. Interview International/02 (7 June 2016).
4. https://en.unesco.org/creativity/cdis (accessed June 2021).
5. Interview International/02 (7 June 2016).

4
Project design and management

This chapter focuses on intertwined international and national frame-works for the four selected projects. More specifically, it is concerned with the overall structure, rules, and regulations that guided the inter-national design, structure, and durability of these initiatives. Such analyses provide a macro-understanding of the schemes, while the sub-sequent chapters provide more fine-grained study of the contribution of heritage to key global challenges. From now on, I focus on all the culture-for-development projects in sub-Saharan Africa that were funded by the Millennium Development Goals Achievement Fund and undertaken jointly by various UN organisations (under the leadership of UNESCO). These are: 'Harnessing Diversity for Sustainable Development and Social Change in Ethiopia' (July 2009–December 2012); 'Strengthening Cultural and Creative Industries and Inclusive Policies in Mozambique' (August 2008–June 2013); 'Sustainable Cultural Tourism in Namibia' (February 2009–February 2013); and 'Promoting Initiatives and Cultural Industries in Senegal – Bassari Country and Saloum Delta' (September 2008–December 2012). These initiatives, introduced at greater length in Chapter 1, aligned with the Millennium Development Goals (MDGs) and the Sustainable Development Goals (SDGs) and aimed to use heritage to ensure gender equality through equal access to training (SDG 4, Target 4.3; MDG 3) and employment (SDG 5, Target 5a; MDG 1); to develop economic opportunities for marginalised groups and to reduce poverty (SDG 8, Target 8.9; MDG 1); and finally, to conserve biodiversity (SDG 15, Target 15.5; MDG 7).

All of the conditions were available to ensure successful project design and implementation, and a tangible demonstration of the contri-bution made by heritage (and culture more broadly, understood in its broadest sense as the whole complex of distinctive spiritual, material, intellectual and emotional features that characterise a society or social

group) to these key global challenges. Each programme received major funding from Spain (almost US$6 million per project) allowing wide-scale impacts to occur. In addition, two major international reforms – the 2005 Paris Declaration on Aid Effectiveness and the 2007 UN Delivering as One restructuring – should have helped with delivery. Finally, the timing allowed their results to feed into the post-2015 international development agenda.

This chapter discusses the principles and policies guiding the design, implementation and durability of the four selected schemes. It assesses whether they were designed and managed differently to other international development programmes, and if so, how. This approach questions the common belief that heritage-led schemes, as embodiments of the so-called cultural turn in international aid, take greater account of local communities and local contexts, are better aligned with national and local priorities, and are run more ethically, than other types of endeavours (see also Labadi, 2019a for a discussion of this cultural turn). More specifically, the first section critically assesses project design and selection. Moving onto implementation, the next section discusses how key aspects of the 2005 Paris Declaration on Aid Effectiveness had an impact on programme delivery. It concentrates particularly on the notion of ownership, which ties in with the narrative of the cultural turn and with the increasing alignment of activities with national and local priorities. The second key reform item of the time, the UN's Delivering as One (2007), is also considered for its impact on delivery. Finally, I look at project sustainability, that is, how the outputs live on after the end of funding, which is a key measure of success. The chapter therefore considers every aspect of macro-project management, from design to implementation to durability.

Promising the moon

The selected projects in Ethiopia, Mozambique, Namibia and Senegal were funded by the Millennium Development Goals Achievement Fund (MDG-F), created by the Government of Spain and the United Nations Development Programme (UNDP) in 2006. The aim of this fund was to accelerate progress towards attainment of the MDGs in specific countries and through nine different thematic areas, including one on 'Culture and Development'. Indeed, the start of the implementation of, and progress towards, the MDGs had been rather slow, and the omission of culture was considered a reason for this situation. All of the

130 initiatives funded by the MDG-F, including the four selected ones, passed through a rigorous two-stage process of selection. In response to a request for proposals, a short concept note had first to be prepared by the UN Resident Coordinator together with other UN agencies, governments, and civil society groups, in an inclusive process. The UN Resident Coordinator functions like the conductor of a large orchestra. Her role is to bring together the different UN agencies and coordinate their actions, working in close collaboration with national authorities, in support of national priorities. The concept notes produced were then assessed by a technical sub-committee composed of UN and independent experts, with final decisions taken by the steering committee, made up of representatives of the Spanish government and UNDP (UNDP/Spain Millennium Development Goals Achievement Fund, 2007: 4).

At the second stage, successful teams submitted detailed joint programme documents evaluated again by a technical sub-committee. The sub-committee's recommendation options were to accept the plan, to request revisions, or to reject it. In making its decision, the sub-committee assessed proposals according to specific criteria. These included whether and how the proposals would tackle multiple forms of poverty without accentuating inequalities and the social exclusion of disadvantaged people. The principles of the 2005 Paris Declaration on Aid Effectiveness, considered at length below, also had to be respected. More specifically, documents had to be aligned with national and local priorities, identified in the United Nations Development Assistance Frameworks (UNDAF), a document that details how UN Country Teams will address development priorities identified by member states from the Global South. The aims and results had to be measurable, impactful, sustainable, and credible. The projects also had to be implemented by the various UN organisations according to the Delivering as One principles (see below), in full cooperation with national and local stakeholders. The recommendations were then submitted to the Steering Committee, who took the final decision on which proposal to fund (UNDP/Spain Millennium Development Goals Achievement Fund, 2007).

The selection process also took additional geopolitical and diplomatic aspects into consideration. In sub-Saharan Africa, for instance, each of the successful projects is located in a country with a unique past, belonging to a specific sphere of influence. Senegal was colonised by the French and belongs to the Francophone world; Namibia was colonised by Germany and administered by South Africa and is now part of the Commonwealth; Mozambique was part of the Portuguese empire and is now part of the Commonwealth, and acts as observer of the

Francophonie; and Ethiopia was never colonised (except for a brief occupation by Italy from 1935 to 1941). One wonders how important these geopolitical considerations were, compared to the technical sub-committee's evaluations and the official criteria. Uneven consideration of the official criteria might explain why many issues in project design were not addressed, leading to shortcomings in the implementation phases. For instance, during the assessment process, the sub-committee requested revision of the Namibian plans, to focus on fewer activities, targets, and indicators. The goals were to build and open nine fully equipped heritage/interpretation centres housing new exhibitions, each in a different region; and to train tour guides and artisans to work in these structures, as well as promoting and integrating them into existing tourism circuits. These ambitious activities were supposed to take place in three years. Too many activities were therefore spread over large regions, resulting in the thin distribution of funds, and in a lack of thematic and geographical focus (Tadesse, 2013: 27). Yet the proposal was funded even though it did not take account of the comments and was not scaled down. The mid-term evaluation of the Namibian case (conducted 18 months after its start) questioned why these requests for change were not acted upon, and urged the programme leader to consider these issues, as they had created confusion and delays (Maconick, 2010: 11).

Not all of the assessment criteria seemed to have been consistently applied during the assessment phases, which may also explain some of the issues faced by projects during their implementation. A number of additional shortcomings in design, which had not been raised during the evaluation phase, were also identified during the mid-term assessment. This occurred in particular for the project in Ethiopia, the first target outcome of which was to strengthen 'intercultural/religious dialogue to foster mutual understanding of heritage and the sharing of common values with a view of contributing towards social process and social cohesion' (UNDP, 2008a). This outcome was recognised in the mid-term evaluation as impossible to achieve within the timeframe allocated, since attitudinal changes occur slowly and cannot be achieved quickly (Arbulú, 2012: 17).

Above all, the mid-term evaluations considered all of the plans too ambitious, with too many competing goals, outcomes, and outputs, and too many targeted beneficiary groups. The indicators used to monitor the implementation of activities were also unclear in most cases (Maconick, 2010: 11; Arbulú, 2012: 17; Metwalli, 2010: 15; Bugnion, 2010: 32ff). These evaluations clearly requested that the goals be scaled down, that

activities be reduced in size and scope, and that more robust monitoring mechanisms be put in place. Despite these clear requests, the plans of work and activities were not fundamentally altered, and the original programme goals and outcomes were retained. The question is: why did the implementing UN organisations remain deaf to the request to scale down their proposals, knowing that they could not achieve their goals? They may have feared that a reduction in scale and activities would lead to a decrease in funding. In addition, implementing agencies may have wished to persist with their ambitious plans, viewing them as a once-in-a-lifetime opportunity for a chronically underfunded sector lacking data to demonstrate the contribution of culture and heritage to development. Are these trends of proposing and implementing over-ambitious projects unique to this sector? Not at all. 'Overselling' is common in proposals, and is a process in which 'a "client is promised the moon" without thinking of how much time and energy it takes to deliver on such promises' (Ely and Padavic, 2020: 62). It has even been documented that the MDG framework encouraged projects to adopt a 'do everything' approach and to try to address as many goals as possible (Easterley, 2006: 164).

International frameworks tackling many global issues, such as the MDGs, have sometimes led initiatives to fall into 'grand developmentalism' (Bayo Ogunrotifa, 2015: 44–5; Mills, 1959). This is a macro and abstract approach to the identification of problems and solutions, rather than a consideration of issues in their complexity and localised nuances. Grand developmentalism establishes big narratives without necessarily grounding them in socio-economic and cultural realities. The project documents considered here suffered from such a grand developmentalism approach, claiming that culture in general and heritage in particular contribute to all of the MDGs without providing any clear and specific methods for achieving them. For instance, the Ethiopian programme document explains that culture 'greatly impacts' gender, youth, children, and HIV/AIDs. It then details that Ethiopia has one of the highest rates of HIV/AIDs in the world, proposing to tackle this issue through enhancing 'social cohesion' and 'an inclusive approach' (UNDP, 2008a: 46). How exactly HIV/AIDS was to be tackled through such an approach was not clear, and no further detail was provided. This example illustrates how in some cases (but not all the cases considered, see Chapter 6), the grand developmentalist narrative is not grounded in any meaningful or realistic methods for implementation. Considering that the SDGs are now composed of 17 Goals, all of which target major issues from climate change to gender equality, poverty, and sustainable cities, one can only anticipate that this trend of 'grand developmentalism' will continue. However,

the trend is not unique to the worlds of development and aid. A lack of grounding and of serious consideration of global challenges happens everywhere. Concerned about my carbon footprint (which before Covid-19 was higher than I would have liked), for example, I requested help in carbon offsetting from people working on climate change, and from other academics (who all take flights and thus have large carbon footprints) during conferences and on social media. The lack of response received was quite a revelation to me. People consider these issues the abstract subject of academic lectures or reports, rather than as concrete realities with their own dynamics, upon which we can act on a daily basis.

Hence, a pitfall of some of the schemes was their 'do everything' approach. The downscaling of ambitions and activities might have resolved some of the issues considered in the next pages. Yet, the projects were designed and implemented by different UN organisations, each with its own specialisms, which could have helped to tackle the lack of precision and grounding in the proposals. For instance, in Mozambique the activities were to be implemented through the joint efforts of UNESCO, which brought its expertise in heritage and culture; ILO, with its expertise on decent job creation and social security; FAO, with its knowledge and experience of the integration of socio-cultural data and traditional knowledge systems in forestry resources management; and UNFPA, with technical expertise in sexual reproductive health and HIV prevention. The synergy of these specialisms could have enabled the completion of the outputs. This hypothesis is considered and discussed further in this chapter and in the rest of the book.

It is their project!

To reiterate UNESCO's slogan, culture (understood in its broadest sense as the whole complex of distinctive spiritual, material, intellectual and emotional features that characterise a society or social group) is an enabler of sustainable development. This motto refers to the cultural turn in international aid and development, which emerged during the implementation of the first UN Development Decade in the 1960s, as charted in Chapter 2, with UNESCO as one of its leading voices. It means that development interventions, rather than being externally devised and imposed on recipient countries, take account of, and are responsive to, national and local socio-cultural contexts and particularities (UNESCO, 2012a: 1; UNESCO, 2012b). In my analyses, I wanted to understand whether and how the selected projects had integrated these socio-cultural contexts

and particularities. Of course, one can immediately criticise international intergovernmental organisations for only working at a macro and international level and thus for not being in touch with socio-cultural realities on the ground. However, the selected initiatives had to integrate the principles of the 2005 Paris Declaration on Aid Effectiveness, adopted at the Second High-Level Forum on Aid Effectiveness (Capra International, 2014: 49–51). This document requests that international aid initiatives have greater consideration for national and local specificities. The conclusion of decades of reflections, this 2005 document aims to improve the quality of aid and its impacts on development. During discussions leading to its adoption, aid was recognised as still being too strongly aligned with externally imposed conditions. Development, it was reiterated, depended primarily on efforts at country level, and aid should accompany these efforts (Booth, 2012: 539). In other words, aid effectiveness does not necessarily, and only, depend on the amount of funding provided, but also on how aid can be, and is, spent. For this reason, the Paris Declaration affirms the principle of ownership, meaning that 'Partner countries exercise effective leadership over their development policies and strategies, and coordinate development actions' (OECD, 2008: 3).

This text also requests the alignment of donors' funding with national development strategies, institutions, and procedures. In other words, aid should be aligned with recipient countries' own policies and priorities and developed under the receiving nation's own terms. To achieve such ownership and leadership, aid should be channelled directly into the central budget of the recipient government (Sjöstedt, 2013: 144; Booth, 2012). This does not mean that there is no checking up on how funding is spent. 'Mutual accountability' is promoted, where 'donors can hold developing countries to account for their performance but developing country governments should also be able to hold donors to account for whether they have delivered on their commitments' (Glennie, 2002: 552). The principles of ownership, alignment, and mutual accountability promoted in the Paris Declaration have been continually reaffirmed in follow-up meetings, including the 2008 Accra Agenda for Action (adopted at the Third High-Level Forum on Aid Effectiveness); the 2011 Busan Partnership for Effective Cooperation (adopted at the Fourth High-Level Forum on Aid Effectiveness); and the 2015 Addis Ababa Action Agenda signed at the Third International Conference on Financing for Development, the major framework guiding financing for development in the SDGs era.

The four programmes considered have all respected the principles of the Paris Declaration to some extent. They were devised at a

national level by the UN Resident Coordinator, in cooperation with the other participating UN organisations and relevant national ministries, and respecting national priorities (Capra International, 2014: 3). For instance, the proposal in Namibia was in line with the government's goal to create a tolerant society that is proud of its diversity (UNDP, 2008b: 1–2). The programme aimed to identify, protect, and valorise cultural heritage sites from Indigenous and rural communities through nine fully equipped heritage/interpretation centres, and in the process to provide valuable livelihoods for these groups. However, most of the Namibian cultural heritage sites on the established tourism circuit are related to the colonial period, and the associated tourism sector is controlled by white people. Changes in these tourism routes would ultimately create a more egalitarian society, because Namibia has some of the highest levels of income inequality in the world (Schmidt, 2009: 4), in part the result of its colonial past. This echoes Objective 2 of the UNDAF for Namibia at the time (2010), which identified cultural tangible and intangible heritage as important for the sustainable livelihoods of vulnerable groups, primarily Indigenous people and rural communities (UNDP, 2008b: 1; United Nations, 2006: 15). The MDG-F project was also in line with Namibia's 2001 Policy on Arts and Culture, which aimed to promote the cultures and heritage of the country in all their diversity (UNDP, 2008b: 7). Such alignment of this international scheme with national priorities is assumed to lead to national ownership and leadership in implementation. Another example is the strong ownership of some of the aims of the scheme in Senegal, primarily the inscription of the Saloum Delta and Bassari Country on the World Heritage List in 2011 and 2012, as well as the construction of an interpretation centre in Toubacouta (Saloum Delta), and a community village in Bandafassi (Bassari Country). Finally, the Government of Mozambique's five-year plan (2005–9) and the PRSP (Poverty Reduction Strategy Papers) identify culture as an important contributor to the country's human, social, and economic development (UNDP, 2008c: 7).

However, ensuring ownership of international projects is complex and can take multiple forms at different levels, whether national, regional, or local (Gibson *et al.*, 2005: 227–8). Here the focus is national ownership, while the next chapters will focus on more local appropriations of programmes, which follow different dynamics. The alignment of the four selected programmes with national priorities did not necessarily mean that national governments would readily embrace them. My interviews with some ministry staff revealed that aid is still thought to maintain asymmetrical power relations between donors and receiving

countries (see also Glennie, 2002: 554). Asymmetrical power relations happen when one country has more funds, influence, and bargaining power than another (Quinn and Wilkenfeld, 2006: 442; Womack, 2016: 8). They also occur when donors control the aid and use it to maintain neocolonial relations through dominating the economic, social, and cultural spheres of receiving countries (Escobar, 1995; Basu and Modest, 2015: 8–9). Many initiatives have created and maintained these power relations between donors and receiving countries. For instance, I have detailed elsewhere how France has spent its aid to define and control perceptions of the history of its former colonies, through protecting, rehabilitating, and interpreting its colonial heritage at the expense of 'Indigenous' sites (Labadi, 2019e: 247–8). This imbalance has created long-lasting distrust and disengagement between donors and receiving countries, with aid being regarded as a humiliating process by the latter.

Additionally, weak ownership and leadership occurred because a large part of the allocated budget was spent directly by the UN agencies involved. In the words of one of my interviewees from Maputo (Mozambique): 'If you have money, you introduce the rules of the game. You want things to work your way'.[1] But mistrust also happened when funds were transferred into the central budget of recipient countries, as in the case of Namibia. This transfer occurred under the condition that the Namibian government provide asset registers and audited accounts. This condition was interpreted as a demonstration of 'lack of trust in Namibia's accountability for the funds' (interview February 2013, reported in Enhancing Heritage Resources, 2013: 22), despite mutual accountability being one of the principles of the Paris Declaration. These two examples demonstrate the difficulty of finding a suitable solution, because the Global South may see international aid as neocolonialism in disguise, and because trust, the social glue between different organisations and individuals, is lacking (Easterley, 2006: 70–1).

Frustration was also expressed, primarily in Mozambique and Namibia, over the lack of power over the hiring of consultants to write reports, documents, and studies. UN organisations controlled large parts of the allocated budget and therefore hired the consultants they wanted for the work (some of them nationals, and others internationals). The fact that Mozambican authorities did not have control over all the hires led them to regard these projects as external, rather than nationally owned. One of my informants from Maputo explained to me that he had no power to check the work of hired consultants. It was the recruiting agency that was responsible for the consultants' terms of reference and deadlines for output submission, as well as for overseeing their work and

checking its quality. The result was a lack of ownership and participation, as also highlighted in the official evaluation (see for example Enhancing Heritage Resources, 2013: 23). These shortcomings were expressed by one of my interviewees from Maputo: 'This is a project of UNESCO. It is their project. So, people crossed their arms, waiting for results. If it moves forward, good. If it fails, too bad – it is their project'.[2] Therefore, in the cases of Namibia and Mozambique primarily, international organisations maintained unequal power relationships by controlling the funds and the staff who produced some of the knowledge for outputs. It is interesting to note that, when hiring national consultants, the UN would respect the Paris Declaration and strengthen national institutional capacities. Yet national authorities still expressed frustration over the process, and this might reveal power struggles still occurring between member states and UN organisations.

Unequal power relations and the consideration of projects as external, rather than nationally owned, were problems exacerbated by some UN agencies not being resident. A non-resident agency does not have national offices in the country where projects are implemented. This was the case, for example, for three of the four implementing agencies in Namibia: UN-Habitat, ILO, and UNEP. Hence, the great majority of the implementing agencies in Namibia were not resident. The final evaluation reports many problems with non-resident organisations. Not only were they seen as very expensive, as their staff had to fly in, but they also had limited capacity for meaningful action because of their lack of a permanent base in the country, limited communication because of the high costs of foreign phone calls at that time (Enhancing Heritage Resources, 2013: 27), and a lack of control over the work of the consultants hired, who had to be monitored from abroad. These organisations were then seen as only marginal contributors to activities, even while being officially entrusted with key outputs and substantial funding.

The continuing unequal power relations and related frustration raise the question: did project documents truly reflect national priorities? Plans, including UNDAF, are supposedly based on a country's own defined priorities, to ensure ownership and a bottom-up approach to aid, in line with the Paris Declaration on Aid Effectiveness. This has been hailed as a positive change. Previously, donors informed receiving countries of their priorities and plans of work, and would distribute aid accordingly in a top-down manner. Schemes often failed as a result: they did not reflect national and local aspirations and realities, and lacked buy-in on the ground. However, in some cases, UNDAF and project documents for international aid use ideas and themes that donors want to

see, in order to secure international aid. This is what Van de Walle has termed 'ventriloquism': donors make clear what they expect, and governments tell them what they want to hear (Van de Walle, 2005: 67; De Renzio, 2006: 137). Ventriloquism can be a lens through which to view different understandings of the term 'culture' and 'heritage' for international organisations on the one hand, and the governments of receiving countries on the other. For international organisations, culture (understood in its broadest sense as the whole complex of distinctive spiritual, material, intellectual and emotional features that characterise a society or social group), including heritage, is a neutral and apolitical concept. All types of heritage and cultures are respected for their own intrinsic values. This is how these concepts have been presented in the four selected project documents.

However, ventriloquism hides more complex realities on the ground: culture and heritage are not neutral concepts, but instead are politically loaded, and can be used for the construction of the nation. In this context, which forms of cultures are being valued and prioritised for development? For instance, many interviewees in Mozambique shared the view that culture is only valued when it has a political meaning and benefits the ruling party.[3] As explained by one informant: 'when you introduce a song, the politicians ask about the song's message and suggest including the president's name in the song. But my god! Are we here to extol the president or the culture? So that's the big problem, culture has to have a political taste'.[4] This concern for political meaning has meant that the colonial heritage of the country, highly valued by the international donors and selected as the focus of some of the key activities (for instance guided tours on the Island of Mozambique and Inhambane city), was undervalued at a national political level. This point will be further considered in the next chapters. This understanding of culture as political means that some governments, such as that of Mozambique, have given low priority to narratives on the contribution of heritage to the different pillars of development, further showing the lack of real project ownership (Eurosis, 2012: 81). However, other programmes add nuance to this idea of ventriloquism. In Namibia and Senegal particularly, the aim was to propose new heritage and tourism destinations based on Indigenous history. The next chapter will detail the difficulty of realising these ambitions due to local and national power struggles or to the lack of involvement of key partners. The Namibian example also demonstrates that if priorities are national, but the implementing teams international, then there is a danger of dislocation and lack of grounding.

Delivering as *If* One

All of the 130 projects funded by the Spanish MDG-F had to be imple-
mented under the Delivering as One UN modalities (Evaluation
Management Group, 2012: 25), launched in 2007 to make the UN
system more coherent, cohesive, effective, and relevant. Aligned with
the 2005 Paris Declaration on Aid Effectiveness, this reform calls for har-
monisation between UN agencies through common arrangements, sim-
plified procedures, sharing of information, transparent approaches, and
synergies, in order to enhance their capacity for strategic action. With
'one programme, one leader, one budget and, where appropriate, one
office', this model intends to reduce duplication of effort and eliminate
fragmentation, multiple procedures, low capacity for action, and over-
lapping responsibilities (Campos, 2017: 49; OECD, 2006: 6). All too
often, in past approaches, each UN organisation would pursue their work
in isolation, in a fragmented manner, at times even in competition with
each other, without benefiting from one another's presence (Richter,
2018: 30). This work in silos would be rather counter-productive and
would not help UN organisations to accomplish their mission, especially
when tackling sustainable development issues, which are multi-dimen-
sional by nature. With this reform, UN organisations were supposed to
work together coherently to achieve planned and substantial changes
in delivering countries. Delivering as One seems, on paper, an admir-
able and much needed improvement. While it reflected the zeitgeist as
well as the 2005 Paris Declaration, it had in reality been on the table
for some time. In 1969, a UNDP report by Sir Robert Jackson, entitled
Capacity Study of United Nations Development System, already advocated
horizontal centralisation of the UN system at national and local levels,
with unified programming, leadership, and budgeting (Jackson, 1969;
Campos, 2017: 50–1). Vertical decentralisation was also promoted, with
the UN agenda primarily driven by national priorities and issues, rather
than by the offices in Paris, Geneva, or New York. In the next paragraphs,
I analyse the impacts of the Delivering as One reform on the implemen-
tation of the selected programmes. I do not look at how successful this
reorganisation has been, as this is beyond the scope of the research.
However, it is important to consider the reform, as it certainly framed
and impacted project delivery.

It is important first to understand the management structure of the
four cases, which reflects both the requirement for national ownership
(as requested in the Paris Declaration) and for synergies between UN
organisations. At a national level, the 130 projects funded by the Spanish

MDG-F for US$840 million, as well as the other pilot Delivering as One plans, followed a structure composed of four management layers: a UN Resident Coordinator, a National Steering Committee, a Programme Management Committee, and a Programme Management Unit (Capra International, 2014: 19; Evaluation Management Group, 2012: 48–9). Some consider this a rather heavy structure, although it is commonly used in aid. Moyo has indeed found that aid supports 'large, unwieldy and often unproductive public sectors' (Moyo, 2009: 66; see also Boone, 1996: 289–329), a trend described by Easterley as 'the aid curse', where revenues are paid to members of national governments and political insiders instead of to those whom the aid was supposed to benefit (2006: 120).

More specifically, the UN Resident Coordinator led the implementation of the work programmes, oversaw the budget, and facilitated collaboration between participating UN organisations (Capra International, 2014: 3; Enhancing Heritage Resources, 2013: 20). Hence, the Resident Coordinator played a central role in management and delivery. However, in the case of the project in Namibia, this person changed three times over the course of three years, impacting negatively on the coordination, management, and delivery of the activities. This lack of continuity might have been compensated for by the work of UNESCO, designated as the lead organisation and responsible for addressing technical matters.

Second, the National Steering Committee (NSC) was tasked with providing oversight and strategic guidance. It reviewed and approved annual work plans and budgets, and thus had a bird's-eye view of the projects, rather than a detailed understanding. In the case of the Namibian programme, to continue with this example, the NSC (co-chaired by the UN Resident Coordinator and the Director of the National Planning Commission) saw the participation of a senior representative from the Spanish Embassy, as well as from three Namibian ministries: of Youth, National Service, Sports and Culture; of Environment and Tourism; and of Education (Enhancing Heritage Resources, 2013: 19 and 21). This represented obvious efforts to ensure national ownership, an inclusive approach, and mutual accountability. However, the national elections in Namibia in late 2009 led to the deployment of new staff in these ministries, who only started work in March 2010. They were required to become familiar with the initiative more than a year after its start (in February 2009), which limited their effective involvement in the initiative.

Third, the role of the Programme Management Committee (PMC) was to coordinate implementation of the plan, with participation from all the involved UN agencies and key ministries. In Namibia, the PMC

was composed of UNESCO, ILO, UNEP, and UN-Habitat, as well as staff from the Ministry of Youth, National Service, Sports and Culture; the National Planning Commission; the Ministry of Environment and Tourism; the Ministry of Trade and Industry; the Ministry of Education; the Ministry of Regional and Local Government and Housing and Rural Development; the Ministry of Gender Equality; and finally a representative of the Spanish Embassy (Enhancing Heritage Resources, 2013: 20). Initial enthusiasm for the project meant that the PMC at first met more frequently than the planned quarterly meetings. However, this fizzled out in the later stages, with only two meetings in 2012, perhaps due to the impossibility for the organisations to deliver as one – or to deliver at all – as will be later explained in greater detail.

Finally, the Programme Management Unit (PMU) managed the day-to-day work on behalf of the implementing partners, drafting bi-annual monitoring reports, and leading communication efforts. To involve communities and local stakeholders in the process and ensure some local ownership in implementation, Regional Councils were also formed, which worked in close cooperation with the PMU (Enhancing Heritage Resources, 2013: 98).

Despite these layers of committees, the joint and successful implementation of projects was the exception rather than the norm. When joint implementation occurred, significant changes followed. Understanding intangible heritage practices that women found discriminatory, and assisting them in changing such practices, was one such successful joint scheme, undertaken by UNESCO and UNFPA in different regions of Mozambique (further detailed in Chapter 6). However, in most cases, implementing activities under the Delivering as One UN framework led to more problems than improvements. This is perhaps unsurprising, given that these projects occurred during the first years of the reform. The principle of 'one budget' is just one example. Resource flows were not simplified, and instead efforts were duplicated, leading to major delays in fund disbursement and implementation, for example in Senegal. At the beginning of this project, the full budget was located at the UN in New York. This funding was then dispatched from the UN to each of the five executing UN agencies (UNDP, UNESCO, UNFPA, UNIDO, and UNWTO). Each of these organisations then transferred part of this budget to a new common pot at country level for specific activities (in the case of Senegal, for the construction of the community village in Bandafassi and the interpretation centre for the Saloum Delta, at Toubacouta). This meant that the common funding was first split into five parts before being partially reconstituted. It might have been easier to transfer funding directly from

the UN in New York to the UNDP in Senegal, and then to disburse it directly for activities at country level.

Worse, once the budget had been reconstituted at country level, it faced delays in being spent, as there was a lack of understanding of the responsible entity and modalities for expenditure (Bugnion, 2010: 17 and 24). Similar over-complicated transfers of funds have been reported for other projects under the Delivering as One approach (Richter, 2018: 43). Meanwhile, other programmes in other countries adopted easier and more successful procedures, including the use of harmonised cash transfers, which enabled some programmes to have a joint budget and facilitated the joint delivery of activities (Bugnion, 2010: 24; Evaluation Management Group, 2012: 27–8). These diverse experiences may indicate that 'simplification of business practices has not received the strongest guidance', as pointed out in the official and independent evaluation of the Delivering as One reform (Evaluation Management Group, 2012: 20).

The inadequacy of the Delivery as One mechanisms might explain the lack of efforts made by the different agencies to deliver jointly the selected projects (Damiba, 2012: 46–7; Enhancing Heritage Resources, 2013: 48). Above all, the key issue is that each agency had to respect its own operational and administrative procedures. How is it possible to implement a joint system when each implementing agency must report to different bosses with different agendas? As remarked by a UNDP Administrator speaking at the UN General Assembly, 'as long as you fund us separately and evaluate us separately there will be competition and incoherence' (cited in Maconick, 2010: 22). The recent UN reforms seem to have overlooked the fact that each UN organisation has worked separately over decades, and thus has developed its own processes, working methods, and operating practices, making it difficult to identify common approaches (Richter, 2018: 44). A related issue is that intergovernmental staff work to implement their agency's plans, rather than the priorities of the country they are supposed to assist. These staff are evaluated on whether they implement the goals of their organisation (see also Easterley, 2006: 6–7). They thus do not have any incentive to implement a joint programme with other UN organisations, especially since such a coordinated approach seems to create a higher workload (Enhancing Heritage Resources, 2013: 24). From the design stage, the projects provided distinct roles and activities for each of the participating UN agencies. Each organisation worked in parallel, advancing its own agenda, rather than contributing to a coherent programme.

Even though their designs aligned with the recipient country's agenda, the focus of the projects' implementation was diverted towards

the objectives of each UN organisation, for instance towards culture in the case of UNESCO or towards the empowerment of women in the case of UNFPA. As a result, activities were simplified, while the issues (such as poverty reduction, which should have been addressed in a transectoral manner for best results) were not. Even when some activities were implemented jointly, simplification meant that the cohesive vision of using heritage for development was not fully realised. As extensively discussed in the following chapters, one example is that of the community village of Bandafassi and the interpretation centre in Toubacouta, Senegal. Their construction was a joint effort of UN organisations and the government, but most of the ambitions for these places have not been realised, because of a lack of activity coordination or continuity. Are these shortcomings unique to the cultural projects considered, or do they also characterise other 'joint' programmes? The independent evaluation of the Delivering as One report provides a clear answer, explaining that each individual organisation remained the sole unit for assessing performance and management. The report concludes, rather ironically, that the reform would have been better termed 'Delivering as *If* One', because collaboration can only be superficial when no proper measures have been put in place to realise a common approach (Evaluation Management Group, 2012: 83).

Not only was there little cooperation, but there was also limited sharing of information, as reported for instance in the mid-term evaluation of the project in Namibia (Maconick, 2010: 14). Again, this is not unique to the cases considered in this book. Official evaluations for other Delivering as One initiatives that focus on other challenges such as poverty reduction or gender equality report a 'silo culture', that is, the reluctance of UN organisations to collaborate with each other and to share information (Keyzer, 2010). Organisations do not have experience in working together, and fear that it may dilute their 'brand' and uniqueness, and thus affect the funding they receive (Evaluation Management Group, 2012: 58). Such fragmentation and lack of coordination may indicate a fear of seeing the galaxy of UN organisations become a single UN agency with a single fund, an idea supported by powerful leaders such as Gordon Brown, former Prime Minister of the UK (Richter, 2018: 36), but vehemently rejected by UN staff, who have considered this move as a threat to their jobs (Campos, 2017: 53).

Considering the issues with Delivering as One, even down to an unwillingness to share information between different agencies, it is a wonder that the projects still adhered to such a heavy management structure, which ended up having little impact on their daily management and implementation. This top-heavy system, coupled with the lack

of joint delivery, led to the fragmentation of aid and accumulated delays. There were delays: in starting activities (due to the different management structures that needed to be set up); in disseminating funds; in formalising implementation agreements (due to the different procedures of each organisation); and in recruiting key coordinating staff. Delays were also due to the high number of stakeholders in the project management committees, which on the one hand ensured a democratic approach, but on the other hand made it a challenge to organise meetings, achieve consensus, and make decisions to move forward. The initiative in Namibia, for instance, had ten programme stakeholders and nine pilot cases with their own management committees, creating communication, expectation, and procedural challenges. All these problems were exacerbated by the aforementioned staff changes within both ministries and UN agencies. These delays had concrete and damaging impacts on each of the selected projects, resulting in some activities not being completed by the end of the allocated time. For instance, not one of the nine heritage/interpretation centres was completed by the end of the programme in Namibia. Worse, there were so many delays in the implementation of plans in Ethiopia that its budget was cut by more than US$1 million (Tadesse, 2013: 6). This is ironic considering that cultural heritage suffers from underfunding. Since a key measure of successful implementation is how much of the original budget is actually spent, such a reduction must have been considered a major step back.

Delivering as One therefore seemed, on paper, a necessary reform, which would have facilitated the implementation of the selected projects and their ambitious and intersectoral plans of work. In reality it led to setbacks, with heavy management structures, no real collaboration efforts from UN organisations, the duplication of activities, little sharing of information, and multiple delays. These issues at macro levels did not prevent some interesting activities being implemented on the ground, and some UN organisations even considered culture and heritage for the first time, as will be discussed in the following chapters. Before considering these more localised approaches, the last section of this chapter considers the durability of the schemes.

1% of projects are sustainable

'Sustainability' is an official measure of project success, and a criterion used to assess aid effectiveness. It is defined as the continuation of the activities and the long-lasting socio-economic benefits for target

groups after donor funding ceases. In short, it refers to project durability (UNESCO, 2012c: 27; Honadle and VanSant, 1985; Evaluation Management Group, 2012: 4). All the MDG-F programmes were supposed to be sustainable. In the past, long-lasting results were more the exception than the norm. The mid-term evaluation for the scheme in Senegal even mentions that as much as 99 per cent of international aid projects in the country had been unsustainable before 2010 (Bugnion, 2010: 30). One reason for such a high failure rate is that some organisations have sabotaged international aid activities on purpose, as a strategy for obtaining continued funding to address global challenges (Drazen, 2007: 671–2). Were the selected projects any different? Did the overall principles guiding their implementation (such as the Paris Declaration) help to ensure their long-lasting impacts on the ground?

My field trips to Mozambique and Senegal aimed to understand the legacy of the projects more than five years after they had officially finished. My observations complement the official evaluations, conducted immediately after the end of the schemes. Indeed, the sustainability of projects should be measured with regular evaluations every five or even ten years afterwards (Moyo, 2009: 44–5; Labadi, 2011b). In Mozambique and Senegal, I met many participants who remembered the various activities – some more vividly than others, but this is normal after such a long time. One of my interviewees in Inhambane city in Mozambique had even kept all the training materials provided (in this case on handicraft making, tour guiding, and marketing). He explained:

> I have them well kept. You know, it's something I'm proud to show my colleagues because others haven't had the chance to participate. I show them the books and pass them from hand to hand. Those books helped us. At that time, I had no idea what an executive summary was, so that project made me realize that there is a project behind it all. I am a painter and did not conceive of an exhibition as a project, so the training showed me that all I was doing was a project … [5]

Long-lasting impacts were achieved at an individual level, as discussed at length in the following chapters. However, each programme cost millions of dollars, and in poverty-stricken countries like Mozambique and Ethiopia their long-term sustainability cannot be assessed at the level of individuals only, but must also be assessed according to their ability to provide lasting, tangible socio-economic benefits for local communities, including marginalised ones. Some long-term results, including tangible

ones, were achieved, especially in Senegal where the Saloum Delta was inscribed on the World Heritage List in 2011 and the Bassari Country in 2012, accompanied by the construction of their respective interpretation centres (which in the Bassari Country case is also a community village). These are significant outputs, in light of the under-representation of African sites on the World Heritage List, as well as the management issues highlighted in the previous section. The officials I met in Senegal proudly told me that these two structures are unique in the whole country. Yet the centres fall short of their original aims. The interpretation space in the Saloum Delta in Toubacouta, for instance, functions nowadays solely as a one-room museum. The associated craft village has never been used. Rooms were provided for women to produce and sell local products (such as honey or jams made with local fruits), but they are now closed and have subsequently been allocated for other, unrelated initiatives (for instance for courses given by US Agency for International Development (USAID)). While the next chapters provide fine-grained thematic analyses of these projects according to their long-term successes and failures in achieving poverty reduction, gender equality, and environmental protection, the next paragraphs focus on sustainability in terms of resources, the motivation of civil servants and participants, and long-term networks and vision.

Most of the activities did not continue, because of insufficient or non-existent human, financial, and technical resources, which is a common shortfall of aid-funded initiatives (Jopela, 2015). The final evaluation of the project in Namibia, for instance, asks candidly how the efforts and initiatives launched would be continued in the future, as the government's statements of intent were not supported by clear resource identification and allocation (Enhancing Heritage Resources, 2013: 29). This lack of funding reflects the absence of political and national commitment and support for the schemes. In the unique case of Senegal, public funding from the Ministry of Culture is still being provided to the interpretation centres in the Saloum Delta and Badafassi, although it has decreased in recent years because the structures are not fulfilling their intended functions as forces for socio-economic change. In addition, small grants were supposed to have been distributed to different socio-economic groups in these two regions. However, according to my interviewees, the lack of accountability and transparency meant that either people never saw the money, or that they spent it on unrelated and personal matters (such as buying clothes for social events).[6]

Additionally, evaluations report that some civil servants either lacked motivation or were only motivated by the financial incentives provided. Different scenarios seem to have occurred. On the one hand,

in Namibia, the project management unit seemed to have been partly created to provide civil servants with 'extra incentives' beyond their normal salary (Maconick, 2010: 16). The heavy management groups seemed not only to have impeded the timely implementation of activities, as already detailed, but also to have prevented these outputs from being sustainable. Obviously, these civil servants were not interested in the long-term impacts of projects, but in short-term financial gains. On the other hand, in Mozambique, civil servants acting as focal points were not motivated because they were not paid for their work, which went against their normal praxis (Eurosis, 2012: 81). Is this significantly different from the motivations of international staff working on other development ventures? Rare are the people who work selflessly for the greater good, as explained by Stirrat in his discussion of the profiles of people in the development field, particularly the 'mercenaries' who are only interested in the material benefits of working in the aid industry, whether it be financial remuneration, the prospect of new contracts, or a promotion (2008: 407–8). However, it can also be argued that it is perfectly normal for people to be remunerated for extra work.

Remuneration is important, yet building supportive networks and alliances among stakeholders is absolutely fundamental for sustaining activities and participant morale (Lee, 2017: 15). As expressed by one of my interviewees from Inhambane, explaining the failure of the tour-guiding there: 'Sometimes it is not giving money as such, it is giving advice, and when there is no such accompaniment, people get discouraged, feel lonely, fail to comply with the cultural tour programme and return to their routine to ensure livelihood. So, the lack of monitoring and continuous training at some point influenced some groups to become discouraged'.[7] These comments might reveal that the programmes did not engage enough key local stakeholders, committed to pursuing the goals of the projects, who could have been points of contact that continued to provide support after the end of the funding. A transitional step was thus missing – that of new roles and responsibilities being transferred to local actors to ensure that they took on responsibility for the continuation of activities after 2012/13 (Bao et al., 2015; Brinkerhoff and Goldsmith, 1992: 369–83).

Beyond each individual activity, the development of networks across all the concerned projects would have helped with their overall implementation and long-term impacts. They had similar ambitious objectives: to reduce poverty, to promote gender equality, and to ensure environmental sustainability. Their methods to implement these objectives were similar in a number of cases, including training local people

from the tourism sector (guides, business owners, artisans) in order to improve their products and services; providing a formal space for artisans to sell their products; improving the socio-economic prospects of women and youth; and ensuring reforestation. Considering these similarities, activities could have been run as horizontal networks across the various key stakeholders, to ensure the sharing of experiences and solutions as well as the replication and expansion of these cases, advocated by many as good practice (Kurlanska, 2019). However, each project was run in isolation, and the official knowledge management booklet from UNESCO recognises that such a silo approach might have had a negative impact on their results and sustainability (UNESCO, 2012c: 20).

In addition, practical visions and approaches for true long-term durability were missing. This is the case in particular for the two interpretation centres in Toubacouta (Saloum Delta) and Bandafassi in Senegal, supposedly significant tangible results of the programmes. On the one hand, the very staff who led some of the funded activities stayed on at the official end of the scheme. However, concrete plans were lacking for translating the objectives of long-term poverty reduction, gender equality and environmental sustainability using these spaces into a reality (Bugnion, 2010: 31). Besides, these staff lacked funding, resources and the relevant training to pursue their mission. This might explain the limited impact these interpretation centres have had on these global challenges since their opening. Major delays in implementation also meant that projects were rushed through with not much time for long-term planning to ensure their future durability. In addition, the innovative dimensions of the interventions meant that baseline data were missing and meaningful indicators for evaluation were difficult to identify. The next chapter addresses these issues in greater depth.

Furthermore, some of the prerequisite steps were not taken, which prevented long-term and sustained results from being achieved. For instance, in Namibia it was expected that the Protected Area and Wildlife Bill, almost twenty years in the making, would be passed by the country's parliament before the end of the funding. However, this Bill is still being finalised as of October 2021. Finally, there was some resistance to acting on the recommendations from the studies conducted during the projects. Studies have therefore remained theoretical scenarios of what could have happened if there had been the will to implement them. I recorded this lack of willingness for mainstreaming a cultural approach in the area of sexual and reproductive health (SRH). As one of my informants explained to me, in relation to Mozambique: 'we have many good ideas, we have many studies [e.g. on SRH]. When it comes to

implementation, there is a bit of constraint. I think for me, that's the big issue'.[8] The projects considered were thus unsustainable because many of their outputs were reports that got shelved as soon as they were released. This may demonstrate that reports are not the best way to implement programmes, as they were the last thing the target populations needed (Easterley, 2006: 145).

Conclusion: the changing landscape of aid?

The focus of the selected cases on heritage did not mean that they were unique in their design and implementation. In fact, they suffered from the same strengths and weaknesses as other mainstream development schemes. They achieved a number of local successes at the micro-level, discussed in the following chapters. However, analyses of the management framework and international guiding principles reveal many problems with the four projects from their inception, that are similar to those arising in other development approaches. They adopted a 'do everything' approach and were too ambitious, had too many competing goals, involved fragmented activities and outcomes, and were not specific and measurable enough. At the same time, the recent reforms of the aid and UN systems (the Paris Declaration on Aid Effectiveness and the implementation of Delivering as One) should have improved programme implementation, but in reality, they created even more hurdles. There was low national ownership, and power relations were not reworked in favour of the receiving countries; as a result, activities were considered as external by national governments. In addition, rather than collaborating, each UN organisation worked alone, without sharing information and budget, and through a complex and impractical system of management structures. This was not unique to the cases considered, and the official evaluation of the Delivering as One reform mentions such shortcomings for other ventures (Evaluation Management Group, 2012). No wonder, then, that the studied cases suffered many delays in implementation, that some activities were rushed through, and that most of the objectives and activities were discontinued when funding stopped. Hence, the aid reforms guiding the implementation of these initiatives did not change anything. International actors ended up repeating past mistakes, or even amplifying them as this chapter has shown. Easterley arrives at exactly the same conclusion in his 50 years analysis of the international aid framework, concluding that 'plus ça change, plus c'est la même chose' (2006: 174–5).

Of course, the aid landscape has changed over the ten years since the selected projects started. But has it changed for the better? Major donors such as Australia and the UK have recently made clear that aid should benefit their national priorities, economy and security first and foremost (see Labadi, 2019a; Logan, 2019). At a time when ideas of national preference and protectionism are so popular in the West, these approaches help to convince the public of the need for continued disbursement of international aid, rather than using it for domestic national priorities such as education or health. These considerations soften the principles of the Paris Declaration and follow-on meetings, and of declarations on ownership and the alignment of aid-funded schemes with recipient countries' own policies and priorities. In addition, the well-documented problems with the Delivering as One reform do not seem to have been resolved in recent years, revealing continuing internal resistance. The 2016 quadrennial comprehensive policy review of operational activities for development of the UN system, for instance, is rather evasive on the harmonisation of UN procedures and further integration into a One UN system. It only encourages the implementation of standard operating procedures, rather than making such standardisation compulsory, which is a fundamental step in harmonising procedures between all of the UN organisations and ensuring that they can effectively deliver as one (United Nations, 2016; Campos, 2017: 63).

The landscape of aid has also become more fragmented, with new actors funding heritage initiatives. China is one such new actor, and is fast becoming one of the key providers of international aid. In 2019, it launched a large-scale multi-country programme, with significant funding for capacity-building and the management of African World Heritage sites. Whether this collaboration provides new models of cooperation is beyond the scope of this research. Yet recent meetings, including the June 2019 UNESCO-Africa-China Forum on World Heritage Capacity Building and Cooperation, seem to have led to a reproduction of unequal power relations between China as controlling funding and defining priorities and African countries as passive receivers.[9] Chapter 7 discusses whether such funding for heritage and culture is not used by China for covering up and accelerating the wide-scale destruction of non-renewable environmental resources. These recent changes in the aid landscape over the past ten years reproduce past relations and dynamics, and do not invalidate my findings. On the contrary, the shortcomings identified in the previous pages are still valid for most international aid-funded projects, and beg a reconsideration of the system, with tentative suggestions provided in the conclusion to this book.

Notes

1. Interview Mozambique/11 (5 May 2018).
2. Interview Mozambique/11 (5 May 2018).
3. Interview Mozambique/58 (7 April 2019).
4. Interview Mozambique/59 (7 April 2019).
5. Interview Mozambique/59 (7 April 2019).
6. Interview Senegal/18 and 19 (2 October 2019).
7. Interview Mozambique/58 (7 April 2019).
8. Interview Mozambique/26 (23 July 2018).
9. Interview International/08 (5 June 2019).

5
Poverty reduction: local economic growth, tourism development and capacity building

Having looked at the macro level of project management, the following chapters discuss project implementation on the ground. Poverty reduction was one of the three challenges (along with gender equality and environmental sustainability) that the selected programmes in Ethiopia, Mozambique, Namibia, and Senegal aimed to address. Because of delays in their start and implementation, as explained in the previous chapter, poverty reduction became the key focus of the programmes following their mid-term evaluations. Poverty is a 'complicated tangle of political, social, historical, institutional and technological factors' (Easterley, 2002: 5), going beyond just income and GDP. The Human Development Index, created by UNDP, is one such attempt to move away from poverty understood only as income, and is instead composed of GDP per capita, life expectancy, and a measure of educational achievement. Embracing this complexity, the selected projects adopted a comprehensive understanding of poverty reduction, as job creation and income-generating activities, but also as strengthening rights, and ensuring that disenfranchised communities take part meaningfully in the development of activities. This was considered an innovative approach – at the time, the MDG 1 had a rather restrictive definition of fighting poverty as achieving widespread employment and halving the proportion of people whose daily income was less than US$1.25.

Using a post-structuralist lens, this chapter aims to assess the main strategies for poverty reduction in the four selected initiatives. In doing so, the complex web of structures, power networks, actors, and contexts that constrain or enable actions are examined and explained. Differences

between places and situations, and how interactions occur in these localities, are also considered (Davis, 2001). Additionally, the following pages view poverty reduction and economic development initiatives as complex systems, rather than as exclusively 'good' or 'bad'. Each situation is recognised as having possible positive dimensions as well as negative ones, with a variety of participants behaving differently when taking part in heritage projects. The chapter also continues the discussion of the forms taken by heritage for development narratives in the context of post-colonial African nation-states, how interpretations of this notion might differ internationally, nationally, and locally, and whether cultural projects are designed and managed differently from other development initiatives.

In order to address this aim, the first section of this chapter assesses innovative uses of heritage for comprehensive local economic development. Initiatives using heritage for tourism development and tour guiding are then considered. The final section critically evaluates capacity-building for artists, artisans, and other service providers, primarily in the tourism sector. Tourism was indeed identified in all the four selected schemes as a powerful tool for poverty reduction. An extensive literature exists on pro-poor tourism, community-based tourism, or sustainable tourism that aims to generate benefits for the poor, as well as helping to preserve the built and natural environment. This chapter considers whether and how these published critical approaches have been used for the various activities.

Multidirectional power relations

Of all those considered, the project in Senegal was the most ambitious in its coherent vision to use heritage for a comprehensive programme of poverty reduction that would benefit different groups (men, youth, women), as well as specific local economic sectors. A first step was the inscription of the Saloum Delta and the 'Bassari Country: Bassari, Fula and Bedik Cultural Landscapes' on the World Heritage List in 2011 and 2012 respectively. Both regions face serious socio-economic challenges. The Saloum Delta encounters difficulties in local development, with the majority of the population working in small-scale fisheries and subsistence agriculture. Yet the Saloum Delta is a beautiful marshy labyrinth of mangroves and brackish channels (bolongs). The site is marked by 218 shellfish mounds, some of them several hundred metres long, produced by its human inhabitants over the ages, as well as diverse fauna and flora. It was inscribed on the World Heritage List as a cultural landscape, under criteria (iii), (iv) and (v). One of the poorest parts of Senegal, the Bassari

Country counts 89 per cent of its households as living under the national poverty line at the time of the nomination (République du Sénégal, 2011: 57). However, the ethnic minorities of the territories, including the Bedik, Bassari, and Dialonké, have rich and unique intangible and tangible heritage that have been well preserved and make respectful and sustainable use of local resources for construction and subsistence. The Bassari Country was inscribed under criteria (iii), (v) and (vi), to acknowledge the rich heritage, complex cultures, and interactions among environmental factors, land-use practices and social rules that have shaped the landscape.

Once the sites were inscribed on the World Heritage List, the second step of the project was to build an interpretation centre in Toubacouta (Saloum Delta) and a community village in Bandafassi (Bassari Country). These two spaces were intended to encourage various socio-economic benefits, including but not limited to tourism. More specifically, the interpretation centre in Toubacouta was designed to include a craft space with around thirty booths for artists and artisans to exhibit and sell their goods; a room for local women to process and sell local products (jams for example); a multimedia place and library for youth; a room for local groups (including musicians, singers and dancers) to rehearse; and a small museum where local tourism guides could take their visitors for a fee. Adopting an inclusive approach, the economic development of two promising sectors – fishing and cashew nuts – was to be driven by this interpretation centre. A technical committee would promote the growth of these sectors, through different actions defined in collaboration with local stakeholders, including direct sales to tourists and tourism structures (like restaurants and hotels). Meanwhile, the community village in Bandafassi, planned to be managed entirely by locals, would provide accommodation for tourists in huts; a small exhibition would present local heritage, accompanied by ethno-cultural spaces reproducing the architectural techniques of each local minority; and local artists and artisans would have a dedicated space to sell their products. Crops would be grown in the garden by local villagers to strengthen their food security, and some of these products could then be sold to both tourists and locals. A community radio would also be located in this structure and would broadcast programmes for the different local ethnic groups. A technical committee, directed by the site manager of the Bassari Country World Heritage site, would manage the economic growth of fonio and shea crops, two sectors identified as having high potential for supporting economic development in both Bandafassi and the wider Kédougou region. The shea tree bears nuts that are widely used for cosmetics in the

West; they are also used for food in some African countries. Fonio is the Senegalese couscous, and has recently become fashionable in the West as a gluten free and nutritionally rich cereal (although it is mainly imported into European markets from Mali and Burkina Faso). As in Toubacouta, local tourist guides were expected to bring their tourists to the exhibition, as an entry point to the site, and as a way to collect a small fee. To ensure that they could immediately benefit from the project, locals participated in the construction of these two structures, although the work was short-term.

Public figures expressed pride when we discussed these two structures. I was repeatedly reminded that they are unique in the whole of Western Africa. Despite major delays, the completion of these places shows renewed official support by the government, as they required additional funding following the end of the international project in December 2012. The centre in Toubacouta opened on 5 May 2013. The community village in Bandafassi was inaugurated even later, on 16 April 2014, almost a year and a half after the official closure of the MDG-F scheme. Hopes were high. These structures would become unifying spaces for different economic actors and sectors. In other words, they would become central and inclusive nodes for poverty reduction in the region. The plans were enticing. However, in reality these plans were not feasible. What struck me when I arrived in Bandafassi, after an eight-hour drive from Dakar, was the state of deterioration of the village, with the exception perhaps of the huts for the tourists (where I stayed). The hut for artists and artisans (Figure 5.1) was being used only for storage, the ethnocultural space was left crumbling, the museum had been stripped of its content, and little was growing in the garden. To add to the desolation, an accidental fire had destroyed the community radio, administrative, and meeting spaces (Figure 5.2) in May 2019. In Toubacouta, the craft space was never occupied and has been left empty, the room for women has been loaned to other projects (for example to USAID for an unrelated scheme when I was there in September 2019). Only the small museum is open, and the multimedia room used by some local schoolchildren.

Conflicting multidirectional power relations between local stakeholder groups, between locals and national authorities, and between national and international actors have prevented the realisation of the plans for these structures, beyond the shortcomings in the overall project management already exposed. These multidirectional power relations reveal the complexity of the situation on the ground, where development approaches cannot be neatly categorised as working along lines of

Figure 5.1 Hut for artists and artisans, community village of Bandafassi (November 2019). © Sophia Labadi.

Figure 5.2 Community radio, administrative, and meeting spaces, community village of Bandafassi (November 2019). © Sophia Labadi.

domination (by international actors) and resistance (by locals), despite what previous research has highlighted (see for example Escobar, 1995). In addition, a key ingredient for the 'success' of projects is local consensus and agreement, which helps to channel power relations towards a common vision for implementation (Mosse, 2005: 232). However, interviews with stakeholders in Dakar, Toubacouta and Bandafassi revealed different, and sometimes even contradictory, understandings of the initiatives, and a lack of translation of the plans and intentions into coherent

practice, exacerbated by multiple power dynamics (see also Gibson *et al.*, 2005: 40–1 for similar results).

The first issue concerns conflicting understandings of the project vision for the two sites. In both Toubacouta and Bandafassi, national, regional, and local authorities danced to the tune of the international partners and never seemed to question the idea of using heritage for inclusive economic and social development when the funding was available. Regular meetings between international partners and national and local stakeholders were held to define the vision, approach, and management structures enabling the two centres to drive the local economy in sectors with promising growth rates and address some social issues. However, in both locations these meetings were discontinued at the end of the programme. In the words of one interviewee in Toubacouta: 'when the project ended … everything evaporated. The centre took a different turn, but it is not the same as when it started'.[1] This is not to say that there was no support from the state of Senegal, which provided funding for the two structures, demonstrating some commitment to their construction. However, these institutions seem to have suffered from a lack of understanding about how to use heritage as a force for inclusive social and economic development. This is reflected in the financial commitment from the state of Senegal. Although the annual budget allocated in the first years of the two structures by the Ministry of Culture was 20 million CFA francs (US$35,000), this has been reduced to 10 million CFA francs (US$17,500) in recent years because of a lack of activities and a lack of transparency in the use of these funds. There are many reasons for this, including a lack of understanding and support from the site management team to implement this novel vision. It reveals how disruptive the heritage for development approach can be on the ground, as it often means changing the way in which World Heritage sites have traditionally been managed. The vision for these two structures was too far removed from the usual management approaches of World Heritage sites in Senegal, whose current aim is to protect and promote their Outstanding Universal Value. This narrow focus is at odds with the planned inclusive approach, mirroring debates on the use of heritage at an international level. For instance, Sustainable Development Goal 11.4 focuses solely on the protection of heritage in itself, and not on the protection of heritage to address other SDGs (such as poverty reduction).

Even some changes in heritage management that have long been called for by the wider heritage community were not implemented at the World Heritage sites of Saloum Delta and the Bassari Country. This was particularly the case for community participation. Both structures were

supposed to benefit from the direct input of, and daily management by, the local communities. In reality, both sites are managed by a World Heritage site manager, who is a staff member of the Ministry of Culture and an official representative of the state, rather than by local authorities and stakeholders. There is no direct input or contribution from locals. This explains why the community village in Bandafassi looked so empty even though it is supposed to be run and used by locals. When I enquired as to why the original vision of community participation remained unfulfilled, I was told that World Heritage sites in Senegal have always been managed by the Ministry of Culture and this means that they can only be the responsibility of the state and that locals do not have a space in this process. No exception can be made for the World Heritage sites of Saloum Delta and the Bassari Country. This illustrates the double language of international heritage protection. Meaningful local community participation has been called for, including in official World Heritage documents, for at least the last eighteen years (Labadi, 2013a: 88–92; Labadi, 2007: 164–6; UNESCO, 2002), but there is also a long tradition of community exclusion in the name of protection that has never really been condemned in international fora. These heritage sites are not unique, as exclusionary practices inherited from colonial times are still operating at some African sites (as documented for example by Ndoro and Wijesuriya, 2015: 139–40; Taruvinga and Ndoro, 2003; Meskell, 2010: 196ff and Meskell, 2012). Set up in colonial times to divide and rule (Nkrumah, 1965), these exclusionary regimes, laws, and models of conservation have been maintained after independence by Africans themselves (as documented by Chirikure *et al.*, 2018; Chirikure *et al.*, 2010; Ndoro and Pwiti, 2001; and Abungu, 2006: 150). Educational systems have often been complicit in maintaining this (neo)colonial mentality, as many university courses, including on heritage management, are still not yet fully decolonised, as made clear for instance by the 'Rhodes Must Fall' movement in South Africa (Ndlovu-Gatsheni, 2018: 221–42).

These exclusionary practices inherited from, and continued after, colonisation have been exacerbated in the Bassari Country, a territory made up of the ethnic minorities of the Bassari, Peul, and Bédik, who are treated with disdain and contempt by state representatives. This is not necessarily surprising, as many ethnic minorities all over the world are treated as inferior and pre-modern, and have been discriminated against (Churchill and Smyth, 2016). I constantly encountered such distrust of the local ethnic minorities, from the massive gate protecting the community village in Bandafassi (from its own population!), to the security guard instructing me not to go out of the village on my own, and the prefect (the official representative of the state in the region) confusing the ethnic

background of his own staff. The financial settlement between the Ministry of Culture/site manager and the locals further highlights these unequal power relations. It was originally agreed that 7 per cent of the revenue generated by the village (through tourists staying there, for example) would be redistributed to locals, the rest being kept by the site manager/Ministry of Culture. In reality, the community gets nothing. I was reminded during interviews that the site belongs to the state of Senegal. Therefore, the site manager is accountable to these state services. In the words of one interviewee: 'It is not to this population that we must report'.[2] The creation of the community village has thus clearly resulted in the appropriation and control of the land and the confiscation of its associated revenues by representatives of the state, which has also been documented at other sites in sub-Saharan Africa (see Nelson, 2012: 361–2 and Ake, 1996 among others). These examples show that inclusive approaches to economic development are sometimes thwarted by private interests, legislation, and management practices inherited from colonial times as well as unequal power relations between different stakeholders.

Discussions with locals also exposed different understandings of the goal and vision of the interpretation centre and community village, rather than a united approach. In Bandafassi, for instance, elder villagers and representatives of local ethnic minorities explained that the community village had been created first and foremost to house the Ethnic Minorities Festival. A gathering of local ethnic minorities from different surrounding villages, this event is an occasion to perform songs and dances and share their intangible heritage. It provides a space for people from many different groups to meet and create social ties, which can be maintained after the end of the festival. These locals had lobbied local, regional, and national authorities to have a decent space for this event, which performs an important social and cohesive role. The economic dimension of the site was secondary for these elder individuals, perhaps reflecting the fact that they do not consider themselves to be economically poor (though this cannot be generalised, as they represent a local elite). These different understandings on the ground expose the simplification of the reality in the project in Senegal, with the whole population being categorised as 'poor'. Such a lack of serious consideration of the multiplicity of local characteristics and vision has been identified as a key failure of development (see for example Escobar, 1995). Yet the festival has only occurred twice since the opening of the village, in 2015 and 2020. This is due to the unequal power relations detailed above, associated with a lack of human, financial and organisational capital. It is difficult to organise the event, as the villagers have no regular connection with the site outside

of the festival, with the exception of the very small Catholic community that goes there for mass and a few children who go there to collect water.

However, power is multidirectional and among locals, tour guides have contested and resisted the domination of the state and the agreed plans for the community village of Bandafassi. The guides here are local men who were able to open their own small campsite with direct funding from European tourists (usually Spaniards). As mentioned above, guides were supposed to bring their clients to visit the exhibition and ethno-cultural spaces, for a small fee. Financially supporting the village and ensuring its sustainability, these visits would also serve as an introduction to the history and heritage of the region. However, in Bandafassi guides have hardly ever brought tourists to the village. One reason is that right from its opening, the information provided was very poor, and at the time of my visit (November 2019) most interpretation signage had been removed. In addition, tourists prefer to visit actual villages that have been well preserved (particularly those in the mountains, like Iwol, Andjiel and Ethwar), rather than seeing a purpose-built replica. Above all, this refusal to take tourists to visit the exhibition space can be read as an act of protest against a public structure seen as competing with the private camps of the local guides. Both the community village and the guides provide accommodation for tourists, and the prices for accommodation at the community village are cheaper than those of local campsites. It was reported to me that, as a direct result of the opening of the village managed by the state, at least one private local campsite was forced to close. The example of the community village in Bandafassi demonstrates how good intentions can lead to negative outcomes. Although the village was supposed to help with poverty reduction, in reality it has increased the problems of some local campsites, as it did not fully understand the situation on the ground and the economic context. The situation is very different in Toubacouta. The interpretation centre does not offer accommodation for tourists, its museum provides in-depth information, and it is seen as a good place for tourists to be introduced to the Saloum Delta. I met some guides who took their tourists there. They see the interpretation centre as providing an additional, complementary service to theirs.

Artisans and artists have also resisted, refusing to exhibit their crafts in the purpose-built spaces in both Toubacouta and Bandafassi. The craft space in Toubacouta contains identical booths and is located in front on the interpretation centre; the one in Bandafassi is a vast, round hut with open rooms for different ethnic minorities to exhibit their wares. Providing a secure and appropriate space for artists and artisans is a favourite initiative of international cooperation (the Spaniards

also financed a craft space and artisanal market in Maputo, the Feìra de Artesanato, Flores e Gastronomica, during a previous scheme in Mozambique). These structures aim to provide an official, appropriate and formal space for artisans and artists. However, both purpose-built structures have never been used and have always stayed empty. This resonates with other international projects, as many buildings and structures built with international aid in the Global South remain empty or start crumbling when funding ends (Barber and Bowie, 2008).

What were the problems in Senegal? Local characteristics, organisations and the market structure were not fully considered by the experts working on the project. These empty booths also reflect the power struggle around defining and controlling space and movement by the different stakeholders. In the Bassari Country, when tourists go to visit villages, they buy crafts and art directly from villagers there. In Toubacouta, artisans and artists have set up their booths between the entrance gates of the two main upmarket hotels and thus are strategically placed. Why would they want to move away from this central place, which would surely lose them some of their customers as a consequence? Even local authorities, when interviewed about the craft space, recognised that it is too far from the main hotels.[3] In the case of Toubacouta, basic failures also make the place unusable. None of the booths have doors, so they cannot be locked at night and wares can easily be stolen. Besides, only 32 booths were built for more than 50 artists and artisans, so the space is not big enough (see Figure 5.3). These structural failures are additional arguments used by artists and artisans against moving there. It seems thus that both in Bandafassi and Toubacouta, ready-made solutions to problems were offered by experts without full understanding of the local dynamics – approaches that have been widely documented as leading to failure (Gould, 2017: 20–1; Novelli, 2016; O'Reilly, 2014: 204–12).

These issues were exacerbated by the assumption that the inscription on the World Heritage List of the Saloum Delta and the Bassari Country would increase national, regional, and international tourism. The hypothesis that the World Heritage 'brand' will drastically increase visitor numbers has already been proven erroneous (see for instance Salazar and Zhu, 2015: 247). The inscription of these two sites from Senegal was part of a wider strategy by the country to move away from an over-reliance on beach tourism, to diversify and strengthen the products on offer, and to attract new markets in line with the Poverty Reduction Strategy paper of that time (2006–10) (République du Sénégal, 2006).[4] In parallel to expecting increased numbers of tourists with the introduction of the World Heritage brand, the government also took a number

Figure 5.3 Empty craft space in Toubacouta. © Sophia Labadi.

of key decisions (as recommended for instance by Sofield, 2003). Visas have not been required of some Europeans, particularly French people who are the main tourists to Senegal, representing around 30 per cent of all the international tourism entries (AD Conseil, 2015: 71). However, tourism growth in Senegal has been negatively affected by entangled external and internal factors. Security issues, diplomatic relations with European countries, and the rules of reciprocity may lead to the require-ment for tourist visas being reinstated. The Bassari Country is still not a very touristic place: it is far from the capital, infrastructure is lacking, and it is only accessible by a long road trip. Many foreigners also con-sider it to be too close to Mali, and therefore potentially dangerous. The Saloum Delta is suffering from climate change and overfishing, which had led to a decrease in fishing tourism (see Chapter 7).

To conclude, as a result of erroneous assumptions, as well as a lack of consideration for power relations, local dynamics and economics, the innovative vision and goals for the interpretation centre in Toubacouta and the community village in Bandafassi have not been achieved. Let us now analyse the more traditional approach of heritage for poverty reduc-tion through tourism.

Tourism and tour guiding

Heritage has long been recognised as a catalyst for poverty reduction through tourism (Boswell and O'Kane, 2011; Mthembu and Mutambara,

2018; Christie *et al.*, 2013; Chirikure and Pwiti, 2008: 470; Keitumetse, 2011; Long and Labadi, 2010; Staiff *et al.*, 2013). It is therefore unsurprising that the selected projects aimed to use heritage for tourism development, with the ultimate objective of poverty reduction. In Ethiopia, capacity-building activities were rolled out to professionalise the tour-guiding trade and increase income generation. In Namibia, an ambitious network of trails and infrastructure around nine newly identified heritage sites in rural areas was supposed to lead to sustainable livelihoods, social equity, and economic development (Enhancing Heritage Resources, 2013: 10). In Mozambique, four pilot cultural-tourism packages were set up, with the hope that they could be replicated in other parts of the country. Two of these took place on the Island of Mozambique, in the north of the country. A World Heritage site since 1991, the Island of Mozambique served as the capital of the Portuguese colonial government from 1507 until 1898 and bears witness to the rise of Portuguese maritime routes between Western Europe and the Indian sub-continent. A rather small island, about 3 km long and between 200 and 500 metres wide, it is divided in two parts, the northern part characterised by stone and lime buildings of Swahili, Arab, and European influence; and the *Macuti* town in the south deriving its name from the Swahili architectural materials of dried palm leaves used to make roofs (Nguirazi, 2008: 16). The other two tours were devised in Inhambane city, a commercial port in the south of the country endowed with unique Art Deco buildings from the time of the Portuguese, as well as being witness to a rich history of slavery, Portuguese colonisation, struggle for independence and post-colonial period. Identifying and developing tours was also the strategy adopted in other MDG-F programmes, including at Dahshour World Heritage site in Egypt, as part of the projects 'the Dahshour World Heritage Site Mobilization for Community Development' (2009–13), and 'Cultural Heritage and Creative Industries as Vectors for Development in Morocco' (2008–12), demonstrating the popularity of this approach for poverty reduction.

The decision to develop the guided tours in Mozambique had not been taken by, or in collaboration with, local communities, but at national and international levels, as discussed in the previous chapter. Yet real efforts were made to ensure that they were devised in an inclusive and comprehensive manner. These efforts are in line with basic principles on pro-poor and community-based tourism, which nonetheless insist on the need to involve communities right from the start of projects, to ensure real benefits for them (Musavengane, 2018; Ashley and Roe, 2002; Scheyvens and Biddulph, 2018: 596–7; Goodwin, 2009: 90–4; Iyer, 2018: 1–9; Mitchell, 2012: 461). Artists, artisans, unofficial tour guides,

and small local business owners were empowered to create the routes and new socio-economic opportunities for themselves in this process, while also ensuring the interpretation and valorisation of some heritage. Devised to share the benefits of tourism with as many people as possible, through a horizontal network and diverse experiences, the tours were supposed to last for a whole day, with interpretation of tangible heritage by guides, dances performed by local troupes, talks on traditional construction techniques, lunches to taste the local cuisine prepared by inhabitants, and storytelling, among other activities (Eurosis, 2012: 50). Interestingly, more recent exercises on identifying tours on the Island of Mozambique, including those prepared as part of the 2018 3rd African World Heritage Regional Youth Forum, applied the same comprehensive and inclusive approach, and identified similar routes and activities.

To professionalise the tours, classes were delivered on local history, on communicating with tourists, on setting the right prices, and on marketing. The project in Mozambique ended in June 2013, and I visited the Island of Mozambique in spring 2018. I was surprised to learn that only 6 young men had finished the course on tour guiding delivered by UNESCO, whilst the official evaluation mentions 72 community-based cultural tour providers (UNESCO, 2012a: 18). In fact, 72 people had started the course and only 6 had finished it, representing a mere 8 per cent rate of student retention. The training course represented a major commitment and many people ended up having to leave it to attend to other matters, such as earning a living. Attending the course was particularly difficult for women, as discussed in the following chapter. Some individuals might also not have wanted to stay on the course, as they knew that they would not find work subsequently, as 72 guides is far too many for a site like the Island of Mozambique where tourism is nascent. The high rate of registration might have demonstrated how much faith the projects put into tourism as the (externally driven) solution to poverty reduction. On the other hand, the low rate of retention might have reflected the lack of belief in this solution. Despite this low completion rate, the six men who finished the course are still tour guides on the Island of Mozambique. This is a much better result than in Inhambane city, which I visited in the spring of 2019. There, none of the UNESCO trained guides are still in the business. I was informed that they quickly stopped providing the tours, because of a lack of support and marketing materials and a decrease in tourists for this particular city, as well as a lack of a viable product to sell to tourists.

I interviewed the six guides who had finished the course on the Island of Mozambique, and they all agreed that this capacity-building

activity has had a transformative impact on their lives. In the words of one of them: 'The training helped me a lot. Before I was a tour guide, but I was not really a tour guide like I am now'.[5] Legitimacy is what the training gave the young men. Before the course, most of them were street children. It is on the street that they had started picking up English and a few tricks for talking to tourists. The project was an opportunity for these young men to learn how to behave in a professional manner. At the end of the course, one of the participants decided to call himself an 'official UNESCO guide', and was quickly followed by the other five young men, who imitated him and decided to use this brand as well. Ironically, no such official designation exists; no plan aims to make this title official, and apparently there is even hostility by UNESCO towards such unofficial use. Yet, this title might arguably be one of the long-term, unexpected and positive legacies of the project. For these tour guides, training allowed them to acquire professional skills and this title distinguishes themselves from those who did not follow the course. The process was taking an international and recognisable brand, that of UNESCO, and appropriating and localising it. The brand can be considered a seal of approval and excellence, and provides a competitive advantage. These guides wanted to create a positive perception of their work in comparison to that of others, and to attract more tourists through recognisable brand use (Ryan and Silvanto, 2009: 292–3). With this appropriation of the training programmes for their own needs, guides could take ownership of plans on the ground, during the implementation phase, even though such ownership was difficult to create on a national level, as discussed in the previous chapter. The key question is whether the six trained professionals on the Island of Mozambique were able to move out of poverty. Three of them at least have a full-time job and are paid the official minimum wage for tourism services in Mozambique, which means that they have moved out of extreme poverty. In addition, these guides really value their newfound status and legitimacy. However, the one who changed his life to the greatest extent has had access to regular funding from private European sources, was able to open his own tourism company, run his own tours, and capitalise on the knowledge he acquired during the trainings. He is thus able to compete at the same level as foreigners, who tend to own tourism companies, because they have the necessary capital, skills, and knowledge (Mowforth and Munt, 2003).

Although they were designed to include multiple activities and to benefit as many people as possible, the tours on the Island of Mozambique have now been simplified and consist only of a walk through the northern stone town and the southern *Macuti* town. As such, they do not

fulfil their original objective of creating new opportunities for, and benefiting, a variety of stakeholders, nor do they focus on the needs of the poorer sections of society, fundamental for poverty reduction (Zhao and Brent Ritchie, 2007; Mitchell and Ashley, 2010). The tours are delivered in a vertical manner (involving only the tour guide and tourists), rather than in a horizontal one for benefit-sharing between different stakeholders (tour guides, dancers, restaurant owners, story tellers and so on) as first designed. So why did the inclusive and benefit-sharing version of the tours fail? The strength of the project became its shortfall. The poor became the sole focus of concern, at the expense of the development of a product that would fit the demand and the market. In the words of a tourist business owner from the region (and a Westerner): 'there are very few tourists who are looking for a package that includes so many things as a tour, watching some dancing, watching someone cooking, some craft making … Tourists just want a little bit of it, and something here and there. And you can't put that on for two people or four people, you need a group of ten or twenty. So I think [the tour] was doomed even before it got going, it was just a bad idea to try and do it that way'.[6] For him, the structure of the market was not considered.

On the Island of Mozambique, groups of tourists are not large enough to make it feasible for cooks or dancers to put on a show on a regular basis. Although tourism figures for the island have been increasing, they remain low at less than 20,000 tourists per year (including from cruise ships) (AIM Moçambique, 2016). This is equally true for Inhambane city. Although this port has a rich history, it is not popular with tourists and has even seen tourist numbers drop in recent years. Some of the most sought-after sites are as far as 20 km away and are 'paradise' beaches, with opportunities for scuba diving and for watching megafauna, as in Tofo. But the tours failed to connect with the beach tourism market, and hence were unsustainable from the start. Trainees could have made these links after the end of the training programme, but they needed a connection with the tourism market, as well as a car. A number of them have neither a car, nor the financial capital to invest in marketing, nor the knowledge to do so. Not only did the tour guides not connect with the local market, they also did not partner with tour operators, thus limiting market access (Dodds, Ali and Galaski, 2018: 1561–2). Besides, the absence of any public infrastructure, for instance buses, makes it impossible for these trainees and potential tourists to connect. Here the direct consequences of the destruction of public services as a result of reforms imposed by the International Monetary Fund (IMF)

and World Bank can be observed (Omoyefa, 2008: 19–30). These wider issues add to the shortcomings of the initiatives and make their goals difficult to achieve.

Finally, some of the activities may not have been designed with tourists in mind. On the Island of Mozambique, for instance, the plan was to bring tourists to eat in the *Macuti* town. However, this area has been detailed as having serious sanitation problems and poor-quality construction of houses, with the majority of its inhabitants living in 'absolute poverty' with incomes well below US$1 per day (Jopela, 2015: 44). Even inhabitants of this part of the island told me that an improvement in the living conditions and hygiene conditions would first be required for this activity to work.[7] These issues question whether developing guided tours was a good idea in the first place. The failure of the tours in Mozambique demonstrates how much faith is put into tourism as the panacea for poverty reduction, yet how ill-fitted the approach is. The idea of erasure, presented in the introduction, is a useful lens here, to understand this aspect of the project. Indeed, tourism is externally based and tends to respond to the needs of foreigners/Westerners. In this process, the needs of locals have been omitted. It is not only their needs but also their voices which have been erased. If local communities had been involved from the beginning of the project, they might have had other plans that would have been better suited to the reality of the island, and might not have selected tourism and tour guiding as the activity for growth. As further detailed in the conclusion, there are different sectors that could be supported on the Island of Mozambique, including fisheries, or the newly opened university. The sole focus on tourism erases locals and their needs.

These issues of tourism development are also entangled with the construction and political representation of post-colonial and independent nations. In the case of Mozambique, officials have had ambiguous attitudes, and have not necessarily actively marketed and promoted the Island of Mozambique and Inhambane city due to their strong historical, political, economic, social, and architectural connections with the Portuguese colonial rulers. For one interviewee: 'For our leaders here, unfortunately, a ruin means colonisation ... Inhambane has many beautiful ruins that could be restored with the help of artists (who could) work on returning the life that once lived there, not in order to perpetuate the inequalities that lived then, but to show history, because history no one can erase'.[8] Since the places are not well maintained and protected, they have difficulty fulfilling their potential to attract visitors and tourists. But political authorities show ambiguities in dealing with the past, as other symbols of colonialism have been hidden rather than destroyed or erased. For instance, in Inhambane city, a statue of Vasco da

Figure 5.4 Statue of Vasco da Gama at a garage in Inhambane.
© Sophia Labadi.

Gama, who stopped there on his way from Portugal to India in 1498, has been moved to the courtyard of a garage (see Figure 5.4). Although it is hidden, it is still a stop on local tours. If the government's primary motivation were anti-colonial, it would have been easy to destroy the statue. Although a number of colonial statues were demolished or damaged just before and right after Mozambique's independence, in a second period, the government has aimed to preserve some of these statues. For some, the aim of such an approach is to configure a national identity that has fewer voids, and requires both memory and oblivion (De Sousa, 2019).

Such ambiguity is similarly found in the government's approach to tourism development. Tourism has been identified as an area for economic growth in the Action Plan for the Reduction of Absolute Poverty (2006–9) and the Poverty Reduction Action Plan (2011–14) prepared by the government of Mozambique in cooperation with international stakeholders, including the Bretton Woods institutions (Republic of Mozambique, 2006: 36; Republic of Mozambique, 2011: 20). However, these documents may be examples of ventriloquism, as discussed in the previous chapter, in the sense that they repeat the priorities of international institutions. The reality on the ground is different. For instance the complicated process for foreigners of getting a visa, and the lack of clear information on visa requirements (as pointed out by local tourism professionals),[9] or of direct flights to potentially important tourism destinations (such as from Johannesburg in South Africa to Inhambane city), might reveal detachment from, and reluctance to, engage with a sector

that might be considered by national authorities to be neocolonial in the asymmetrical power relations it maintains between international tourists and locals (Basu and Modest, 2015; Labadi, 2019a; Joy, 2012; Thiaw, 2014: 76). Tourism is also structurally neocolonial as a number of the core tools of tourism, including information technologies and e-commerce companies, are all concentrated in the North (Chok, Macbeth and Warren, 2007: 150).

The difficulties in fulfilling the potential of tourism were exacerbated during the tour-guiding training by the disconnection between local guides and the history they had to recount. The history of the island was taught by UNESCO from a colonial perspective, and there were very few local histories or personal anecdotes included. Although the project focused on 'the poor', it was only inclusive in its economic part. No attempt was made at redressing some of the epistemic injustices through including pre-colonial histories or histories of resistance to colonialism (although other international schemes have tried to provide multiple histories, particularly the Slave Route Project which led to the creation of a memorial garden on the Island of Mozambique). This demonstrates the narrow understanding of poverty here, only considered from an economic angle. Here again the idea of erasure can be used. Participants were taught a history of the Island of Mozambique in which local perspectives and events had been erased. If the intention had been to address these historical erasures and epistemic injustices, then the government might have been more invested in the project. However, for this shift to happen, culture should have been considered as contested; but was not, as discussed in the previous chapter. As a result, no attempt was made at changing dominant historical narratives focusing on the Portuguese.

In Namibia, the plans were remarkable in their attempt to build tourism in a post-colonial nation. But it is also a cautionary tale that exposes the difficulty of developing post-colonial tourism; of identifying relevant sites; of building interpretation centres and trails around these sites; and of meaningfully involving local communities in these processes. This programme also reveals the entanglement of colonial history and tourism. Most of the popular cultural heritage sites in Namibia are connected to colonial history (for example Swakopmund, Lüderitz, Henties Bay). The power, connections, and resources in the tourism industry are all in the hands of white people (Nelson, 2012: 370). It is difficult to change the power dynamics and enable disadvantaged Namibians to benefit from tourism, because the structure of the business still mirrors the 'pre-independence apartheid regime where development of business was unavailable to the majority of Namibians' (Millennium Challenge

Account Country Report for Namibia, 157, cited in Maconick, 2010: 17). Having the ambition to change this situation, the Namibian project aimed to develop tourism destinations at nine sites, most of them linked to the liberation struggle or to the post-colonial period. Whilst these sites are historically important, they are not on any popular tourism trail; they currently receive few or no visitors, and have not so far benefited from any major tourism infrastructure. A key shortcoming of the initiative was the lack of involvement of the actors working in international and national private tourism sectors, perhaps because the involvement of the Ministry of Tourism was felt to be sufficient. Yet, as indicated in the Final Evaluation Report: 'Regional stakeholders, without sufficient knowledge and understanding of, or mandate in tourism development, have shaped the utilisation of the bulk of the programme budget' (Enhancing Heritage Resources, 2013: 47). One result is that the selected sites could not be linked to exiting tourism markets and established tourism routes. This is disappointing considering that a large number of organisations – 16 in total – were involved in the project. Another important challenge was the lack of time. Considering the unequal structural organisation of the tourism sector in Namibia, changing mentalities and power dynamics to ensure a more inclusive sector would have taken some time. The rushed nature of the activities was therefore a recipe for failure. Finally, the interpretation centres for the nine sites were all in different stages of con-struction at the end of the scheme, without identified budgets and plans for their completion and utilisation (Enhancing Heritage Resources, 2013: 31). These three shortcomings (lack of private tourism sector involvement, unfinished construction, and insufficiently precise develop-ment plans), in addition to the lack of trust between national and inter-national actors discussed earlier, meant that the project could not really achieve its goals.

Capacity-building, the cornerstone of sustainable development?

Building the capacity of actors in the field of heritage and the wider cultural field was also a key goal of the selected four projects, making them no different from other development initiatives: 'Capacity-build-ing has been a cornerstone of development policy for 70 years and vast amounts of money have been spent on it. The Organisation for Economic Cooperation and Development (OECD) calculated that capacity-building accounts for 25 per cent of aid expenditure, representing about US$15bn

(£12bn) a year' (Guy, 2016). The 2005 Paris Declaration on Aid Effectiveness even requests stronger support for capacity-building. In line with such recommendations, the four cases considered moved away from the sole provision of technical training. Isolated technical training provisions have been proven to fail. Most donors have recognised the shortcomings of such approaches, as they do not take account of the political, social, and cultural contexts, and often lack country ownership (see for example the reports by the OECD, 2006, and the World Bank, 2005). These models often endeavoured to 'reform' people from the Global South, to provide them with the right framework and knowledge to improve themselves, and to move them from 'backwardness' to progress and development. From a pedagogical viewpoint, this model of the transfer of knowledge from teachers from the Global North to participants considered as empty vessels in the Global South has long been criticised, as this does not take account of local situations and the knowledge and expertise of participants (Freire, 1970).

As a result, all the selected projects adopted a more comprehensive and inclusive approach, supposedly aligned with the receiving country's priorities (Venner, 2015: 89–90). The administrative and institutional capacity to protect and promote heritage and/or to support the growth of creative industries was strengthened, in parallel to providing training for artists and artisans to improve their skills and capabilities. Improving the administrative framework took different forms in each country. For instance, in Mozambique the 'Draft Revision and Draft Regulation of the Copyright Law and its Related Rights' was produced, and the 'Regulations of Performance and Public Entertainment' was released. In Ethiopia, site protection laws were prepared for the World Heritage properties of Aksum, Lalibela, Tiya, and Fasil Ghebbi, and were submitted to the Council of Ministers for endorsement. Although these actions are commendable, existing policies and regulatory frameworks in Ethiopia were also reported to be poorly enforced and implemented, in part due to a lack of capacity and public awareness, which did not seem to have been tackled in depth in the projects (Arbulú, 2012: 10).

As for the training components, they targeted artists, artisans, and small local business owners working in the tourism sector (such as restaurant owners). As with the activities on tourism trails and tours, their goal was to reach poorer sections of society and those working in informal sectors. Research has regularly highlighted that these target groups lack the skills and training opportunities they need to benefit from tourism and other opportunities for poverty reduction (see for instance Mahony and Van Zyl, 2002; Scheyvens, 2007: 241; Chok *et al.*, 2007; World Bank

Group, 2016: 13). The contents of the courses were similar in the four countries, but also in other similar MDG-F projects on culture for development, including the ones implemented in the MENA region (Giliberto and Labadi, 2022). One reason for this was that the various studies conducted to shape the content of the programmes identified similar trends and shortcomings. Crafts were of low quality, and could therefore not be sold nationally and internationally; artists, artisans, and local business owners lacked business and managerial skills such as sales promotion and inventory control, as well as sufficient opportunities for market linkages. Lack of resources prevented raw materials from being bought and/or businesses from being expanded. These existing shortcomings in craft, art and tourism-related businesses were to be addressed with the capacity-building activities.

To ensure their success, the training programmes were organised around partial value chain – that is, on the full range of activities required to bring a product or service from conception, through the different phases of production, and finally delivery to consumers (Kaplinsky and Morris, 2001). Focus on the value chain is partial here, as no work was done on access to consumers. Despite such a shortcoming, this was a novel approach, as previously most training for artists and artisans had focused on production only. The value chain approach meant that, in Mozambique for instance, wood banks were set up in Nampula and in Inhambane provinces in order to improve carvers' access to raw material. Training components were also provided on supporting product development, improving product quality, and supporting marketing. Aware of the crucial issue of access to financial resources, mechanisms were also set up to facilitate access to funding. Another strength of the activities was the teaching of business plans, product development, and marketing strategies. Previous research has highlighted the failure of training programmes for the very reason that they did not provide knowledge about business or marketing (Spenceley and Meyer, 2012). The courses here avoided this pitfall. But although a number of craft activities have negative impacts on the environment (for example, pottery production can contribute to soil degradation), training programmes did not consider this pillar of sustainable development (I address it fully in Chapter 7), but focused mainly on its economic dimension.

The official evaluation reports by UNESCO count an impressive number of people trained. In Mozambique, for instance, 390 artisans located in the provinces of Inhambane, Maputo, and Nampula are presented as having attended courses to increase their portfolio of market-driven products. As a result of the training received, according to official

evaluations, 87 new craft collections were launched, comprising 382 products in total. In addition, more than 500 artisans were linked to local, national, and international markets (UNESCO, 2012c: 18). In Ethiopia, 568 artisans (mainly those involved in pottery, weaving, and leather production), 15 artists, and 59 culture professionals in the six targeted regions (Addis Ababa, Amhara, Tigray, Harar, Oromia, and the Southern Nations, Nationalities, and Peoples) benefited from training in product design, quality control, marketing, accounting, and business planning (UNESCO, 2012c: 14). However, this support was not restricted to the economic aspects of the trade. In parallel to improving administrative, legal, and institutional capacities, training was provided to ensure that these improvements were enacted. For instance, in Senegal 300 independent professionals, 270 artists, creators, and artisans, and 120 small and medium-sized enterprises in the culture sector working in Dakar, in the Saloum Delta, and the Bassari Country were trained in copyright law, to ensure that rights and obligations were widely understood and that the copyright of artists could be protected (UNESCO, 2012c: 28). This official evaluation reveals some of the reasons why capacity-building activities have been so popular in international aid: the number of trained people provides quantified impacts and an explicit measure of what was achieved (Hummel and Van der Duim, 2012: 331–2). These figures easily demonstrate how many people were reached by the programme, and help convince both funders and taxpayers in the Global North of its worth. Yet, as explained in the previous sections, these figures are misleading since they refer to those who started the capacity-building activity and not to those who completed it.

The capacity-building activities were useful for some participants, reflecting the personal enrichment gained from these courses, as documented elsewhere (see for example Roca, 2017: 123–5). Artists and artisans interviewed found the exchange of experiences very useful in gaining new expertise. An improvement in the quality of products was also documented.[10] As a result, in a very few cases artists were able to secure larger orders, for instance a group of weavers in Addis Ababa who were offered a large order by a hotel (Arbulú, 2012: 20). In Mozambique, thanks to the market linkages formed by the Centre for the Study and Development of Craft (CEDARTE), artists and artisans from Maputo were able to participate in the Expo 2010 Shanghai, where they sold more than US$200,000 worth of goods.[11] Above all, the training programmes were useful at an individual level. Some artists and artisans in Senegal (particularly in Dakar and the Saloum Delta) already had a network of Westerners who bought directly from them or brought them clients. Thanks to the

courses, the quality and quantity of their products was improved, as was their ability to negotiate fairer prices. A number of the trainees also mentioned the importance of learning about some of their rights and the ability to act upon them, although these rights further aimed to recognise the economic importance of heritage. This was the case for a performing artist in the Saloum Delta who registered his music at the BSDA (Bureau Sénégalais du Droit d'Auteur) and was then able to be remunerated whenever it was played in public spaces,[12] although he recognised that this remuneration was very little. For others, the capacity-building sessions were taken as a recognition of their importance, boosting their self-esteem and confidence, as explained in the previous chapter.

However, training did not have the large-scale and transformative impacts intended in all of the considered cases. There is not just one reason for this failure, but rather multiple entangled issues ranging from their quality and content, to structural shortcomings, and a lack of serious consideration of the wider political and social environment. Some shortcomings also relate to the governance of projects – the 'rules of the game' – and formal and informal mechanisms to ensure accountability, transparency, trust, fairness and the clear definition of obligations for participants (Gould and Paterlini, 2017: 140–3; Siakwah, Musavengane and Leonard, 2020: 361). A core shortcoming, the quality of the training, relates to the governance of projects, as there was no external mechanism in place to validate their content, relevance, and standard. During interviews, some trainers complained about the short timeframe of courses, in particular the lack of time available to go through all the steps needed for acquiring adequate knowledge and skills. For one interviewee, a local Mozambican from Inhambane city, hired to deliver classes on improving the design and quality of basket weaving: 'First, there was not enough time for me to train people and give them proper products. Second, to have a quality product means you have to teach people from the beginning to the end; from harvesting good quality material all the way to the good quality finishing. But there was not enough time for people to really get anything from me'.[13] The structure of the training programme and the short timeframe for delivery did not allow for these different steps to be performed and thus for the anticipated change to take place. In addition, although evaluations recognised the need for continuous support (Eurosis, 2012: 13), this did not occur either, and the provision of a one-off course was not sufficient to instigate change.

A second shortcoming was the lack of transparency and accountability in the use of some of the funding and equipment. To ensure the viability and sustainability of the training, several funding mechanisms

had been created in Senegal. For example, mutual guarantee societies were set up in the Saloum Delta and the Kédougou region (where the Bassari Country is located), to facilitate access to funding for artists and artisans (Damiba, 2012: 41). They were intended to provide guarantees for people to access loans. However, in neither place did this mechanism work. As explained by one interviewee: 'There was no transparency, there was no report, there was no meeting to report on what was done. In addition, when the project ended, the funding disappeared'.[14] Equipment bought and left in these two places suffered the same fate. In Toubacouta, interviewees related that machines and equipment had been provided for the interpretation centre, including software, musical instruments, and a sound system, but that they had then disappeared without a trace after its official opening. In some cases, small pieces of equipment such as fridges had been donated to a specific organisation or business, for example a restaurant, and were still being used. However, such equipment is not really able to make the anticipated transformative change. Therefore, the lack of accountability and transparency meant that the supposed beneficiaries were left with nothing at the end of the project.

Third, there was a mismatch between the training provided and what consumers, primarily tourists, are interested in. The programmes understood tourism as a positive phenomenon without considering what Jafari calls the 'cautionary platform', i.e. its more negative aspects and impacts (Jafari, 2001: 29–30). Craft goods are produced to cater to the taste of tourists (who in the four countries considered are predominantly Westerners, or white South Africans in the case of Mozambique and Namibia) and in the process become commoditised. In the words of an artist from Inhambane city who took part in some courses: 'So automatically tourists overshadow the reality when they get here, introduce new ways of thinking and artists get lost. Because either the artists dance to the tourists' tunes or they sell nothing. But to sell something, the artists have to give up their culture. So those on the beach no longer make dolls of African women or African houses, now they make motorcycles, land rovers with special rims, etc. because this is what the tourist wants. So, tourists come here to change us'[15] (see also Diagne, 2004: 483, for similar findings in the case of Senegal). These comments reveal that some of the basic assumptions guiding the projects were wrong, including a naive belief in the virtuous and ethical nature of tourists who are interested in understanding localities, culture, and intangible heritage. It has been well-documented that tourists want products that support their own idea of a place, forged as an 'imagined authenticity' (MacLeod, 2006). Tourists consume 'exotic' cultures, while locals view the authenticity of

their heritage differently (Salazar and Zhu, 2015: 244). These training programmes, and the rhetoric that heritage contributes to economic development, might thus lead, in the long term, to the opposite of the intended result. Instead of supporting and safeguarding the crafts and their associated intangible heritage, the association of craft-making with selling and revenue-making may lead to their commoditisation, trans-formation, and even disappearance (these phenomena have been well documented, see for instance Schmitt, 2005).

This commoditisation has led to the increased mass production of souvenirs, as well as the increased importation of cheap products from neighbouring countries and from China, as documented in the case of Senegal (Bolongaro, 2016) and explained by my interviewees in Mozambique.[16] Some artists are thus engaged in trade and in buying and selling, rather than producing and vending crafts. Tracing the origin of these souvenirs and crafts is challenging, as most retailers are not licensed. Hence, there is difficulty in using data from the United Nations COMTRADE database, the official repository of official international trade statistics on imports and exports. This database has been used by other researchers to explain trends towards the import from China of crafts sold to tourists, for instance in Peru (Grobar, 2019). Data from COMTRADE does indicate that imports of paintings, wooden craft objects such as statuettes, basketry, precious jewellery, and imitation jewellery are greater than the exports of these types of handicrafts for the four countries considered in this volume (Ethiopia, Mozambique, Senegal, Namibia). The data thus confirm that some (but not all) of the crafts sold have been imported instead of locally produced. A mainstream tourist guidebook for Senegal even proclaims that most of the handicrafts sold in the country are imported (Gloaguen, 2019: 47). Considering the trend of commoditisation, why would anybody spend hours producing crafts when they can get cheap copies from abroad and sell them for a profit?

In addition, the power relationships at national and local levels were again disregarded, although they had already been singled out to explain the failure of previous capacity-building initiatives elsewhere (see for example the work of Denney et al., 2017). Time and again, inter-views highlighted the lack of public and political support for artists and artisans, mainly in Mozambique. This would further confirm that the government might have used ventriloquism and repeated what inter-national organisations wanted in order to obtain international funding, rather than being convinced by the rhetoric that culture leads to sustain-able development. Politicians devalue dissident artists, because artists use their freedom of expression and their power to produce and exhibit

art that might criticise the government and the party in power. Culture is only welcome when it benefits government officials, as discussed in the next chapter. For one interviewee from Inhambane city: 'In a country [Mozambique] where when someone comes up with a different idea they are seen as enemies, things hardly flow. So, we have to deconstruct this idea that thinking differently and doing different things means rebellion. Often artists are considered rebellious'.[17] This suspicion towards some artists seen as (potentially) rebellious has led to a lack of public recognition and support for them, and to their marginalisation. Hence the training courses did not go far enough. Wider structural, political and social changes were needed to ensure greater freedom of speech for artists.

In addition, although training in different arts and crafts is offered (including university degrees) and has been diversified in recent years in the countries considered, some artists and artisans still lack basic capacity and capability to take part in opportunities offered to them, preventing them from putting into practice what was learnt in class. For instance, South–South opportunities for exhibitions and collaborations for artists have increased in recent years (El Bennaoui, 2018: 118–23) and some of these opportunities have been promoted on digital platforms. However, as explained by one interviewee:

> Most artists are not well educated. They are unable to manage digital platforms, and this is what causes them to miss application opportunities for contests, exhibitions, workshops, because they don't even have email, Facebook, even WhatsApp, so that makes things more difficult. For example, in my case, I try to promote activities … and we finally ended up getting funding for a big exhibition, but I have serious difficulties because sometimes I need the artist to send me his photo in digital format by email or WhatsApp, but the artist can't. Sometimes they do a manuscript of their biography, take a photo from a friend who has WhatsApp and then send to me. Sometimes the photos look blurred, I have to make adjustments, type in my email the biography they sent in manuscript, then I ask them to come and they say that they have no time. Sometimes I have to borrow a camera to go take a picture of the artist in their studio because we need the photo to produce the catalogue; so the difficulties make things more difficult and for my work it gets more frustrating.[18]

A mismatch is here expressed between the training provided and the basic skills required for artists to access (online) opportunities. Short-term

capacity-building cannot offset a basic lack of skills in digital communication or in literacy. Such deficiency exacerbated the situation and resulted in the disuse of digital platforms created for the different projects. For instance, the website launched in 2013 to promote Ethiopian crafts and facilitate their international visibility no longer functions, probably due to a lack of maintenance and skills. Similar findings were made for other comparable projects. For instance, a website launched for the MDG-F funded programme in the Occupied Palestinian Territory was only short lived (Giliberto and Labadi, 2022).

Post-colonial resistance towards, and/or a lack of serious consideration of, the training offered to the participants can also explain their failure. Some participants attended the course as a one-off event, to have a good time, to enjoy international aid funding, and to participate in a globalised world in the form of the lunches, coffee breaks, and dinners. They had no intention of implementing what they learnt. This would go against their own ambition – which was to continue to attend courses and enjoy the food and drinks offered. These participants, I was told in interviews[19] (in line with previous research, see Fall, 2011: 77), do as little as possible after the training, hoping to be offered more opportunities. This detachment can occur for a number of reasons, from a different understanding of what local development should be, to a defiance of and resistance against Western ideas (Rahnema, 1997: 377–404), to a belief that the training would not work. However, structural issues, including the lack of long-term support for participants in achieving the ideas and proposals taught could also explain these attitudes. In addition, participants might not have believed in the value of the courses provided because of their marginal impact on their lives. For instance, although classes were delivered on artists' rights, these were often inadequate, as artists lack any social protection that would ensure that they could make a decent living.

Above all, the training programmes did not work because of a lack of access to markets and of market demand for products and services. In a similar fashion to the tour guides, artists, artisans, and business owners reported a lack of tourists and opportunities, both in Senegal and in Mozambique. In the case of Ethiopia, the project failed to engage with the private sector, as originally envisaged, to increase economic benefits to the trainees. Weavers in Addis Ababa were documented as having been able to secure only one large order from a hotel. In addition, there was no assessment of whether local markets could absorb new products and craft lines. This could have had terrible consequences, as some of the trainees in Ethiopia had acquired debts through loans to undertake some of the income-generating activities promoted by the programme, that they

might have had difficulty repaying (Arbulú, 2012: 8). In Mozambique, I was regularly reminded of the difficulties of international market expansion. CEDARTE closed because of a lack of funds and is no longer assisting artists and artisans with international exposure and sales. It is also difficult to sell some crafts to international tourists because of a lack of adequate networks, and preferential treatment for developing countries (see also Deloumeaux, 2017). Lack of adequate authorisation and paperwork is also a common issue. For example, some crafts in specific types of wood (such as sandalwood and blackwood) lack quality assurance certificates for exportation purposes in specific countries. In the words of one interviewee: 'We have issues at our airport (in Maputo) because tourists are not allowed to depart with our timber products. We already complained a lot to the ministry and they said they would solve this issue, but they still haven't [as of July 2018]'.[20] These issues demonstrate the inadequate nature of the capacity-building programmes, which adopt a narrow approach without addressing wider and structural concerns. They further reveal an over-reliance on the complex tourism sector for poverty reduction. These shortcomings relating to lack of access and demand were also identified in other similar MDG-F projects on heritage for development, including those implemented in the MENA region (see results in Giliberto and Labadi, 2022). All of these shortcomings reveal the difficulties, or even impossibility, of implementing the principles of the 2005 Convention that aim to promote creative industries in the Global South, without a major change of international aid and trade relationships with the Global North.

Conclusions

Substantial efforts were deployed in the implementation of the four projects considered to use tangible and intangible heritage for poverty reduction. In the process, innovative ideas were applied, including the meaningful participation and empowerment of the poorer sections of society to prepare tourism products and improve crafts. In Senegal, the World Heritage brand was supposed to be used for the comprehensive economic development of promising sectors. Capacity-building activities were carried out through wide-ranging training courses but also through the strengthening of administrative and institutional competencies for substantial transformation. However, the grand ambitions of these activities were not achieved. These efforts did not have the transformative and large-scale impacts planned. Positive results only occurred at small-scale, individual levels.

There is a disconnection between the international narrative that heritage contributes to economic and social development and the reality on the ground. At a local level, there is still a limited understanding of the narrative on heritage for development, with instead a focus on heritage protection for its own sake. In Senegal, the two purpose-built structures (the interpretation centre in Toubacouta and the community village in Bandafassi, both managed by the Ministry of Culture) are only concerned with the Outstanding Universal Value of the World Heritage sites where they are located, and their management and interpretation. The inclusive use of these structures to drive local economies through the development of crafts, and also of fishing and cashew nuts in the Saloum Delta and of shea and fonio in Bandafassi and the wider Kédougou region, never occurred.

When heritage is considered as contributing to poverty reduction, it is often viewed through the lens of tourism only. However, the popularity of a heritage site as a tourism destination depends upon many factors, some of which can be controlled nationally to a certain extent (for instance through visa requirements) but some of which cannot (such as insecurity and reputation). This makes tourism a volatile sector, difficult to manage, as also made clear with the Covid-19 pandemic. Some of the best contemporary ideas in sustainable tourism have also proven problematic. This was the case for instance with the guided tours developed on the Island of Mozambique and in Inhambane city (Mozambique). These tours were developed by local stakeholders (tour guides, artists, artisans, and small local business owners) in a horizontal manner to create new opportunities and to benefit as many people as possible. Hence the projects were based, to some extent, on bottom-up and empowering approaches. However, these models, as well as the training courses in craft-making, overlooked different dynamics.

In particular, they overlooked the fact that tourism is first and foremost a business enterprise. The products (whether a guided tour or a souvenir) must correspond to the expectations, needs, and imaginaries of tourists. A market and a demand must also exist for products to be sold. Maybe projects better aligned with local needs would have been more successful, as the tourism market is still small. Additionally, for new destinations to be developed, local tourism and business sectors must be involved and unequal power relations, where companies from the Global North tend to dominate lucrative sectors, must be addressed. This requirement was not met in Namibia, for example, and this may highlight the difficulty of, or uneasiness with, engaging with the business sector. There may be a reluctance to associate heritage with business (and vice versa) because this sector is thought of as unethical and only interested

in profit. Even Corporate Social Responsibility has had a bad press (Starr, 2013). Yet involving the world of business might help to address some issues of market access, inequalities and alignment with demand, and some ethical examples of poverty reduction initiatives by businesses have been documented (for instance Ashley and Haysom, 2006). Involving local businesses from Africa might also help to challenge the stereotypes that the region is only a land of poverty, war and instability. The Conclusion of this book further discusses these aspects.

The projects also rely too much on tourism as the panacea for poverty reduction, as illustrated for instance by the high number of people registered for the courses on tour guiding who quickly dropped out. However, tourism does not address the needs of locals, but of international travellers (often Westerners). This sector is neocolonial in its stereotyping of locals, in its erasure of many aspects of their histories and in its focus on external needs, first and foremost. The conclusion of the book explains how to change this focus in order to address the needs of locals to reduce poverty through heritage, as well as to transform heritage narratives through decolonised approaches.

Furthermore, the projects were too simplistic. They did not consider and integrate the power relations that were at play at international, national, and local levels. In other words, they did not fully consider the different local dynamics, a common issue for international aid. Multidirectional power relations and issues of local resistance (for example, to training), rejection of imposed ideas (such as the location of crafts in purpose-built spaces), and the legacies of colonialism were not sufficiently taken into account. Heritage was consistently considered a neutral field, despite being hotly contested as one of the key embodiments of (post-colonial) African nations, and used in different ways by different stakeholders. This neutral understanding underestimated exclusionary heritage management models; the use of international heritage schemes for land-grabbing and personal gain; and the suspicion towards artists as forces against the political appropriation of heritage.

Finally, the projects failed because of structural issues with international aid. Capacity-building activities were short-term and did not teach essential basic skills (such as how to use email). Major issues in governance impeded the success of the initiatives: there was no transparency and accountability in the use of funding and equipment after the end of projects; no quality assurance for the training courses; and no follow-up after the international teams left. In the words of Fall: 'International organizations teach the art of development for lack of being able to implement it'[21] (2011: 75).

Not much has changed in the world of heritage for poverty reduction since the end of these projects. Short-term capacity-building for artists and artisans, bottom-up initiatives that are not linked to the market, and approaches that rely too much on tourism as a panacea are still common at heritage sites, as highlighted for instance at the platform on Tourism for the SDGs hosted by UNWTO.[22]. Although SDG 8.9 ('devise and implement policies to promote sustainable tourism that creates jobs and promotes local culture and products') is a promising goal, its indicator is moving away from inclusive approaches. Indicator 8.9.1 measures 'tourism direct GDP as a proportion of total GDP and in growth rate'.[23] It includes international air arrivals and transportation-related commodities, as well as accommodation, recreation, entertainment, and shopping. Such a focus on GDP will not address the issues identified in this chapter, but will exacerbate inequalities (Higham and Miller, 2018). The Conclusion to this book provides further discussion of this topic and offers possible ways forward.

Notes

1. Interview Senegal/15 (30 September 2019).
2. Interview Senegal/31 (14 November 2019).
3. Interview Senegal/20 (3 October 2019).
4. This vision was reaffirmed in the 30-year development plan (Plan Sénégal Emergent) adopted in 2012.
5. Interview Mozambique/05 (28 April 2018).
6. Interview Mozambique/03 (26 April 2018).
7. Interview Mozambique/04 (26 April 2018).
8. Interview Mozambique/59 (7 April 2019).
9. Interview Mozambique/03 (26 April 2018).
10. Interview Mozambique/66 (10 April 2019).
11. Interview Mozambique/20 (18 July 2018).
12. Interview Senegal/15 (30 September 2019).
13. Interview Mozambique/60 (8 April 2019).
14. Interview Senegal/27 (14 November 2019).
15. Interview Mozambique/58 (7 April 2019).
16. Interview Mozambique/57 (6 April 2019).
17. Interview Mozambique/58 (7 April 2019).
18. Interview Mozambique/65 (10 April 2019).
19. Interview Mozambique/18 (15 July 2018).
20. Interview Mozambique/19 (17 July 2018).
21. 'Les organisations internationales enseignent l'art du développement, faute d'être capable de le mettre en œuvre.'
22. http://tourism4sdgs.org/the-platform/.
23. https://sdg.data.gov/8-9-1/.

6
Gender equality and the empowerment of women

Gender equality was a mandatory component of the four selected cases. Gender is defined by UN Women as 'the social attributes and opportunities associated with being male and female and the relationships between women and men and girls and boys, as well as the relations between women and those between men'[1]. Gender in the Millennium Development Goals (MDGs) and Sustainable Development Goals (SDGs) has also been understood according to this binary division. Yet gender is more diverse than this, and includes queer, transgender, and non-gender identities that are culturally specific and locally defined in plural ways. Gender identities can also be subject to change and fluidity, with one person having different genders at different times of life. This complexity has not been considered in the international development framework. By adopting a binary lens, it creates situations of exclusion. The projects selected reflect this exclusionary approach, focusing on fixed concepts of 'female' and 'male' as the only possible genders (Magubane, 2014). In addition, Western considerations of male and female seem to have been adopted, even though the projects were implemented in territories which all had very different family and gender structures (for instance see Gomila and Ferry, 1966, for the case of the Bedik in the Bassari Country). In my fieldwork and desk-based analyses, I applied a broader and more inclusive approach. I looked for a diversity of understandings of genders, but could not find any.

This chapter critically assesses the strategies used to promote gender equality and the empowerment of women. Gender equality aims to ensure that women and men have 'equal conditions, treatment and opportunities for realising their full potential' (UNESCO, 2014c: 72). To achieve gender equality, the concerns of women and men must be integral to the design of the actions, and discriminatory and exclusionary

practices must be acknowledged and dealt with (a process termed 'gender mainstreaming'). In some cases, equity measures (targeted actions to compensate for historical and socio-cultural disadvantages around gender) may be necessary. Empowerment is about self-worth and the respect of rights as well as the possibility for women to have choices and to control their lives. Conscious that these concepts originate from the West, I consider how they have travelled and have been received, adopted, adapted or resisted on the ground, and why. As much as possible, I have tried to expose different reactions to these concepts, according to geographic locations and different groups, with the understanding that 'women' and 'men' are not cohesive groups and often intersect with issues of class, race, poverty level, ethnicity, religion or age.

To reflect these issues fully, the first section of this chapter discusses joint initiatives to ensure women's equal enjoyment of their cultural rights. The second section critically assesses the strengths and weaknesses of the training programmes, in their attempts to achieve gender equality and the empowerment of women. The last section considers the long-term impact of these programmes. I have tried my utmost to focus on heritage only, although it is often entangled in social norms. A number of intangible heritage manifestations are considered in this chapter and I have made explicit why and how I consider each of them to have cultural components.

In considering these issues, I am mindful that heritage has been gendered and has perpetuated stereotypes (Smith, 2007: 161). This includes, for instance, how gender identities have been constructed in narratives on the past, such as how women have been naturalised as always belonging to the private sphere, as mothers and wives (Labadi, 2013a: 83–6). Because of this negative role played by heritage as a vehicle for gender stereotypes, it is particularly important to include a chapter on these issues. This chapter, and especially its last section, considers how the grammar of heritage can be used to rework gender stereotypes and redefine gender performativity – in other words to free women from the social role that is expected of them (Butler, 1990).

This chapter also considers whether and how the projects selected dealt with stereotypes and discrimination that have been ingrained in past development initiatives in Africa. African women in particular have been imagined and constructed as opposite to European women, as the Other, and as 'exotic' objects (Oyewùmi, 1997). These imaginaries are part of wider colonial and post-colonial constructions of the African continent as fuelled by violence against women (primarily in the private sphere), and as not respecting any markers of gender equality. This can

be considered a way of maintaining notions of the superiority of Europe over Africa and other parts of the Global South. Yet, some powerful markers of gender equality also characterise the countries considered, with women occupying important leadership positions in political life. For instance, in Mozambique, 106 of the 250 Members of Parliament at the Assembly of the Republic are female. Since 2010, the President of the Assembly, the second most important figure in the state hierarchy of Mozambique (after the President of the Republic), has been a woman. Some local authorities also see women in leadership positions, as is the case for instance at Toubacouta, in the Saloum Delta of Senegal, where 26 of the 56 councillors are women.[2] Conversely, recent movements, including the #MeToo movement and the increased criminalisation of femicide in European countries, have revealed the extent, diversity and pervasive nature of gender violence in the West, which have been downplayed for decades. Although I focus on Africa for the purposes of this research, my view is that gender inequalities are a worldwide reality. Hence the wider importance of this chapter in considering whether and how heritage can tackle these issues.

Equal enjoyment of cultural rights?

Heritage (and culture in general, understood in its broadest sense as the whole complex of distinctive spiritual, material, intellectual and emotional features that characterise a society or social group) tends to be considered as an impediment to women's human rights (Shaheed, 2012: 4), a comment valid for Othered groups in societies, including migrants and stateless individuals (Labadi, 2017b; Logan, 2012). Shaheed, former UN Special Rapporteur in the field of cultural rights, even wrote that 'no social group has suffered greater violation of human rights in the name of culture than women. For example, women are denied the right to vote, subjected to violence and customs that deny them personhood, for instance, by being forcibly married (or denied the right to marry), being prevented from earning, or disallowed freedom of movement, association and expression, all in the name of culture' (2014: 6). For some, the focus on the negative dimensions of culture is an attack on non-European societies, in order to impose a Western and neoliberal agenda so that women can participate in the global labour force (in sweatshops for instance) (see Hickel, 2014: 1363). For Shaheed, who has a different understanding of the situation, a paradigm shift is proposed, from viewing culture as an obstacle to considering it as a tool for ensuring women's

equal enjoyment of cultural rights. Cultural rights include the right of everyone to participate freely in cultural life (Article 27 of the Universal Declaration of Human Rights and 15 of the 1966 International Covenant on Economic, Social and Cultural Rights), as well as the right of minorities to enjoy their culture (Article 27 of the 1966 International Covenant on Civil and Political Rights). As rights are interdependent, enjoying cultural rights ensure that women also enjoy their economic, political, and social rights (Shaheed, 2012: 5).

For this paradigm shift to happen, all concerned groups, including women, should have the equal right to decide which cultural traditions to keep, change, or discard, including the right of women not to participate in intangible heritage practices if these are considered discriminatory. The 2015 UNESCO policy document on World Heritage and Sustainable Development includes a section on gender equality that I wrote, in line with this paradigm shift. Such an approach means, for instance, that women and girls should be consulted about heritage sites to which their access is prevented, such as Mount Athos in Greece, inscribed on the World Heritage List in 1998, or the Japanese island of Okinoshima, inscribed in 2017. If practices are considered discriminatory on the ground, that is if they 'have the intention or effect of nullifying or impairing the recognition, equal enjoyment or exercise of human rights' (Blake, 2014: 52), then patterns of access should change. It is indeed not because segregation (on the basis of age or sex for instance) characterises a heritage site or practice that it should automatically be changed or discarded (Blake, 2014: 54). Many sites or intangible heritage manifestations have differential approaches to women, girls, men and boys, or to specific age groups. It is only when approaches are considered locally as discriminatory that they should change (Blake, 2018: 217). However, women's equal enjoyment of cultural rights can be constrained structurally or socially. Women may have internalised unjust practices and stereotypes and accepted them. Actions may need to be taken locally to highlight these issues, making both women and men conscious of them, and introducing ways to address them in a manner that is acceptable to the concerned communities.

Ensuring women's equal enjoyment of their cultural rights, primarily in intangible heritage manifestations, became a key theme of the project in Mozambique, and was associated with issues of SRH. One of the main aims of the project was to fight HIV/AIDS and improve maternal health (UNDP, 2008c: 5). Both the MDGs and the SDGs have aimed to combat the HIV/AIDS epidemic. Mozambique has one of the highest rates of HIV/AIDS in the world. At the time of the project

in 2009, 11.5 per cent of adults aged 15–49 were HIV positive, and Mozambique was the 8th most HIV-afflicted nation globally (Instituto Nacional de Saúde, 2009). This rate has remained relatively stable over time. In 2018, 12.6 per cent of adults in the same age bracket were HIV positive and Mozambique still had the 8th-highest rate of HIV/AIDS in the world (CDC, 2019). However, HIV/AIDS should not only be thought of in numbers. It deeply affects many families. During my research trips on the Island of Mozambique, I became friends with some of the children living on my street. They were often outside and loved playing with my camera. One day I was chatting with one of them and naively asked her if she lived with her parents (assuming that she did). She told me she was living with her grandmother. I later learned that she is as an orphan due to AIDS.

Some intangible heritage practices have been identified as responsible for the spread of HIV/AIDS. External agencies have attempted to stop these practices without understanding their socio-cultural functions. These externally imposed approaches have often failed, constructing Mozambicans as objects of curiosity, and with an exoticised sexuality different from 'civilised' Europeans (Gausset, 2001: 509–10; Settler and Engh, 2015). The discussed project in Mozambique attempted to change this approach. It aimed to ensure women's equal enjoyment of their cultural rights through the internal and community-led understanding and changing of cultural practices that they considered discriminatory or dangerous to them. In this process of understanding, cultural practices can be transformed so that they can continue in a different way, without losing their core meaning and function (Blake, 2014: 55). This happened through the collaboration between UNESCO and UNFPA and was considered in the final evaluation as the most successful example of joint work between different UN agencies (Eurosis, 2012: 67). A team (composed of representatives of the formal education and health-care sectors, as well as local leaders, traditional healers, traditional midwives, and religious leaders) set up meetings at schools and community sites to talk about problems relating to sexuality in the provinces of Nampula, Inhambane and Maputo.[3] One objective of having such a comprehensive group was to avoid conflicting messages from the formal health-care sector and the traditional system (traditional leaders, healers, and religious leaders), which may render interventions ineffective. The team invited local women, girls, men, and boys to present their problems. Through discussions and negotiations, suitable solutions were found. Such fora helped to transform cultural practices, which are not static, but instead are always changing and dynamic. These discussions were held with and

within communities, thereby avoiding the pitfall of being led entirely by foreign agents. Individuals do not want to be required by foreigners to stop their cultural practices, even if it is dangerous for their health, as they consider this to be a Western imposition and a neocolonial practice (Melching, 2001: 156–70).

My interviews revealed that many of these discussions centred on the cultural practice of widow cleansing, particularly in the province of Inhambane in Mozambique.[4] Cleansing rituals for widows are found in a number of Eastern and Southern African countries, including Kenya, Zambia, Tanzania, Zimbabwe, and Mozambique. Known as *kutchinga* in the south of Mozambique (where Inhambane is located), and as *pita-kufa* in the centre of the country, this ritual requires unprotected sex between the widow and the purifier (a man who must be a brother of the deceased), and has been proven to contribute to the spread of HIV (Cruz *et al.*, 2018; Audet *et al.*, 2010: 2; Carolyn *et al.*, 2010: 279–92), although data is not available on how widespread this practice is. The rationale behind this practice is, for some, that when a man dies his widow becomes contaminated with misfortune and can spread it to the rest of the family or community. Sex with one of the husband's brothers will break the bond with his spirit. This practice or ritual can be considered intangible heritage as it relates to the stages of a person's life, structures the lives of communities, is a rite of passage, and is closely linked to important events. However, the ritual is viewed by some as a violation of the rights of women when it occurs without their consent. In some cases, it is also considered locally as being rooted in gender inequality, as male widows are purified only with water and medicinal plants. Women and men thus receive different treatment (Cruz *et al.*, 2018). Open discussions by community members concluded that purification of widows is necessary, and there was a general agreement that the same purification methods for men (that is, with herbs and water) should be applied to women as well, as was already being done in northern Mozambique. The ritual was being transformed, but without altering its core significance.

My interviews with different participants confirmed that there was a wide consensus on the proposed change and decisions were taken from within the community and not externally imposed.[5] The change was promoted on community radios and through leaflets and community discussions. Radio programmes in particular were found to be a very popular and successful way of reaching local communities. The initiative respected the principles of the UN Gender Equality Marker,[6] which measures the contribution of international projects to gender equality, and has been a measure of the success of UN activities since 2009. It was

gender-sensitive in that it identified right from the beginning the differences and inequalities between women and men. It was also gender-responsive because it addressed the different needs, aspirations, and contributions of women and men locally, through taking their views into consideration. Finally, this initiative was gender-transformative as it challenged and changed practices locally considered to be discriminatory, while fully safeguarding the meanings of the intangible heritage.

However, a number of our interviewees lamented the end of the project, which also curtailed the promotion of changes to the practice of widow cleansing.[7] Until recently when the practice was banned, in an agreement between the Association of Traditional Doctors of Mozambique (AMETRAMO) and the Ministry of Health (MISAU) (Amadeu, 2021), it was still occurring in its original form in Inhambane province (as documented for instance by Cruz *et al.*, 2018 but also by my informants).[8] The discontinuation of the project also led to a resurgence of antagonisms between different community groups, for instance between religious leaders, traditional healers and the formal health-care system. The lack of funding for local discussions, negotiation, and resolution since the end of the project has partially contributed to the present situation. Some of my interviewees from local NGOs staffed by Mozambicans in Maputo also pointed out an unwillingness in central government to provide any funding for continuing these approaches, or to give greater consideration to culture in SRH practices.[9] This lack of funding and interest might also be entangled with fears by the government that international programmes would want to impose neocolonial approaches that would aim to control, police and discipline African bodies (Settler and Engh, 2015: 127–8).

What I found striking, though, was the lack of data on the practice of *kutchinga* in southern Mozambique. It is therefore unclear whether this practice was widely spread, or its impact on rates of HIV/AIDS. Conversely, data was clear that the southern provinces were characterised by higher rates (at 21 per cent) than the central and northern ones (18 per cent and 9 per cent respectively).[10] It is widely documented that a high proportion of the population from the south work in the mines in neighbouring South Africa and that these migrant workers have high rates of HIV/AIDS (for more information on why, see Hickel, 2012: 518). Although cultural practices might have been peripheral in their contribution to this spread, they were the focus of the project's activities. However, high rates of HIV/AIDS might not be due to these individual circumstances, but more to wider issues of labour structure, migration, work conditions and declining national health spending. The project could have highlighted these issues and identified whether cultural

values and practices can help address these issues and behaviours, rather than focus on individual cultural practices.

In Senegal, a different approach was adopted with community radios built as intended long-term outputs of the project. In Bandafassi, the radio station was a building within the community village. Unfortunately, it burned down completely in an accidental fire in March 2019, and had not been rebuilt at the time of writing (summer 2021). Indeed, it is very unlikely that it will ever be rebuilt, for the various project shortcomings identified in the previous chapter (primarily that public funding for the community village has recently been reduced over the lack of concrete results, and that significant multidirectional power struggles handicap activities) mean that the village focuses mainly on maintaining the 'Outstanding Universal Value' of the World Heritage site, without much connection with local issues. When I was in Bandafassi, I met a few people who either participated in the radio programmes or listened to them. Access to the radio, like access to the community village, is closed off by an imposing door with a guard, as explained previously. This separation meant that villagers did not feel it was really their radio, and it was thus difficult to assess how useful it had been as a democratic forum for discussing issues relating to cultural heritage and rights. The situation is very different in Toubacouta in the Saloum Delta. There, the community radio is still functioning (see Figure 6.1). With its own building, it is located far away from the interpretation centre, is independent from it, and locals totally disassociate these two entities. It was easy to enter the premises and the gate was wide open the few

Figure 6.1 Community radio, Toubacouta. © Sophia Labadi.

times I passed through it. The community members interviewed praised the radio for being a medium for promoting cultural events occurring locally, but more importantly for discussing intangible cultural heritage practices. In the words of one woman, this space is 'actively used … for awareness-raising activities. The radio has also made it possible to bring to the table and discuss indirectly sensitive subjects within society and for which a change in behaviour and mentality is advocated.'[11]

The radio seems to have been particularly important for discussing complex socio-cultural practices, including Female Genital Cutting/Circumcision (FGC) and early marriage. FGC is still considered a significant and meaningful practice in some cultures, and is therefore widely prevalent in some regions of Senegal. In the Kédougou region where Bandafassi is located, 80 to 100 per cent of women have undergone it. In the Fatick region, where Toubacouta is located, fewer than 10 per cent of women have undergone FGC (Andro and Lesclingard, 2016: 252). FGC can be considered an intangible heritage practice, including as a religious practice (although it has also been publicly denounced as having no religious basis) or as a puberty initiation rite, but it also has many other entangled meanings, including being a psychosexual procedure (to ensure monogamy), a hygienic approach (through purifying the body), and a way of subordinating women and over-virilising men (Gibeau, 1998: 88; Bourdieu, 1998). The community radio has provided a space for local women and men to talk about these socio-cultural issues, mindful of their complexity. These awareness-raising efforts complement short-term training sessions to which women, traditional leaders, and men are all invited. Rather than speaking for women and telling them what to do, the community radio has given a voice to the people concerned. The use of languages other than Wolof and French has also widened its reach to different communities. This local radio has been considered as moving away from Westerners controlling discourses on socio-cultural practices and preaching their own agendas, which some view as having alienated and objectified women (Marglin, 1990: 173; Nandy and Visvanathan, 1990: 145). Through the community radio, there is a greater understanding of the internal logic of intangible heritage practices, their uses, their dangers, and the needs fulfilled (Nnaemeka, 2001: 183; Diop and Askew, 2009: 313). Staff from the radio have also used other media to elicit debates on cultural practices. For instance, with funding from USAID, a film on early marriage was shown at villages in the Toubacouta region, followed by debates. I was told these activities yielded positive results and revealed greater understanding by the populations of the issues at stake, through, for instance, visual performances and stories that people

can relate to.[12] They confirm previous research highlighting the import-ance of art forms produced by Africans for Africans, including films or plays, on gender-based violence (Nnaemeka, 2001: 185–6; Gausset, 2001: 516).

However, the community radio faces some serious issues. Human and financial resources are the major problem. Most of the staff work-ing for the radio are volunteers. Community participation is a further issue. The radio relies on the unpaid participation of community mem-bers. This model only works if people are willing to give their free time to run programmes and contribute content. In situations where people have multiple responsibilities, the extra responsibility of the radio might not be sustainable in the long term. This model has led some to comment that: 'community radio is exploitation of the poor, by the poor' (cited in Tacchi, 2002: 72). In the case of the radio in Toubacouta, public funding covers only the equivalent of three to four months of activities per year.[13] The radio is thus heavily dependent on programmes funded by NGOs and external donors. When I was in Toubacouta, for instance, a number of radio programmes were run by USAID (with their own technical teams) as part of the Kawolor project, implemented jointly with the Senegalese government on fighting malnutrition and food insecurity. All such projects have their own specific ideas and agendas to push for. This means that the radio actually loses its community empowerment aspect, reducing the airtime for locals to discuss issues on their own terms, and becoming a medium for amplifying the views of international donors and NGOs. This might lead to a distrust of community radio programmes, especially those relating to women, for fear they would impose external and neocolonial programmes that would aim to continue to control their bodies.

It is true that these sensitisation activities should be just one aspect of multidirectional efforts towards ensuring the equal enjoyment of cul-tural rights by women and men. They go hand in hand with national strategies and laws punishing various forms of violence against women. The national legislative framework aiming to ensure gender equality is an important tool that people can refer to when combating discriminatory practices, providing official rights for women. Yet it has already been proven that condemnation and coercion do not necessarily work if there is no understanding of the situation involved and the reasons for having to abandon cultural practices (Melching, 2001: 166). Education is there-fore a further necessary tool for ensuring the equal enjoyment of cultural rights. However, there are major exclusionary patterns relating to educa-tion along gender lines and the intersection of gender, wealth, ethnicity,

and location (UNWomen, 2019: 4). For example, at the end of the project in Senegal in 2012, the overall literacy rate was 54 per cent for men and 35 per cent for women.[14] However, there were significant regional discrepancies and in certain rural areas, including in the Bassari Country targeted by the programme, the illiteracy rate was around 80 per cent, which represented a handicap for the adoption of the various initiatives (Damiba, 2012: 14). I found it rather striking, when I collected data in the Saloum Delta and the Bassari Country, that the great majority of women interviewed could not speak French, the official language and the language of education, but instead spoke Wolof, the vernacular language of communication between Senegalese. In contrast, most men interviewed spoke French perfectly. This is a clear marker of the differences in educational levels between men and women. In education, preference is given to men and this is a trend that goes beyond Senegal and characterises other countries in sub-Saharan Africa (Mwobobia, 2012: 116). Yet education is fundamental for gender equality and the enjoyment of cultural rights. It has also been documented as giving women the tools to live more healthy lives, and to be able to raise healthier and better-fed children (Fuller, 2019; Momsen, 2009: 51). The education of women therefore has long-term impacts on inter-generational measures of well-being.

Of course, there are many issues with education, including stereotyped curricula. During my interviews in both Senegal and Mozambique I also noted a real distrust of education as an imposition of Western values (see also Tuwor and Sossou, 2008 for similar findings), and a tool to force people to adhere to a neoliberal agenda as their choice of life (see Hickel, 2014: 1363). In addition, multiple cases of violence, including widespread cases of rape in schools, were also recorded during our interviews and in research, in both Mozambique and Senegal.[15] Yet I did meet activists who were trying to change these practices to ensure that education can lead to empowerment and change, and to providing people with a diversity of meaningful options in life (Brock-Utne, 2000). My key point here is that the projects considered did not work in a transversal manner with other sectors (such as formal and informal education, sensitisation, and law-making). As a result, the project results are not as transformative and substantial as they could have been and were intended to be. This is one of the overall findings of this research. Ambitious in their goal to instigate significant behavioural changes, the projects failed as they did not consider all the intricate dimensions that would lead to success. This idea is further considered in Chapter 7, on environmental sustainability. Let us now assess a central activity of the programmes considered: that of training.

Subject or object?

The various training courses aimed at improving the socio-economic conditions of diverse stakeholders, primarily disenfranchised individuals, as well as their positive and negative impacts, have already been outlined in Chapter 5. I am now going to discuss these training opportunities from a gender perspective. The UNDP and the Spanish government made the promotion of gender equality a condition of the funding for each of the selected 130 projects, including the ones considered in this research. The courses on the ground then presented a new and objective reality that donors want: the provision of training on any topic to both women and men, indiscriminately. In this process, the capacity-building activities aimed to ensure at least an equal number of female and male participants, or even a greater participation of women. For instance, in the Namibian project, the target was for at least 60 per cent of trainees on tour guiding and traditional handicraft skills to have been women (Enhancing Heritage Resources, 2013: 38ff). The final evaluation in Mozambique presents the disaggregated target numbers of trainees and the actual number of people trained. In Inhambane city, for instance, the target was 12 women and 15 young artisans.[16] Instead, 29 men, 42 women, and 74 young artisans started the training, with the evaluation indicating that the gender goal had been 'significantly overreached' (Eurosis, 2012: 41). The fact that more (adult) women than men participated in these activities is thus an indicator of success. Ensuring at least an equal number of female participants is an indicator often used by international organisations to assess the success of the gender equality component of programmes.

This is the case, for instance, with UNESCO. Gender equality has been one of its two overall priorities (with Priority Africa) since 2008. Activities in its different fields of competence – in education, science, communication, and culture – are supposed to integrate gender equality systematically (Corat, 2020: 9). Most of the indicators used to measure the achievement of gender equality in these activities focus on the balanced numerical participation of women and men, as revealed in the successive programme and budget documents (Labadi, 2018: 91–2). This approach to training reflects the 'Women in Development' theory formulated in the 1970s, which has been widely criticised (Labadi, 2018; see also below). For proponents of this model, women had until then been marginalised or excluded from every aspect of development. The solution was simple: women needed to be included in all projects in an

indiscriminate manner and in equal numbers to those of the men, which would then lead to gender equality (Tinker, 1990). Before considering the shortcomings of the courses provided, let us first consider some of their more positive impacts on the ground. In my interviews, I wanted to go beyond the statistics and understand whether and how the activities had been useful for the participating women.

When in Mozambique, I met very few women who thought that the courses were very useful. Small business owners in particular needed training to develop and consolidate their activities. One example is a restaurant owner on the Island of Mozambique World Heritage site, who gained skills in management (how to deal with staff), finance (how to manage a budget with fluctuating numbers of tourists), and practice (how to deal with different customers). In her own words: 'The training was important because I learned how to save money … what to do when the business is good and when the business is bad. I also learned how to deal with my employees, how to pay the wages …'.[17] This interviewee found the training so useful that she thought it should be regularly offered to both managers and staff. Women weavers from the Inhambane province also found the course useful for other reasons: as a networking platform, as a way to share and exchange practices, and as a way to learn new techniques in craft design and manufacture. In Senegal, the coaching provided women from Economic Interest Groups (EIGs, the organisational unit through which most women work) with new saving techniques. In this process, EIGs, which play vital social roles for women beyond just providing them with an economic activity, were strengthened.[18] For instance in Kédougou city (the biggest city close to the Bassari Country World Heritage site) I met women from EIGs specialised in processing and selling fonio and shea who participated in different trainings offered by UNESCO and UNFPA. Beyond merely paying them a salary (albeit an irregular one), the more successful EIGs are also a source of financial and social assistance. Members can turn to the EIG if they have an unexpected expense, such as medical care. In addition, at the start of the school year, some EIGs provide financial help for school registration and the purchase of supplies for children whose mothers work in this group.

However, the courses also faced multiple shortcomings. They did not have the wide scale and transformative impacts intended. A fundamental problem was their gender blindness: they did not consider the complex dynamics between men and women (Aregu et al., 2016: 287). The MDGs, the wider UN system, and governments have all been criticised

for their gender blindness (Steady, 2006: 11; Momsen, 2009: 221). This is of course the result of the requirement to have at least the same number of women and men attending courses, indiscriminately. In this approach, a neoliberal consideration of women was imposed in the selected projects. According to this neoliberal approach, women are able and free to undertake any training, and then take any work that would help them to be empowered, without having any impact on their private life (Arkinbobola, 2019: 50–61). However, this indiscriminate approach did not identify, acknowledge, and work through the local socio-cultural differences between men and women. These issues were highlighted in the final evaluation of the project in Senegal, which lists as major constraints (often worsened by class and ethnicity): housework; traditional behaviours, with women not being allowed to undertake some activities; marriage (sometimes early) which forces them to withdraw from certain occupations; and all types of violence against them (Damiba, 2012: 38). In Toubacouta (Saloum Delta), for instance, I met women who could not go to work because it was their day to cook. Similar observations were made in Ethiopia, in that the initiative was blind to the specific challenges faced by women, and neither did it work through gender stereotypes (Tadesse, 2013).

This lack of consideration of gender dynamics resulted in many women quickly dropping the training sessions, particularly those on tourism. As already detailed in the previous chapter, those participants (six people in total) who finished the tour guiding course on the Island of Mozambique, aimed at disenfranchised individuals, were men. Women seemed to face difficulties in attending and finishing courses. This was confirmed by tourism professionals who had tried to organise teaching sessions with equal proportions of female and male participants at this World Heritage site. Not just one or two, but all of the registered women dropped out of these classes shortly after they started. According to one tourism professional interviewed, the reason was that 'The women generally have got responsibilities; they've got other things to do'.[19] In the words of one woman interviewed: 'We are everything: we are the men, we are the women: we take care of children, of the problems of the household, and we work'.[20] Hence, the training did not factor in the many duties that women are expected to perform. This finding is not very different from the conclusions of my 2017 book *Museums, Immigrants and Social Justice*, which focuses on the provision of language learning classes and employment skills classes at museums in Manchester (England), and Copenhagen (Denmark). I found that female immigrants from low socio-economic backgrounds would not attend the language

learning courses, even when these opportunities specifically targeted them, because of their many responsibilities at home. Only when free childcare was provided, for instance, would women be able to attend some daytime courses (Labadi, 2017b).

Besides, the training provided for the African projects did not respect the basic principles of the aforementioned gender equality marker. Activities were required to be gender sensitive by first identifying the differences and inequalities between women and men, and then addressing these issues and being transformative. The programmes discussed here aimed to be transformative without any consideration for the structure of societies, the definitions of women and men, and their different gender dynamics. In particular, no attention was paid to the various responsibilities that women have. This is rather surprising considering that ILO, which has documented that women do most of the unpaid (care) work all over the world (Antonopoulos, 2009: 11), was one of the implementing organisations in Mozambique and Namibia. Yet the short timeframe of these projects when compared to their ambitious aims meant that only such a lack of consideration for gender dynamics and the use of crude figures would lead to a narrative of 'successful' outcomes that would satisfy donors. As a result, gender equality has been emptied of its meaning and has become a box-ticking exercise where training courses are externally imposed and their success only measured in the number of female and male registered participants, without working through barriers preventing women from completing the course.

The need to construct a 'successful' narrative led the four projects considered to predict from the outset how women would be impacted, without first making a serious consideration of their needs and wants. Women's empowerment and the enhancement of their capacity for self-determination were supposed to be at the heart of these projects. However, the external imposition of ideas about what women need and should do runs counter to any possibility for empowerment (Kabeer, 1999: 462). As explained in Chapter 4, all of the considered schemes were devised by international and national stakeholders, without meaningful involvement of the local women concerned. The removal of their power to choose transformed these women into objects of development, rather than agents for change. As highlighted by Wendoh and Wallace: 'It is not for external agents to determine what changes women need, or to tell them what roles they must play and what resources they need to access. Women must – with support – define and work for the changes they need' (2005: 71).

In addition, the courses did not understand, consider, and rework the gendered construction and representation of space and place, which perpetuate gender stereotypes and discrimination, particularly in the field of heritage and tourism. As a result, the courses were not useful for many women, which might also explain the low rate of retention. An inheritance from colonial times, women's activities have been traditionally identified with and relegated to the private or domestic sphere, while men have had a monopoly on the public sphere. These stereotypical colonial divisions have continued in post-colonial times, and have been perpetuated and reinforced through tourism (Aitchison, 2001: 140; Kinnaird and Hall, 1994). I have never met a single guide in Southern Africa or in Senegal who is a woman. Men occupy public spaces as guides, while women are confined to working in enclosed and private spaces as waitresses, as maids, or in hotel lodges and shops. Women are the invisible and often exploited staff of tourism. They tend to serve tourists quickly and are not remembered. Conversely, guides spend more time with tourists, sometimes entire days. Tourists discover a country through his eyes and his descriptions. For this reason, a guide tends to be remembered and is thus visible. Some women working in private spaces have reached positions of dominance and power as managers of hotels, and I met some of them. Yet the available literature does reveal that the majority of women working in the field of tourism occupy lower-level posts, and also often do not benefit from decent working conditions (Momsen, 2009: 225). Worryingly, and as further discussed below, the selected programmes did not attempt to rework these structural issues for the benefits of women.

The gendered representations of space and place in tourism are closely associated with the different paths leading to becoming a tourist guide, and can partially explain the failure of the training modules and their lack of retention of women. For instance, as explained in Chapter 5, on the Island of Mozambique the guides who finished the classes were young men, and most of them had spent their childhood and teenage years on the street. Begging for money, food, or drink from tourists, they learned English little by little. There are no girls on the street. The world of tourism is unfamiliar to them and they have had no opportunity to learn a foreign language. They have not mastered the soft skills needed for interacting with tourists in the way boys have. Providing a short-term training course to women in tourism guiding is simply not going to work, because of these differences in skill level, rooted in gendered representations, stereotypes and occupation of space. At the other end of the spectrum, all the guides I met in the southern province of Inhambane,

who were also young males and had created their own company, had a university degree in tourism and some even had multiple university degrees. With only 7.31 per cent of the population attending tertiary education, these men are part of a privileged, highly educated minority. Figures on tertiary education attendances for women vary from only 1 per cent according to USAID[21] to 6.53 per cent according to UNESCO[22] (figures for 2018). Women enrolled in university education choose more secretarial and administrative courses, but 60 per cent of the students enrolled in agriculture and technical training are men, reflecting deeply ingrained gender stereotypes around work (Hesmondhalgh and Baker, 2015; Dufrêne, 2014). Although I was informed that some women had gained university degrees in tourism, I could not meet a single one who was working as a tour guide, maybe because they have internalised the stereotypes that it is not acceptable for a woman to be out on the street.

However, the lack of female guides is also caused by the discriminatory practices of other actors. It has been documented that tourism industry businesses, particularly in South Africa, do not want to employ women as tour guides, for instance because they believe that women cannot drive or work for the long hours required (see for instance De Beer, Rogerson and Rogerson, 2014: 94–5). These discriminatory practices are not exclusive to business actors. During my interviews on the Island of Mozambique, a number of male guides told me that it was not acceptable for a woman to spend time on the street, guiding tourists or selling them souvenirs.[23] Male guides themselves are resisting the feminisation of their trade, because of socio-cultural norms rooted in the gendered representation of space and place. This resistance from men was also noted for other trades, and also concerns production. A female artisan interviewed mentioned the difficulties she sometimes had in getting tools and equipment from a public workshop on the Island of Mozambique, as men had developed strategies to keep these resources for themselves.[24]

The fact that gender relations were not understood, and those deeply ingrained stereotypes, structural discrimination and oppression not addressed or made provision for, was another reason for failure. There is no point in training women in a field where they cannot or will not work. The intertwined issues and representations that lead to stereotypes and discrimination would need to be reworked in parallel with courses for them to yield positive and transformative impacts (Cornwall and Rivas, 2015: 409–11). The influence of Sen's capability approach might explain the lack of consideration of these stereotypes and discrimination. According to Sen, people are free to choose to achieve what they want to do and be (Sen, 2007: 271, see also Labadi, 2017b for a use of

Sen in museum studies). Previous studies that have used the capability approach to study women's empowerment in tourism in an African context have drawn rather positive conclusions about women's success and 'independence' (Moswete and Lacey, 2015). However, a major shortcoming of Sen's approach is the lack of serious consideration of institutions and socio-economic and cultural capital, as well as the structural stereotypes, discrimination and inequality that impede people's choices. Women are not going to be free to make transformative changes if these factors are not addressed. These issues are further considered in the Conclusion of this book.

Training in socio-economic opportunities, and to reduce poverty, thus adopted very different approaches to the activities on intangible heritage practices supporting gender-based violence. Only the initiatives addressing gender-based violence in the private sphere were gender-sensitive and gender-transformative. There was no consideration and transformation of the stereotypes and discrimination women face in public spaces, their unequal access to employment opportunities, and the inequalities they encounter once in employment. Yet previous research had already demonstrated that merely providing training or education is not enough to improve women's participation and betterment in the workplace (Plantenga, 2004; Kaplan and Goodman, 2017). Sociocultural gender dynamics (and their interactions with other characteristics such as race and class), which are very different in all the regions considered, were not factored into activities (Oyewùmi, 2002; Wilson, 2018: 9). This lack of serious consideration might reflect neocolonial and stereotyped views of African women as wives and mothers, first and foremost, rather than as workers (Polla, 2019: 88). Aware of the multiple trajectories of women, I discussed with women interviewed in Senegal whether they would prefer to stay at home and be a wife and a mother, or to work and earn a living (in addition to being a wife and a mother). All of these women told me that they wanted to work, not only because of the income generated, but also because of the social functions of work (as discussed above and below), even though most of their work is in the informal sector (Ampofo *et al.*, 2004: 699–700). However, these findings should not be too quickly generalised, as some women, particularly those from higher socio-economic classes, might not want to work, as they are also provided with more choices over their life.

Importantly, while labour is an essential aspect of many women's lives, the courses seem to have missed an important aspect – that is, how to ensure decent living conditions through work. Indeed, the structure of tourism, as already detailed previously, furthers neocolonialism, as it

benefits first and foremost actors from the North who own hotels, tour-guiding companies, means of travel, and e-commerce vehicles. None of the projects intended to change these neocolonial and neoliberal structures. The lack of attempt to change these structures, to address existing power inequalities in the field of tourism in particular, and to propose decent living conditions meant that the courses would not have had any real and profound impacts on improving women's lives and thus in empowering them.

To sum up, while these were cultural projects, they did not, paradoxically, take account of the complexity of the cultural reality on the ground, and were not based on bottom-up approaches. Again, the concept of erasure can be a lens to assess the trainings: they erased the needs and voices of local women; they erased any structural discrimination and stereotypes women face; they erased differing gender relations in the regions considered, including issues of intersectionality as well as local norms and obstacles (Tucker and Boonabaana, 2012: 452). A fundamental question, though, is how useful have these training courses been for the very few women who attended them in the long term? A longer timeframe for the consideration of the impacts of these courses might indeed reveal more positive aspects.

Legitimising practices

I want to end this chapter by critically analysing two intangible heritage manifestations: the Mozambican Women's Day/Dia da Mulher Moçambicana and the Festival of the fonio/la Fête du fonio, held in the town of Kédougou in Senegal. Some of the women who attended the training courses of the MDG-F projects in Mozambique and Senegal have participated in these two annual events, offering an insight into the usefulness of these programmes on a longer-term basis. Their analysis also reveals the strategies used by women to maximise their benefits or, conversely, the issues they faced in putting into practice what was learnt. This discussion further highlights the disconnection between the international and neoliberal discourse on heritage for economic development and its reality on the ground.

In Mozambique, groups of women who publicly perform traditional dances and songs benefited from various courses in the MDG-F project, including on market access and diversification, as well as on marketing. Dancing and singing during official political gatherings is a regular source of income for these groups. A significant event of this kind is the

Mozambican Women's Day, organised annually on 7 April, the day of the death of Josina Machel (1945–71), in different parts of the country. Josina Machel was one of the key figures of, and a combatant for, the liberation struggle. She also occupied various posts within FRELIMO (the Mozambique Liberation Front) during the liberation struggle, including in its Department of International Relations and Social Affairs, and she used this role to advocate for and advance the rights of women and children. Samora Machel, the first president of the independent People's Republic of Mozambique, was married to her. Josina Machel died four years before independence was achieved in 1975. The festival is a celebration in her memory and that of the many other women who participated in the fight for independence, but is also a celebration of modern women, who are all regarded as fighters, and presented as such. I attended the 2019 Mozambican Women's Day in Inhambane city, which included political speeches as well as traditional dances and singing by women. As a festive event with the aim of reaffirming the identity of a specific group and aspects of their history, transmitted from generation to generation, it can be considered intangible heritage. However, far from being a light and shallow festive event, it is a deliberately 'invented tradition' with multiple political functions (Hobsbawm, 1984: 1–14). The exaltation and celebration of women is, to a certain extent, only a façade.

The Mozambican Women's Day is really used to legitimise FRELIMO, the party that fought for independence and has ruled the country ever since, demonstrating the performative and constructed nature of heritage and its collision with political and nationalist considerations. Collective memory shared by the imagined community made up of all Mozambicans is also being shaped, through constructing a common past and present centred on FRELIMO (Halbwachs and Coser, 1992; Anderson, 1991). References to FRELIMO were plenty at this event, and they structured the space and the day. Political leaders, including the mayor and other representatives of the region, gave speeches, often interrupted by cheers to the party. Flags of FRELIMO were regularly waved. The women dancing and singing were instrumental in legitimising FRELIMO, and in validating its construction of the past. Most of them wore the traditional *capulana* (a cotton sarong frequently used as a wrap-around skirt) with political messages on them, or the face of Josina Machel or the colours of FRELIMO (see Figure 6.2). For me, the annual organisation of the Mozambican Women's Day aims to remind citizens of the direct link between the national heroes of the fight for independence (such as Josina Machel) and the current national party in power. FRELIMO thus appears as a political heir of the liberation movement

Figure 6.2 *Capulana* featuring Josina Machel, Mozambican Women's Day, Inhambane (7 April 2019). © Sophia Labadi.

and as the natural ruling party of the country, through building continuity with the past and with the foundation of the nation (see Jopela, 2017: 318 for similar findings on the uses of the past by FRELIMO). This intangible heritage manifestation contributes to justifying the longevity of the party, its power, and its central space in the nation. In a multi-party democracy, it is part of a process of discrediting other political groups (Souto, 2013). The party in power is able to keep full ownership of the liberation discourse and movement, while silencing and delegitimising other liberation movements (Coelho, 2013: 28).

But more than just legitimising FRELIMO or ensuring its full ownership of the liberation narrative, this day in 2019 was also part of this political party's campaign for that year's presidential elections. Women were willingly instrumentalised for and by the main party, and they seem to have accepted the use of their bodies and clothes as political spaces. Some of the *capulana* showed the dates to register for the elections. Some songs were about the voting procedure. The songs and dances thus almost became secondary, and a mere vehicle for the political messages

transmitted. The whole event, rather than being solely about women, aimed to demonstrate that the only political party to legitimately win the 2019 presidential election was FRELIMO (and they did win, as the incumbent President Filipe Nyusi was re-elected). Women were thus knowingly dancing and singing to maintain FRELIMO in power. This intangible heritage manifestation further demonstrates the rupture between the apolitical nature of the documents drafted jointly by the UN and national authorities, and the reality on the ground. The UN project document presented heritage as neutral and consensual, and able to provide equal socio-economic benefits for all. Yet in reality, heritage is the object of political struggles and of appropriation by the powerful for their own benefit, as also already discussed with the approaches for poverty reduction.

Although dancing and singing clearly have wider political meanings, women did gain benefits. Previous research has highlighted the importance of dancing and singing for women from the Island of Mozambique, providing these artists with a sense of common identity, belonging, and pride. Being part of a group can also provide these women with status, as members of the dance troupes all have different ranks (Arnfred, 2004: 55–6). Yet during my interviews women regularly complained about inadequate payment for their public performances, which they associate with a lack of consideration and contempt for them by politicians. In the words of one interviewee: 'For example, when a group of 15 members dances and is paid 1,000 meticais [around US$14], they complain. Is that enough for 15 people? If you divide equally by each member, what are they going to do with so little money? What will they give their children? There are always these complaints from the cultural groups … and often they complain to the (local government) and they say: "is it that they are despising our work? Is it that people do not know that dancing is a job?" '[25]

This quote further highlights issues with the training provided, and demonstrates their limited usefulness. Indeed, it is clear that women did not necessarily require courses on market access, diversification and marketing. Instead, they required decent rates of pay that would also help to enhance their sense of dignity. Again, the idea of erasure is a useful lens here. Not only were the needs of women erased as already discussed, but also the situation on the ground. Indeed, these traditional songs are increasingly politicised and used by FRELIMO to communicate widely to the masses (Arnfred, 2004: 61–2). Therefore, the current internal market expansion for songs and dances at political rallies was not understood and taken into account. Instead, the trainings focused on a neoliberal paradigm

of market extension and marketing to tourists, as if tourism was the only possible solution for these women. Local and national circumstances and specificities were erased, in order to focus on serving external tourism markets, which are nascent (as explained in the previous chapter). If the projects had focused on the specificities of the local market, then they would have gathered that the singing and dancing are important identity markers for women, and their politicisation a way of keeping these heritage manifestations alive. Using such understanding, the project could have helped to work on power relations between government officials and women, and to renegotiate rates of payment so that groups get fairer wages for their singing and dancing. Such an approach would certainly have moved away from a neoliberal stance, but, on the other hand, it would have helped to empower local women, which was the overall aim of the considered projects. By not touching on these power relations, the project leaves intact the systemic basis for women's poverty (Miraftab, 2004).

The other example I wanted to analyse occurs in Senegal. It is the regional Festival of the fonio in Kédougou (the biggest town near the Bassari Country), an intangible heritage manifestation that occurs annually and shares similarities with the Mozambican Women's Day. Re-using the codes of heritagisation, the Festival of the fonio centres on the character and work of Adja Aïssatou Aya Ndiaye, president of an EIG that prepares and sells pre-cooked fonio (the Senegalese couscous) and shea in Kédougou. Her nickname, 'Queen of the fonio', a quasi-official name used by many, including politicians and journalists (FAAPA, 2020), stands as an official recognition of her efforts to promote the crop. As part of the MDG-F project, she received, along with other women from her EIG, training in financial management and marketing, as well as direct funding to develop her activities. Interviews revealed that the assistance received then and since has helped her to consolidate and expand her business.[26] Over the years, her EIG has become one of the most important producers of fonio in Senegal (Cruz and Béavogui, 2011: 136).

Traditionally cultivated in the south-east of Senegal (including around Kédougou), fonio used to be considered a poor man's diet, a transition food eaten when waiting for other crops to be ready, and is still not as popular as other cereals such as rice. To try to further improve its reputation, the different heritage manifestations associated with fonio were inscribed on the intangible heritage register of Senegal in 2019. Fonio is indeed linked with social practices that structure the lives of communities from these territories, serving as a typical dish of, and offering for, initiation ceremonies (Nionko, 2020). I attended the 10th edition of the Festival on 15 November 2019 in Kédougou, with the theme 'Fonio, a cultural crop in

the context of climate change in Senegal'.[27] This theme is a reference to the recent recognition of the association of the crop with intangible heritage manifestations, as well as studies highlighting that it will better adapt to climate change than other crops such as maize, as it is able to withstand both drought and heavy rain (Andrieu *et al.*, 2015). This festival can thus be considered an intangible heritage manifestation closely associated with the agricultural calendar and socio-cultural practices.

The celebration saw the participation not only of local and regional politicians and elites, but also of organisations from the other regions of Senegal and even from neighbouring countries, such as Guinea and Mali. The codes of heritagisation, as they were applied in Mozambique, were also used in the celebration of the fonio. Echoing the Mozambican Women's Day, speeches from leaders were followed by traditional dances and singing. Everything was geared towards celebrating the 'Queen of the fonio', as was done in Mozambique for FRELIMO, from the speeches of different leaders to the dances. Most people also wore t-shirts with her face on them (she had made these especially for the day and distributed them to everybody), echoing the *capulana* with references to FRELIMO. One of the few differences were offerings made to Ndiaye, which did not occur in Mozambique. Through such exaltation and celebration, her role as President of the EIG and her actions are legitimised; her regional power over, and domination of the sector are also justified. This event contributes to the normalisation of a situation in which her group receives most of the private, public, national, and international funding available for the sector, and also gets the support, network, equipment, and official authorisation to sell the products prepared. Her EIG has also been a recipient of many prizes, even the 2008 Grand Prix du Chef de l'État pour la promotion de la femme (Grand Prize of the Head of State for the Advancement of Women) that aims to recognise and promote female working groups and their know-how. Through the festival and prizes won, Ndiaye can have the ear of local and regional politicians, be listened to, and gather political legitimacy in order to continue to access resources (Smith, 2007: 160). These intertwined strategies of legitimisation of her EIG, and her very public figure, make it difficult to challenge her domination. Women who have formed their own EIG on fonio[28] are thus living in the shadow or hers, and are not able to benefit from public and private funding on the same scale. The reality is very different for the other groups affiliated with Ndiaye's EIG, who have many benefits. Their women are regularly trained, and when their goods do not find customers, they are bought back for resale, to help and encourage them. Many women are thus supported in their activity.

This example demonstrates the importance of heritagisation in legitimising the work of women. Considering the discrimination faced by women in Senegal, already discussed in this book and also reflected in Senegal being ranked 163rd in the Gender Inequality Index,[29] this festival in honour of a woman is rather unusual. It can be understood as a unique example reworking, disrupting, contesting, transgressing, and transforming the dominant codes and behaviours of society (Aitchison, 2005: 217). When we interviewed her, the 'Queen of the fonio' spoke Wolof (and did not speak French), which might indicate that she did not attend formal education for long. She thus corresponds to the main profile of women working in fonio in the region. Although unusual, this example could potentially provide a model to apply elsewhere, as 50 per cent of the small-scale agricultural activities in the country are performed by women.

This example of the 'Queen of the fonio' further demonstrates how restricted the understanding of heritage is for the community village of Bandafassi and the Ministry of Culture, and how totally unrelated it is to wider development concerns. The community village and the inscription of Bandafassi on the World Heritage List was supposed to be a catalyst for the promotion of the region and its comprehensive development, including that of the fonio. This has not happened, despite the fonio being an intangible heritage manifestation able to address a number of key development challenges. None of the activities undertaken by women related to fonio is connected to the community village. This demonstrated how unconnected the village is to local dynamics and potential for socio-economic growth.

However, the difficulties faced by the EIG of the 'Queen' and the wider sector of the fonio further shows the disconnection between the transformative aspirations of the training and their reality. Although the courses, including those provided as part of the selected project, aimed to open market opportunities, these are still very limited. During our interviews, the 'Queen' lamented the lack of promotion of her products in Senegal. In her words: 'The fact that what we make is not selling is a problem. You know we want to have a television or radio to show our work so that the whole of Senegal knows what we are working on'.[30] This quote highlights that, despite the support she has been able to gather and the fact that she leads the most successful EIG on fonio, she still has problems with promoting her products. Although the training implied that the issues were simply about better marketing and finding new markets, the reality is however more complex. It is this lack of consideration of such complexity that has rendered the

courses and funding received not as transformative as it aimed to be. In particular, research has demonstrated increased urbanisation all over Africa, accompanied by changes to a more Westernised diet, more convenient and more appealing to younger generations, with imported food often cheaper than local products (Bricas *et al.*, 2016; Raschke and Cheema, 2007). Hence wider issues need consideration, including: how to encourage local consumption of products when imported ones can be cheaper; how to promote pride in local culinary traditions when Westernised ones can be more appealing; and how to promote local products that might not correspond to changing and urban lifestyles. The Conclusion of this book discusses some of these questions.

The training did not fully work because of the gap between the knowledge provided on theoretical market expansion and the reality, which is entangled in issues of neocolonialism, acculturation of tastes and cheaper imported food products. Besides, during our interview, Ndiaye lamented the lack of governmental support for gaining authorisation and quality control mechanisms for exports. The result is that Senegal exports low quantities of fonio compared to neighbouring and nearby countries, such as Mali and Burkina Faso. The training was not adequate in terms of opening up new, external markets, hence their limited impact. However, opening up external and international markets is entangled in wider issues, from a lack of price control, to lack of decent conditions for workers, a lack of protection of national markets for food security, and dependency (Darkoh and Ould-Mey, 1992). These discussions demonstrate that it is impossible to consider the field of culture in isolation, without broader and connected issues. This is what capacity-building should be about, as explained in the Chapter 5. However, the short-term framework of the projects, and the lack of consideration of structural issues such as neoliberal policies imposed from the West and the unequal power relations between North and South meant that these capacity-building efforts did not have the expected transformative impacts. These issues are further considered in Chapter 7, on environmental sustainability.

Conclusions

This chapter has highlighted the multiple connections between gender equality and heritage for sustainable development. Discussions on, and consensual transformations of, some intangible heritage practices were promoted in order to improve SRH, to address gender-based violence,

and to ensure healthy lives and well-being for all, by contributing to the reduction of the epidemics of HIV/AIDS and other communicable diseases. Crops associated with intangible heritage manifestations could assist with food security and improve nutrition, in particular those that are better adapted for climate change. The fonio, for instance, almost exclusively cultivated by women in Senegal, fits these characteristics. Finally, heritage could potentially provide decent employment, and thereby help to reduce the poverty faced by women.

However, the potential for heritage to have a transformative impact on gender equality for development was not fulfilled for several reasons. In particular, the different courses provided to improve the economic situation of women did not take account of, or address the different stereotypes, discriminations, and barriers women face; they were gender-blind. The need for equal proportions of female and male participants (or even better, a greater number of women compared to men) in training activities led to the objectification of target populations as mere numbers. This equal participation is based on the assumption that women and men have equal access to the labour market and compete on equal terms for job opportunities, thereby ignoring job separations and unequal opportunities. In addition, gatekeepers, change-makers, or key actors who could have addressed stereotypes and discrimination faced by women were not involved in the schemes. Initiatives did not work, for instance with owners of tourism outlets who tend to discriminate against women, to try to alter their approaches to recruitment. Moreover, key issues preventing women from attending training courses or employment, including household chores and caring responsibilities, were neither considered nor addressed. Hence, the principles of gender mainstreaming, that is that the concerns of women and men must be integral to the design of the actions, and discriminatory and exclusionary practices must be acknowledged and dealt with, were not accounted for. Although training is often understood to be expanding the choices that people can make, and is linked to Amartya Sen's definition of development (1999), in reality, most of them did not play this role of expanding options and choices for women, because they did not consider wider structural and institutional issues.

Conversely, strategies and training had been deployed to address gender-based violence, stereotyping, and discrimination occurring in the private sphere. However, these initiatives were too short-lived and sporadic to have profound impacts on the lives of women. The discrepancy between the gender-transformative approaches to private gender-based violence and the gender-blind approaches to training on employment

may indicate a lack of serious consideration of African women as formal workers and public figures. Even though the projects were cultural, they did not take account of the local situations and the conditions enabling women to work. In addition, the projects imposed training in fields that had not been chosen by the women themselves, reducing them to objects, rather than considering them as empowered subjects capable of making their own decisions. These initiatives also put too much emphasis on individual cultural practices, without considering other structural impacts.

Besides, the lack of continuity in the activities, funding, and intermediaries on the ground prevented long-lasting, meaningful, and transformative impacts, as also highlighted in the previous chapters. It has also long been recognised that effective actions for gender equality require not just training, but also the deployment of multiple initiatives across different sectors (see for instance Rao and Kelleher, 2005: 60), which did not occur in the selected projects, as reflected for instance by a lack of educational opportunities.

Furthermore, the projects did not rework situations where women could have had the power to renegotiate circumstances for their own socio-economic benefits. For instance, in Mozambique, dancing and singing is very much instrumentalised and used as propaganda for the party in power. The project did not consider these politicised uses of heritage and neglected to address renegotiating decent rates of pay for women in these fundamental roles. This demonstrates that the projects did not map out the different local uses of heritage, how these situations could be improved for the benefit of the most disenfranchised members of the population, as well as the potential of local solutions beyond tourism. Nevertheless, the 'Queen of the fonio' is a positive example of a woman who has been able to use international funding and the codes of heritagisation for her own benefit and that of her company. This example, although unique, is an important reminder of the potential of aid to start having empowering impacts on the ground. These issues are further considered in the Conclusion.

Notes

1. https://www.un.org/womenwatch/osagi/conceptsanddefinitions.htm.
2. Interview Senegal/12 (28 September 2019).
3. Interview Mozambique/24 (19 July 2018).
4. Interview Mozambique/40 (28 March 2019).
5. Interview Mozambique/52 and 53 (2 April 2019).
6. https://en.unesco.org/sites/default/files/priority_gender_equality_handout_2018.pdf.

7. Interview Mozambique/52 and 53 (2 April 2019).
8. Interview Mozambique/49 (27 March 2019); Interview Mozambique/52 and 53 (2 April 2019).
9. Interview Mozambique/26 (23 July 2018).
10. 'UNICEF: Mozambique: Statistics'. UNICEF.
11. Interview Senegal/16 (30 September 2019).
12. Interview Senegal/07 (27 September 2019).
13. Interview Senegal/07 (27 September 2019).
14. In 2017 the literacy rate in Senegal was 46.6 per cent for women and 69.6 per cent for men, which is an improvement.
15. Interview Mozambique/50 (20 March 2019); see also Gomis (2013) for a summary of the situation in Senegal.
16. The category of 'young artisans' was used indiscriminately for either gender.
17. Interview Mozambique/14 (30 April 2018).
18. Interview Senegal/39 (18 November 2019).
19. Interview Mozambique/03 (26 April 2018).
20. Interview Senegal/33 (16 November 2019).
21. https://www.usaid.gov/mozambique/education.
22. http://uis.unesco.org/en/country/mz.
23. Interview Mozambique/12 (6 May 2018).
24. Interview Mozambique/18 (15 July 2018).
25. Interview Mozambique/15 (30 May 2018).
26. Interview Senegal/34 (16 November 2019).
27. 'Le fonio, une culture culturelle dans un contexte de changement climatique au Sénégal'.
28. Some 90 per cent of women from the region around Kédougou work on the production of fonio (as per figures released by Nionko 2020).
29. The Gender Inequality Index has been used by UNDP in its Human Development Reports. It 'measures gender inequalities in three important aspects of human development – reproductive health, measured by maternal mortality ratio and adolescent birth rates; empowerment, measured by proportion of parliamentary seats occupied by females and proportion of adult females and males aged 25 years and older with at least some secondary education; and economic status, expressed as labour market participation and measured by labour force participation rate of female and male populations aged 15 years and older', as explained on the UNDP website at http://hdr.undp.org/en/content/gender-inequality-index-gii.
30. Interview Senegal/34 (16 November 2019).

7
Environmental sustainability

The environment has always been at the heart of the theory and practice of sustainable development. The Brundtland Report (discussed in Chapter 2), which coined the first, widely used definition of sustainable development, aimed to ensure the consideration of environmental concerns within an economic development framework. Environmental sustainability was an MDG and, with the acceleration of natural degradation, the rapid loss of biodiversity, and the climate crisis, it is also the focus of several SDGs. Environmental protection and natural resource management were a focus of the selected projects, understood as leading to improved safeguarding of heritage and providing enhanced socio-economic benefits for locals. However, delays in the start of activities resulted in an incomplete consideration of environmental issues, despite their central space in environmental discourses.

In this chapter, the connections between the protection of cultural and natural heritage and the wider environment are considered. Conscious of the silo approach of the previous chapters, the next pages offer a reflection on whether the pillars of sustainable development make sense or whether they are empty buzzwords composed of paradoxical aggregations. The pillars of the environment and the economy are the particular focus. This chapter also continues some of the reflections running through this book, particularly assessing whether and how some of the concepts of environmental protection, which originated in the West, have been adopted and transformed on the ground in the African case studies. The following pages are particularly careful in their analyses of the stereotypical construction of Africa as primarily a continent of natural beauty and wilderness – engaging with this image, deconstructing it, and assessing its impacts.

I begin by discussing the obsolete distinction between culture and nature and its negative impacts on the projects' goals. I then focus on

three key environmental issues facing Africa: trafficking of protected species, overfishing, and deforestation. Using the example of trafficking in Mozambique, I discuss the difficulty of identifying an acceptable limit to economic growth for environmental protection, highlighting the need for social justice and more equitable approaches. I continue this reflection through considering the support for artisanal fisheries and how this intangible heritage practice is entangled in broader issues, including overfishing, climate change, and mangrove depletion. The final section analyses efforts to reforest and prevent illegal wood cutting, and to preserve intangible heritage manifestations, and discusses how such efforts are restrained by the significant issues of corruption, illicit logging, lack of capacities, and poverty.

Artificial separation

The MDG-F projects were selected because of their ambitious aim to use heritage to address the social, environmental, and economic pillars of sustainable development in a cohesive manner. In order to fulfil this aim, heritage was sometimes understood holistically, as including both nature and culture. In Senegal in particular, the World Heritage List nomination dossiers for the Saloum Delta and the Bassari Country linked nature and culture, as reflected in the use of the 'cultural landscape' category. Introduced into World Heritage vocabulary in 1992, cultural landscapes supposedly represent the interface between nature and culture and the 'growing recognition of the fundamental links between local communities and their heritage, humankind and its natural environment' (Rössler, 2006: 334). The cultural landscape idea is part of the increased attention being given to the dynamic links between human beings and their environment, and a consideration of human impacts on Earth's geology and ecosystems (Parra, 2018: 59–60; Lane, 2015). This category helped move the World Heritage List beyond Eurocentric approaches, with their distinction between 'nature' and 'culture' that arose in the Enlightenment (among other times and places), and was later imposed on colonial territories as a way for Europeans to redefine and dominate them (Taruvinga, 2020: 7; Ndoro and Pwiti, 2001). Hailed as a major (r)evolution, the new paradigm of the cultural landscape is thus a notion supposed to better align the World Heritage Convention with the complex realities of heritage sites. Indeed, most heritage sites around the world see interactions between human beings and their environment: in this sense they are all cultural landscapes. Although not originally considered in those terms,

the 'Banks of the Seine' World Heritage site in Paris, for instance, has the river as its backbone, and includes all the inscribed properties built along the river course, from the Louvre to the Eiffel Tower, and from La Concorde to the Grand and Petit Palais – all clearly 'cultural' monuments set within the river landscape. Sites whose connections with the environment were omitted when inscribed on the World Heritage List, are increasingly being reconsidered and redefined from a cultural landscape perspective. For example, the Island of Mozambique buffer zone was recently revised to include its underwater archaeology, which illustrates the various eras of the history of the Indian Ocean (Duarte, 2012). However, 'cultural landscape' does not only apply to cultural heritage. Many natural heritage sites, from Kruger National Park in South Africa to Yellowstone in the United States have been constructed as 'artificial wilderness' or as 'terra nullius' – empty lands (Meskell, 2009: 89). Yet these are living cultural landscapes with the presence of Indigenous people, who were forcibly removed for the creation of national parks or protected areas (Meskell, 2007: 386; Meskell, 2012: 21; Sibongile, Van Damme and Meskell, 2009: 69).

Although the majority of sites are indeed cultural landscapes in the broader sense, only 119 World Heritage properties (10 per cent of 1,154 total properties) have been recognised under this category as of August 2021. Considering how little this category has been used in general, and even less in an African context, the nomination and inscription of the Saloum Delta and Bassari Country as cultural landscapes is innovative. The criteria chosen to justify their Outstanding Universal Value explain the interconnectedness of culture and nature. In the case of the Bassari Country, criterion (iii) was used to acknowledge the complex interactions among environmental factors, land-use practices, and social rules that have shaped the landscape; criterion (v) to recognise the unique uses of the land, including traditional agricultural systems; and criterion (vi) for the complexity of practices, social rules, rites, and beliefs that have helped the Bassari, Fula and Bédik people regulate their environment. The Bassari Country was inscribed by the World Heritage Committee under the same criteria as those under which it was nominated by the Republic of Senegal. The Saloum Delta, on the other hand, is quite different and reveals the problematic nature of the concept of cultural landscape. It was inscribed on the World Heritage List under criteria (iii) and (iv) for its exceptional shell mounds, some of which are funerary sites with baobab vegetation. Criterion (v) was also used to recognise a unique way of life centred on the gathering of shellfish and fishing, in a balanced interaction between humans and the fragile ecosystem. While these are

cultural heritage criteria, they also strongly demonstrate the interconnectedness of nature and culture, justifying the inscription of the site as a cultural landscape. The Saloum Delta was originally nominated under both cultural heritage criteria (iii), (iv), and (v); and natural heritage criteria (vii) for its exceptional natural beauty and (x) for its significant natural habitats and species, including the river dolphin. In its evaluation, the International Union for Conservation of Nature (IUCN) concluded that the property did not meet the natural heritage criteria proposed, a conclusion supported by the World Heritage Committee (IUCN, 2011). In the end, the Saloum Delta was only inscribed under cultural heritage criteria.

This decision caused confusion on the ground. Many people interviewed, even those who had in-depth knowledge of the site and the documents for its inscription, believe that only the cultural values of the Saloum Delta have been inscribed. This confusion stems from the fact that the site was only listed under cultural heritage criteria and not under the natural heritage criteria as well. For one interviewee, closely associated with the interpretation centre at the World Heritage site in Toubacouta: 'during the proposal, there was the natural side and the cultural side. As it is finally the cultural side which was classified World Heritage, [the interpretation centre] is much more focused on the cultural side'[1]. However, as just explained, the cultural heritage criteria also reflect some of the natural heritage values of the site. But because of the distinction in the criteria, there is a shared belief that only the cultural heritage values have been recognised. This has resulted in the centre activities being restricted to explaining the cultural values, including of the archaeological sites and shell mounds, and to supporting local cultural initiatives, such as theatre troupes and music groups through the provision of a rehearsal space. Only 'Club Nature' provides activities on the natural elements of the Saloum Delta. Aimed at children, the club raises awareness of environmental issues such as deforestation and overexploitation of the mangroves. The intention is that children, being sensitised from an early age, will want to continue to protect the environment when adults. In addition, it is hoped that parents may also be more easily sensitised to environmental issues by their children than by means outside of the private sphere. More than just raising awareness, children from the club also participate in reforestation campaigns organised by local NGOs.

However, the distinction between nature and culture means that issues are not looked at holistically, but in a compartmentalised manner (Harrison, 2015: 33). With this separate consideration, some goals of the interpretation centre as defined in the MDG-F project (to protect the

environment better for the benefit of locals) were difficult to implement (Damiba, 2012: 42). This was well-expressed by one interviewee, concerning the limits of the Club Nature: 'It should not be a Club Nature. It should be a Club Nature and Culture, so that children could understand what culture is as well. They shouldn't think culture is just dancing and music ... A Club Nature and Culture should be about building citizens to give them values that will be cultural values with an environmental education'.[2] This interviewee calls for the greater integration of nature and culture. In this approach, the protection of heritage would be undertaken in a holistic manner. For instance, reforestation would not only be considered as protecting the environment, but also as a way of preventing climate change, which affects both cultural values and the ecosystem services available for locals. This would lead locals to consider the site and the issues it faces as interconnected and to perhaps find more relevant and efficient solutions. Hence a consideration of the connection between culture and nature would help to address more effectively sustainable development challenges.

More than just a lack of holistic consideration, this distinction between nature and culture makes it impossible to understand the Saloum Delta. Again, the notion of erasure can be used to read this inscription. Missing is the people–environment relationship that defines the site and is at the heart of traditional protection mechanisms. The site itself reflects the inseparable connection between humans and their environment, with its different river arms, man-made shell mounds and funerary baobabs (see Figure 7.1). In addition, the landscape reflects different ontologies, some of which include a number of supernatural actors with which one needs to cooperate, such as the protective genius of Laga Ndong, which has led to the better safeguarding of some bolongs. For others, access to rice fields is also regulated by bush spirits (Cisse, Ghysel and Verleulen, 2004). In these traditional systems, which are not necessarily shared by all locally and have evolved and eroded over time, human beings cannot necessarily control nature, which is not an inert object but imbued with supernatural forces. However, these systems demonstrate how disconnected they are from the Western and 'modern' constitution of the separation of nature and culture (Descola, 2005; Latour, 1993; Byrne and Ween, 2015) and how they have been occulted by this dichotomous reality.

The problem is that the concept of cultural landscape has not challenged, moved beyond, or abolished the nature/culture divide. Ironically, the history of the different versions of the World Heritage criteria reveals an increased separation between nature and culture over time

Figure 7.1 Saloum Delta, with its inseparable natural and cultural elements. © Sophia Labadi.

(Larsen and Wijesuriya, 2015). In 1992, the year that the notion of cultural landscape was introduced, explicit references to the interactions of humans with their environment were removed from the natural heritage criteria. Indeed, the criteria for assessing and inscribing sites on the List still follow this strict divide between cultural and natural heritage. How can a cultural landscape, supposedly representing the interface between natural and cultural values, only be listed under one of these two sets of criteria? It causes confusion, as exemplified at the Saloum Delta. The implementation of this concept therefore runs counter to its spirit and definition. This continuous divide is exacerbated by the two organisations separately assessing heritage sites nominated for inscription: ICOMOS for cultural heritage and IUCN for natural heritage. According to some, the divide is here to stay (see for example Liley, 2013). However, aware that, as expressed by Phillips (2005), 'the separation of the cultural and natural world – of people from nature – makes little sense', IUCN, ICOMOS and the International Centre for the Study of the Preservation and Restoration of Cultural Property (ICCROM) have implemented projects and training activities to bridge the divide. But despite these laudable projects, the case of the Saloum Delta illustrates that the bounded concepts of 'nature' and 'culture' continue to define heritage.

Post-colonial African countries are still working with these bounded concepts inherited from the colonial past and from the contemporary North, as they have used international legislation to frame their regional and national laws (Ndoro and Pwiti, 2001: 33). This is the case for instance in the Charter for African Cultural Renaissance,[3] adopted by

the African Union in 2006 to empower member states to strengthen their national policies, and in the Senegalese national law for the protection of heritage. The Charter for African Cultural Renaissance, in particular, calls for greater recognition and enhancement of endogenous cultures as springboards for sustainable development, reflecting the very origin of the heritage for development movement, as charted in Chapter 2. However, quite ironically, the frameworks and associated legislations that should lead to such a change have not been able to move away from European and colonialist taxonomies, in order to impose their own heritage categories. Hence, on the ground, internationally and nationally protected areas have to be managed according to an imposed and external reality that is different from local, traditional and holistic understanding of culture and nature. This situation has led to various conflicts between local models of heritage management and imported ones, as recorded, for instance, during projects for the sustainable development of Mosi-oa-Tunya/Victoria Falls Transboundary World Heritage Property, Livingstone, Zambia (Zulu, 2020).

This siloed and compartmentalised approach also freezes heritage, rather than recognising its dynamic nature (Larsen and Wijesuriya, 2015: 6). This is because concepts such as 'nature', 'culture', and 'heritage' are understood in a stereotypical and essentialist way. This goes against consideration of heritage for sustainable development – that is, as necessarily evolving, in order to take account of, and integrate, contemporary pressing issues. Although heritage for sustainable development has been a recurring narrative for UNESCO, the implementation of the World Heritage Convention (the flagship programme of UNESCO) works against this approach when it solidifies and pigeonholes concepts. The nomination dossier and evaluation document of the Bassari Country provide good illustrations of these issues, particularly the way in which locals have been represented. Chapter 5 has already explained the exclusion of local ethnic minorities from the conservation, management, interpretation, and promotion of their heritage, and the contempt for them expressed by their government representatives. These negative considerations of local communities have been exacerbated by this siloed, unchanging, and stereotyped understanding of nature, culture, and heritage. Indeed, the nomination dossier uses the supposedly unchanging nature of the locals and their surroundings as the reason why the site is of Outstanding Universal Value:

> The Bassari country is known throughout Senegal for the richness
> and good preservation of its traditions … The external influences

that have distorted many regions of Senegal both on the natural and cultural plane are absent here. Despite the difficult living conditions, the populations of the area proudly defend their traditions, which means that architecture, natural resource management, and cultural practices are respected ... that the landscapes, masks, hairstyles, costumes, and all other tangible manifestations of these cultural practices have not changed ... This permanence, illustrated by the similarity of the two sets of photographs, is remarkable in a globalised world that moves so quickly. (République du Sénégal, 2011: 72)

Instead of regarding cultural landscapes as dynamic, this quote and the wider inscription of the Bassari Country as a World Heritage site focus on its unchanged and unchanging aspects. Local communities have been essentialised and viewed as no threat to their environment because they live in harmony with it. The ICOMOS evaluation, echoing these statements, explains that the local ethnic minorities have lived away from 'modernity', with the exception of the adoption of 'Western' clothes (ICOMOS, 2012: 73). Africa has been constructed as a wild continent, rich in natural heritage, its populations either erased (see Meskell, 2009; Keitumetse, 2016) or exoticised as 'tribal cultures' and 'good savages' who live in harmony with nature, as exemplified by the stereotyped representation of the Maasai (of Kenya and Tanzania) and the San (of Southern Africa). As illustrated by the Bassari Country, the same grammar and narratives are being used to describe cultural heritage sites as natural heritage ones. This narrative has been adopted by the Senegalese themselves (see Chapter 5) as a way of establishing a hierarchy between ethnic minorities, and of controlling their representation, identity and living conditions. Living in harmony with nature, these minorities are also presented as not being a threat to heritage, as they are frozen in time and not seen as wanting change.

This static presentation of heritage has nothing to do with reality. The Bassari in particular do not live in autarky. They had to take part in forced labour during colonial times and to emigrate seasonally from their village (Nolan, 1977). This seasonal emigration has increased since independence, and has been made easier since the opening of a road from Kédougou to Toubacounda in 1994. In addition, children go to school and so have less time to learn social traditions and rituals. In terms of landscape and architecture, it has been documented that more and more people adopt a square house – easier to set up – rather than a round one (N'Dong, 2009). Most people I met in the Bassari Country have cell

phones with internet access. Since 2015, houses (including traditional houses) are even equipped with a satellite dish to receive satellite TV, thanks to Chinese bilateral aid.

This static, frozen, and compartmentalised approach to heritage, and the stereotyped consideration of minorities, has detached properties from their contemporary sustainable development issues. For instance, to use again the case of the Bassari Country, the ICOMOS evaluation explains that locals are frozen in time, but also notes that these populations will be massively affected by climate change, including an increase in temperature and a decrease in rainfall. This approach limits the way current challenges like climate change can be meaningfully addressed. No document related to the World Heritage listing or management reflects upon the fonio, discussed in the previous chapter, as one possible intangible heritage manifestation from the region that could provide food security, and which can thrive despite climate change. And although some heritage properties might provide interesting solutions to contemporary challenges, a static approach focused on the past prevents solutions from being considered. For instance, the Saloum Delta shell mounds have always provided natural and efficient barriers against rising sea levels, a pressing issue with climate change.[4] Yet this innovative solution is being overlooked because local communities are not considered as fully living in the present and hence as not being able to contribute to contemporary issues. This has also led to the exploitation of seashells as building materials. The temporal discontinuity between present-day issues and local people considered stereotypically as living in the past means that traditional solutions are still too often not considered as relevant to solving these challenges and are discarded for more 'scientific' (read Western) ones, setting thus hierarchies of knowledge (Jopela and Fredriksen, 2015: 267).

The project in Ethiopia provides another example of a separate consideration of culture and nature, but also of a lack of serious consideration of the negative impacts of heritage conservation and management, partly due to the stereotypical understanding by international organisations of heritage as benevolent and neutral, as already discussed. Such neutral understanding has been used to shape the various activities on the ground. In the Ethiopian case, policies and guidelines on the management and protection of heritage were revised and developed. Training increased the government's capacity to enforce policy implementation. Awareness was raised in targeted communities about the impact of environmental degradation, particularly for people living around the National

Parks. This was accompanied by highlighting and promoting ecosystem services available due to improved protection of the environment, as well as Indigenous knowledge and good practice in natural heritage management. However, the final evaluation of the project laments the lack of understanding of the negative environmental impacts of heritage protection and associated cultural activities. Moving away from considering heritage as simply about laws and the number of sites or areas being protected, this document calls for thorough analysis of environmental degradation and impacts related to the cultural activities supported at heritage properties. Negative environmental impacts include, for example, soil degradation related to pottery manufacture and the pollution and associated health issues (such as respiratory problems) resulting from the use of traditional ovens (Tadesse, 2013: 22). Importantly, this example further demonstrates that the protection of heritage and its associated cultural activities are not necessarily positive or benevolent and that heritage in some cases is not aligned with principles of environmental sustainability, as reflected for instance in the term 'polluting culture' (De Beukelaer, 2019). The lack of understanding of the interaction between heritage conservation, environmental protection, and well-being might explain these cases, in addition to an inability to move beyond obsolete categories of natural and cultural heritage, backwards-looking understandings of their benevolent nature, and the stereotyping of locals.

Limits on heritage for sustainable development?

The strength of the concept of sustainable development lies in its holistic and complementary consideration of the economy, social relationships, and the environment. This notion has also regularly been criticised as merely paradoxical aggregations attempting to bring together fields with contradictory objectives and methods (Baillie and Sørensen, 2010b; Flipo, 2005: 1; Boccardi, 2007: 10). Critics of the MDGs and the SDGs ask how it is possible to protect the planet and environment from degradation while at the same time ensuring continued global economic growth (Adelman, 2018). Aren't these goals contradictory? As explained through this book, sustainable development has been considered by institutional actors mainly in terms of economic impacts and the generation of revenues, as reflected for instance in the myriad training courses delivered on

marketing, business planning, and product design and control, discussed at length in Chapters 5 and 6. This has led to conflicts between the different pillars of sustainable development, primarily between the economic and environmental pillars.

Mozambique is a telling case. During my fieldwork on the Island of Mozambique, when looking for artisans who participated in the MDG-F training, I was introduced to a Makonde carver. Makonde artists are popular for their wood carvings, for instance the 'trees of life', tall sculptures depicting intertwined human figures that may symbolise connectedness among and assistance between different generations. Although the carver was not a participant in any of the training programmes, he had heard about the project, and its message that culture should be used for development. He started the conversation by telling me that he was using his intangible heritage skills for his economic and social development. Studying his case illustrates the wider impacts of the projects' heritage-for-development narratives on locals, demonstrating their influence beyond the narrow circle of participants. At the start of our meeting, this carver took out a brand-new tablet computer and proudly showed me pictures of exquisitely carved artefacts made from elephant tusks and tortoise shells. He apologised for not being able to show me the actual artefacts, which he had already sold. Artefacts carved in ivory, he explained, were in great demand by Chinese customers, who were willing to pay high prices for them. This was not an isolated case. When walking around Independence Square in downtown Maputo, the capital of Mozambique, a street vendor tried to sell me a wood carving, arguing that as a European this would correspond to my taste, though if I were Chinese, he would have offered me ivory carvings, because 'Chinese want ivory objects'.

In 1989, the Convention on International Trade in Endangered Species of Wild Fauna and Flora (CITES) proclaimed a total ban on the ivory trade, concerned about the declining elephant population. However, distinguishing between pre-1989 and recently poached ivory is almost impossible (Gossmann, 2009: 51). Mozambique is a country with a high level of poaching and illegal ivory trade (UNODC, 2020: 50). Even in the Niassa National Reserve for instance, although it is home to 70 per cent of the country's elephants, as many as 6,000 (out of a total of 11,000) were killed between 2009 and 2018 (Hirsch, 2019). Between 2005 and 2017, 90 per cent of the known destinations of poached ivory were in China, Vietnam and Cambodia (UNODC, 2020: 52). In reaction to these alarming figures Mozambique, a country that has been party to CITES since 1981, has taken a number of measures in line with

recommendations from leading organisations working on the trade in wild animals (for example from the non-governmental organisation TRAFFIC), including introducing stronger legislation, stronger fines for poachers, training for guards in protected areas, fighting corruption within the police and closer cooperation between customs services and the National Administration of Conservation Areas (ANAC). In an attempt to curb the demand, China has also taken the bold move of banning the sale of ivory as of 2017 (Bielicki, 2019).

Despite this background, ivory products were widely available in retail outlets and open-air curio markets in Mozambique until the mid-2000s (see Milliken, Pole and Huongo, 2006: 34–5). These products are no longer sold openly. Yet my experience of easily meeting artists ready to sell me ivory craft items, even without me asking for them, may reveal how popular and widely accessible they are. The structure of the market also seems to have remained the same over the years. In 1999 ivory carvers were primarily found in Maputo and Nampula Province (Martin and Stiles, 2000). In 2018, I was offered ivory artefacts in these exact places. It is true that artefacts made from legally sourced ivory exist in Africa in general, and in Mozambique in particular, and that the artefacts I was offered could have come from stocks of ivory acquired prior to the ban.

However, my interview with the Makonde ivory carver from the Island of Mozambique makes it clear that additional measures are required. First, he strongly believed that his work was contributing to implementing the heritage-for-development narrative promoted by the international community. He explained to me that he was using his intangible heritage of carving skills, passed down to him by previous generations of Makonde carvers, to ensure his economic subsistence. By isolating economic development as a major driver of heritage conservation, without linking it to other major concerns such as the environment, a negative interpretation can occur. Yet the previous chapters, particularly Chapter 4 focusing on the management of the selected projects, have highlighted how difficult it is for different organisations to work together towards a common goal. In addition, this use of the concept for the opposite of its intended purpose demonstrates again the lack of careful consideration of the potential negative impacts of heritage. During my interview with the Makonde carver I naively tried to explain that ivory and tortoiseshell come from endangered species and that protecting biodiversity is essential for the survival of the planet and of human beings. My interviewee was unconvinced by this discourse. Although the conservation movement has increasingly taken root and been shaped according

to national and local priorities and realities, rather than being an externally driven and neocolonial endeavour for the benefits of Western interests (José, 2017: 198–230; Witter, 2013: 407–8), our encounter reveals a complex situation.

Indeed, until the 1989 ban and even for a decade afterwards, it was not uncommon to find animal products as souvenirs for tourists in and around national parks and other popular spots, from ivory carvings to elephant hair bracelets (Macgregor, 1989). The CITES ban has obviously created a loss of income for ivory carvers. Yet in making their trade illegal, no alternative seems to have been provided for Makonde artists to survive. My interviewee made me realise that wildlife protection can only be taken seriously by locals if revenue earned from protecting wildlife is shared equally with communities or if viable alternative livelihoods are provided to compensate for loss of revenue. As summarised by Walker, echoing my informant's view: 'Most disadvantaged communities cannot consider conservation, as we know it, when their bellies are empty. Their own survival is the issue ...' (Walker, 1987/1988: 28). This example illustrates the fundamental importance of an integrated approach to sustainable development, where combating poaching and trafficking of protected species can only happen if local communities are able to pursue sustainable alternative livelihood opportunities (see SDG 15c) or where the benefits of conservation are shared. This would put social justice at the heart of the concept of sustainable development, without which deterrent measures such as stronger legislation and increased number of guards for protected areas will not work (Parra, 2018: 60–1). This approach has slowly started to be applied in several countries, and even in some parts of Mozambique (Witter, 2013), as well as in some regions, for example by the Central Africa World Heritage Forest Initiative (CAWHFI; see Biada, 2020: 37). Although several different approaches have been promoted, a number of them focus on alternative livelihood activities around tourism that adopt the same model as the MDG-F projects assessed here. The cautionary tales of the limits and shortcomings of such approaches, highlighted in Chapter 5, demonstrate the importance of moving beyond tourism to focus on fulfilling the needs of locals, as has been done to some extent for the CAWHFI, with a focus on fish farming, the rearing of small livestock or fish smoking and their sale. Locals in this approach are the only ones asked to adapt themselves, while no efforts are made to change buyers. Parallel initiatives should target buyers of illicit ivory, to have real impacts on the trade, rather than putting all of the emphasis and blame on source communities.

Finally, my encounter with the Makonde carver echoes some of the international debates on heritage and sustainable development that led to the drafting of SDG 11.4, detailed in Chapter 3, and their entanglement with issues of neocolonialism and neoliberalism. For this reason, it is sometimes difficult to establish the limits of economic considerations. Some may consider, as could have been the case with the Makonde carver, that the protection of wildlife is tainted with neocolonialism and that his actions are a reaction against that. The eighteenth and nineteenth centuries witnessed the widespread killing of wildlife, including elephants, and an international trade in ivory for Western consumption (as piano-keys or fan parts, for example), followed in the early twentieth century by the establishment of game reserves, set up for the enjoyment of Westerners and often at the expense of locals (Kelly, 2021). In some places this model still prevails, and game reserves are created primarily for Western tourists in an attempt to create an imagined 'wild Africa'. Locals rarely benefit from these invented landscapes (in the case of Botswana for instance; see Matswiri, 2020). Thus the 'moral imperative' to protect wildlife takes different forms and represents diverging realities, whether one is white and rich or black and poor. As charted by Meskell, discussing the specific case of South Africa, while it is acceptable for rich Westerners to 'hunt' on private game farms, for poor blacks, this is not possible and their actions are categorised as wrongdoing (2005: 97–8). Under these circumstances, the Makonde carver's position can be read as a defiant one, challenging such neocolonialist approaches and power relations.

These discussions echo the international situation. During debates on 'World Heritage and Sustainable Development' at the annual sessions of the World Heritage Committee, African delegates have expressed defiance at the concept of sustainable development and its limits on economic development. During both these sessions and the debates on the draft of the Policy on World Heritage and Sustainable Development in 2015, some African states questioned the principle of the 'no-go' commitment which does not permit extractive activities within World Heritage properties. This no-go commitment has so far been signed by twenty-two of the world's leading mining and oil companies, including Shell and Total, as well as several financial companies, including Paribas, HSBC, and JPMorgan (Labadi, 2019c: 21). Restrictions such as the no-go commitment seem to have been interpreted as (neo)colonialism by African countries, and as way of using the Eurocentric World Heritage Convention to prevent the economic development of the continent.

The 2018 Position Paper on World Heritage and Sustainable Development in Africa, approved by various institutions including the AU, even indicates that the no-go areas 'appear to be disproportional to the nature, scope and complexity of the problem at hand' (African Union, 2018). For African countries, a parallel can be drawn between the colonial period, when their resources were massively exploited for the benefit of colonial powers, and post-colonial times when these same powers claim that resources should no longer be exploited, in the name of heritage protection (Abungu, 2015: 385). This can partially explain the rejection of the no-go principle. However, one of the key concepts of sustainable development is social justice, a principle of the 2015 Policy. Major extractive industries may benefit from foreign capital investors, consultants, and governments, all the while destroying the local environment, heritage, and history yet bringing, in the majority of cases, very little benefit for locals (Chirikure, 2014: 218–31). Reports have regularly highlighted that mining, for instance, is capital-intensive and thus may sharpen inequality without leading to benefits for locals (see for instance South African Human Rights Commission, 2017). Hence contesting the 'no-go' principles may be a way for African governments to protect their own interests rather than those of locals, thus using the rhetoric of heritage-for-development for their own benefits, an idea that has already been expressed in other parts of this book.

Artisanal fisheries vs overfishing

The previous section discussed how the idea that heritage can contribute to sustainable development can be wrongly interpreted, and in fact be detrimental to environmental protection. Closely related to this is the difficulty of reaching a balanced approach between the pillars of the environment and the economy. This section discusses support for traditional fisheries, widely recognised as environmentally friendly and as a way to conserve and sustainably use marine resources, as recognised in SDG 14 and in a number of publications (such as Marti, 2020: 184–6 and Nunoo et al., 2015). However, support for this intangible heritage practice is entangled in a number of issues, including overfishing, climate change, and mangrove depletion. Paradoxically, although some of these issues have been high on the international agenda for years, particularly climate change, they seem to have been overlooked in the MDG-F projects. This lack of consideration has led to the programmes being based on erroneous assumptions, and therefore to the incomplete

achievement of their aims. The end of this section explains how problems were exacerbated by an over-reliance on tourism as a way of bridging and bringing environmental protection and economic benefits.

In the Saloum Delta (Senegal), for example, one aim of the MDG-F project was to support, protect, and encourage small artisanal fisheries. Artisanal fisheries in this part of Senegal are rich intangible heritage manifestations, with twenty-five fishing techniques and seven types of boats recorded for catches, with different gender specificities, in addition to spatial and social rules and norms, including taboos (Bousso, 1994: 26–7). Artisanal fishing was considered not only environmentally friendly (although it is increasingly motorised), but also capable of driving local economic growth. Supporting this sector was thus supposed to contribute to two pillars of sustainable development (the environment and the economy), as well as to encourage the protection of intangible heritage (see Figure 7.2). With the inscription of the Saloum Delta on the World Heritage List, tourists and visitors were supposed to flock inevitably to the region. Fishermen were thus going to benefit from this new market made of these increased tourists and visitors, but also of hotels and restaurants which cater for them. In order to realise this vision, the fishing sector was reorganised into EIGs, which aimed to pool resources, material, and human capacities. Problems were collectively identified, and solutions proposed and acted upon. Lack of equipment and materials was identified as a key issue, and some groups were provided with fishing gear. The implementation and evaluation of activities reflect the

Figure 7.2 Artisanal fishing in the Saloum Delta (September 2019). © Sophia Labadi.

assumption that West African waters have unlimited resources, available to fishermen as soon as they were better organised and had better equipment. Results, detailed in the final evaluation report, are positive. Thanks to the support received, some fishermen increased their monthly fish production. In addition, the price of specific fish rose from 400 to 2000 CFA Franc (from US$0.70 to US$3.50) during the project, representing a substantial revenue increase (Damiba, 2012: 41). Although not clearly explained, this was also assumed to have resulted from a change in consumers, with tourists (and places catering to them) ready to pay higher prices than locals. Hence tourism was again the sector identified to ensure heritage and environmental protection alongside economic growth for locals.

However, these assumptions, and the official documents, are inaccurate. The project's implementation and evaluation reveal a lack of understanding of the environmental situation on the ground and the reasons for the results observed. First, during the project the Saloum Delta was (and indeed still is) characterised by overfishing and a decline in marine resources, despite the ocean off Western Africa having some of the world's richest fishing grounds. Data reveal increased levels of overfishing in the Saloum Delta and Senegal since at least the 1990s (Belhabib et al., 2014; Ecoutin et al., 2010: 290–1). This is not an isolated example. Overfishing occurs in many African countries, including Mozambique, despite their rich fishing waters, and is due in part to legal and illegal foreign industrial vessels. West African waters have the highest levels of illegal catch in the world, at about 37 per cent of their annual catch (Ranta, 2015). Industrial fishing methods are also responsible for the depletion of the ocean. As explained by a local fisherman interviewed in the Saloum Delta: '... these foreign boats from everywhere, Europe, China ... they fished, fished ... It was catastrophic because once they throw the nets, they caught a lot of fish. They then sorted out what they needed, the rest they threw in the water. But the discarded fish were dead. It happened for years and years and people said nothing, and in the end, it posed a big problem for us.'[5] However, overfishing is not the only problem – climate change is also a major issue. With the rising salinity of seawater due to the drop in rainfall, among other factors, mangroves are dying (Dieye, 2007). Mangroves enrich the estuarine and marine environment with nutrients through the biodegradation of organic matter (Ndour et al., 2011). It is against this backdrop that a number of aid schemes, including the MDG-F one, aimed to increase artisanal fishing capacities (Déme and Dioh, 1994: 94). Because of the depletion of fish

stocks, artisanal fishermen have had to fish farther away from the coast. As explained by one interviewee, a fisherman from the Saloum Delta: 'In the past you used a bit of fuel and catch lots of fish. And now you need a lot of fuel to catch very few fish. You can't sell it cheaply; you still have to sell it at a high price so you can get something'.[6] Contrary to the assumptions of the project evaluation, it is not at all because of a change in the market that prices have changed. It is because it is now more expensive to catch fish, due to its entanglements with wider issues, including industrial fishing, overfishing and climate change.

These erroneous assumptions seem to be linked to a lack of clear understanding of the environmental situation on the ground. The project relied on increased tourism as the only option that would help fishermen. Yet the continuous environmental degradation already deterring tourists from visiting the area was not taken into account. During my stay in the Saloum Delta I was constantly reminded in my interviews with fishermen that a high number of tourists used to travel to the area to fish. However, fewer and fewer of these visitors have been coming to the region. In the words of one interviewee: 'Overfishing has led to a decrease in tourism because, among all the tourists who came only for fishing, most of them don't come back anymore because there aren't enough fish like before, so that poses a problem for us, that poses a big problem for us ...'.[7] Interviewees also warned that the construction of hotels and houses by foreigners on the coast is destroying mangroves, thus accelerating the impoverishment of marine life.[8] The focus on the economic dimension through tourism development can therefore exacerbate issues on the ground.

In addition, although fish are an essential part of the Senegalese diet (as exemplified by the national dish Thiéboudienne/ceebu jën, meaning 'fish with rice') and most of the population gets its animal protein intake from fish, the activities did not take account of the potential impacts of the project on local food security. Worse, all the issues discussed (overfishing, mangrove depletion, and climate change) are problems that local community-based projects were already tackling before the start of the MDG-F scheme. Indeed, at least one community-led initiative from the early 2000s created a protected marine area in Bamboung (close to Toubacouta) where no fishing, oyster harvesting, or firewood collection is allowed. Such local actions demonstrate that the issue of overfishing was well known on the ground, and was not sufficiently considered in the MDG-F project. Although this particular activity did not implement its goals, some of the reports produced on fishing have led, in the long term, to the embryonic development of aquaculture in the region, to diversify

production methods and fish sources. However, the lack of basic equipment such as refrigerated trucks for local EIGs means that this venture will require some time before it becomes successful.

This example continues and expands some of the discussions from the previous chapters. In particular, it reveals clearly how inefficient a focus on individuals, tourism and the market is for (intangible) heritage and environmental protection. Indeed, this approach does not consider broader issues, often linked to neoliberal views of natural resources as unlimited. Here we have discussed how difficult it is to protect artisanal fisheries as intangible heritage alongside an environmentally sustainable approach for economic growth without a serious understanding of the broader contexts of industrial, legal and illegal fishing. The project ignored issues of racial environmental justice and unequal access to resources, including the rise in illegal fleets and fishing (Belhabib *et al.*, 2014: 7). Indeed, competition for local resources was omitted, as well as the fact that locals might be disadvantaged compared with industrial fleets coming from abroad, especially Europe and China. Rather, a neutral approach was adopted where resources were assumed to be equally available for all, which might reveal a lack of comprehension of local issues. In addition, the narrow focus on intangible heritage practices erased existing local solutions that addressed some of the unequal power relations, including the community-led protected areas that have emerged in Senegal, but also in other African countries (for instance in Mozambique). This demonstrates how some of the SDGs (including SDG 2 and SDG 14), as well as the narrative of heritage for development, will be difficult to fulfil without considering unjust industrial systems of natural resource exploitation, unequal access to these resources, issues of environmental and social justice, and locally based solutions. This example also makes clear that ensuring the protection of artisanal fisheries and the environment is not compatible with intensive resource extraction and resource scarcity. The structure of market economies needs to be reconsidered rather than left out, as happened with the SDGs (Jackson, 2009: 86).

This chapter has so far discussed the lack of serious consideration of the links between nature and culture and the difficulty of holistic considerations of heritage for sustainable development because they are often entangled in broader issues. I have also discussed one of the most pressing issues facing the African continent: overfishing and threats to artisanal fisheries as intangible heritage manifestations. Another leading environmental issue facing the region is deforestation, the focus of this final section.

Sustainable forestry?

The selected project in Mozambique focused on forest management, specifically on training for increased knowledge of existing laws, reforestation, and the prevention of illegal wood cutting. Deforestation is one of the most pressing issues in Africa, the result of many different factors, including slash-and-burn agriculture, timber demand from around the world, and illegal wood cutting, fuelled by corruption in the sector (see Lemos, 2014). In Mozambique alone, eight million hectares of forest have been lost since the 1970s, an area almost the size of Portugal (World Bank, 2017: 3). Reforestation is one solution that is not new, as exemplified by the work of the Nobel Prize winner Wangari Maathai of Kenya as early as the 1970s. Trees provide a simple solution to complex problems: their roots prevent soil erosion; they absorb carbon dioxide; they give habitats for wildlife and encourage biodiversity; and they procure many services for humans, from shade and food, to sacred meanings and places for contacts with ancestors. As climate change escalates and local environments are damaged, tree planting has become a booming 'economy of repair' sector. Many NGOs focus on reforestation. In addition, with Westerners increasingly becoming conscious of their impacts on the planet, carbon offsetting is becoming an important trade. Carbon offsetting works by calculating the carbon dioxide emissions of certain activities and then compensating for these emissions by funding an equivalent carbon dioxide sink (such as trees) elsewhere. Most carbon offsetting companies offer schemes that include reforestation. For four trips from London to Mozambique, I must plant 28 trees to offset my carbon footprint. Of course, it is not about actually planting trees, but giving money to a reforestation venture, often in Africa (which may represent a combination of tree planting and charity giving), which plants the trees on my behalf. When browsing through the catalogue of projects offered by these 'economy of repair' companies, reforestation is presented as easy and straightforward. However, the example of Mozambique demonstrates its complexity.

As part of the Mozambican project, training courses were provided on sustainable forestry management, wildlife laws, and the sustainable exploitation of natural resources. Endogenous and endangered species that support intangible heritage practices were also replanted. Specifically, four kilos of *mwendje* seeds were bought from a *timbila* maker and player, and tree nurseries were set up in Maculuva, Nhamassuae, and Tofo (in the Inhambane province) to compare developments (Metwalli, 2010: 22). *Mwendje* tree is used to make *timbila* (singular *mbila*), xylophones of varying sizes and pitch ranges made by the

Chopi communities in Zavala. *Timbila* were inscribed on the UNESCO Representative List of the Intangible Cultural Heritage of humanity in 2008. Often played during festivals or other events, there are accompanying traditional dances. The Mozambican Women's Day, discussed in Chapter 6, saw many *timbila* groups performing. *Timbila* makers, based in Zavala (in the Inhambane province), complained that they no longer had any wood with which to make their instruments. *Mwendje* trees, like many other species in Mozambique, are threatened by deforestation and forest clearance to make way for cash crops, charcoal production (which people turn to as a supplement to their income) and exports. Although some nurseries did not work (the water was too salty in Maculuva, for instance), the nursery in Nhamassuae was a success. Plants were then distributed to community members,[9] including musicians and *timbila* makers in Zavala, and replanted in community forests there. These activities correspond to the goal of former President Guebuza (2005–15) to encourage each and every Mozambican to plant trees ('um líder, uma floresta' and 'um aluno, uma planta').

Replanting native species has a number of benefits, in contrast with other reforestation or afforestation schemes. Industrial projects in particular are externally oriented and based on the needs of Northern countries, such as carbon credit for sale or the production of wood-based materials for pulp, paper, and packaging. Profitability being the guiding principle of these projects, a species that grows quickly is usually privileged, even if it is not a native one, and even if a lot of water is required, depleting aquifers (as is the case for Eucalyptus, for instance, which has been chosen for some World Bank ventures). These activities tend to result in large areas of native forest being cleared to make way for monocultures (Neimark, 2018; World Rainforest Movement and Timberwatch Coalition, 2016). Replanting native species supposedly corresponds to a different logic: it is undertaken by and/or for community members, who hope to benefit from ecosystem services and to ensure the continuity of intangible heritage practices. Hence this project addressed challenges faced by the community and responded to national priorities.

Yet the scheme aiming to replant the native *mwendje* tree faced many issues, clearly explained in the final evaluation report for the project and by my interviewees. First, the activities relied on community members to reforest. Most of these community members, with the possible exception of *timbila* makers and musicians, had little interest in a tree that is slow to grow and can take more than fifty years to be market-ready. Since reforestation was approached from the angle of economic benefit, rather than from the angle of environmental protection or health,

frustration was expressed among the local population, who wanted additional incentives (Eurosis, 2012: 56–7). Some interviewees also told me bluntly that people are not interested in planting trees. This is not necessarily surprising, considering the multiple tasks that economically disadvantaged communities must perform in their daily struggles. This echoes some of the comments made on the running of community radios in Chapter 6, which relied on the goodwill of locals. It also shows the discrepancy between the narrative on sustainable development, which is long-term, and projects that focus on people who may have no choice but to prioritise the present. However, this frustration may also be due to the way in which the tree-planting activities were framed and explained to locals, with too much emphasis on the economic returns. Indeed, reforestation activities have successfully occurred in other places, for instance in the Saloum Delta (Senegal), where a local NGO is involving locals in reforestation activities for a healthier environment and with increased ecosystem service benefits for locals.

Another problem was that nobody was taught how to collect *mwendje* seeds, a difficult skill that in Zavala had been mastered by only one elder (Eurosis, 2012: 57). This certainly limits the possibility of regular seed collection for reforestation on a long-term basis. Ironically, although the project aimed to replant *mwendje* trees in Zavala, many people pointed out that the tree is not actually native to the area and does not naturally grow there. According to some of interviewees: 'it seems that our soil is not suitable for planting *mwendje* trees, because there are people who had the plants, but they died'.[10] Apparently, an old *timbila* player in Zavala planted seeds with some success in the 1970s, leading to the belief that the tree was native to the locality. However, *mwendje* tree planting is more successful in the northern part of the Inhambane Province than in the southern part (where Zavala is located), as reflected by the success of some nurseries. This example reflects a lack of interest in this initiative, a lack of understanding of which species grow where, and a need for a fine-grained understanding of the local tree species before reforestation activities occur. Interviews with locals demonstrated such fine-grained understanding, and thus the need for their greater involvement, rather than relying on external consultants. Again, the idea of erasure can provide a lens to assess this reforestation project, with the erasure of local knowledge on endogenous trees and their location, on seed collection, as well as on local needs.

In addition to reforestation, the programme in Mozambique aimed to create two wood banks, one in the Northern province of Nampula and another in Maputo. Artisans would then be provided with secure

access to raw materials for their products, through obtaining a concession licence to cut wood. The ultimate goal was to prevent carvers from illegally chopping wood, and so to protect forestry resources. Artisans would form groups of ten to pay for a licence from the Direcção Provincial de Agricultura (Provincial Directorate of Agriculture). Locals would then be consulted about areas where wood could be chopped, and the forestry inspector would control the amount cut. Twenty per cent of the fees would go back to the community for projects. Forestry sector officials interviewed said that the legalisation of logging and the accompanying introduction of licences were the most positive outcomes of the programme.[11] However, a number of shortcomings prevented the goal of legalising wood cutting from being realised. First, participants only reluctantly accepted the restrictions on wood cutting (Eurosis, 2012: 72). This is not necessarily surprising. The prospect of a fine might be enough of a deterrent for some people, but others might have wanted to continue accessing free wood. So much logging happens illegally that it is difficult to change attitudes and find convincing rationale for such changes. In 2013, as much as 93 per cent of the logging was happening illegally, driven by demand from China as reported by the Environmental Investigation Agency (2014).

This very high figure reflects the many issues with monitoring cutting areas, as expressed in interviews with forestry officials and in reports, including factors such as the lack of staff to implement the law, of training, and of adequate logistical support (such as maps, GPS receivers and cameras). There is also poor law enforcement by officials, endemic corruption, and a lack of transparency (Environmental Investigation Agency, 2014: 10). I was also repeatedly reminded that a missing key tool is a log-tracking system, which would allow verification of the origin of the woods and control of the levels of harvesting.[12] Without such a system, differentiating legally from illegally cut wood is impossible. Besides, community members often only receive a portion of the 20 per cent of fees that should legally go back to them, and community projects to be funded are not identified transparently, which is another reason limiting compliance with the law (World Bank, 2018c: 18; Del Gatto, 2003). Finally, extensive interviews reveal that most of the wood collected by artisans was used for charcoal production for local consumption rather than to make artefacts for tourists. Charcoal is the most common source of energy for households in Mozambique (and in most of the African continent). Millions of people make their livelihoods from producing charcoal, due to its low investment requirements. Yet the vast majority of charcoal is produced informally, with less than 10 per cent of the total

production being registered (Del Gatto, 2003: i). The wood banks thus did not correct a system where most of the wood collected for different activities is done informally or illegally. In addition, charcoal production occurs at a higher rate than reforestation efforts,[13] demonstrating that efforts for reforestation (including of indigenous species) can only be successful if they take a comprehensive approach that seriously considers local needs. This requires looking beyond what tourism and external solutions can bring locals, to considering how local needs (such as having fuel to cook food) can be fulfilled without destroying native species that support intangible heritage manifestations. This also requires looking at other approaches that have worked elsewhere, for example the use of charcoal made from straw instead of wood, promoted by a local NGO in Senegal to combat deforestation. This NGO has also developed clay ovens that consume less wood than traditional ovens, and which can be made by community members for free.

Conclusions

It is widely agreed that cultural and natural heritage are interlinked, and that separating them makes little sense, particularly when addressing global challenges. The MDG-F projects intended to bridge the nature/culture divide and use heritage to address development challenges comprehensively. Yet this plan was not successful, as illustrated by the inscriptions of the Saloum Delta and the Bassari Country on the World Heritage List, understood on the ground as fulfilling cultural heritage criteria only. There is thus a conceptual divide between the holistic approach of heritage for sustainable development and the essentialised reality on the ground, with separate concepts inherited from Europe's Enlightenment still used in a very rigid and at times stereotyping manner. This separation has grave consequences, particularly as concerns local communities, who are regarded as 'frozen in time' and as excluded from the modern world and from pressing challenges such as climate change. Freezing the concept of nature has also had negative impacts, for instance on reforestation, and the lack of understanding of recent phenomena, including of climate change on certain species (such as mangroves), explains partially why reforestation strategies have failed.

This chapter has also explained the fundamental importance of a social justice approach relating to environmental protection. Combating poaching and the trafficking of protected species (often used for craftmaking), as well as deforestation (often impacting intangible heritage

practices) will not happen until and unless there are alternative liveli-hood strategies in place, or approaches that help local communities to benefit from environmental protection. This fully respects a sustainable development approach, which aims to balance environmental protection, economic development, and social inclusion. It is only when alternative livelihood strategies (or compensation mechanisms) exist that deforest-ation or trafficking will diminish or cease. Indeed, how can a carver of ivory stop his work if he has no alternative livelihood? Why should com-munities be fully engaged in reforestation or afforestation activities if they gain nothing in the process? Unfortunately, a running thread of this book is the exclusionary nature of international aid and international projects, as well as of heritage conservation. Unequal power dynamics and the furthering of personal interests (as explained in this chapter with documented corruption relating to forestry in particular) at the expense of those of locals, prevent these questions from being addressed fully.

Since the end of the schemes considered, mostly about a decade before the time of writing, the trends identified in this chapter have not changed. One issue being external demands for wood and ivory products from Mozambique in particular, for Chinese, Vietnamese and Cambodian markets. Companies and individuals from these countries have taken advantage of the existing situation of poverty, corruption and weak law enforcement. In these circumstances, one should be wary that recent investments by China in Africa, in the field of museums (for instance the Museum of Black Civilisations in Dakar, opened in December 2018) and in the reinforcement of capacity-building and cooperation at African World Heritage sites, are not used as 'heritage washing', a way for China to cover up its negative impacts and buy itself a cleaner reputation. All of these issues are now considered in the final chapter.

Notes

1. Interview Senegal/02 (26 September 2019).
2. Interview Senegal/10 (28 September 2019).
3. https://au.int/en/treaties/charter-african-cultural-renaissance.
4. Interview Senegal/09 (28 September 2019).
5. Interview Senegal/14 (30 September 2019).
6. Interview Senegal/14 (30 September 2019).
7. Interview Senegal/14 (30 September 2019).
8. Interview Senegal/02 (26 September 2019).
9. Interview Mozambique/33 (5 April 2019).
10. Interview Mozambique/37 (28 March 2019).
11. Interview Mozambique/33 (5 April 2019).
12. Interview Mozambique/25 (19 July 2018).
13. Interview Mozambique/21 (18 July 2018).

Conclusions and recommendations: is another world possible?

This book has discussed whether and how heritage has contributed to three key dimensions of sustainable development (namely poverty reduction, gender equality and environmental sustainability) within the context of its marginalisation from the SDGs and from previous international development agendas. A first finding of this intellectual journey was the origin of the culture-for-development narrative in Africa. In the 1960s and 1970s, recently independent African countries wanted to move away from models imported from the West, to forge their own future based on their own history and culture. Therefore, it was appropriate to consider how this narrative has been implemented in various African countries.

When considering the implementation of projects, I documented and discussed several successful uses of heritage for sustainable development. Yet heritage did not have the expected large-scale impact on the ground. One reason for this was that the selected schemes were funded by international aid, which still caters to the priorities and logics of donor countries and international organisations, who imposed their views, approaches, and methods on receiving countries in a top-down manner, often disregarding local needs and specificities. Receiving countries used ventriloquism to secure funding, echoing the ideas of donor countries in their national documents. Once adopted, projects tried to involve communities, and faced diverse fates and success rates in this process. Yet, because of this framework, the schemes did not successfully rework asymmetrical power relations between the Global North and South. Rather than being defined nationally or locally, 'sustainable development' became an idea from the North that the selected countries lacked and needed to achieve.

In addition, heritage still operates along colonial categories of 'cultural' and 'natural' or 'material' and 'immaterial', concepts that are still used in most of the relevant legislation in Africa, but these categories are disconnected from local considerations for heritage which do not

operate along these taxonomies. Stereotypes of women, ethnic minorities, and their heritage, to a certain extent inherited from colonial times, structured considerations, understandings, and promotions of heritage. Another issue that was overlooked was the political use of heritage by multiple stakeholders at international, national, regional, and local levels, often leading to power struggles, as documented throughout the book. International rhetoric focusing on the politically neutral and benevolent nature of heritage neglected these different political uses and struggles. The schemes thus led to the erasure of local considerations and uses of heritage; erasure of local gender considerations and definitions; erasure of the dignity of some ethnic minorities; and the erasure of the political uses of heritage by diverse stakeholders.

Finally, the projects focused primarily on individuals, although in many cases wider structural issues and inequalities needed to be tackled first or in parallel. Addressing issues of poverty reduction through tourism, for instance, requires changes in the structure of the market. Indeed, locals tend to be trained to remain in low-level and precarious jobs such as tour guiding or selling souvenirs. Meanwhile, at the other end of the scale, lodges, tour-guiding companies, and restaurants remain predominantly owned and managed by white foreigners. Similarly, heritage practices cannot be protected and promoted for sustainable development without considering wider unregulated, illegal and neoliberal practices. For example, traditional fishing practices cannot be protected and promoted when there are so many illegal industrial fishing vessels. Yet, the different programmes did not take account of these wider issues.

Considering these different shortcomings, the next pages will identify possible recommendations on how heritage can better contribute to sustainable development and why this is important. Although my case studies are all located in sub-Saharan Africa, the conclusions and recommendations are intended to be applicable worldwide, primarily for heritage sites that benefit from national or international recognition and protection. To ensure its long-term relevance, my conclusions do not focus on achieving the SDGs, which have an end date of 2030, but rather focus on achieving key pillars on economic, social and environmental sustainability.

The following pages take account not only of the results of my research, but also of the more practical work I have been involved in over the past few years, including the 2015 UNESCO Policy on World Heritage and Sustainable Development, which I helped to draft; the various workshops I have co-organised in Europe and Africa to implement the policy and the subsequent publications of the papers presented; and the

ICOMOS Policy Guidance on Heritage and Sustainable Development, which I co-led and to which I contributed.

I begin by presenting seven prerequisites that are not necessarily new, but are areas that must still be urgently addressed. Inspired by the main themes emerging from the analysis of the selected programmes, the following sections focus on poverty reduction, gender equality, and environmental sustainability.[1]

Prerequisites

Prerequisite 1: Integrate heritage into sustainable development challenges

All the site managers I met during my research worked solely towards the protection of official site values. They did not consider how heritage properties can contribute to wider sustainable development challenges. I believe these are not isolated examples – in fact, most site managers focus on the sole preservation of the values of heritage properties. This restricted understanding reflects SDG 11.4, with its focus on the protection and safeguarding of the world's cultural and natural heritage. That this approach is too restrictive has been clearly recognised, for example, in the 2015 UNESCO Policy on World Heritage and Sustainable Development, which acknowledges that protecting the values of a heritage property is fundamental, but that 'at the same time, strengthening the three dimensions of sustainable development that are environmental sustainability, inclusive social development, and inclusive economic development, as well as the fostering of peace and security, may bring benefits to World Heritage properties and support their outstanding universal value, if carefully integrated within their conservation and management systems'.

Among the diverse reasons for this restricted understanding seems to be a fear that associating sustainable development with heritage sites will open the doors to any type of development, and there are indeed many examples of problematic development at heritage sites. However, various mechanisms exist to define limits of acceptable change, and this is the whole philosophy of sustainable development, including both the 'no go' commitment by leading industry stakeholders not to conduct extractive activities within World Heritage properties and the use of environmental, social, and cultural impact assessment tools when undertaking planning activities in sectors such as urban development,

transport, infrastructure, and waste management. Other reasons for this restricted approach include the limited understanding of the potential contribution of heritage to sustainable development; the nature of the role of site manager, which requires a focus on the protection of heritage values; a shortage of staff; siloed working practices; and power relations limiting the implementation of projects that consider heritage beyond its preservation.

What can be done about this restricted understanding of heritage as protection rather than as contributing to sustainable development? One way forward is to advocate for the role of heritage as a potential solution to contemporary challenges beyond its mere conservation and management, using new and existing documents, including the 2021 ICOMOS Policy Guidance on Heritage and the SDGs and the 2015 UNESCO Policy on World Heritage and Sustainable Development. Another potential solution is to integrate elements of the 2015 Policy into national legislation. Finally, more research could focus on the limits to acceptable change, as well as environmental, social, and cultural impact assessment tools to identify and avoid the negative impacts of projects on heritage sites.

Prerequisite 2: Consider heritage as dynamic

Heritage properties are too often viewed as static, unchanging, and frozen in time. One reason for this is that they must be considered 'authentic' (that is, in their 'original' design, materials, workmanship, and setting) to have the required heritage value. Another reason is the political use of heritage as a static embodiment of nationhood. However, this is an invented reality, as most properties have changed over time, often because of alterations in function or fashion or to improve people's living conditions.

This static view of heritage is problematic since external changes are often overlooked, as is the case with climate change at some heritage sites. Senegal, for instance, has seen a drop in annual average rainfall of around 300 mm, more intense rainfall of shorter duration, and an increase in temperature of about 1.7°C over a 30-year period. Negative impacts are multiple, including the advance of the sea, coastal erosion, desertification, loss of mangroves, loss of arable land and pasture, and a reduction in the availability of water for irrigation.[2] This has obvious impacts on heritage. Because heritage is also considered as frozen in time and as belonging to the past, its potential contributions to sustainable development, including solutions to climate change, are often ignored and/or overlooked. For instance, in the Saloum Delta World Heritage site

in Senegal, seashells have historically been used as barriers against the rising sea, until recently when they have been extracted for use as construction materials. Heritage solutions to contemporary issues, like this one from Senegal, can be better considered if one stops seeing heritage as a thing of the past.

Possible solutions include the recognition that heritage values and authenticity are dynamic and change over time; deeper reflection on whether 'authenticity' is a relevant concept or whether it should be discarded; and greater acknowledgement of heritage management practices that have adopted and adapted dynamic solutions to contemporary challenges.

Prerequisite 3: Stop essentialising locals

In many cases, the static consideration of heritage properties is not limited solely to their physical attributes, but is also applied to their communities, who are only positively considered when presented as 'authentic', or frozen in time. This is dangerous, because it essentialises and stereotypes individuals and communities, particularly in Africa. There are many examples of such archaic, simplified, and stereotyped understandings, and one example is the treatment of ethnic minorities in the nomination dossier of the Bassari Country (Senegal) for inscription on the World Heritage List and its evaluation by ICOMOS. In the dossier of this property local people are described as follows:

> The external influences that have distorted the nature and culture of many regions of Senegal are absent here. Despite the difficult living conditions, the populations of the area proudly defend their traditions, which means that architecture, natural resource management, and cultural practices are respected … that landscapes, masks, hairstyles, costumes, and all other physical manifestations of these cultural practices have not changed …

The ICOMOS evaluation echoes these comments when it states that local ethnic minorities have lived away from 'modernity', with the sole exception of the adoption of 'Western' clothes. However, this static presentation is divorced from reality, as extensively detailed in Chapter 7, and the Bassari people in particular have emigrated seasonally from their village since colonial times, and their cultural traditions and lifestyles have changed as a result. In addition, all of the ethnic minorities living

in the region have cell phones with internet access, and since 2015 some traditional houses have even been equipped with satellite dishes for TV, thanks to bilateral Chinese aid.

Possible solutions that could change the situation include the delivery of training to international, national, and local practitioners and authorities on (implicit) biases, stereotyping, and systemic racism in heritage practices, and steps to address them. Heritage documents, including nominations for inclusion on the World Heritage List, need to follow a more inclusive participation process, and need to receive the free, prior, and informed consent of communities, which can be recorded and made publicly available.

Prerequisite 4: Consider heritage in its multiple dimensions

Heritage is still too often compartmentalised as tangible or intangible, natural or cultural, and the different UNESCO conventions and programmes considering each of these categories separately have had the negative long-term effect of maintaining these divisions. In addition, heritage legislation in many African countries, often inherited from colonial times, still use these categories. However, it is only through a holistic and comprehensive understanding, bridging tangible and intangible aspects and natural and cultural features, that heritage can contribute to sustainable development.

For instance, the Bassari Country was nominated to the World Heritage List so that its heritage manifestations could be used as a catalyst for sustainable development. Its inscription on the List was accompanied by different support mechanisms to assist particularly with the economic growth of fonio, the local couscous. As a crop more adaptable to climate change than others such as maize, it can withstand both drought and heavy rain, thus being able to address SDG 2 (no hunger). To try to further improve its reputation, fonio and its associated heritage manifestations were inscribed on the intangible heritage register of Senegal in 2019.

However, fonio was not recognised as part of the Outstanding Universal Value (OUV) of the Bassari Country. As the site manager's responsibilities are only to protect and maintain the OUV of the property, the promotion of this crop is not part of his work, contradicting the vision for inscription of this property on the List. This example illustrates that a narrow focus on tangible heritage, without a wider understanding of its connections, will only rarely lead to sustainable development.

Possible ways forward include the use of the term 'heritage' to bridge boundaries between different heritage forms and manifestations,

as was consciously done in the ICOMOS Policy Guidance on Heritage and the SDGs and the 2015 UNESCO Policy on World Heritage and Sustainable Development. This would help to move beyond the divide between 'cultural', 'natural', 'tangible' and 'intangible' heritage. Another option is to identify how the divide between nature and culture, and between tangible and intangible heritage, can be dissolved through measures such as revising the Operational Guidelines of the World Heritage Convention and the working practices of international, regional, and national NGOs and legal systems.

Prerequisite 5: Reject the idea that heritage is always positive

SDG 11.4. reinforces the idea that heritage protection and management is intrinsically good, neutral, and benevolent. But heritage academics and professionals need to move beyond this naive belief. Heritage is and has always been contested, and has often been appropriated by powerful groups for their own benefit and to achieve political aims. In particular, basic human rights are often violated in the name of heritage protection and safeguarding. The right to access and enjoy heritage is still jeopardised by land-grabbing politicians; the livelihoods of people are threatened by tourism development programmes; and the dignity of women and girls is trampled in the name of continuing intangible heritage practices. These various examples demonstrate how many of the structural inequalities and injustices highlighted in the SDGs are actually perpetrated in the name of heritage and culture. Tackling these issues of equality and dignity would certainly make heritage and culture more relevant to the sustainable development agenda.

However, it is unhelpful to view culture as an obstacle to sustainable development. In line with the proposal from Farida Shaheed, former UN Special Rapporteur in the field of cultural rights, culture and heritage should be used as tools to ensure the fulfilment of human rights. Human rights here relate to the dignity of people in the different ways in which the concept can be understood, and not as narrow philosophical principles from the West. For this paradigm shift to occur, all concerned groups and communities should have, for instance, the equal right to decide which cultural traditions to keep, change, or discard, including the right of women not to participate in heritage practices if they are considered discriminatory. These principles have guided the drafting of the 2015 UNESCO Policy on World Heritage and Sustainable Development. Academics can also document how heritage is used to maintain, but

also to address, structural inequalities and injustices in different parts of the world.

Prerequisite 6: Manage heritage for social justice

My research has detailed how the conservation and management of heritage can sometimes work for the benefit of only a small number of people. Heritage can contribute better to the Agenda 2030 goal of 'leaving no one behind' if it also benefits disenfranchised local communities and rights holders. For this to happen, heritage protection and safeguarding need to be concerned not only with human rights, but also with social justice. A social justice approach is a commitment to social equality and equity, and reveals and disrupts systems of domination, discrimination, and exclusion.

This can take different forms, including mechanisms to ensure compensation for people affected by cultural and biodiversity preservation decisions. Some of the most successful social justice projects I recorded on the ground had in common one respected leader who provided the vision or the support for an initiative, who worked through local power relations and dynamics, and who ensured that the activities were realised by locals in cooperation with long-term financial partners who brought regular sources of funding (whether from private donors or international ones). For instance, the Community Marine Area of Keur Bamboung in the Saloum Delta was initiated locally, with technical and financial support from a national NGO. This protected area aims to provide alternative livelihood projects for fishermen, while ensuring the fish populations have appropriate periods of biological rest. And on the Island of Mozambique, a local NGO funded by international aid for the empowerment of women through education and culture faced issues of credibility until a Sheikh's wife went to work with them. Hence a social justice approach takes account of the realities on the ground, integrates and works through power relations, with funding to help realise the local vision. A key aspect is co-production between the various stakeholders to ensure not only sustainable outcomes but also ownership on the ground. For instance, I helped to shape a scheme in northern Mozambique that was for the community and by the community. We applied for funding around issues of heritage preservation for poverty reduction, dealing with epistemological injustices. All of the ideas came from the ground; my work was to translate their ideas to fit the narrative of international grant makers.

Prerequisite 7: Reject the self-serving logic of the international aid framework

Heritage- and culture-led projects have been unable to challenge the logic of international aid and international development. Although a heritage- and culture-based approach should take account of local specificities, in reality wider issues of asymmetrical power relations between donor and receiving countries have not been successfully addressed. One reason for this is that the international aid system, despite reforms, still responds to self-serving logics in which programmes benefit donors, which tend to be Western powers instead of receiving communities (an idea already considered at length in Labadi, 2019a).

In addition, a lot of the funding for the programmes considered was used to cover the costs of UN organisations or consultants, or pay for national civil servants to attend meetings, some of whom did not make a significant contribution to the outcome of the activities. The result was that only a small portion of the funding reached targeted populations, often with limited impact. Moving away from this self-serving and inward-looking approach could include changing project-evaluation mechanisms, with qualitative feedback gathered from the beneficiaries themselves. Such feedback would ensure that the voices of the targeted populations were heard. Some views were gathered at the end of the selected schemes for the UNDP evaluations, but it was very limited, and only some of the shortcomings were identified. With beneficiaries becoming the main evaluators, donors and implementing actors would then focus on addressing beneficiary concerns, as they would report to them. How to improve things if feedback is not gathered from the very people targeted? It is strange that this move to people-centered feedback has not already happened, since most experiences are now evaluated by clients or beneficiaries, from shopping online to higher education courses. Evaluation could include forms to be filled by beneficiaries on what worked well and what could be improved or could have been done differently. Feedback gathered could then shape the design and implementation of subsequent initiatives. These evaluations could reveal the mechanisms and paths that worked and those that did not, through greater understandings of the dynamics and power relations on the ground.

To capture fully the long-term impacts of projects, another evaluation would be conducted five years after the end of the funding. Considering how important the sustainability of projects is, such a long-term framework for feedback could be useful, as hopefully demonstrated

by this research. For this to happen, increased funding should be provided for the evaluation phase of activities. Some organisations are doing this already, but this model needs to be applied more systematically and the number of those providing feedback extended. Should these evaluations and feedback be made public, donors could be made more accountable for their work, what they intend to deliver and the reality on the ground. This might push them to implement their goals, as the public might not be willing to support international or bilateral aid if the feedback is not positive.

Poverty reduction

Moving beyond jobs and income in tourism

Most of the MDG-F projects focused too much on international tourism, in the neocolonialist view that the Global North (where most tourists in Africa come from) could bring an end to poverty. In other words, heritage as poverty reduction follows a model where activities aim to address the needs of foreigners. Very few benefits are received by local communities, as tourism benefits foreigners, the government, or corporations first and foremost. Tourism must be seriously reconsidered for it to bring significant benefits for local communities, and Covid-19 has revealed how urgent it is to change this model. A few suggestions are provided below.

Most importantly, future projects need to move beyond a sole focus on tourism and external markets, by using heritage to address local needs in an integrated approach. Heritage, if some or all the listed prerequisites are considered, can help to address the many dimensions of poverty. Some heritage sites provide traditional water and sanitation systems, which need to be actively protected, as they can provide affordable services and infrastructures for all. If local crops are protected and promoted, as already explained in the case of fonio in Senegal, food security can also be reinforced. Another example is the interpretation centre built in the Bassari Country, which intended to provide local products for the surrounding village, but which failed to do so due to power relations, the national elite's distrust of local ethnic minorities, and the appropriation of the site by the government. Addressing these issues could include making site managers and their staff accountable for areas of work additional to the preservation of sites' values, and ensuring greater participation of local representatives in heritage management. Another solution is to link better heritage and new or planned ventures. On the Island of Mozambique, for instance, a university has recently opened. Why not

provide goods and services for its students, rather than focusing on tourism development?

Second, any approach to poverty reduction must go beyond considering only income and employment, especially since heritage workers often neither receive the living wage nor experience secure employment conditions. Most heritage workers are employed in the informal sectors, and this is particularly true in Africa. I therefore argue for providing licensed workers with a number of basic rights, including labour rights, access to health care or social protection benefits, and the respect of a decent wage. Future research could strive to identify heritage employment models that work. This would help to move away from the failed attempts of the MDG-F projects, which tried to formalise informal markets by focusing on partial, limited, and marginal activities, for instance the provision of purpose-built craft booths for artisans, which did not correspond with local needs (in Toubacouta, Senegal, there were not enough booths, they were too small, and they were too far from the main hotels, therefore remaining empty and slowly becoming ruins). Approaches that effectively ensure that basic wages are paid could also be widely promoted and adapted to local situations.

Linking providers and users

A key shortfall of all the ventures was a lack of connection with the needs of local people on the ground, as well as local businesses, individual entrepreneurs, local organisations, and universities (as hubs for research and development). Not only are they sources of local solutions, if they are involved, but they can also bring longlasting social and economic benefits. Local people, particularly in Africa, have often been treated as empty vessels with no needs. Businesses, institutions, and organisations located at or near heritage sites can procure their goods and services locally, rather than on the international market. There are many empty colonial buildings both in Inhambane and on the Island of Mozambique, and they are both university towns. Why not use international funding on heritage to develop relevant and sustainable reuse approaches through understanding the needs of students and addressing those issues by providing accommodation, libraries, cafes, and restaurants in these empty buildings?

Local businesses can assist in the development of models for such linkages. Yet they are rarely part of heritage projects, for many different reasons. The first is the assumption that businesses are crass and only interested in profit. Companies have the power and means to change the game, but their neoliberal approaches often run counter to agendas

proposing equality, equity, and inclusivity. Even the concept of corporate social responsibility has had a bad press, decried as an empty communication and branding tool (Starr, 2013). Some local or national businesses have moved beyond the limits of corporate social responsibility to integrate the principles of sustainable development into their core management structure. In this approach, the performances of a company and its staff are assessed on non-financial indicators such as supporting local social and economic benefits; they are not solely driven by profit. In South Africa, for instance, some tourism businesses source their supplies and services locally, from laundry services to gardening and landscaping, as well as using local products in their restaurants and cafes (Ashley and Haysom, 2006: 272–4). Another example can be found in Inhambane (Mozambique), where some local companies provide free education activities (including English classes) for local children and youth.

However, the issue is not only with business models, but also with building trust between different stakeholders. I have noted distrust of business owners towards local products and services, even for simple products such as jams provided in restaurants, which are often imported from abroad rather than bought locally. This distrust is often reciprocated, with some locals being rather hesitant to engage with businesses. I have met young entrepreneurs wary of losing their independence and vision for their projects if they become associated with local businesses. Yet it is sometimes a way to ensure the success and durability of their ventures. For instance, in Tofo (southern Mozambique), local alternative livelihood initiatives that aim to bring a solution to overfishing have teamed up with diving businesses (owned by foreigners). This cannot be done overnight, and negotiation takes time because of the multiple actors and their different views and approaches, besides the need for projects to be tested, adjusted, and improved. Even so, this example proposes a new model for linking different approaches, businesses, and interests, to ensure poverty reduction and to address local needs rather than external ones.

Another way of moving forwards would be for funders and activities to focus on how different sectors could be linked up on the ground, how they could work together for poverty reduction, and how to deal with potential mistrust between them. In addition, although there are many certification programmes encouraging companies to have a more ethical approach to business, uptake is often low due to a lack of awareness, information, and incentives. For instance, it has been documented that fewer than 3.4 per cent of all hotels in Africa have been certified, and the ones that have done so tend to have adopted national certifications

(for instance Ecotourism Kenya; see Spenceley, 2019). Why would heritage programmes not be effective in improving uptake of certification or even in assisting with the creation of national certification schemes?

Challenging power relations and inequalities

Tourism – at least until the Covid-19 pandemic – was still constructed around neocolonialist hierarchies and relations. As extensively documented in this book, locals were trained to remain in low-level and precarious jobs, such as tour guiding or selling souvenirs. Meanwhile, at the other end of the scale, lodges, tour-guiding companies, and restaurants remain predominantly owned and managed by white foreigners. Attempts have been made in the past to challenge these hierarchies and power relations, and to assist with the creation of community-owned guest houses, tour-guiding companies, and restaurants. However, these attempts have faced many challenges, including appropriation by local and national governments for personal gain, the remote locations and low levels of occupancy of guest houses, and inadequate promotion and marketing. For some of these structures, sustained funding and capacity-building on a long-term basis would assist in addressing some of these issues. Why would international projects and funding bodies not target these existing structures and initiatives? This would improve what already exists and thus make projects more durable on the ground, ensuring delivery. In addition, this would help to challenge power relations and structural inequalities. Such a long-term approach can help us to learn from past mistakes, and feedback and evaluations from local people may also prevent the misuse of funds by local and national authorities.

Targeted training could help these structures thrive, providing staff with skills that they need, based on their own assessments. This might facilitate a move away from the mismatch that I documented in my research between the training provided in heritage-for-development projects and people's actual needs, which might include practical communication skills (how to use the internet, for example) or marketing tools for these companies to attract visitors. Another ingredient for success could be the creation of mutually supporting networks, which I have already promoted as a way of lowering the risk of failure for inclusive, community-based initiatives. In my 2019 book on *The Cultural Turn in International Aid*, I argued for the creation of mutually supporting networks in different sectors, which could share experiences, communication strategies, expenses, and skills (Labadi, 2019a: 243–52). Indeed, several initiatives, be they on the creation of hotels or of guiding companies, share common

approaches and face similar issues. Sharing of information and experiences between different countries in Africa, rather than considering each case in isolation, could help address some of the issues raised on the previous pages.

Defining new maps of heritage and tourism

The Covid-19 pandemic has acutely shown the need for heritage and tourism to target national and regional visitors rather than international ones. Changing the map of tourism may become even more relevant as regional tourism attempts to mitigate the downturn in international arrivals that has resulted from Covid-19. Yet this mitigation cannot occur if ownership of, and pride in, heritage is foreign to locals and nationals; if the preservation of colonial heritage is given prominence against local forms; or if Africa is continually constructed mainly as a place of wilderness for the enjoyment of Westerners, as is currently the case. A reappropriation of the maps and heritage of Africa is in line with the 2006 Charter for African Cultural Renaissance, which aims to eliminate all forms of alienation, exclusion, and cultural oppression on the continent. The MDG-F project in Namibia had this very goal: to refocus the heritage and tourism circuit on sites of memory from the War of Independence. The failure of this initiative, detailed at length in the previous chapters, is a cautionary tale that these reconfigurations will not happen overnight and that they cannot be dictated by external imperatives and agendas.

Such change will necessarily reflect political struggles and may also exacerbate the uses of the past for national political gains, as is the case for the recent Liberation Heritage Trail in Southern Africa. Yet most heritage sites all over the world are used for political gains and the representation of the nation, as I have discussed in previous books (see for example Labadi, 2013b). Such change would help to challenge the consideration of heritage as neutral. Above all, it would help to transform the unhealthy relationship between Europe and Africa, and the domination of Europe in defining the history, past, and collective memory of Africa through funding the preservation of colonial heritage at the expense of the national (see Labadi, 2019a) in order to perpetuate their ideas of universal domination and power, with the strategic concealment of the continuous violence and pillaging of resources. There are examples that can be followed, for instance the Island of Gorée (Senegal) and Robben Island (South Africa). Such a reappropriation of the maps and heritage of Africa can also be an opportunity to broaden who benefits from tourism, and to develop diversified models that do not only rely on tourism. The Covid-19

crisis has been used by some African governments as an opportunity to do so, and that can also provide a way forward. The South African government, for instance, has established a long-term recovery plan for rural and township communities, although its short-term Tourism Relief Fund, which targeted 'businesses that are Black-owned', was marred by corruption and the disappearance of funds (Kiewit, 2020).

Reinventing tourists

Tourism will never change if tourists do not change. Tourists may have widely varying profiles. At one end of the scale, there are hedonists who want to enjoy life as superficial customers. There are hundreds of tours or attractions all over the world that are shallow, and that consider tourists as cash cows or as people looking for instant gratification and fun. At the other end of the scale, there are 'ethical' tourists who attempt to do good or no harm, with volunteerism being one of the fastest-growing sectors of tourism until the Covid-19 pandemic. Yet volunteerism is problematic for numerous reasons, including volunteers often taking the jobs of locals, and the paternalistic, neocolonial and white-saviour view that local people need to be 'helped' or 'looked after'. Additionally, tourists often want to give money, but they themselves make the decisions on what and where to give, which limits their usefulness and short-circuits significant local priorities and initiatives.

Research undertaken locally could assess the impacts of tourists and propose local solutions to address their negative environmental, social, and economic effects. These solutions can be small. For example, in Tofo (Mozambique), initiatives involve tourists in cleaning beach areas, to ensure that they leave no trace behind, protect the environment, and that they understand their negative impacts. If more powers are provided to locals regarding how they would like to shape tourism, then the behaviour of tourists might also change. Providing more powers might also improve the usefulness of philanthropic donations. I have seen this at individual levels, with tourists contributing on a long-term basis to the business models of entrepreneurs or individual projects, for example assisting with the creation of campsites in the Bassari Country (Senegal).

A bottom-up approach to tourism projects might also help to dismantle the exoticisation of local communities, which I have already discussed. For instance, Tofo Life is based on engagement between local women and tourists, and was developed according to what local people wanted, including diversifying their economic income based on their intangible heritage, and reducing reliance on fishing, thereby

contributing to the protection of the environment and marine diversity. Tourists travel to a village to take part in daily activities and cook the traditional *matapa* dish. I talked to the women who organise these activities and they mentioned how proud they are that tourists are interested in their lives and in the mutual learning from this encounter. They also stress how such encounters help to close the divide between foreigners and locals, and how they help to reveal the similarity of our needs and wants (such as providing a good education for our children, having a phone to contact our families and so on). Although very small-scale, this programme does address a number of shortcomings highlighted in the previous pages, including the overambitious nature of tours or their mismatch with what tourists want.

Gender equality and the empowerment of women

No SDG can be reached without a gendered approach to heritage for development

I am often asked to justify the relevance of a gendered perspective on heritage for sustainable development. I hope that this book has highlighted that only a full consideration of gendered perspectives, particularly a full inclusion of women, will help to address most of the challenges of the SDGs, particularly in Africa. Women, for instance, are often maintaining resilient agricultural practices, considered as intangible heritage practices, that help to protect ecosystems and strengthen capacity for adaptation to climate change, extreme weather, and drought. These activities can contribute to fulfilling SDG 2 (to 'End hunger, achieve food security and promote sustainable agriculture') and Goal 13.2 ('To strengthen resilience and adaptive capacity to climate-related hazards and natural disasters in all countries'). SDG 3 on Healthy Lives and Well-Being will not be realised without the adoption of a gendered lens and a greater focus on heritage. Fishermen's wives have also been targeted for alternative livelihood programmes, based on their traditional or intangible heritage, to bring additional income and thereby combat overfishing, contributing to fulfilling Goal 14 on sustainable uses of the oceans, seas, and marine resources. However, many issues prevent the mainstreaming of such a gendered perspective on heritage for sustainable development. One issue is the lack of a localised understanding of genders, beyond Western considerations, resulting in imposed definitions, which are often not appropriate or relevant. This could potentially be addressed

through involving local organisations working on gender and women's empowerment that can provide local understanding and move beyond Western definitions of these concepts, also taking into account intersecting notions of race, (dis)ability, age, marital status, and other identities.

Abolishing a gender-blind approach

Many efforts to 'improve' the prospects of women, including short-term capacity-building activities, have failed because they were gender-blind. With a gender-blind perspective activities are imposed onto women and men indiscriminately, without their input. To move away from such an approach, projects have to stop expecting to train women in specific fields, without having asked them what they want to do and without consideration for stereotypes and discrimination. What is the point of training women to be tour guides if this is not what they want to do or if local social constraints do not allow it? Would activities not be more effective if women (and other genders) were first asked which skills they want to gain or which activities they want to take part in? When in Mozambique and Senegal, I asked the women who had taken part in the MDG-F projects whether they wanted to work and earn a living or stay at home and care for their children. Not a single woman told me that she did not want to work. Earning a living is essential for the women I met because it provides them with some financial independence and the means to cover essential expenses for their children, such as school fees. But work is also a means of socialising and benefiting from networks of solidarity. Yet one should also not assume that all women want to work; their individual preferences matter.

Of course, women's choices are not free. Instead, they are shaped by ingrained stereotypes and discrimination. For this reason, any project that aims to ensure gender equality must seriously consider and fight systemic discrimination and stereotypes in public, social-economic, and cultural spaces. Indeed, the current situation of women's over-representation among informational workers, continuing gender wage gaps, and exclusion from specific trades, cannot continue to be overlooked and will not be solved by increased capacity-building only. This is in line with the African Union's Agenda 2063, which requires that all forms of violence against women and harmful social norms should be reduced or ended by 2023. One way forward is for power brokers such as local elites, site managers, business owners, and government and local leaders to be involved in challenging and changing stereotypes in the heritage and tourism sectors, particularly gender-segregated employment. Workshops can

be organised to discuss hard questions around who is at the table, who decides, who acts, who strategises, and who benefits. Such an approach would refocus discourses of inclusion away from the 'poor communities' onto the organisations and their structures, to highlight inequality and discrimination. In parallel, women should be encouraged to take on leadership roles as managers and officials, so that they can take part in decision-making processes. I have also met directors of tourism companies who opened certain tour-guiding posts specifically for women and provided on-the-job training, as well as organizing discussions with local people and leaders on fighting the stereotypes associated with women in the public sphere and on the streets.

Fighting discrimination one day at a time

The various projects analysed did not take account of or address the stereotypes, discrimination, and barriers women and other genders face in Africa. Yet women, men and other genders from Africa, the wider diaspora and their allies have made visible the multiple, intersectional, and mutually constructed aspects of identity that contribute to public and private stereotyping and discrimination, including ethnicity, class, age, and education. This momentum is fundamental to changing the prevailing situation in many spheres. Academia, in particular, as a creator of knowledge and power, has been an important forum for perpetuating, justifying, and amplifying the discrimination and stereotyping of women. For instance, 'Arab women' were described as 'submissive' and 'passive' in a presentation I attended by a PhD student from a prestigious university at the annual meeting of the American Anthropological Association in Denver in 2015. I seemed to be the only person offended by the presentation. But this is just one instance. Academic women from Africa and the diaspora, despite an increasing number of them in academia or working professionally in heritage and archaeology, are still marginalised, silenced, and invisible. I was recently surprised to be asked (by a white European man) for names of women from the Arab region who could write on the heritage and archaeology of the region. There are many competent women from the region who have worked on this theme for many years. That these names are not known by Europeans working in the region reveals the extent of their marginalisation and invisibility, which surely also reflects the Orientalist stereotypes applied to them.

But all is not doomed and academia has also recently become a place to challenge the *status quo*. Women and men from the African diaspora and their allies have been active in making marginalised voices

heard. Strategies include, among other things, publishing women from the African continent, inviting them into public and academic fora, amplifying their work on social media, citing them, and supporting them in their professional careers. The road is not straight and simple, and I have encountered some resistance in this area. For instance, a senior Black heritage professional from Africa recently commented on a preliminary list of African participants to a meeting I organised that there were too many women invited. This comment denotes how normal and expected it is to marginalise or exclude women. Finally, in academia in the UK, some extraordinary work has been undertaken by a group of ten Black women professionals, academics, researchers, and community representatives involved in research, to reveal the persistent discrimination and marginalisation of people of colour in the receipt of public funding for research (according to official figures, less than 1 per cent of academics receiving public research funding in the UK identify as Black).[3,4] It is now the perfect time, when a decolonial agenda is a priority, to ensure that research, publication, and the creation of knowledge moves away from the saviour approach that has maintained neocolonial and Orientalist representations of African women, and provide funding for those very people.

Redistributing (caring) responsibilities

A key problem of heritage for development projects is that they do not take account of structural and often socio-cultural obstacles preventing women from participating. Heritage for sustainable development will never occur if there is no redistribution of time, work, and responsibilities between women and men. It is well documented that women lack time, as they often have many unpaid and unacknowledged caring duties and undertake most of the domestic work. There is no point in developing heritage programmes targeting women if lack of time and multiple additional responsibilities are not tackled in parallel, as women might register but not attend these opportunities. For instance, in the Saloum Delta I met a woman who could not work for an NGO on the environment that day because it was her turn to cook. On the Island of Mozambique, many women registered for the provided training courses, but quickly dropped them because of their other commitments.

SDG 5.4 does request that unpaid care and domestic work be recognised through 'the provision of public services, infrastructure and social protection policies and the promotion of shared responsibility within the household and the family as nationally appropriate'. This is an important first step, but such recognition and provisions will take years

to be implemented, and projects should therefore already begin address-ing the invisible work undertaken by women. For this reason, activities involving women could for instance provide financial support so that women can put their children in day-care facilities, when they exist, as is the case in Senegal. Vouchers provided to cover the costs of childcare in other projects have already yielded positive results in terms of freeing time for women, ensuring that they can do other things they consider important. In this process, projects should use existing structures, rather than creating additional and parallel ones that would surely not survive when funding runs out.

Projects also have a role to play in raising national awareness of the importance of creating legal structures, social protection systems, and longlasting nationally owned infrastructures to ensure that women have the necessary support for their empowerment and for gender equality to become a reality. Do these support mechanisms mean that women will attend training courses and other activities? Maybe for some. Yet when I was in the Saloum Delta, I was also made aware of the low attendance at literacy classes, even though they had been requested by women them-selves, because of their many social engagements (such as the organisa-tion of weddings). How should activities that have been requested by women be organised? Maybe training courses and other activities that are free are therefore undervalued. Should training then be delivered for a fee? What are the other incentives to ensure that women fully engage with activities? Obviously, the answer will differ from place to place, but these questions should frame any engagement with women.

In addition, building networks of solidarity, within (extended) families, neighbours, or working environments are essential for women, as I discovered during my fieldwork. One advantage of networking is that people with the same vision work together to share resources and expertise, while providing each other with support to achieve the desired results. Examples of networks of solidarity include communal kitchens, which not only provide food security but also free up some women's time. Most importantly, in some cases such organisation to meet practical needs may lead to political activism, such as better political representa-tion (as documented for instance by Waylen, 1996). Documenting and promoting these different networks of solidarity might help to provide women and men with ideas that can be adopted and adapted.

Finally, and most importantly, gender equality in the heritage field will not occur if men are not involved and if they take no responsibility for change. Men all over the world, including in Africa, have been challen-ging traditional gender dynamics and ingrained socio-cultural traditions,

including that women should be entirely responsible for childcare. But more work needs to be done, as women are still disproportionately responsible for childcare and household chores. Women are also generally viewed as belonging to the private sphere and the house, while men belong to the public sphere and the street. In order to help women to move more towards the public sphere (and also to be freer to attend training courses and so on), men need to stay more at home, cooking and taking care of the family. A number of African men have led the way, including David Moinina Sengeh, a minister in Sierra Leone who, during the Covid-19 lockdown posted on social media a photo of himself carrying his 10-month-old daughter and asking other male leaders to share how they worked from home. This and other stories are necessary, as they are about men asking other men to challenge and change the status quo. Men who do this can be role models and be invited into international projects that aim to improve gender balance, for example to give a talk and discuss why and how the status quo should be changed and how people might help on the ground. These discussions might help to make visible the invisible work done by women, and thus reveal their workload. Therefore, changes can be made at an individual level, in addition and in parallel to the institutional ones made to address structural discrimination and stereotyping.

Heritage, environment, and climate change

Heritage: an asset and a threat to the environment

The projects considered, like many similar heritage initiatives, aimed to promote environmental protection. However, their own negative impacts were overlooked, as they were organised around and relied on international experts and on promoting international tourism. International experts and tourists actively contribute to climate change, particularly through air travel. The coronavirus pandemic has led to new ways of working as in-person international meetings are replaced with online meetings, thereby reducing air travel. Continuing to promote online meetings, as well as the greater involvement of national and local experts, would help to reduce the carbon footprint of projects. The promotion of more regional and national approaches to tourism, as well as social and eco-tourism projects, might also help to address negative environmental impacts.

The narrative that heritage contributes to sustainable development can also be used to justify environmental degradation, for instance in

craft production. Solutions range from addressing the negative impacts of the creative industries, including changes in production (for instance the move away from using traditional ovens), to using environmentally friendly or recycled materials. Heritage for sustainable development can also be used to defend craft production using resources from endangered species, including ivory and tortoiseshell. The discussion in Chapter 7 on ivory carvers from Mozambique makes clear that such negative trends will continue until and unless local communities and rights holders are compensated for protecting the environment and are able to pursue sustainable alternative livelihood opportunities, as promoted in SDG 15c. Why would locals participate in heritage and environmental protection if they lose out in the process? Locals need to be involved to define what is considered a decent alternative opportunity. A number of local solutions exist, which should be analysed in order to identify those that can be reproduced, rather than applying externally imposed approaches.

Finally, a number of projects promote small-scale intangible heritage practices without considering their entanglement in wider unsustainable practices. For instance, traditional fishing, which supports intangible heritage skills, is increasingly entangled in issues of ocean resource depletion (although this is often due to industrial fishing coupled with climate change and pollution). Hence, the protection of these intangible heritage practices needs to be understood in the wider context, as local individuals and organisations have done in several African countries. For instance, the Community Marine Area of Keur Bamboung in the Saloum Delta, mentioned above, aims to ensure that fish populations are given biological rest periods while ensuring alternative livelihoods through a community-run eco-lodge. Fish farming is also being tested in the region, to address overfishing. Importantly, intangible heritage practices cannot be sustained on a long-term basis if the current industrial processes of resource depletion are not challenged as well.

Heritage as adaptation to climate and environmental change

'Heritage and climate change' is becoming a top priority, as reflected in its inclusion in the 26th session of the Conference of Parties to the UN Framework Convention on Climate Change (COP26, held in 2021). In these international events, heritage is still too often considered as being negatively impacted by climate change, and as needing to be protected (see for instance the summary report of the COP25 discussions by the leading governments in the negotiations[5]). Yet heritage, particularly its intangible manifestations, is a resource that can provide innovative

approaches and solutions for adapting to and mitigating climate change and related disasters. At the beginning of this chapter, I discussed the use of seashells in the Saloum Delta as barriers against the rising sea. There are many other examples, and one of the most recent is that of the potential to use Indigenous knowledge to help prevent Australian bush-fires, whose scale and severity was unprecedented and is partly the result of climate change (Phillips, 2020). Therefore, ensuring that locals and rightsholders are listened to and involved in relevant decision-making is also important for understanding how heritage has been contributing to adaptation and mitigation strategies.

As already stressed, this will not happen until and unless Indigenous people and locals stop being essentialised, considered as belonging to the past, and as having no knowledge. Importantly, Indigenous knowledge and traditional approaches are not static, but are always evolving. In the Saloum Delta, I have met individuals who have tried and tested different tree species, to assess how they may resist and adapt to environmental change and altered soil composition. One potential way forward would be to record and share these different solutions and approaches to climate change and other environmental events, in order to help other sites and communities to develop their own responses, adapting them to their local circumstances. Such initiatives can lead to a greater inclusion of local knowledge and ideas in future projects on heritage and climate change.

Locally sourced products

A key finding of the research is the importance of local crops and dishes, which are often considered to be intangible heritage manifestations because of their significance for social practices, rituals, and festive events, and include fonio and the fruit of the baobab tree (reported as having six times more vitamin C than oranges and twice as much calcium as milk, in addition to being rich in antioxidants).[6] The intangible heritage dimension of fonio is detailed in Chapter 6, while the fruit of the baobab is used, among other things, for *ngalakh*, a sweet dish served during religious holidays. As 'superfoods' (with a high nutrition value), some of these crops can assist with achieving SDG 2 – ending hunger and malnutrition and achieving food security. Some of these crops can also adapt better to climate change than other (imported) products, because they can withstand both drought and heavy rain. They further address the challenge of climate change by encouraging short supply chains, shortening the transport route from producer to consumer and supporting a zero-kilometre philosophy. However, these crops are endangered,

due in part to the popularity of Westernised diets influenced by global-isation and colonisation, but also to Western food imports being sold at very low prices in some African countries. Additionally, there has been a commercial push for the use of genetically modified crops that are pat-ented and privatised, such as varieties of maize and potato, and a ris-ing number of African countries (including Kenya, South Africa, Sudan, and Egypt) have passed legislation to allow these products because they are supposedly disease-, virus-, and insect-resistant, though these claims have been questioned. These changes in industrial agriculture threaten local crops as well as human and environmental health.

To address these issues, internationally recognised designations such as the intangible heritage lists and the World Heritage List can raise the visibility and prestige of these crops. These labels could be intercon-nected to ensure maximum impact for communities and necessary finan-cial assistance on the ground. A more cohesive approach between the different schemes would certainly result in a greater and more in-depth understanding of the supportive impact and multiplier effect that they can have in addressing the various aspects of sustainable development. Again, for this to happen, people working on heritage, including site managers, need to understand the connections between these different aspects. Another way of supporting local crop production and consump-tion would be for international donors to buy local food in times of crisis and encourage food distribution companies to promote local products, rather than flooding markets with imports, thereby encouraging the long-term sustainability and resilience of local producers. Finally, the example of the fonio illustrates how important international projects and long-term financial support can encourage local crop production and marketing, and can be of some benefit for locals (primarily women), thus addressing multiple SDGs.

Decreasing pressure on heritage and the environment

Population growth is one of the major upcoming challenges for Africa. According to UN estimates, its population will reach 2.5 billion by 2050 (about 26 per cent of the world's total population), and will then almost double, reaching 4.5 billion by 2100 (about 40 per cent of the world's total population)[7]. This growth will certainly increase the pressure on heritage. However, as extensively detailed in this book, heritage protec-tion is still too dependent on the goodwill of the population. Although there are compensation mechanisms (sometimes only partially imple-mented, as already explained), they do not correspond to or include

all the voluntary work undertaken by locals on reforestation, fighting against overfishing and poaching, or on monitoring compliance with quotas (for example on ecosystem services and benefits). They often do not work because people are disconnected from their heritage and environment, and are over-burdened with other priorities.

I observed one possible solution to this when I was in Toubacouta, in the Saloum Delta, where I met an NGO working closely with locals to promote the integration of heritage and environmental protection into practical education from the earliest age. Not only has this local NGO raised children's awareness about the entanglement of heritage and environmental protection, but it has also implemented multiple activities involving children. Local fruits have been planted with pupils in and around schools; children have been taught how to prepare tree nurseries and have then replanted the trees in local forests and observed if they can adapt to climate change; they have been instructed on how to make compost; and they have participated in cleaning some of the shell mounds. These activities aim to sensitise children to heritage and environmental protection, but most importantly to make them realise the benefits of heritage and environmental protection from the youngest age, from benefiting from shade in the school courtyard to fruit cultivation and healthier and better protected surroundings.

Such individual actions are necessary, but they need to be backed up by politicians both locally and nationally. Legal mechanisms do exist that intend to promote environmental protection, including the introduction of compulsory fees (for example as an incentive for licensed wood cutting) that return to the communities for investment in certain projects. However, corruption, lack of implementation of the legislation, and a lack of transparency in the selected community projects have all reduced the efficacy of these mechanisms. In other words, there is a wider, connected political situation that needs to be addressed for these approaches to heritage and environmental protection to work. Under such circumstances, locals and international stakeholders have an important role to play in documenting these issues and the entanglement of environmental protection with wider issues of corruption, lack of transparency, and nepotism. Enhancing children's understanding and willingness to protect heritage and the environment can help them to then become concerned citizens and to hold their politicians accountable. Simultaneously, international and bilateral funding could support locally formed civil society organisations and activists working on environmental protection, to ensure that, with time, politicians become more accountable for their acts.

(University) education on heritage for sustainable development

Education on the environment can help to address some of the issues highlighted in this book. I would argue that education in general is crucial to realising Agenda 2063, and the key challenges discussed in this book.

In his foreword to J. D. Sachs's *The End of Poverty*, Bono, the singer of the universally known band U2, wrote that 'it is up to us' to help the Global South (Bono, 2004). I interpret this as meaning that it is up to the West to help the Global South, as the 'white man's burden'. What is wrong with that position? I would contend that it is up to the Global South to find its own solutions, just as it is up to the Global North to find its own solutions. Yet if Africans have to find their own paths to heritage- or culture-based approaches to development instead of relying on external expertise, then the first step is to ensure that the population of the continent is well-educated. If the continent is serious about achieving Agenda 2063, which should see Africans free to take charge of their history and future without being dependent on others, then expertise must be acquired, serving as a powerful tool to disrupt the profound structural inequalities between a so-called 'superior', 'developed' Global North and a 'backwards' and 'under-developed' or 'developing' Global South. Obviously, this is not going to be quick and easy and I have attended meetings where international experts (particularly from the World Bank) question the value of education in Africa, as this would certainly disrupt the domination of the North and neoliberal policies.

One way forward is to democratise access to universities as a way to improve and strengthen innovation, knowledge, workable solutions and change. Greater national investment can make this democratic access a reality, as also requested in the past – see Mbembe, for instance, who noted that in 2016 South Africa only spent 0.6 per cent of its GDP on higher education (2016: 30). Greater regional and international schemes, including fellowships and scholarships for students from targeted countries, can also help with widening access. In parallel, improving the quality and quantity of higher education courses on heritage both in Africa and in other regions could realise the goals of sustainable development and social justice. So far, university curricula on heritage studies are still too focused on silo approaches that regard conservation and management as separate from wider contemporary challenges. Silo approaches even occur within the narrow field of heritage studies, for instance between heritage science and management. If sustainable development challenges are integrated within education, then

a number of the issues discussed in this book could be addressed. This includes considering heritage in a holistic manner, beyond Eurocentric and neocolonial approaches – as both tangible and intangible, and as moving beyond the divide between nature and culture. Besides, such higher education courses could have practice-based components, and bring solutions to tackle heritage for inclusive poverty reduction, moving beyond the usual approaches, discussed in this book, which do not work. Intangible heritage manifestations, including culinary traditions, could be assessed as a way to address food security or gender equality. Student projects could be devised to record and share local heritage solutions that adapt to climate change, and which conserve and sustainably use both marine and terrestrial resources. As a result of these new and integrated approaches, students who would subsequently become professionals in the field would consider the continuum between heritage management and the SDGs to be normal and would know about and implement relevant approaches.

Education, particularly higher education, also needs to be decolonised. Such an evolution has been well summarised by Amon Murwira (Minister of Higher and Tertiary Education, Science and Technology Development, Zimbabwe), who emphasised that Africa 'must move away from a colonial education system that was purposely designed to produce "clerks and pseudo engineers", into "Education 5.0" that inculcates values such as research, innovation, and community service, and uses African resources to produce the goods and services that the continent needs' (International Institute for Sustainable Development, 2020: 2). Calls, protests, and actions to decolonise curricula have erupted in many different countries, including in South Africa (Fees Must Fall; Rhodes Must Fall), and echoed and followed in the UK ('Why is My curriculum White'; 'Decolonising the Curriculum').

Decolonised curricula take various forms, combating and eradicating the very foundations of colonisation: racism, sexism, and xenophobia. Decolonised curricula can also be a key tool to combat the current neoliberal system that maintains Africa as a 'developing' continent. A first step is a recognition that knowledge is not necessarily objective and that education has often perpetuated inequality, gender stereotyping, and discrimination. Opening curricula to a diversity of sources, voices, and writings, including but not limited to authors from the Global South, women, or LGBTQ+ authors, helps to diversify approaches on heritage for sustainable development and to transform the ways in which knowledge is produced and transferred. Second, decolonised curricula aim to redress epistemic domination and injustices through challenging and

displacing Europe as the centre of knowledge (see also Ndlovu-Gatsheni, 2018). For instance, traditional management systems at heritage sites have been presented as addressing several SDGs during workshops I have organised on Heritage for Sustainable Development in Africa (see for instance Maombe, 2020). These presentations and related publications expose that heritage can be valued and managed according to tools and approaches that do not originate from Europe. Solutions to the greatest challenges of our times can also be found in the Global South.

However, a decolonised approach is still too often equated with a chauvinistic and essentialised understanding of Africa that some have warned against, from Fanon to Mbembe (Fanon, 2002: 200–35; Mbembe, 2016: 34–5). A decolonised approach cannot be restricted to an African perspective only, but should be open to the wider world and to epistemic diversity, just as Europe cannot be understood without considering its history of domination, colonisation, slavery but also external contributions. Erasing or marginalising these connections is widespread, as is the case for instance at the recently opened Museum of Black Civilisations in Dakar, which does not mention slavery or colonisation and has no related artefacts, thereby omitting two fundamental periods of the history of the continent and presenting an amnesiac story of it. Through engaging with these difficult memories, histories, and legacies, the continent can challenge the place and space occupied by Europe. Most importantly, decolonisation does not consist of withdrawing into oneself, but rather it encourages openness to diverse channels of knowledge-making and diffusion. In particular, this approach includes participation in international knowledge-production fora, such as international publications and conferences, which currently tend to be dominated by academics from the Global North. Only through such an open approach can the location of Europe and North America as the centre of knowledge and the attendant asymmetries in knowledge production be disrupted. This worldwide dissemination of knowledge also deprovincialises Africa and non-European spaces as central territories of production (Ndlovu-Gatsheni, 2018). In the past, I have published works by Africans that have adopted a critical and dialogical approach to African heritage in relation to its construction in Europe and the rest of the world (for instance Thiaw and Ly, 2019, but also Labadi *et al.*, 2020). These are ways of reappropriating representations of the history and heritage of the continent, but are also aimed at unmasking and disrupting world systems and global orders.

All of these different suggestions, from the prerequisites to rethinking tourism, gender issues, environmental sustainability and university education could help the African continent to reach its own paths to

sustainable development, growing it from inside and from its heritage, rather than depending on externally driven approaches. Only then would the slogan of 'heritage for development' be true to its original meaning and ambitions.

Notes

1. A shorter version of these conclusions, written in a more direct style for an audience of practitioners and policymakers, is available from: https://blogs.kent.ac.uk/heritagefordevelopment/impacts/.
2. http://www.iedafrique.org/Nouveau-rapport-d-etude-sur-le.html.
3. https://www.researchprofessionalnews.com/rr-news-uk-views-of-the-uk-2020-8-knowledge-is-power-an-open-letter-to-ukri/.
4. https://www.ukri.org/news/ukri-publishes-ethnicity-analysis-of-funding-applicants-and-awardees/.
5. One summary report is available from: https://ccich.gr/side-event-to-unfccc-cop25-on-addressing-climate-change-impacts-on-cultural-and-natural-heritage-the-day-after/.
6. http://news.bbc.co.uk/2/hi/uk_news/7506997.stm.
7. https://www.un.org/development/desa/en/news/population/world-population-prospects-2017.html.

References

Abungu, G. (2006). 'Practicing archaeology in eastern and southern Africa: Coming of age or the indigenisation of a foreign subject?'. In Layton, R., Shennan, S. and Stone, P. (eds.), *A Future for Archaeology: The past in the present*, 143–55. London: Routledge.

Abungu, G. (2015). 'UNESCO, the World Heritage Convention, and Africa: The practice and the practitioners'. In Logan, W., Nic Craith, M. and Kockel, U. (eds.), *A Companion to Heritage Studies*, 373–91. Oxford: Wiley Blackwell.

AD Conseil. (2015). *Bulletin des statistiques: Enquête sur l'offre et la demande touristique (2014–2015)*. Dakar: AD Conseil et Ministère du Tourisme de la République du Sénégal.

Adelman, S. (2018). 'The Sustainable Development Goals, anthropocentrism and neoliberalism'. In French, D. and Kotzé, L. J. (eds.), *Sustainable Development Goals: Law, theory and implementation*, 15–40. Cheltenham: Edward Elgar.

African Union. (2018). *Position Paper on World Heritage and Sustainable Development (WH-SD) in Africa*. Third Specialised Technical Committee Meeting on Youth, Culture and Sports (STC-YCS-3), 21–5 October 2018, Algiers, Algeria. Addis Ababa: African Union.

Aikawa-Faure, N. (2009). 'Le patrimoine culturel immatériel: Naissance d'une convention'. In Bolla, G., Aikawa-Faure, N. and Isar, Y. R. (eds.), *Le patrimoine à l'UNESCO: Le défi de la sauvegarde*. Paris: UNESCO.

AIM Moçamique. (2016). 'Probably one of the most beautiful places in the world: Mozambique Island receives five cruise ships'. *Club of Mozambique*, 17 November. https://clubofmozambi que.com/news/mozambique-island-receives-five-cruise-ships/ (accessed 26 July 2021).

Aitchison, C. (2001). 'Theorizing other discourses of tourism, gender and culture: Can the subaltern speak (in tourism)?'. *Tourist Studies* 1(2), 133–47.

Aitchison, C. (2005). 'Feminist and gender perspectives in tourism studies: The social–cultural nexus of critical and cultural theories'. *Tourist Studies* 5(3), 207–24.

Ake, C. (1996). *Development and Democracy in Africa*. Washington, DC: Brookings Institute.

Albert, M.-T. (ed.). (2015). *Perceptions of Sustainability in Heritage Studies*. Berlin: De Gruyter.

Albert, M.-T., Bandarin, F. and Pereira Roders, A. (eds.). (2017). *Going Beyond: Perceptions of sustainability in heritage studies, no. 2*. Dordrecht: Springer.

Amadeu, V. (2021). 'Kutchinga: um acto de "purificação" da viúva'. *Tsevele*. 06 July. https://www. tsevele.co.mz/index.php/artigos/item/151-kutchinga-um-acto-de-purificacao-da-viuva? fbclid=IwAR1GCmhWC1n4gimMCmQFV6PItCSRW6vJ2Our8XPKy8g8ZkE4fz5c_ilFYhk (accessed 13 February 2021).

Amin, S. (2006). 'The millennium development goals: A critique from the South'. *Monthly Review: An Independent Socialist Magazine* 57(10): 1–15.

Ampofo, A. A., Beoku-Betts, J., Ngaruiya Njambi, W. and Osirim, M. (2004). 'Women's and gender studies in English-speaking sub-Saharan Africa: A review of research in the social sciences'. *Gender and Society* (18), 685–714.

Anderson, B. (1991). *Imagined Communities: Reflections on the origin and spread of nationalism*. London: Vergo.

Andrieu, N., Vall, E., Blanchard, M., Béavogui, F. and Sogodogo, D. (2015). 'Le fonio: Une culture climato intelligente?'. *Agronomie, Environnement et Sociétés* 5(1), 101–5.

Andro, A. and Lesclingand, M. (2016). 'Les mutilations génitales féminines: État des lieux et des connaissances'. *Population* 71(2), 224–311.

Antonopoulos, R. (2009). *The unpaid care work–paid work connection*. Working Paper No. 86. Geneva: ILO.

Arbulú, A. (2012). *Mid-Term Evaluation: MDG Achievement Fund. Thematic Window: Culture and Development. Harnessing Diversity for Sustainable Development and Social Change in Ethiopia*. New York: UNDP.

Aregu, L., Darnhofer, I., Tegegne, A., Hoekstra, K. and Wurzinger, M. (2016). 'The impact of gender-blindness on social-ecological resilience: The case of a communal pasture in the highlands of Ethiopia'. *Ambio* 45, 287–96.

Arizpe, L. (1998). 'Our creative diversity: A composite view of culture and development'. In Wright, S. (ed.), *Cultural Diversity and Citizenship: Report of a joint UNESCO/University of Birmingham seminar*, 13–21. Birmingham: University of Birmingham.

Arizpe, L. (2015). *Culture, Diversity and Heritage: Major studies*. Cham: Springer.

Arkinbobola, Y. (2019). 'Neoliberal feminism in Africa'. *Soundings* 71, 50–61.

Arnfred, S. (2004). 'Tufo dancing: Muslim women's culture in northern Mozambique'. *Lusotopie* 11, 39–65.

Ashley, C. and Haysom, G. (2006). 'From philanthropy to a different way of doing business: Strategies and challenges in integrating pro-poor approaches into tourism business'. *Development Southern Africa* 23(2), 265–80.

Ashley, C. and Roe, D. (2002). 'Making tourism work for the poor: Strategies and challenges in Southern Africa'. *Development Southern Africa* 19(1), 61–82.

Audet, C., Burlison, J., Moon, T., Sidat, M., Vergara, A. and Vermund, S. (2010). 'Sociocultural and epidemiological aspects of HIV/AIDS in Mozambique'. *BMC International Health and Human Rights* 10(15), 1–10.

Azzi, S. (2005). 'Negotiating cultural space in the global economy: The United States, UNESCO, and the convention on cultural diversity'. *International Journal: Canada's Journal of Global Policy Analysis* 60(3), 763–84.

Baillie, B. and Sørensen, M.-L. (eds.). (2021a). *African Heritage Challenges: Communities and sustainable development*. Singapore: Palgrave-Macmillan.

Baillie, B. and Sørensen, M.-L. (2021b). 'Heritage challenges in Africa: Contestations and expectations'. In Baillie, B. and Sørensen, M.-L. (eds.), *African Heritage Challenges: Communities and sustainable development,* 1–43. Singapore: Palgrave-Macmillan.

Bak, S. (2008). 'Domestic and international cultural tourism in the context of intangible heritage'. In UNESCO Principal Regional Office for Asia and the Pacific (ed.), *Safeguarding Intangible Heritage and Sustainable Cultural Tourism: Opportunities and challenges*. UNESCO-EIIHCAP Regional Meeting. Hué, Viet Nam. 11–13 December 2007, 27–31. Bangkok: UNESCO and EIIHCAP.

Bandarin, F., Hosagrahar, J. and Saller Albernaz, F. (2001). 'Why development needs culture'. *Cultural Heritage Management and Sustainable Development* 1(1), 15–25.

Bandarin, F. and Van Oers, R. (2012). *The Historic Urban Landscape: Managing heritage in an urban century*. Chichester: Wiley-Blackwell.

Bao, J. R., Rodriguez, D. C., Paina, L., Ozawa, S. and Bennett, S. (2015). 'Monitoring and evaluating the transition of large scale programs in global health'. *Global Health: Science and Practice* 3(4), 591–605.

Barber, M. and Bowie, C. (2008). 'How international NGOs could do less harm and more good'. *Development in Practice* 18(6), 748–54.

Barthel-Bouchier, D. (2012). *Cultural Heritage and the Challenge of Sustainability*. New York: Routledge.

Basu, P. and Modest, W. (2015). 'Museums, heritage and international development: A critical conversation'. In Basu, P. and Modest, W. (eds.), *Museums, Heritage and International Development*, 1–32. London: Routledge.

Bayo Ogunrotifa, A. (2015). 'Grand developmentalism: A critical appraisal of Millennium Development Goals'. *Journal of Asian Development Studies* 4(2), 43–57.

Belhabib, D., Koutob, V., Sall, A., Lam, V. and Pauly, D. (2014). 'Fisheries catch misreporting and its implications: The case of Senegal'. *Fisheries Research* 151, 1–11.

Benedetti, M. (1981). 'Letter to the U.S. People'. *The Nation*, 10 October.

Berry, J. (1963). 'L'Unesco se propose de donner une nouvelle orientation à son action, déclare au "Monde" M. René MAHEU Directeur Général de l'Organisation internationale'. *Le Monde,* 21 August, 1–2.

Biada, A. (2020). 'The challenges of implementing the 2015 UNESCO policy on world heritage and sustainable development in Cameroon: Lessons learned from the Dja Faunal Reserve'. In Labadi, S., Giliberto, F., Taruvinga, P. and Jopela, A. (eds.), *World Heritage and Sustainable Development in Africa: Implementing the 2015 policy,* 29–40. Midrand: African World Heritage Fund.

Bielicki, K. (2019). 'China's ivory ban: A work in progress'. *The Diplomat,* 15 March.

Bigio, A. and Licciardi, G. (2010). *The Urban Rehabilitation of Medinas: The World Bank experience in the Middle East and North Africa*. Washington, DC: World Bank.

Binswanger, H. and Aryar, S. (2003). *Scaling Up Community-Driven Development: Theoretical underpinnings and program design implications*. Policy Research Working Paper 3039. Washington, DC: World Bank.

Binswanger-Mkhize, H. P., De Regt, J. P. and Spector, S. (2010). *Local and Community Driven Development: Moving to scale in theory and practice*. Washington, DC: World Bank.

Blake, J. (2009). 'UNESCO's 2003 Convention on Intangible Cultural Heritage: The implications of community involvement in "safeguarding"'. In Smith, L. and Akagawa, N. (eds.), *Intangible Heritage*, 45–73. New York: Routledge.

Blake, J. (2014). 'Gender and intangible cultural heritage'. In UNESCO (ed.), *Gender Equality, Heritage and Creativity*, 48–59. Paris: UNESCO.

Blake, J. (2018). 'Gender and intangible heritage: Illustrating the inter-disciplinary character of international law'. In Grahn, W. and Wilson, R. J. (eds.), *Gender and Heritage: Performance, place and politics*, 207–20. London: Routledge.

Boccardi, G. (2007). 'World Heritage and Sustainability: Concern for social, economic and environmental aspects within the policies and processes of the World Heritage Convention'. Unpublished MA thesis. London: University College London.

Bokova, I. (2011a). 'Allocution de Mme Irina Bokova, Directrice générale de l'UNESCO, en réponse au débat de politique générale à la 36ème session de la Conférence générale'. Paris: UNESCO.

Bokova, I. (2011b). 'Discours de Madame Irina Bokova, Directrice générale de l'UNESCO à l'occasion de la cérémonie de lever du drapeau de la Palestine'. Paris: UNESCO.

Bokova, I. (2016). 'Interview with Irina Bokova, Candidate for UN Secretary General: "My biggest priority is to keep the United Nations relevant"'. *LSE blog* (13 September). http://blogs.lse.ac.uk/europpblog/2016/09/13/interview-irina-bokova-unsg/ (accessed 9 May 2021).

Bolongaro, K. (2016). 'Senegal's handicrafts: Made in China?'. *Al Jazeera*, 10 May. https://www.aljazeera.com/features/2016/5/10/senegals-handicrafts-made-in-china (accessed 9 May 2021).

Bono. (2004). 'Foreword'. In Sachs, J., *The End of Poverty: How we can make it happen in our lifetime*, xiii–xvi. New York: Penguin.

Boone, P. (1996). 'Politics and the effectiveness of foreign aid'. *European Economic Review* 40(2), 289–329.

Booth, D. (2012). 'Aid effectiveness: Bringing country ownership (and politics) back in'. *Conflict, Security and Development* 12(5), 537–58.

Bosredon, P. (2017). 'Le processus patrimonial à Hébron, dans les territoires palestiniens occupés: Accaparements d'une centralité urbaine disputée dans le contexte de la colonisation israélienne'. In Bonny, Y., Bautès, N. and Goüeset, V. (eds.), *L'espace en partage: Approche interdisciplinaire de la dimension spatiale des rapports sociaux*, 55–81. Rennes: Presses Universitaires de Rennes.

Boswell, R. (2008). *Challenges to the Management of Intangible Cultural Heritage in Zanzibar, Seychelles and Mauritius*. Dakar: Codesria.

Boswell, R. (2011). 'Challenges to sustaining intangible cultural heritage'. *Heritage and Society* 4(1), 119–24.

Boswell, R. and O'Kane, D. (2011). 'Introduction: Heritage management and tourism in Africa'. *Journal of Contemporary African Studies* 29(4), 361–9.

Bourdieu, P. (1998). *La domination masculine*. Paris: Editions du Seuil.

Bousso, T. (1994). *Typologie des engins et techniques de pêche artisanale utilisés au Siné-Saloum (Sénégal)*. Dakar: Institut Sénégalais de Recherches Agricoles.

Bricas, N., Martin, P. and Tchamda, C. (2016). 'Le secteur agroalimentaire: Un point de vue par la consommation'. In Bricas, N., Tchamda, C. and Mouton, F. (eds.), *L'Afrique à la conquête de son marché alimentaire intérieur: Enseignements de dix ans d'enquêtes auprès des ménages d'Afrique de l'Ouest, au Cameroun et du Tchad*, 75–85. Paris: Agence Française de Développement.

Brinkerhoff, D. W. and Goldsmith, A. A. (1992). 'Promoting the sustainability of development institutions: A framework for strategy'. *World Development* 20(3), 369–83.

Brock-Utne, B. (2000). *Whose Education for All? The recolonization of the African mind*. New York: Falmer Press.

Buckley, R. (2000). *Egypt: Regional leader on a tight-rope*. Cheltenham: Understanding Global Issues Limited.

Bugnion, C. (2010). *Evaluation à mi-parcours: Promouvoir les initiatives et les industries culturelles au Sénégal: Pays Bassari et Delta du Saloum*. New York: UNDP.

Butler, B. (2007). *Return to Alexandria: An ethnography of cultural heritage revivalism and museum memory*. Walnut Creek, CA: Left Coast Press.

Butler, J. (1990). *Gender Trouble: Feminism and the subversion of identity*. New York: Routledge.

Byrne, B. and Ween, G. B. (2015). 'Bridging cultural and natural heritage'. In Meskell, L. (ed.), *Global Heritage: A reader*, 94–111. Chichester: Wiley-Blackwell.

Calvo Sastre, A. M., Martinell Sempere, A., Muñoz Llabrés, A. and Vicario Leal, F. (2007). 'Estrategia de cultura y desarrollo de la cooperación Española'. Madrid: Ministerio de Asuntos Exteriores y de Cooperación.

Campos, L. (2017). 'The "Delivering as One" UN initiative: Reforming the UN system at the country level'. *Journal of International Organizations Studies* 8(2), 47–68.

Capra International. (2014). *Global and Thematic Evaluation of the Millennium Development Goals Achievement Fund: Final evaluation report*. New York: MDG-F.

Carillo, C. and Matsuura, K. (2002). 'Koichiro Matsuura dubbed "saviour of Unesco"'. *Art Newspaper* (1 November). https://www.theartnewspaper.com/2002/11/01/koichiro-matsu ura-dubbed-saviour-of-unesco (accessed 14 January 2022).

Carolyn, M. A., Burlison, J., Moon, T. D., Sidat, M., Vergara, A. E. and Vermund, S. H. (2010). 'Sociocultural and epidemiological aspects of HIV/AIDS in Mozambique'. *BMC International Health and Human Rights* 10(15), 279–92.

Cave, C. and Negussie, E. (2017). *World Heritage Conservation: The World Heritage Convention, linking culture and nature for sustainable development*. London: Routledge.

CDC. (2019). *Country Profile: Mozambique*. Washington, DC: CDC.

Chirikure, S. (2014). '"Where angels fear to tread": Ethics, commercial archaeology, and extractive industries in Southern Africa'. *Azania: Archaeological Research in Africa* 49(2), 218–31.

Chirikure, S., Manyanga, M., Ndoro, W. and Pwiti, G. (2010). 'Unfulfilled promises? Heritage management and community participation at some of Africa's cultural heritage sites'. *International Journal of Heritage Studies* 16(1–2), 30–44.

Chirikure, S., Ndoro, W. and Deacon, J. (2018). 'Approaches and trends in African heritage management and conservation'. In Ndoro, W., Chirikure, S. and Deacon, J. (eds.), *Managing Heritage in Africa: Who cares?*, 1–21. London: Routledge.

Chirikure, S. and Pwiti, G. (2008). 'Community involvement in archaeology and cultural heritage management: An assesment from case studies in southern Africa and elsewhere'. *Current Anthropology* 49(3), 467–85.

Chok, S., Macbeth, J. and Warren, C. (2007). 'Tourism as a tool for poverty alleviation: A critical analysis of "pro-poor tourism" and implications for sustainability'. *Current Issues in Tourism* 10 (2–3), 144–65.

Christie, I., Fernandes, E., Messerli, H. and Twining-Ward, L. (2013). *Tourism in Africa: Harnessing tourism for growth and improved livelihoods*. Washington, DC: World Bank.

Churchill, S. A. and Smyth, R. (2016). 'Ethnic diversity and poverty'. Discussion Paper 33/16. Melbourne: Monash University, Department of Economics.

Cidre, E. and Nardella, B. (2015). 'Interrogating communities of expertise on urban conservation and development: Past and future of "public and open spaces" in the old city of Tunis'. In Labadi, S. and Logan, W. (eds.), *Urban Heritage, Development and Sustainability: International frameworks, national and local governance*, 55–79. London: Routledge.

Cisse, A. T., Ghysel, A. and Vermeulen, C. (2004). 'Systèmes de croyances Niominka et gestion des resources naturelles de mangrove'. In De Dapper, M. (ed.), *International Symposium: Tropical forests in a changing global context, 8–9 November*, 307–32. Brussels: Royal Academy of Overseas Sciences.

Clarke, P. (2010). *The UNESCO World Heritage Tourism Programme: Evaluation and future directions*. Wellington: Martin Jenkins.

Claxton, M. (2000). 'Culture and development revisited'. *Culturelink Review,* special issue 2000, 23–32.

Coelho, J. P. (2013). 'Politics and contemporary history in Mozambique: A set of epistemological notes'. *Kronos* 39(1), 20–31.

Commission de la culture, de l'éducation et de la communication du Sénat. (2019). 'Réunion du 6 mars 2019 à 10h30: Observatoire citoyen de l'activité parlementaire'. https://www.nossenate urs.fr/seance/19134#inter_b32166cf24308ec873f40512d3d60dfd (accessed 9 May 2021).

Corat, S. (2020). 'Foreword'. In *UNESCO: Promise of gender equality: Key actions 2018–2019*, 9. Paris: UNESCO.

Cornwall, A. and Rivas, A.-M. (2015). 'From "gender equality" and "women's empowerment" to global justice: Reclaiming a transformative agenda for gender and development'. *Third World Quarterly* 36(2), 396–415.

Crossette, B. (2000). 'UNESCO's fat gets a trim and reform is in the air'. *New York Times*, 5 March, 15.

Cruz, G., Mateus, A. and Dlamini, P. S. (2018). 'HIV prevention: Mapping Mozambican people's views on the acceptability of the widow's sexual cleansing ritual called pita-kufa'. *BMC International Health and Human Rights* 18(37), 1–9.

Cruz, J.-F. and Béavogui, F. (2011). *Le fonio: Une céréale africaine*. Versailles: Editions Quæ-CTA.

Dabou, C. (2013). 'Arts: Maurice Bandaman "impressionné" par les créations de J. Stepholy'. *Fraternité Matin*, 19 December. https://www.fratmat.info/article/62619/20/arts-maurice-bandaman-impressionne-par-les-creations-de-j-stepholy (accessed 19 September 2020).

Damiba, E. (2012). *Rapport final révisé de la mission d'évaluation indépendante*. New York: MDG-F.

Darkoh, M. and Ould-Mey, M. (1992). 'Cash crops versus food crops in Africa: A conflict between dependency and autonomy'. *Transafrican Journal of History* 21, 36–50.

Davis, J. (2001). 'Commentary: Tourism research and social theory – expanding the focus'. *Tourism Geographies* 3(2), 125–34.

De Beer, A., Rogerson, C. M. and Rogerson, J. M. (2014). 'Decent work in the South African tourism industry: Evidence from tourist guides'. *Urban Forum* 25, 89–103.

De Beukelaer, C. (2019). 'What can the arts do in the face of climate change?'. *Pursuit*. https://pursuit.unimelb.edu.au/articles/what-can-the-arts-do-in-the-face-of-climate-change (accessed 9 June 2021).

De Beukelaer, C. and Freitas, R. (2015). 'Culture and sustainable development: Beyond the diversity of cultural expressions'. In De Beukelaer, C., Pyykkönen, M. and Singh, J. P. (eds.), *Globalization, Culture, and Development: The UNESCO Convention on Cultural Diversity*, 203–21. New York: Palgrave Macmillan.

De Beukelaer, C. and Pyykkönen, M. (2015). 'Introduction: UNESCO's "Diversity Convention" – ten years on'. In De Beukelaer, C., Pyykkönen, M. and Singh, J. P. (eds.), *Globalization, Culture, and Development: The UNESCO Convention on Cultural Diversity*, 1–12. New York: Palgrave Macmillan.

Debort, G. (1967). *La société du spectacle*. Paris: Buchet/Chastel.

De Cesari, C. (2019). *Heritage and the Cultural Struggle for Palestine*. Stanford: Stanford University Press.

Del Gatto, F. (2003). *Forest Law Enforcement in Mozambique: An overview: Mission report*. Maputo: Ministry of Agriculture/National Directorate of Forest and Wildlife.

Deloumeaux, L. (2017). 'Persisting imbalances in the flow of cultural goods and services'. In UNESCO (ed.), *Reshaping Cultural Policies: Advancing creativity for development*, 125–42. Paris: UNESCO.

Déme, M. and Dioh, B. C. (1994). 'Aménagement, législation et développement des pêches artisanales au Sénégal: Bilan et analyse d'impact'. In Barry-Gérard, M., Diouf, T. and Fonteneau, A. M. (eds.), *L'évaluation des ressources exploitables par la pêche artisanale Sénégalaise: Compte rendu des discussions et des conclusions*, 25–42. Dakar and Paris: ORSTOM.

Denney, L. and Mallett, R. with Benson, M. S. (2017). *Service Delivery and State Capacity: Findings from the secure livelihoods research consortium*. London: Secure Livelihoods Research Consortium.

De Renzio, P. (2006). 'Briefing: Paved with good intentions? The role of aid in reaching the Millennium Development Goals'. *African Affairs* 106(422), 133–40.

Descola, P. (2005). *Par delà nature et culture*. Paris: Gallimard.

De Sousa, V. (2019). 'Memory as an interculturality booster in Maputo, through the preservation of the colonial statuary'. *Comunicação e Sociedade*. Special Issue, 269–86. https://journals.open edition.org/cs/958 (accessed 11 January 2022).

DeWalt, B. (1994). 'Using indigenous knowledge to improve agriculture and natural resource management'. *Human Organization* 53(2), 123–31.

Diagne, A. (2004). 'Tourism development and its impacts in the Senegalese petite côte: A geographical case study in centre–periphery relations'. *Tourism Geographies* 6(4), 472–92.

Dieye, E. (2007). *Les ensembles littoraux de la lagune de Joal-Fadiouth et de l'estuaire du Saloum (Sénégal): Approche méthodologique de la dynamique de la mangrove entre 1972 et 2005 par télédétection et systèmes d'information géographique (SIG)*. Dakar: FST/UCAD.

Diop, C. (1974). *Les fondements économiques et culturels d'un Etat fédéral d'Afrique Noire*. Paris: Editions présence africaine.

Diop, N. and Askew, I. (2009). 'The effectiveness of a community-based education program on abandoning female genital mutilation/cutting in Senegal'. *Studies in Family Planning* 40(4), 307–18.

Dodds, R., Ali, A. and Galaski, K. (2018). 'Mobilizing knowledge: Determining key elements for success and pitfalls in developing community based tourism'. *Current Issues in Tourism* 21(13), 1547–68.

Drazen, A. (2007). 'Discussion on the paper "Are aid agencies improving?" by W. Easterley'. *Economic Policy* 52, 668–73.

Duarte, R. (2012). 'Maritime history in Mozambique and East Africa: The urgent need for the proper study and preservation of endangered underwater cultural heritage'. *Journal of Maritime Archaeology* 7(1), 63–86.

Dufrêne, B. (2014). 'La place des femmes dans le patrimoine'. *Revue Française des sciences de l'information et de la communication*. https://rfsic.revues.org/977 (accessed 26 July 2021).

Easterley, W. (2002). *The Cartel of Good Intentions: Bureaucracy versus markets in foreign aid*. Washington, DC: Center for Global Development.

Easterley, W. (2006). *The White Man's Burden: Why the West's efforts to aid the rest have done so much ill and so little good*. New York: Oxford University Press.

Eckhard, S., Patz, R. and Schmidt, S. (2019). 'Reform efforts, synchronization failure, and international bureaucracy: The case of the UNESCO budget crisis'. *Journal of European Public Policy* 26(11), 1639–56.

Ecoutin, J. M., Simier, M., Albaret, J. J., Laë, R. and Tito de Morais, L. (2010). 'Changes over a decade in fish assemblages exposed to both environmental and fishing constraints in the Sine Saloum estuary (Senegal)'. *Estuarine, Coastal and Shelf Science* 87(2), 284–92.

El Bennaoui, K. (2018). 'Sortir des paradoxes de la mobilité'. In UNESCO (ed.), *Re-penser les politiques culturelles*, 107–24. Paris: UNESCO.

El-Khatib, M. and Wagner de Reyna, A. (1987). *UNESCO and the Evolution of the Concept of Development*. Paris: UNESCO.

Ely, R. J. and Padavic, I. (2020). 'What's really holding women back?'. *Harvard Business Review* (March–April), 58–67.

Enhancing Heritage Resources. (2013). *Final Evaluation: MDG-F Sustainable Cultural Tourism In Namibia*. *Joint Programme, 2009–2013*. New York: MDG.

Environmental Investigation Agency. (2014). *First Class Crisis: China's criminal and unsustainable intervention in Mozambique's Miombo forests*. London: Environmental Investigation Agency.

Eriksen, T. (2001). 'Between universalism and relativism: A critique of the UNESCO concept of culture'. In Cowan, J., Dembour, M.-B. and Wilson, R. (eds.), *Culture and Rights: Anthropological perspectives*, 127–48. Cambridge: Cambridge University Press.

Escobar, A. (1995). *Encountering Development: The making and unmaking of the third world*. Princeton: Princeton University Press.

Eurosis. (2012). *Final Evaluation: Strengthening cultural and creative industries and inclusive policies in Mozambique*. New York: MDG-F Secretariat.

Evaluation Management Group. (2012). *Independent Evaluation of Delivering as One*. New York: United Nations.

FAAPA (Fédération Atlantique des Agences de Presse Africaines). (2020). 'Le Fonio, une 'culture culturelle' revalorisée par l'engagement des femmes'. http://www.faapa.info/en/2020/02/05/le-fonio-une-culture-culturelle-revalorisee-par-lengagement-des-femmes/ (accessed 26 July 2021).

Fall, M. A. (2011). 'Les experts globaux du développement local au Sénégal'. *Multitudes* 4(47), 71–7.

Fanon, F. (2002). *Les damnés de la terre*. Paris: La Découverte.

Fehling, M., Nelson, B. D. and Venkatapuram, S. (2013). 'Limitations of the Millennium Development Goals: A literature review'. *Global Public Health* 8(10), 1109–22.

Figueira, C. (2015). 'Cultural diplomacy and the 2005 UNESCO Convention'. In De Beukelaer, C., Pyykkönen, M. and Singh, J. P. (eds.), *Globalization, Culture, and Development*, 163–81. New York: Palgrave-Macmillan.

Flipo, F. (2005). 'Les tensions constitutives du développement durable'. In *Développement durable et territoires: Dossier de séance*, 1–6. Paris: DATAR.

Freire, P. (1970). *The Pedagogy of the Oppressed*. New York: Herder and Herder.

Fuller, S. (2019). *The Intersection of Gender Equality and Quality Education in Four Mediterranean Countries: A regional situation analysis of the nexus between SDG 4 and SDG 5 in Cyprus, Greece, Malta, and Turkey*. Venice: UNESCO.

Galla, A. (ed.). (2012). *World Heritage: Benefits beyond borders*. Paris and Cambridge: UNESCO and Cambridge University Press.

Garner, B. (2016). *The Politics of Cultural Development: Trade, cultural policy and the UNESCO Convention on Cultural Diversity*. London: Routledge.

Garner, B. and O'Connor, J. (2019). 'Rip it up and start again? The contemporary relevance of the 2005 UNESCO Convention on Cultural Diversity'. *Journal of Law, Social Justice and Global Development* 24, 8–23.

Gasper, D. (2004). *The Ethics of Development*. Edinburgh: Edinburgh University Press.

Gausset, Q. (2001). 'AIDS and cultural practices in Africa: The case of the Tonga (Zambia)'. *Social Science and Medicine* 52, 509–18.

Geddes, P. (1915). *Cities in Evolution: An introduction to the town planning movement and to the study of civics*. London: Wiliams and Norgate.

Gibeau, A. (1998). 'Female genital mutilation: When a cultural practice generates clinical and ethical dilemmas'. *Journal of Obstetric, Gynecologic and Neonatal Nursing* 27(1), 85–91.

Gibson, C., Andersson, K., Ostrom, E. and Shivakumar, S. (2005). *The Samaritan's Dilemma: The political economy of development aid*. Oxford: Oxford University Press.

Giliberto, F. (2018). 'Linking Theory with Practice: Assessing the integration of a 21st century approach to urban heritage conservation, management and development in the World Heritage cities of Florence and Edinburgh'. Unpublished PhD thesis. Canterbuty: University of Kent.

Giliberto, F. and Labadi, S. (2022). 'Harnessing cultural heritage for sustainable development: An analysis of three internationally funded projects in MENA countries'. *International Journal of Heritage Studies* 28(2), 133–46. https://doi.org/10.1080/13527258.2021.1950026 (accessed 14 January 2022).

Gilman, N. (2015). 'The new international economic order: A reintroduction'. *Humanity: An International Journal of Human Rights, Humanitarianism, and Development* 6(1), 1–16.

Ginzarly, M. H., Houbart, C. and Teller, J. (2019). 'The historic urban landscape approach to urban management: A systematic review'. *International Journal of Heritage Studies* 25(10), 999–1019.

Girard, A. (1972). *Développement culturel*. Paris: UNESCO.

Glennie, J. (2002). 'Aid effectiveness'. In Desai, V. and Potter, R. (eds.), *The Companion to Development Studies*, 551–5. New York: Routledge.

Gloaguen, P. (2019). *Sénégal: Le routard*. Paris: Hachette.

GOAL. (1990). 'Bibliotheca Alexandrina: Record of the inaugural meeting of the International Commission for the Revival of the Ancient Library of Alexandria, Aswan, 11–12 February 1990'. Alexandria: Goal Publications.

Gomila, J. and Ferry, M.-P. (1966). 'Notes sur l'éthnographie des Bedik (Sénégal oriental)'. *Journal de la Société des Africanistes* 36(2), 209–50.

Gomis, V. (2013). 'L'école sénégalaise menacée par les viols sur mineurs'. *SeneNews*, 27 August. https://www.senenews.com/actualites/lecole-senegalaise-menace-par-les-viol-sur-mineurs-vincent-gomis_63256.html (accessed 9 May 2021).

Goodland, R. and Webb, M. (1987). *The Management of Cultural Property in World Bank Assisted Projects: Archaeological, historical, religious and natural unique sites*. World Bank Technical Paper 62. Washington, DC: World Bank.

Goodwin, H. (2009). 'Reflections on 10 years of pro-poor tourism'. *Journal of Policy Research in Tourism, Leisure and Events* 1(1), 90–4.

Gossmann, A. (2009). 'Tusks and trinkets: An overview of illicit ivory trafficking in Africa'. *African Security Review* 18(4), 50–69.

Gould, P. (2017). *Empowering Communities through Archaeology and Heritage: The role of local governance in economic development*. London: Bloomsbury.

Gould, P. and Paterlini, A. (2017). 'Governing community-based heritage tourism clusters: I Parchi della Val di Cornia, Tuscany'. In Gould, P. and Pyburn, K. A. (eds.), *Collision or Collaboration: Archaeology encounters economic development*, 137–52. Cham: Springer.

Gould, P. and Pyburn, K. A. (eds.). (2017). *Collision or Collaboration: Archaeology encounters economic development*. Cham: Springer.

Grafeld, M. (1976). 'Suggested Talking Points and Approvals for Meetings with UNESCO DG M'Bow (October 12)'. *Wikileaks*. https://wikileaks.org/plusd/cables/1976PARIS29939_b.html (accessed 1 August 2021).

Grahn, W. and Wilson, R. J. (eds.). (2018). *Gender and Heritage: Performance, place and politics.* London: Routledge.

Grobar, L. (2019). 'Policies to promote employment and preserve cultural heritage in the handicraft sector'. *International Journal of Cultural Policy* 25(4), 515–27.

Guy, D. (2016). 'Aid workers talk endlessly about capacity building – but what does it really mean?'. *The Guardian,* 10 November. https://www.theguardian.com/global-developm ent-professionals-network/2016/nov/10/what-does-capacity-building-mean (accessed 1 October 2020).

Halbwachs, M. and Coser, L. A. (1992). *On Collective Memory.* Chicago: University of Chicago Press.

Harrison, R. (2015). 'Beyond "natural" and "cultural" heritage: Toward an ontological politics of heritage in the age of Anthropocene'. *Heritage and Society* 8(1), 24–42.

Heritage Foundation. (1982). *UNESCO: Where culture becomes propaganda.* https://www.heritage. org/report/unesco-where-culture-becomes-propaganda (accessed 15 May 2019).

Hesmondhalgh, D. and Baker, S. (2015). 'Sex, gender and work segregation in the cultural industries'. *Sociological Review* 63(S1), 23–36.

Hickel, J. (2012). 'Neoliberal plague: The political economy of HIV transmission in Swaziland'. *Journal of Southern African Studies* 38(3), 513–29.

Hickel, J. (2014). 'The "girl effect": Liberalism, empowerment and the contradictions of development'. *Third World Quarterly* 35(8), 1355–73.

Higham, J. and Miller, G. (2018). 'Transforming societies and transforming tourism: Sustainable tourism in times of change'. *Journal of Sustainable Tourism* 26(1), 1–8.

Hill, P. S., Mansoor, G. F. and Claudio, F. (2010). 'Conflict in least-developed countries: Challenging the millennium development goals'. *Bulletin of the World Health Organisation* 88, 562.

Hirsch, V. (2019). 'La défense des éléphants du Mozambique'. *Le Temps,* 22 April. https://www.lete mps.ch/sciences/defense-elephants-mozambique (accessed 14 January 2022).

Hobsbawm, E. (1984). 'Introduction: Inventing traditions'. In Hobsbawm, E. and Ranger, T. (eds.), *The Invention of Tradition,* 1–14. Cambridge: Cambridge University Press.

Honadle, G. and VanSant, J. (1985). *Implementation for Sustainability: Lessons from integrated rural development.* West Hartford, CT: Kumarian Press.

Hüfner, K. (2017). 'The Financial Crisis of UNESCO after 2011: Political reactions and organisational consequences'. *Global Policy* 8(5), 96–101.

Hummel, J. and Van der Duim, R. (2012). 'Tourism and development at work: 15 years of tourism and poverty reduction within the SNV Netherlands Development Organisation'. *Journal of Sustainable Tourism* 20(3), 319–38.

Huntington, S. (1998). *The Clash of Civilization and the Remaking of World Order.* New York: Simon and Schuster.

Hutter, M. and Rizzo, I. (1997). *Economic Perspectives on Cultural Heritage.* New York: Palgrave Macmillan.

ICOMOS. (2011). *ICOMOS' 17th General Assembly Scientific Symposium Proceedings.* Paris: ICOMOS.

ICOMOS. (2012). *Evaluation of the Bassari Country.* Paris: ICOMOS.

ICOMOS. (2018). *ICOMOS Report on the UN High-Level Political Forum (HLPF).* Paris: ICOMOS.

IEDES. (1964). 'L'humanisme du développement: Note sur une conférence de René Maheu'. *Tiers-Monde* 5(20), 921–4. https://www.persee.fr/doc/tiers_0040-7356_1964_num_5_20_1164 (accessed 1 August 2021).

Ingold, T. (2000). *The Perception of the Environment: Essays on livelihood, dwelling and skill.* London: Psychology Press.

Instituto Nacional de Saúde. (2009). 'HIV in the 2009 Mozambique INSIDA'. Marracuene, Mozambique: Instituto Nacional de Saúde.

International Institute for Sustainable Development. (2020). 'Sixth Session of the Africa Regional Forum on Sustainable Development 24–27 February 2020'. *ARFSD Bulletin* 208(40). https:// enb.iisd.org/uneca/arfsd2020/ (accessed 30 July 2021).

Ionesco, E. (1970). 'L'UNESCO, ou la culture contre la culture'. *Le Monde,* 12 July 1.

Isar, Y. R. (2008). '"Culture", conflict and security: Issues and linkages'. In Hettne, B. (ed.), *Human Values and Global Governance: Studies in development, security and culture,* Vol. 2, 7–33. Basingstoke: Palgrave Macmillan.

Isar, Y. R. (2017). '"Culture", "sustainable development" and cultural policy: A contrarian view'. *International Journal of Cultural Policy* 23(2), 148–58.

IUCN. (2011). *Evaluation of the Saloum Delta,* Gland: IUCN.

Iyer, M. (2018). 'Platforms: A shift in the approach of tourism from 1950s to the 21st Century'. *Journal of Tourism and Ethos* 1(1), 1–9.

Jackson, R. (1969). *A Study of the Capacity of the United Nations Development System*. Geneva: United Nations.

Jackson, T. (2009). *Prosperity without Growth: Economics for a finite planet*. New York: Routledge.

Jafari, J. (2001). 'The scientification of tourism'. In Smith, V.L. and Brent, M. (eds.), *Hosts and Guests Revisited: Tourism issues of the 21st century*, 28–41. New York: Cognizant Communication.

Jopela, A. (2015). 'Conserving a World Heritage Site in Mozambique: Entanglements between politics, poverty, development and governance on the Island of Mozambique'. In Labadi, S. and Logan, W. (eds.), *Urban Heritage, Development, and Sustainability: International frameworks, national and local governance*, 37–56. London: Routledge.

Jopela, A. (2017). 'The Politics of Liberation Heritage in Postcolonial Southern Africa, with Special Reference to Mozambique'. Unpublished PhD thesis. Johannesburg: University of the Witwatersrand.

Jopela, A. and Fredriksen, P. D. (2015). 'Public archaeology, knowledge meetings and heritage ethics in Southern Africa: An approach from Mozambique'. *World Archaeology* 47(2), 261–84.

José, P. (2017). 'Conservation History, Hunting Policies and Practices in the South Western Mozambique Borderland in the 20th Century'. Unpublished PhD thesis. Johannesburg: University of the Witwatersrand.

Joy, C. (2012). *The Politics of Heritage Management in Mali: From UNESCO to Djenné*. London: Routledge.

Kabeer, N. (1999). 'Resources, agency, achievements: Reflections on the measurement of women's empowerement'. *Development and Change* 30, 435–46.

Kabeer, N. (2005). 'The Beijing Platform for Action and the Millennium Development Goals: Different processes, different outcomes'. Baku: United Nations Division for the Advancement of Women. http://www.un.org/womenwatch/daw/egm/bpfamd2005/experts-papers/EGM-BPFA-MD-MDG-2005-EP.11.pdf (accessed 20 December 2021).

Kaplan S. and Goodman, R. (2017). 'Educating girls: Learning doesn't mean a livelihood'. *Japan Today*, 15 October. https://japantoday.com/category/features/opinions/educating-girls-learning-doesn%27t-mean-a-livelihood (accessed 14 January 2022).

Kaplinsky, R. and Morris, M. (2001). *A Handbook for Value Chain Analysis*. Ottawa: International Development Research Centre.

Keitumetse, S. (2006). 'UNESCO 2003 Convention on Intangible Heritage: Practical implications for heritage management approaches in Africa'. *South African Archaeological Bulletin* 61(184), 166–71.

Keitumetse, S. (2011). 'Sustainable development and cultural heritage management in Botswana: Towards sustainable communities'. *Sustainable Development* 19(1), 49–59.

Keitumetse, S. (2016). *African Cultural Heritage Conservation and Management: Theory and practice from southern Africa*. New York: Springer.

Kelly, A. (2021). *Consuming Ivory: Mercantile legacies of East Africa and New England*. Seattle: University of Washington Press.

Keyzer, J. (2010). *Delivering as One: Country-led Evaluation, Mozambique. Final Report*. Maputo: UN and Government of Mozambique.

Kiewit, L. (2020). 'Auditor general points to the state's flaws enabling Covid-19 graft'. *Mail and Guardian* (2 September). https://mg.co.za/news/2020-09-02-auditor-general-points-to-the-states-flaws-enabling-covid-19-graft/ (accessed 26 July 2021).

Killion, D. (2009). 'Scenesetter for November 24 Visit of IO Das Anderson – Wikileaks'. https://wikileaks.jcvignoli.com/cable_09UNESCOPARIS1536 (accessed 9 May 2021).

Kinnaird, V. and Hall, D. (eds.). (1994). *Tourism: A gender analysis*. Chichester: John Wiley.

Kipling, R. (1899). 'The white man's burden'. *New York Sun*, 10 February.

Kozymka, I. (2014). *The Diplomacy of Culture: The role of UNESCO in sustaining cultural diversity*. New York: Palgrave Macmillan.

Kumar, C. (2005). 'Revisiting "community" in community-based natural resource management'. *Community Development Journal* 40(3), 275–85.

Kurlanska, C. (2019). 'Life and death of a community library: A case study in micro-development'. In Labadi, S. (ed.), *The Cultural Turn in International Aid: Impacts and challenges for heritage and the creative industries* 123–38. London: Routledge.

Labadi, S. (2007). 'Representations of the nation and cultural diversity in discourses on World Heritage'. *Journal of Social Archaeology* 7(2), 147–70.

Labadi, S. (2011a). 'Intangible heritage and sustainable development: Realistic outcome or wishful thinking?'. *Heritage and Society* 4(1), 115–18.

Labadi, S. (2011b). *Evaluating the Socio-economic Impacts of Selected Regenerated Heritage Sites in Europe*. Amsterdam: European Cultural Foundation.

Labadi, S. (2013a). *UNESCO, Cultural Heritage, and Outstanding Universal Value*. Plymouth, MA: AltaMira Press.

Labadi, S. (2013b). 'The National Museum of Immigration History (Paris, France): Neo-colonialist representations, silencing, and re-appropriation'. *Journal of Social Archaeology* 13(3), 310–33.

Labadi, S. (2017a). 'UNESCO, heritage and sustainable development: International discourses and local impacts'. In Gould, P. and Pyburn, K. A. (eds.), *Promise and Peril: Archaeology engaging with economic development*, 45–60. New York: Springer.

Labadi, S. (2017b). *Museums, Immigrants and Social Justice*. London: Routledge.

Labadi, S. (2018a). 'World Heritage and gender equality'. In Larsen, P. and Logan, W. (eds.), *World Heritage and Sustainable Development: New directions in World Heritage management*, 87–100. London: Routledge.

Labadi, S. (2018b). 'Historical, theoretical and international considerations on culture, heritage and (sustainable) development'. In Larsen, P. and Logan, W. (eds.), *World Heritage and Sustainable Development: New directions in World Heritage management*, 37–49. London: Routledge.

Labadi, S. (ed.). (2019a). *The Cultural Turn in International Aid: Impacts and challenges for heritage and the creative industries*. London: Routledge.

Labadi, S. (2019b). 'UNESCO, culture, aid and development in the new millennium'. In Labadi, S. (ed.), *The Cultural Turn in International Aid: Impacts and challenges for heritage and the creative industries*, 73–88. London: Routledge.

Labadi, S. (2019c). 'Re-examining World Heritage and sustainable development'. In Bharne, V. and Sandmeier, T. (eds.), *Routledge Companion to Global Heritage Conservation*, 15–26. London: Routledge.

Labadi, S. (2019d). 'The cultural turn in international aid? Setting the scene'. In Labadi, S. (ed.), *The Cultural Turn in International Aid: Impacts and challenges for heritage and the creative industries*, 1–14. London: Routledge.

Labadi, S. (2019e). 'The future of international aid for cultural projects'. In Labadi, S. (ed.), *The Cultural Turn in International Aid: Impacts and challenges for heritage and the creative industries*, 243–52. London: Routledge.

Labadi, S., Giliberto, F., Taruvinga, P. and Jopela, A. (eds.). (2020). *World Heritage and Sustainable Development in Africa: Implementing the 2015 policy*. Midrand: African World Heritage Fund.

Labadi, S., Giliberto, F., Rosetti, I., Shebati, L. and Yildirim, E. (2021). *Heritage and the Sustainable Development Goals: Policy guidance for heritage and development actors*. Paris: ICOMOS.

Labadi, S. and Gould, P. (2015). 'Sustainable development: Heritage, community, economics'. In Meskell, L. (ed.), *Global Heritage: A reader*, 196–216. Oxford: Wiley-Blackwell.

Labadi, S. and Logan, W. (eds.). (2015a). *Urban Heritage, Development, and Sustainability: International frameworks, national and local governance*. London: Routledge.

Labadi, S. and Logan, W. (2015b). 'Approaches to urban heritage, development and sustainability'. In Labadi, S. and Logan, W. (eds.), *Urban Heritage, Development and Sustainability: International frameworks, national and local governance*, 1–20. London: Routledge.

Lafrenz Samuels, K. (2010). 'Material heritage and poverty reduction'. In Labadi, S. and Long, C. (eds.), *Heritage and Globalisation*, 202–17. London: Routledge.

Lafrenz Samuels, K. (2019). 'Heritage development: Culture and heritage at the World Bank'. In Labadi, S. (ed.), *The Cultural Turn in International Aid: Impacts and challenges for heritage and the creative industries*, 55–72. London: Routledge.

Lane, P. B. (2015). 'Archaeology in the age of the Anthropocene: A critical assessment of its scope and societal contributions'. *Journal of Field Archaeology* 40(5), 485–98.

Larsen, P. B. (2015). *Post-Frontier Resource Governance: Indigenous rights, extraction and conservation in the Peruvian Amazon*. Geneva: Graduate Institute.

Larsen, P. B. and Logan, W. (eds.). (2018). *World Heritage and Sustainable Development: New directions in World Heritage management*. London: Routledge.

Larsen, P. B. and Wijesuriya, G. (2015). 'Nature–culture interlinkages in World Heritage: Bridging the gap'. *World Heritage* 75, 4–15.

Latour, B. (1993). *We Have Never Been Modern*. Cambridge, MA: Harvard University Press.

Lee, H. (2017). 'Sustainability in international aid programs: Identification of working concepts of sustainability and its contributing factors'. *International Journal of Social Science Studies* 5(1), 7–19.

Lemos, A. (2014). 'Forests in Mozambique face extinction'. *World Rainforest Movement Monthly Bulletin* 205 (August). https://wrm.org.uy/wp-content/uploads/2014/09/Bulletin205.pdf (accessed 27 July 2021).

Liley, I. (2013). 'Nature and culture in World Heritage management: A view from the Asia-Pacific (or, never waste a good crisis!)'. In Brockwell, S., O'Connor, S. and Byrne, D. (eds.), *Transcending the Culture–Nature Divide in Cultural Heritage: Views from the Asia-Pacific region*, 13–22. Canberra: Australian National University.

Loder, N. (2000). 'UNESCO worse than I imagined, says new director'. *Nature* 404 (March), 113. https://www.nature.com/articles/35004723 (accessed 27 July 2021).

Logan, W. (2012). 'Cultural diversity, cultural heritage and human rights: Towards heritage management as human rights-based cultural practice'. *International Journal of Heritage Studies* 18(3), 231–44.

Logan, W. (2019). 'Blowing hot and cold: Culture-related activities in the deployment of Australia's soft power in Asia'. In Labadi, S. (ed.), *The Cultural Turn in International Aid: Impacts and challenges for heritage and the creative industries*, 152–70. London: Routledge.

Long, C. and Labadi, S. (2010). 'Introduction'. In Labadi, S. and Long, C. (eds.), *Heritage and Globalisation*, 1–17. London: Routledge.

Macamo, S., Hougaard, J. and Jopela, A. (2019). 'The implementation of the historic urban landscape of the Island of Mozambique'. In Pereira Roders, A. and Bandarin, F. (eds.), *Reshaping Urban Conservation: The historic urban landscape approach in action*, 251–76. Singapore: Springer.

Macgregor, J. (1989). 'The paradoxes of wildlife conservation in Africa'. *Africa Insight* 19(4), 201–12.

MacLeod, N. (2006). 'Cultural tourism: Aspects of authenticity and commodification'. In Smith, M.K. and Robinson, M. (eds.), *Cultural Tourism in a Changing World: Politics, participation and (re)presentation*, 177–90. Clevedon, Somerset: Channel View Publications.

Maconick, R. (2010). *Mid-Term Evaluation: Sustainable tourism in Namibia*. New York: MDG-F Secretariat.

Madden, M. and Shipley, R. (2012). 'An analysis of the literature at the nexus of heritage, tourism, and local economic development'. *Journal of Heritage Tourism* 7(2), 103–12.

Magubane, Z. (2014). 'Spectacles and scholarship: Caster Semenya, intersex studies, and the problem of race in feminist theory'. *Signs* 39(3), 761–85.

Maheu, R. (1970a). 'Address by René Maheu at the opening of the intergovernmental conference on the institutional, administrative and financial aspects of cultural policies'. Paris: UNESCO.

Maheu, R. (1970b). 'Closing address'. In UNESCO (ed.), *Final Report: Intergovernmental conference on institutional, administrative and financial aspects of cultural policies, Venice, 24 August–2 September 1970*, 52–5. Paris: UNESCO.

Mahony, K. and Van Zyl, J. (2002). 'The impacts of tourism investment on rural communities: Three case studies in South Africa'. *Development Southern Africa* 19(1), 83–103.

Makuvaza, S. (ed.) (2014). *The Management of Cultural World Heritage Sites and Development in Africa: History, nomination processes and representation on the World Heritage List*. London: Springer.

Mansuri, G. and Rao, V. (2004). 'Community-based and -driven development: A critical review'. World Bank Policy Research Working Paper 3209. Washington, DC: World Bank.

Mansuri, G. and Rao, V. (2013). 'Localizing development. Does participation work?'. World Bank Policy Research Report. Washington, DC: World Bank.

Maombe, C. (2020). 'Traditional management systems and sustainable development: The case study of the Barotse Plains Cultural Landscape (proposed World Heritage site)'. In Labadi, S., Giliberto, F., Taruvinga, P. and Jopela, A. (eds.), *World Heritage and Sustainable Development in Africa: Implementing the 2015 policy*, 41–52. Midrand: African World Heritage Fund.

Marglin, S. (1990). 'Towards the decolonization of the mind'. In Marglin, F. A. and Marglin, S. A. (eds.), *Dominating Knowledge: Development, Culture, and Resistance*, 1–28. Oxford: Clarendon Press.

Marti, S. (2020). *Une planète à sauver: Six défis pour 2050*. Paris: Odile Jacob.

Martin, E. and Stiles, D. (2000). *The Ivory Markets of Africa*. London: Save the Elephants.

Martin, L. (1963). 'Memorandum'. *The Sunday Times*, 11 August, 3.

Marwecki, D. (2019). 'Why did the US and Israel leave UNESCO?' *E-International Relations* (14 February). https://www.e-ir.info/2019/02/14/why-did-the-u-s-and-israel-leave-unesco/ (accessed 12 January 2022).

Matsuura, K. (2009). 'Address by Mr Koïchiro Matsuura, Director-General of UNESCO, to the 4th session of the Intergovernmental Committee for the Safeguarding of the Intangible Cultural Heritage, Abu Dhabi, United Arab Emirates, Abu Dhabi, United Arab Emirates'. Paris: UNESCO.

Matswiri, G. M. (2020). 'Opportunities and challenges in implementing the 2015 World Heritage policy on sustainable development: The cases of the Okavango Delta and Tsodilo Hills World Heritage sites, Botswana'. In Labadi, S., Giliberto, F., Taruvinga, P. and Jopela, A. (eds.), *World Heritage and Sustainable Development in Africa: Implementing the 2015 Policy*, 53–64. Midrand: African World Heritage Fund.

Maurel, C. (2006). *UNESCO de 1945 à 1974*. Paris: Université Panthéon-Sorbonne.

Maurel, C. (2009). 'L'UNESCO aujourd'hui'. *Vingtième siècle: Revue d'histoire* 102(2), 131–44.

Maxwell, S. (2003). 'Heaven or hubris: Reflections on the "new poverty agenda"'. *Development Policy Review* 21(1), 5–25.

Mayor, F. (1993). 'Reply to the General Policy Debate. 27th session of the General Conference'. Paris: UNESCO.

Mayor, F. (1999). 'International Year for the Culture of Peace (Year 2000)'. *Culturelink Review*, 29 (November). https://www.culturelink.org/review/29/cl29dos.html (accessed 12 January 2022).

Mbembe, A. (2016). 'Decolonizing the university: New directions'. *Arts and Humanities in Higher Education* 15(1), 29–45.

McLeod, M. (2015). 'Has it been worth it? Personal reflections on museum development in Ghana'. In Basu, P. and Modest, W. (eds.), *Museums, Heritage and International Development*, 143–9. London: Routledge.

Melching, M. (2001). 'Abandoning female genital cutting in Africa'. In Perry, S. and Schenck, C. (eds.), *Eye to Eye: Women practising development across cultures*, 156–70. London: Zed Books.

Meskell, L. (2005). 'Archaeological ethnography: Conversations around Kruger National Park'. *Archaeologies: Journal of the World Archaeology Congress* 1(1), 83–102.

Meskell, L. (2007). 'Falling walls and mending fences: Archaeological ethnography in the Limpopo'. *Journal of Southern African Studies* 33(2), 383–400.

Meskell, L. (2009). 'The nature of culture in Kruger National Park'. In Meskell, L. (ed.), *Cosmopolitan Archaeologies*, 89–112. Durham, NC: Duke University Press.

Meskell, L. (2010). 'Conflict heritage and expert failure'. In Labadi, S. and Long, C. (eds.), *Heritage and Globalisation*, 192–201. London: Routledge.

Meskell, L. (2012). *The Nature of Heritage: The new South Africa*. Chichester: Wiley-Blackwell.

Meskell, L. (2018). *A Future in Ruins: UNESCO, World Heritage and the dream of peace*. New York: Oxford University Press.

Metwalli, N. (2010). *Mid-Term Evaluation: Mozambique*. New York: UNDP.

Milliken, T., Pole, A. and Huongo, A. (2006). *No Peace for Elephants: Unregulated domestic ivory markets in Angola and Mozambique*, Cambridge: TRAFFIC Online Report Series N. 11. TRAFFIC International. https://www.traffic.org/site/assets/files/4050/no_peace_for_elephants.pdf (accessed 27 July 2021).

Mills, C. (1959). *The Sociological Imagination*. Harmondsworth: Penguin.

Miraftab, F. (2004). 'Making neo-liberal governance: The disempowering work of empowerment'. *International Planning Studies* 9(4), 239–59.

Mirbagheri, F. (2007). 'Narrowing the gap or camouflaging the divide: An analysis of Mouhammad Khatami's "Dialogue of Civilisations"'. *British Journal of Middle Eastern Studies* 34(3), 305–16.

Mitchell, J. (2012). 'Value chain approaches to assessing the impact of tourism on low-income households in developing countries'. *Journal of Sustainable Tourism* 20(3), 457–75.

Mitchell, J. and Ashley, C. (2010). *Tourism and Poverty Reduction: Pathways to prosperity*. London: Earthscan.

Momsen, J. (2009). *Gender and Development*. London: Routledge.

Mosse, D. (2005). *Cultivating Development: An ethnography of aid policy and practice*. London: Pluto Press.

Moswete, N. and Lacey, G. (2015). '"Women cannot lead": Empowering women through cultural tourism in Botswana'. *Journal of Sustainable Tourism* 23(4), 600–17.

Mowforth, M. and Munt, I. (2003). *Tourism and Sustainability: Development and new tourism in the third world*, 2nd ed. London: Routledge.

Moyo, D. (2009). *Dead Aid: Why aid is not working and how there is a better way for Africa*. New York: Farrar, Straus and Giroux.

Mthembu, B. and Mutambara, E. (2018). 'Rural tourism as a mechanism for poverty alleviation in Kwa-Zulu-Natal Province of South Africa: Case of Bergville'. *African Journal of Hospitality,*

Tourism and Leisure 7(4), 1–22. https://www.ajhtl.com/uploads/7/1/6/3/7163688/article_ 58_vol_7_4__2018.pdf (accessed 27 July 2021).

Musavengane, R. (2018). 'Toward pro-poor local economic development in Zimbabwe: The role of pro-poor tourism'. *African Journal of Hospitality, Tourism and Leisure* 7(1), 1–14.

Mwobobia, F. M. (2012). 'The challenges facing small-scale women entrepreneurs: A case of Kenya'. *International Journal of Business Administration* 3(2), 112–21.

Nandy, A. and Visvanathan, S. (1990). 'Modern medicine and its non-modern critics: A study in discourse'. In Marglin, F. A. and Marglin, S. A. (eds.), *Dominating Knowledge: Development, culture, and resistance*, 145–84. Oxford: Clarendon Press.

Ndlovu-Gatsheni, S. (2018). *Epistemic Freedom in Africa: Deprovincialisation and decolonisation*. London: Routledge.

N'Dong, B. (2009). 'Migration interne et acculturation: Le cas des migrants bassari à Tambacounda'. *Hommes et Migrations* 1279, 52–64. https://journals.openedition.org/hommesmigrations/ 299 (accessed 12 January 2022).

Ndoro, W., Chirikure, S. and Deacon, J. (eds.). (2018). *Managing Heritage in Africa: Who cares?* London: Routledge.

Ndoro, W. and Pwiti, G. (2001). 'Heritage management in southern Africa: Local, national and international discourse'. *Public Archaeology* 2(1), 21–34.

Ndoro, W. and Wijesuriya, G. (2015). 'Heritage management and conservation: From colonization to globalization'. In Meskell, L. (ed.), *Global Heritage: A reader*, 131–49. Chichester: Wiley-Blackwell.

Ndour, N., Dieng, S. D. and Fall, M. (2011). 'Rôles des mangroves, modes et perspectives de gestion au Delta du Saloum (Sénégal)'. *VertigO*, 11(3), 1–15.

Nederveen Pieterse, J. (2010). *Development Theory*. London: Sage.

Neil, G. (2006). 'Assessing the effectiveness of UNESCO's new Convention on cultural diversity'. *Global Media and Communication* 2(2), 257–62.

Neimark, B. (2018). 'Greenwashing: Corporate tree planting generates goodwill but may sometimes harm the planet'. *The Conversation*, 25 September. https://theconversation.com/green washing-corporate-tree-planting-generates-goodwill-but-may-sometimes-harm-the-planet-103457 (accessed 27 July 2021).

Nelson, F. (2012). 'Blessing or curse? The political economy of tourism development in Tanzania'. *Journal of Sustainable Tourism* 20(3), 359–75.

Nguirazi, T. (2008). 'Conservation of Traditional Buildings on the Island of Mozambique: A case study of Macuti City'. Unpublished MA thesis. Harare: University of Zimbabwe.

Nionko, S. (2020). 'Le fonio, une "culture culturelle" revalorisée par l'engagement des femmes'. *KoldaNews*, 5 February. https://www.koldanews.com/2020/02/05/le-fonio-une-culture-cul turelle-revalorisee-par-lengagement-des-femmes-a1125930.html (accessed 27 July 2021).

Nkrumah, K. (1965). *Neo-Colonialism: The last stage of imperialism*. London: Panaf.

Nnaemeka, O. (2001). 'If female circumcision did not exist, Western feminism would invent it'. In Perry, S. and Schenck, C. (eds.), *Eye to Eye: Women practising development across cultures*, 171–89. London: Zed Books.

Nolan R. W. (1977). 'L'histoire des migrations bassari: Influences et perspectives'. *Journal des Africanistes* 47(2), 81–101.

Novelli, M. (2016). *Tourism and Development in Sub-Saharan Africa: Current issues and local realities*. London: Routledge.

Nunoo, F. K. E., Asiedu, B., Olauson, J. and Intsiful, G. (2015). 'Achieving sustainable fisheries management: A critical look at traditional fisheries management in the marine artisanal fisheries of Ghana, West Africa'. *Journal of Energy and Natural Resource Management* 2(1), 15–23.

Nut, S. (2019). 'Traditional performing arts under the influce of NGOs: Myth or reality?'. In Labadi, S. (ed.), *The Cultural Turn in International Aid: Impacts and challenges for heritage and the creative industries*, 139–51. London: Routledge.

OECD. (2006). *The Challenge of Capacity Development: Working towards good practice*. Paris: OECD.

OECD. (2008). *The Paris Declaration on Aid Effectiveness and the Accra Agenda for Action*. Paris: OECD.

OECD. (2011). *OECD Development Assistance Peer Reviews: Spain*. Paris: OECD.

Omoyefa, P. S. (2008). 'Public sectors reforms in Africa: A philosophical re-thinking'. *Africa Development* 33(4), 15–30.

O'Reilly, D. J. W. (2014). 'Heritage and development: Lessons from Cambodia'. *Public Archaeology* 13(1–3), 200–12.

Oreskes, B. and Heath, R. (2016). 'How (not) to pick the UN secretary-general: Despite an effort at reform, the process remains opaque'. *Politico*, 22 September. https://www.politico.eu/article/how-not-to-pick-the-un-secretary-general-ban-ki-moon-antonio-guterres/ (accessed 30 July 2021).

Oyewùmi, O. (1997). *The Invention of Woman: Making an African sense of Western gender discourses*. Minneapolis: University of Minnesota Press.

Oyewùmi, O. (2002). 'Conceptualizing gender: The Eurocentric foundations of feminist concepts and the challenge of African epistemologies'. *JENdA: A Journal of Culture and African Women Studies* 2(1), 1–9. https://www.africaknowledgeproject.org/index.php/jenda/article/view/68 (accessed 30 July 2021).

Parra, C. (2018). 'What can culture in and for sustainable development learn from protected areas?'. In Birkeland, I., Burton, R., Parra, C. and Siivonen, K. (eds.), *Cultural Sustainability and the Nature–Culture Interface: Livelihoods, policies, and methodologies*, 49–65. London: Routledge.

Pereira Roders, A. and Bandarin, F. (eds.). (2019). *Reshaping Urban Conservation: The historic urban landscape approach in action*. Singapore: Springer.

Pereira Roders, A. and Van Oers, R. (2014). 'Wedding cultural heritage and sustainable development: Three years after'. *Journal of Cultural Heritage Management and Sustainable Development* 4(1), 2–15.

Phillips, A. (2005). 'Landscape as a meeting ground: Category V protected landscapes/seascapes and World Heritage cultural landscapes'. In Brown, J., Mitchell, N. and Beresford, M. (eds.), *The Protected Landscape Approach: Linking nature, culture and community*, 19–35. Gland: IUCN.

Phillips, N. (2020). 'Climate change made Australia's devastating fire season 30% more likely'. *Nature*, 4 March. https://www.nature.com/articles/d41586-020-00627-y (accessed 1 August 2021).

Plantenga, D. (2004). 'Gender, identity, and diversity: Learning from insights gained in transformative gender training'. *Gender and Development* 12(1), 40–6.

Polla, B. (2019). *Le Nouveau Féminisme: Combats et rêves de l'ère post-Weinstein*. Paris: Odile Jacob.

Porter, G. and Lyon, F. (2006). 'Social capital as culture? Promoting cooperative action in Ghana'. In S. Radcliffe (ed.), *Culture and Development in a Globalizing World: Geographies, actors and paradigms*, 150–69. London: Routledge.

Pwiti, G. and Ndoro, W. (1999). 'The legacy of colonialism: Perceptions of the cultural heritage in southern Africa, with special reference to Zimbabwe'. *African Archaeological Review* 16(3), 143–53.

Quinn, D. and Wilkenfeld, J. S. K. (2006). 'Power play: Mediation in symmetric and asymmetric international crises'. *International Interactions* 32(4), 441–70.

Radcliffe, S. (ed.). (2006). *Culture and Development in a Globalizing World*. London: Routledge.

Rahnema, M. (1997). 'Towards post-development: Searching for signposts, a new language and new paradigms'. In Rahnema, M. and Bawtree, V. (eds.), *The Post-Development Reader*, 377–404. London: Zed Books.

Ranta, K. (2015). 'Illicit migration to Europe: Consequences of illegal fishing and overfishing in West Africa'. Geneva: Global Initiative against Transnational Organized Crime. https://globalinitiative.net/analysis/illicit-migration-to-europe-consequences-of-illegal-fishing-and-overfishing-in-west-africa/ (accessed 30 July 2021).

Rao, A. and Kelleher, D. (2005). 'Is there life after gender mainstreaming?'. *Gender and Development* 13(2), 57–69.

Rao, V. and Walton, M. (eds.). (2004). *Culture and Public Action*. Stanford: Stanford University Press.

Raschke, V. and Cheema, B. (2007). 'Colonisation, the new world order, and the eradication of traditional food habits in East Africa: Historical perspective on the nutrition transition'. *Public Health Nutrition* 11(7), 662–74.

Reading, A. (2014). 'Making feminist heritage work: Gender and heritage'. In Waterton, E. and Watson, S. (eds.), *The Palgrave Handbook of Contemporary Heritage Research*, 397–413. Basingstoke: Palgrave Macmillan.

Republic of Mozambique. (2006). *Action Plan for the Reduction of Absolute Poverty*. Maputo: Council of Ministers, Government of Mozambique.

Republic of Mozambique. (2011). *Poverty Reduction Action Plan (PRAP) 2011–2014*. Maputo: Council of Ministers, Government of Mozambique.

République du Sénégal. (2006). *Document de stratégie pour la croissance et la réduction de la pauvreté*. Dakar: Government of Sénégal. www.bameinfopol.info/IMG/pdf/DSRP2-FINAL-juin2006.pdf (accessed 12 January 2022).

République du Sénégal. (2011). *Proposition d'inscription sur la Liste du Patrimoine Mondial. Pays Bassari: Paysages culturels Bassari, Peul et Bédik*. https://whc.unesco.org/uploads/nominat ons/1407.pdf (accessed 26 July 2021).

Richter, A. (2018). 'The norm life cycle of the UN Reform: "Delivering as One and UN system-wide coherence"'. *Journal of International Organizations Studies* 8(2), 25–46. http://journal-iostud ies.org/sites/default/files/2020-01/4JIOSfall17_0.pdf (accessed 12 January 2022).

Rizzo, I. and Throsby, D. (2006). 'Cultural heritage: Economic analysis and public policy'. In Ginsburg, V. and Throsby, D. (eds.), *Handbook of the Economics of Art and Culture*, Vol. 1, 983–1016. Amsterdam: North-Holland.

Roca, M. V. (2017). 'Archaeology, heritage and development in two South American colonial sites: The Guarani-Jesuit missions (1610–1767)'. In Gould, P. G. and Pyburn, K. A. (eds.), *Collision or Collaboration: Archaeology encounters economic development*, 117–36. Cham: Springer.

Rössler, M. (2006). 'World Heritage cultural landscapes: A UNESCO programme, 1992–2006'. *Landscape Research* 31(4), 333–53.

Rostow, W. W. (1960). *The Stages of Economic Growth: A non-communist manifesto*. Cambridge: Cambridge University Press.

Ryan, J. and Silvanto, S. (2009). 'The World Heritage List: The making and management of a brand'. *Place Branding and Public Diplomacy* 5(4), 290–300.

Salazar, N. and Zhu, Y. (2015). 'Heritage and tourism'. In Meskell, L. (ed.), *Global Heritage: A reader*, 240–58. Chichester: Wiley Blackwell.

Saouma, G. and Isar, Y. R. (2015). '"Cultural Diversity" at UNESCO: A trajectory'. In De Beukelaer, C., Pyykkönen, M. and Singh, J. P. (eds.), *Globalization, Culture, and Development: The UNESCO Convention on Cultural Diversity*, 61–74. New York: Palgrave Macmillan.

Scheyvens, R. (2007). 'Exploring the tourism–poverty nexus'. *Current Issues in Tourism* 10(2–3), 231–54.

Scheyvens, R. and Biddulph, R. (2018). 'Inclusive tourism development'. *Tourism Geographies* 20(4), 589–609.

Schmidt, M. (2009). *Poverty and Inequality in Namibia: An overview*. Windhoek: Institute for Public Policy Research.

Schmitt, T. (2005). 'Jemaa el Fna Square in Marrakech: Changes to a social space and to a UNESCO masterpiece of the oral and intangible heritage of humanity as a result of global influences'. *Arab World Geographer* 8(4), 173–95.

Sen, A. (1999). *Development as Freedom*. New York: Knopf.

Sen, A. (2007). 'Capability and well-being'. In Hausman, D. H. (ed.), *The Philosophy of Economics: An anthology*, 3rd ed., 270–94. Cambridge: Cambridge University Press.

Serageldin, I. (1994). 'The challenge of a holistic vision: Culture, empowerement, and the development paradigm'. In Serageldin, I. and Taboroff, J. (eds.), *Culture and Development in Africa*, 15–32. Washington, DC: World Bank.

Settler, F. and Engh, M. H. (2015). 'The black body in colonial and postcolonial public discourse in South Africa'. *Alternation* 14, 126–48.

Shaheed, F. (2012). *Cultural Rights*, UN General Assembly document A/67/287. New York: United Nations.

Shaheed, F. (2014). 'Foreword'. In UNESCO (ed.), *Gender Equality, Heritage and Creativity*. Paris: UNESCO.

Siakwah, P., Musavengane, R. and Leonard, L. (2020). 'Tourism governance and attainment of the Sustainable Development Goals in Africa'. *Tourism Planning and Development* 17(4), 355–83.

Sibongile, L., Van Damme, M. and Meskell, L. (2009). 'Producing conservation and community in South Africa'. *Ethics, Place and Environment* 12(1), 69–89.

Silva, G. (2015). 'UNESCO and the coining of cultural policy'. 10th International Conference in Interpretive Policy Analysis, 8–10 July. https://ipa2015.sciencesconf.org/conference/ ipa2015/pages/ToledoSilva_UNESCO_and_the_coining_of_cultural_policy_envioV3.pdf (accessed 29 July 2021).

Sjöstedt, M. (2013). 'Aid effectiveness and the Paris Declaration: A mismatch between ownership and results-based management?'. *Public Administration and Development* 33(2), 143–55.

Skounti, A. (2017). 'The intangible cultural heritage system: Many challenges, few proposals'. *Santander Art and Culture Law Review* 2(3), 61–76.

Smith, L. (2007). 'Empty gestures? Heritage and the politics of recognition'. In Silverman, H. and Ruggles, D. F. (eds.), *Cultural Heritage and Human Rights*, 159–71. New York: Springer.

Smith, L. (2008). 'Heritage, gender and identity'. In Graham, B. and Howard, P. (eds.), *The Ashgate Research Companion to Heritage and Identity*, 159–80. Aldershot: Ashgate.

Sofield, T. (2003). *Empowerment for Sustainable Tourism Development*. Oxford: Pergamon.

South African Human Rights Commission. (2017). *National Hearing on the Underlying Socio-Economic Challenges of Mining-affected Communities in South Africa*. Braamfontein: South African Human Rights Commission.

Souto, A. N. (2013). 'Memory and identity in the history of Frelimo: Some research themes'. *Kronos* 39(1), 280–96.

Spenceley, A. (2019). 'Sustainable tourism certification in the African hotel sector'. *Tourism Review* 74(2), 179–93.

Spenceley, A. and Meyer, D. (2012). 'Tourism and poverty reduction: Theory and practice in less economically developed countries'. *Journal of Sustainable Tourism* 20(3), 297–317.

Staiff, R., Bushell, R. and Watson, S. (eds.). (2013). *Heritage and Tourism: Place, encounter, engagement*. London: Routledge.

Standish, D. (2012). *Venice in Environmental Peril? Myth and reality*. Lanham, MD: University Press of America.

Starr, F. (2013). *Corporate Responsibility for Cultural Heritage: Conservation, sustainable development, and corporate reputation*. London: Routledge.

Steady, F. (2006). *Women and Collective Action in Africa*. Basingstoke: Palgrave Macmillan.

Stirrat, R. (2008). 'Mercenaries, missionaries and misfits: Representations of development personnel'. *Critique of Anthropology* 28(4), 406–25.

Stupples, P. and Teaiwa, K. (eds.). (2017). *Contemporary Perspectives on Art and International Development*. London: Routledge.

Subrahmanian, R. (2005). 'Gender equality in education: Definitions and measurements'. *International Journal of Educational Development* 25, 395–407.

Tacchi, J. (2002). 'Transforming the mediascape in South Africa: The continuing struggle to develop community radio'. *Media International Australia incorporating Culture and Policy* 103(1), 68–77.

Tadesse, B. (2013). *Final Evaluation – Ethiopa: Thematic window – culture and development*. New York: MDG Achievement Fund.

Taruvinga, P. (2020). 'World Heritage, sustainable development, and Africa'. In Aldenderfer, M. (ed.), *Oxford Research Encyclopedia of Anthropology*, 1–28. Oxford: Oxford University Press.

Taruvinga, P. and Ndoro, W. (2003). 'The vandalism of the Domboshava rock painting site, Zimbabwe: Some reflections on approaches to heritage management'. *Conservation and Management of Archaeological Sites* 6(1), 3–10.

Terrill, G. (2014). '"Surprise!" is not good system design: The upstream process for nominations to the World Heritage List'. *Heritage and Society* 7(1), 59–71.

Thiaw, I. (2014). 'The management of cultural World Heritage sites in Africa and their contribution to sustainable development in the continent'. In Makuvaza, S. (ed.), *The Management of Cultural World Heritage Sites and Development in Africa: History, nomination processes and representation on the World Heritage List*, 69–82. London: Springer.

Thiaw, I. and Ly, M. A. (2019). 'Behind the façade of the diplomacy of international culture aid'. In Labadi, S. (ed.), *The Cultural Turn in International Aid: Impacts and challenges for heritage and the creative industries*, 109–22. London: Routledge.

Throsby, D. (1999). 'Cultural capital'. *Journal of Cultural Economics* 23(1), 3–12.

Thuram, L. (2020). *La Pensée Blanche*. Paris: Philippe Rey.

Timothy, D. and Nyaupane, G. (eds.). (2009). *Culural Heritage and Tourism in the Developing World: A regional perspective*. London: Routledge.

Tinker, I. (1990). *Persistent Inequalities: Women and world development*. Oxford: Oxford University Press.

Truscott, M. (2011). 'Peopling places, storying spaces'. *Heritage and Society* 4(1), 125–34.

Tucker, H. and Boonabaana, B. (2012). 'A critical analysis of tourism, gender and poverty reduction'. *Journal of Sustainable Tourism* 20(3), 437–55.

Tuwor, T. and Sossou, M.-A. (2008). 'Gender discrimination and education in West Africa: Strategies for maintaining girls in school'. *International Journal of Inclusive Education* 12(4), 363–79.

UNDP. (2008a). 'Joint programme on harnessing diversity for sustainable development and social change in Ethiopia'. New York: UNDP.

UNDP. (2008b). 'Joint programme proposal: Sustainable cultural tourism in Namibia'. New York: UNDP.

UNDP. (2008c). 'Joint programme on strengthening cultural and creative industries and inclusive policies in Mozambique'. New York: UNDP.

UNDP/Spain Millennium Development Goals Achievement Fund. (2007). *Framework Document*. New York: UNDP.

UNESCO. (1962). *Records of the General Conference: Twelth Session: Resolutions*. Paris: UNESCO.

UNESCO. (1970). *Final Report: Intergovernmental Conference on Institutional, Administrative and Financial Aspects of Cultural Policies, Venice, 24 August–2 September 1970*. Paris: UNESCO.

UNESCO. (1975). *Records of the General Conference: Eighteenth Session: Resolutions*. Paris: UNESCO.

UNESCO. (1977). *Records of the General Conference: Nineteenth Session: Resolutions*. Paris: UNESCO.

UNESCO. (1982a). *World Conference on Cultural Policies: Final report*. Paris: UNESCO.

UNESCO. (1982b). *Point 5.1.2 de l'ordre du jour provisoire: Conseil Exécutif: Cent quinzième session*. Document 115 EX/SP/RAP/1. Paris: UNESCO.

UNESCO. (1985). *World Decade for Cultural Development: Draft plan of action submitted by the director-general*. Paris: UNESCO.

UNESCO. (1988). *Final Report: Intergovernmental Committee of the World Decade for Cultural Development, first session*. Paris: UNESCO.

UNESCO. (1989a). *Strategy for the Implementation of the Plan of Action for the World Decade for Cultural Development: Intergovernmental Committee for the World Decade for Cultural Development, first meeting of the bureau (Paris, 20–21 February 1989)*. Document CC-89/CONF.215/BUR.5. Paris: UNESCO.

UNESCO. (1989b). *Reply by the Director-General to the Debate on Items 4.1. and 4.2. Executive Board*. Document 131 EX/INF.9. Paris: UNESCO.

UNESCO. (1990a). *World Decade for Cultural Development 1988–1997: Plan of action*. Paris: UNESCO.

UNESCO. (1990b). *Fourth UN Development Decade: UNESCO contribution to the preparation of the international development strategy*. Document CC-90/CONF.206/BUR.2b. Paris: UNESCO.

UNESCO. (1991). *Report by the Intergovernmental Committee of the World Decade for Cultural Development on its Activities (1990–1991)*. Document 26C/93. Paris: UNESCO.

UNESCO. (1993). *Twenty-Seventh Session of the General Conference, Item 5.5 of the Provisional Agenda: World Commission on Culture and Development*. Paris: UNESCO.

UNESCO. (1994a). *Rethinking Development: World Decade for Cultural Development, 1988–1997*. Paris: UNESCO.

UNESCO. (1994b). *Final Report, Fourth Regular Session: Intergovernmental Committee of the World Decade for Cultural Development*. Paris: UNESCO.

UNESCO. (1996). *Medium-Term Strategy, 1996–2001*. Paris: UNESCO.

UNESCO. (1997). *Report by the Intergovernmental Committee of the World Decade for Cultural Development on its Activities (1996–1997)*. Paris: UNESCO.

UNESCO. (2002). *Budapest Declaration on World Heritage*. Paris: UNESCO.

UNESCO. (2003). *Convention for the Safeguarding of the Intangible Cultural Heritage*. Paris: UNESCO.

UNESCO. (2005). *Convention on the Protection and Promotion of the Diversity of Cultural Expressions*. Paris: UNESCO.

UNESCO. (2010). *Operational Directives for the Implementation of the Convention for the Safeguarding of the Intangible Cultural Heritage*. Paris: UNESCO.

UNESCO. (2011). *Recommendation on the Historic Urban Landscape*. Paris: UNESCO.

UNESCO. (2012a). *Advancing a Human Centred Approach to Development: Integrating culture into the global development agenda*. Paris: UNESCO.

UNESCO. (2012b). *Knowledge Management for Culture and Development: MDG-F joint programmes in Ethiopia, Mozambique, Namibia and Senegal*. Paris: UNESCO.

UNESCO. (2012c). *Culture: A driver and an enabler of sustainable development*. Paris: UNESCO.

UNESCO (ed.). (2014a). *Gender Equality: Heritage and creativity*. Paris: UNESCO.

UNESCO. (2014b). *UNESCO – Culture for Development Indicators: Methodology manual*. Paris: UNESCO.

UNESCO. (2014c). *UNESCO Priority Gender Equality Action Plan, 2014–2021*. Paris: UNESCO.

UNESCO. (2015). *Policy for the Integration of a Sustainable Development Perspective into the Processes of the World Heritage Convention*. Paris: UNESCO.

UNESCO. (2016a). *The Executive Board of UNESCO, Special Edition*. Paris: UNESCO.

UNESCO. (2016b). *Operational Directives for the Implementation of the Convention for the Safeguarding of the Intangible Cultural Heritage.* Paris: UNESCO.

UNESCO. (2018). *Culture for the 2030 Agenda.* Paris: UNESCO.

United Nations. (2006). *United Nations Development Assistance Framework 2006–2010: Namibia.* New York: United Nations.

United Nations. (2015). *Resolution on Culture and Sustainable Development.* New York: United Nations.

United Nations. (2016). *Quadrennial Comprehensive Policy Review of Operational Activities for Development of the United Nations System.* New York: United Nations.

United Nations. (2017). *New Urban Agenda.* New York: United Nations.

United Nations. (2018). *Tracking Progress Towards Inclusive, Safe, Resilient and Sustainable Cities and Human Settlements: SDG 11 synthesis report.* New York: United Nations.

UNODC. (2020). *World Wildlife Crime Report: Trafficking in protected species.* Vienna: UNODC.

UNWomen. (2019). *Progress on the Sustainable Development Goals: The gender snapshot.* New York: UNWomen.

Urfalino, P. (2004). *L'invention de la politique culturelle.* Paris: Hachette.

USAID/Mozambique. (2019). *Gender Equality and Female Empowerment.* Maputo: USAID.

Valderrama, F. (1995). *History of UNESCO.* Paris: UNESCO Publishing.

Van de Walle, N. (2005). *Overcoming Stagnation in Aid-Dependent Countries.* Washington, DC: Center for Global Development.

Van Hout, I. (2015). 'Museum Kapuas Raya: The in-between museum'. In Modest, W. and Basu, P. (eds.), *Museums, Heritage and International Development,* 170–87. London: Routledge.

Van Krieken-Pieters, J. (2010). 'An ivory bull's head from Afghanistan: Legal and ethical dilemmas in national and globalised heritage'. In Labadi, S. and Long, C. (eds.), *Heritage and Globalisation,* 85–96. London: Routledge.

Venner, M. (2015). 'The concept of "capacity" in development assistance: New paradigm or more of the same?'. *Global Change, Peace and Security* 27(1), 85–96.

Vickery, J. (2018). 'Creativity as development: Discourse, ideology, and practice'. In Martin, L. and Wilson, N. (eds.), *The Palgrave Handbook of Creativity at Work,* 327–60. Cham: Palgrave-Macmillan.

Vlassis, A. (2012). 'Développement culturel: La relance du fonds pour la promotion de la culture et ses implications institutionnelles et politiques'. *L'Observatoire: Revue des Politiques Culturelles* (Octobre), 1–5. http://www.observatoire-culture.net/rep-revue/rub-article/ido-456/developpement_culturel_la_relance_du_fipc_et_ses_implications_institutionnelles_et_politiques.html (accessed 29 July 2021).

Vlassis, A. (2014). *Gouvernance mondiale et culture.* Liège: Presses Universitaires de Liège.

Vlassis, A. (2015). 'Culture in the post-2015 development agenda: The anatomy of an international mobilisation'. *Third World Quarterly* 36(9), 1649–62.

Vlassis, A. (2017). 'UNESCO, creative industries and the international development agenda: Between modest recognition and reluctance'. In Stupples, P. and Teaiwa, K. (eds.), *Contemporary Perspectives on Art and International Development,* 48–63. London: Routledge.

Walker, C. (1987/1988). 'Wilderness islands in a sea of humanity'. *Inside South Africa,* December 1987/January 1988.

Watson, E. (2006). 'Culture and conservation in post-conflict Africa: Changing attitudes and approaches'. In Radcliffe, S. (ed.), *Culture and Development in a Globalizing World,* 58–82. London: Routledge.

Waylen, G. (1996). *Gender in Third World Politics.* Buckingham: Open University Press.

Wells, C. (1987). *The UN, UNESCO and the Politics of Knowledge.* New York: Palgrave Macmillan.

Wendoh, S. and Wallace, T. (2005). 'Re-thinking gender mainstreaming in African NGOs and communities'. *Gender and Development* 13(2), 70–9.

Wijkman., A. and Rockström, J. (2012). *Bankrupting Nature: Denying our planetary boundaries.* London: Routledge.

Wiktor-Mach, D. (2020). 'What role for culture in the age of sustainable development? UNESCO's advocacy in the 2030 Agenda negotiations'. *International Journal of Cultural Policy* 26(3), 312–27.

Wilson, R. (2018). 'The tyranny of the normal and the importance of being liminal'. In Grahn, W. and Wilson, R. J. (eds.), *Gender and Heritage: Performance, place and politics,* 3–13. London: Routledge.

Witter, R. (2013). 'Elephant-induced displacement and the power of choice: Moral narratives about resettlement in Mozambique's Limpopo National Park'. *Conservation and Society* 11(4), 406–19.

Wolfensohn, J. (1999). *Culture Counts: Financing, resources and the economics of culture in sustainable development*. Washington, DC: World Bank.

Womack, B. (2016). *Asymmetry and International Relationships*. Cambridge: Cambridge University Press.

Wong, S. and Guggenheim, S. (2018). *Community-driven Development: Myths and realities?*. Washington, DC: World Bank.

World Bank. (1999). *Culture and Sustainable Development: A framework for action*. Washington, DC: World Bank.

World Bank. (2001). *Cultural Heritage and Development: A framework for action in the Middle East and North Africa*. Washington, DC: World Bank.

World Bank. (2005). *Capacity-Building in Africa: An OED evaluation of World Bank support*. Washington, DC: World Bank.

World Bank. (2016). *Community Driven Development: A vision of poverty reduction through empowerment*. Washington, DC: World Bank.

World Bank. (2017). *Mozambique: Mozambique country forest note*. Washington, DC: World Bank.

World Bank. (2018a). *Strong but not Broadly Shared Growth: Mozambique – poverty assessment*. Washington, DC: World Bank.

World Bank. (2018b). *Guidance Note for Borrowers: Environmental and social framework for IPF operations. ESS8: Cultural Heritage*. Washington, DC: World Bank.

World Bank. (2018c). *Mozambique country forest note*. Washington, DC: World Bank.

World Commission on Culture and Development. (1995). *Our Creative Diversity: Report of the World Commission on Culture and Development*. Paris: UNESCO.

World Commission on Environment and Development. (1987). *Our Common Future*. Oxford: Oxford University Press.

World Rainforest Movement and Timberwatch Coalition. (2016). *Industrial Tree Plantations Invading Eastern and Southern Africa*. Montevideo (Uruguay) and Hillcrest Park (South Africa): World Rainforest Movement and Timberwatch Coalition.

Wright, S. (1998). 'The politicization of "culture"'. *Anthropology Today* 14(1), 7–15.

Zhao, W. and Brent Ritchie, J. R. (2007). 'Tourism and poverty alleviation: An integrative research framework'. *Current Issues in Tourism* 10(2–3), 119–43.

Zulu, J. (2020). 'Notions of sustainable development: The case of Mosi-Oa-Tunya/Victoria Falls Transboundary World Heritage Property, Livingstone, Zambia'. In Labadi, S., Giliberto, F., Taruvinga, P. and Jopela, A. (eds.), *World Heritage and Sustainable Development in Africa: Implementing the 2015 policy*, 96–109. Midrand: African World Heritage Fund.

Index

References to images are in *italics*; references to notes are indicated by n.

climate change 1, 85, 209–13
 and fishing 178, 180
 and heritage 192–3
 and Senegal 114, 168, 172
 and tree planting 183
Cold War 25, 27, 28, 31, 33, 36
colonialism 15, 17, 75, 82–3, 189–90
 and aid 88
 and exclusionary practices 110–11
 and Mozambique 115, 119–20, 121
 and Namibia 87, 121–2
 and resources 178
 and tourism 202
 and wildlife 177
 and women 136–7, 150
 see also decolonisation; neocolonialism
commercialisation 60–1
commoditisation 128
community see local communities
conflict zones 70
consent 61
conservation 174–7
construction 66
consultants 88–9
consumerism 26, 29
Convention for the Safeguarding of the
 Intangible Cultural Heritage (2003) 55,
 57–8, 59–61, 77–8
Convention on the Protection and Promotion
 of the Diversity of Cultural Expressions
 (2005) 55, 58, 61–4, 78
cooperation 38, 39, 41
Covid-19 pandemic 1, 2, 132, 202–3
crafts 8, 9, 12
 and environment 210
 and exports 131
 and promotion 65
 and Senegal 106, 107, 112–13
 and training 124, 125–8
 and World Bank 50
crops 8, 198, 211–12; see also fonio
cultural identity 32, 35, 37, 38, 42–3, 47, 49
cultural rights 137–45
culture 1–6, 16–17
 and 1970s 30–2
 and Africa 169–70
 and Bokova 67–8
 and civilizations 58
 and destruction 26
 and development 13–14, 24–5
 and diversity 15, 44–5, 61–4
 and erasure 15–16
 and Ethiopia 11–12
 and international aid 85–6
 and MONDIACULT 32–7
 and Mozambique 7–8
 and Namibia 9–11
 and nature 164, 165–9, 187
 and peace 41, 42
 and politics 90
 and SDGs 73–5
 and Senegal 8–9
 and sub-Saharan Africa 6–7
 and sustainable development 70–2
 and UNESCO 27–30
 and women 136

 and World Bank 49–51
 and World Decade 38–9, 46–7
 see also heritage
Culture Action Europe 4, 72

Da Gama, Vasco 119–20
dance see performing arts
Decades of Development 25, 26
decolonisation 25, 27, 29, 215–16
deforestation 6, 9, 187–8
delays 96, 100
Delivering as One principles (2007) 81, 82,
 91–6, 101, 102
development 16–21, 32, 41
 and World Decade 38–9, 44–5
 see also Intergovernmental Conference on
 Institutional, Administrative and Financial
 Aspects of Cultural Policies; sustainable
 development
dictatorships 33
digital platforms 129–30
disarmament 27
discrimination 15, 17, 46, 136
 and women 138, 139, 144, 150, 151–2,
 161, 205–7
disease 2, 37
Duineveld 10

Ebola 2
economics 1–2, 29, 36
 and environment 173–4, 175, 177–8
 and fisheries 179
 and New Order 32, 35
 and reforestation 184, 185
education 6, 17, 67
 artistic 32
 and colonialism 110
 and culture 35, 71
 and gender equality 144–5, 151
 and heritage 214–17
 and local businesses 200
 and poverty 104
 and South Africa 49
 and UNESCO 72–3, 78
Egypt 31, 42, 115
EIGs (Economic Interest Groups) 147, 157,
 158, 179, 182
elephants 174–5, 176
employment 104, 199
 and women 152, 161, 205
empowerment 135–6, 149, 152, 157, 204–9
endogenous development 32
environmental protection 2, 3, 5–6, 26, 164–5,
 187–8, 209–13
 and Brundtland Report 44, 46
 and cultural diversity 71
 and development 16
 and economics 173–4, 175, 177–8
 and Ethiopia 172–3
 and fisheries 178–82
 and forestry 183–7
 and 'success' 14
 see also nature
erasure 15–16, 190
 and education 216
 and environment 168

and Mozambique 121, 156
and women 153
Ethiopia 5, 11–12, 81, 96, 97
and artisans 125, 130–1
and environment 172–3
and gender equality 148
and MDG-F 64, 83, 84
and poverty reduction 104
and site protection 123
and tourism 115
ethnic hatred 41
ethnic minorities *see* Indigenous people;
minority groups
Europe 15, 16, 17
European Union (EU) 62, 64
experts 36
extractive industries 177–8

Fall, Yoro 44
Fasil Ghebbi 12, 123
femicide 137
Festival of the fonio (fête du fonio)
153, 157–60
festive events 59, 60, 111–12, 153–8
FGC (female genital cutting/circumcision) 143
film 143
fishing 8, 9, 176, 178–82, 190
and diving businesses 200
and protection 210
and Senegal 105, 106, 114, 132
and women 204
flagship projects 42–3
fonio 9, 106, 107, 132, 161, 211
and climate change 172
and festival 157–60
and heritage 194
and women 147
Food and Agriculture Organisation (FAO) 7
food security 8, 144, 161, 172, 198
forestry *see* deforestation; reforestation
France 17, 18, 28, 31
and 2005 Convention 62, 63–4
and ALIPH 70
and 'Banks of the Seine' 166
and colonialism 88
and Senegal 82, 114
freedom fighters 26
FRELIMO (Mozamique Liberation Front) 14,
154–7, 158
funding 30, 42–3, 63, 93–4, 109
and artists 124, 126–7, 131
see also international aid; MDG-F
(Millennium Development Goals
Achievement Fund)
funeral practices 2

game reserves 177
Gangneung Danoje festival (South Korea) 60
GDP (gross domestic product) 73–4, 104, 134
gender-blindness 161–2, 205–6
gender equality 2, 3, 5–6, 135–6, 204–9
and cultural rights 137–45
and development 16
and Ethiopia 12
and festive events 153–60
and heritage 21, 160–2
and MDGs 52

and Namibia 10–11
and 'success' 14
and training 146–53
see also women
gender inequality 140–1, 149
General History of Africa 38
gentrification 76
geopolitics 13, 24, 41; *see also* Cold War;
colonialism
Germany 82
Global North 17–18, 26, 28–9, 214
Global South 17–18, 25, 26–7, 28–9, 32, 37–8;
see also Africa
globalisation 36
Gondar 11
Gondwanaland Geopark 11
governance 76, 126, 133
grand developmentalism 84–5
'Grapholies, Salon Africain des arts plastiques'
exhibition 43
Group of 77 26–7
Guatemala 65
Guebuza, Armando 184
guides *see* tour guides
Guinea-Bissau 48, 158
Guterres, António 70

Hangzhou International Congress 'Culture:
Key to Sustainable Development'
(2013) 71
Harar 11
healers 139, 141
healthcare 139, 141
Helsinki conference (1972) 30
Henties Bay 10
heritage 1–6, 12–13, 189–90
and Africa 169–70
and artists 127–8
and Bassari Country 170–2
and community 193–4
and conflict zones 70
and development 13, 18–21
and dimensions 194–5
and diversity 15
and dynamism 192–3
and education 214–17
and environment 165–6, 209–13
and equality 195–6
and Ethiopia 12, 172–3
and gender 136, 204–5
and Mozambique 8, 115–21
and Namibia 10–11, 87, 121–2
and new maps 202–3
and politicisation 14, 90
and poverty reduction 132–4, 198–9
and SDGs 75–7
and Senegal 105–14
and sustainable development 191–2
and tourism 47–8
and UNESCO 74–5
urban 66–7
and women 138
and World Bank 49–50
and World Decade 45
see also intangible heritage; tangible
heritage; World Heritage Convention
Hiroshima 58

pollution 26
population growth 212
Portugal 82, 115, 119–20, 121
poverty reduction 1, 2, 3, 5–6, 12, 104–5,
 131–4, 198–204
 and capacity-building 122–31
 and development 16
 and Ethiopia 11–12
 and MDGs 52
 and Mozambique 115–21
 and Namibia 10, 121–2
 and Senegal 105–14
 and 'success' 14
 and tourism 190
 and World Bank 76
Power, Samantha 69
power relations 17, 201–2
prejudice 41
prerequisites 191–8
Preston, Lewis T. 48
Priority Africa 146

'Queen of the fonio' see Ndiaye, Adja
 Aïssatou Aya

racism 27
radio 9, 106, 107, 185
 and cultural rights 140–1, 142–4
Recommendation on the Historic Urban
 Landscape (2011) 55–6, 66–7, 76
reforestation 8, 167, 168, 183–7
resources 17, 18, 178; see also fishing
restaurants 7, 106, 123, 147, 190
Río Plátano 65
rituals 2, 14, 59, 60, 140–1
Roads of Faith, The 42
Rundu 10
Russia 69–70; see also Soviet Union
Rwanda 41

Saddam Hussein 42
Saloum Delta 8, 9, 98
 and climate change 172
 and education 145
 and fisheries 179–81
 and heritage 105, 109–10, 113–14
 and Keur Bamboung 196, 210
 and nature 165, 166–9
 and reforestation 185
 and seashells 193, 211
Scandinavia 72
SDGs (Sustainable Development Goals) 1,
 2–4, 5, 6, 16
 and Bokova 69, 70
 and environment 164
 and gender equality 204–5
 and heritage 75–7
 and UNESCO negotiations 73–4
seasonal migration 171
Sen, Amartya 44, 60, 151–2, 161
Senegal 5, 8–9, 12, 81
 and artisans 125, 127, 128, 130
 and climate change 192–3
 and cultural rights 142–4
 and Delivering as One 93–4, 95

and education 144–5
and environment 165, 166–8, 170–1
and ethnic minorities 193–4
and fisheries 179–81
and France 82
and gender equality 147, 148, 152,
 153, 157–60
and Gorée 202
and indigenous history 90
and MDG-F 64, 87
and poverty reduction 104, 105–14, 132
and reforestation 185
and social justice 196
and sustainability 97, 98, 100
and women 205
Sengeh, David Moinina 209
Serageldin, Ismail 48
sexual and reproductive health (SRH) 100,
 138–41, 160
sexuality 139
Shaheed, Farida 137, 195
shea trees 9, 106–7, 132, 147
Sian Ka'an 65
Sierra Leone 209
site managers 109–10, 111, 191–2, 194, 198
Slave Route 42
slavery 115, 121, 216
social justice 196
socio-cultural contexts 85–6, 143–4, 148, 152
South Africa 35, 49, 82
 and gender equality 151
 and higher education 214
 and HIV/AIDS 141
 and local businesses 200
 and 'Rhodes Must Fall' movement 110
 and tourism 202, 203
 and wildlife 177
South Korea 60
Southern Nations, Nationalitiess and
 Peoples 11
souvenirs 127–8, 176
sovereignty 33, 35
Soviet Union 31, 36
Spain 5–6, 64–5, 81, 112–13, 146
statues 14, 119–20
stereotypes 21, 133, 136, 138, 190
 and Africa 22, 164, 171, 172
 and education 145
 and gender 150, 151–2, 161
 and heritage 170–2
 and women 205–6
Stockholm Intergovernmental Conference on
 Cultural Policies for Development (1998)
 45, 50, 51, 58, 62
sub-Saharan Africa 6–7, 15; see also Ethiopia;
 Mozambique; Namibia; Senegal;
 South Africa
supernatural forces 168
sustainable development 59, 96–101, 164, 165
 and culture 70–2
 and economics 173–4, 177–8
 and heritage 191–2
 and UNESCO 77
 see also SDGs
Swakopmund 10

Milton Keynes UK
Ingram Content Group UK Ltd.
UKHW051826040324
438897UK00011B/87